John C. Laughton

ENGAGING ART

ENGAGING ART

THE NEXT GREAT TRANSFORMATION OF AMERICA'S CULTURAL LIFE

EDITED BY STEVEN J. TEPPER
AND BILL IVEY

This book was made possible with support from The Wallace Foundation.

Routledge
Taylor & Francis Group
New York London

This book was made possible with support from The Wallace Foundation.

First published 2008
by Routledge
2 Park Square, Milton Park, Abingdon, Oxon OX14 4RN

Simultaneously published in the USA and Canada
by Routledge
711 Third Avenue Avenue, New York, NY 10017
Routledge is an imprint of the Taylor & Francis Group, an informa business

© 2008 by Taylor & Francis Group, LLC

Transferred to Digital Printing 2008

International Standard Book Number-13: 978-0-415-96042-7 (Softcover) 978-0-415-96041-0 (Hardcover)

Library of Congress Cataloging-in-Publication Data

Engaging art : the next great transformation of America's cultural life / edited by
 Steven J. Tepper and Bill Ivey.
 p. cm.
 Includes bibliographical references and index.
 ISBN 978-0-415-96041-0 (hardback) -- ISBN 978-0-415-96042-7 (pbk.)

 1. Arts--United States--Citizen participation. 2. Arts audiences--United States. I.
Ivey, William, 1919- II. Tepper, Steven J.
NX230.E54 2007 700.1'030973--dc22 2007018048

Visit the Taylor & Francis Web site at
http://www.taylorandfrancis.com

and the Routledge Web site at
http://www.routledge.com

CONTENTS

SECTION THREE:
NEW TECHNOLOGY AND CULTURAL CHANGE

SECTION FOUR:
REVISITING CULTURAL PARTICIPATION AND CULTURAL CAPITAL

ACKNOWLEDGMENTS

This book represents the efforts of many people, whose collective dedication, intelligence, and insight have produced what we hope will be an enduring analysis of cultural participation in America. First, we would like to acknowledge the foresight and commitment of Lucas Held and Ann Stone at the Wallace Foundation, who recognized the need for such a book, garnered the resources to make it happen, helped to frame its contents, and provided suggestions and feedback on the entire manuscript. Alberta Arthurs was also instrumental in conceiving of the book, offering feedback, and helping facilitate a meeting of the authors at Vanderbilt. We ae indebted to Tom Bradshaw, Jeffrey Brown, Alan Brown, Aaron Flagg, Joe Lamond, Marcia Mitchell, and Alaka Wali, who provided helpful advice and counsel during the 2005 Vanderbilt meeting to review an early draft of the book.

Heather Lefkowitz oversaw the project from start to finish, holding together what at times seemed like an unwieldy set of authors, editors, and funders. She is also a contributing editor. The major bulk of editing was done by Ashli White, who did a masterful job of pruning, massaging, and otherwise making all of us sound much smarter than we are. Nan Zierden served as an assistant editor and helped pull all of the chapters together at the very end into a meaningful whole. Dan Cornfield, one of the authors in the volume, helped us raise our sights to see the larger significance of the book, encouraging us to develop our thesis that cultural participation in America was experiencing a renaissance that would reshape scholarship and policy. Neala Swaminatha, Brielle Bryan, and Chethena Biliyar provided excellent research assistance. Elizabeth Long Lingo also read several versions of the conclusion and provided extremely useful feedback.

We are grateful to our colleagues who contributed chapters and who patiently worked through multiple drafts. The work in this volume is both smart and original. The authors took up our challenge to investigate how our cultural landscape is changing and what the implications of these changes might be for policy. The quality and reputation of the authors are direct testimony to the importance of the subject matter.

Finally, we would like to recognize the support of Mike Curb and the Curb Family Foundation. The book is a project of the Curb Center for Art, Enterprise, and Public Policy. It was Curb's vision to create a center that would explore bold, new approaches to improving America's cultural life. *Engaging Art* embodies this vision.

INTRODUCTION: THE QUESTION OF PARTICIPATION

Bill Ivey

In 2002, Lucas Held, director of communications for the New York City-based Wallace Foundation, received a phone call that left him puzzled. A *Chicago Tribune* reporter was on the line, gathering reactions to a press release that summarized the results of the Survey of Public Participation in the Arts (SPPA), a long-established survey conducted every five years by the National Endowment for the Arts. The press release highlighted the fact that overall attendance was up and that a majority of Americans had participated in an arts activity over the last year. But the figures also showed participation was down in some areas and that some audiences were getting older. "The Wallace Foundation has been supporting arts participation for years, what is your reaction to these figures? What do these figures mean?" the reporter asked.

Held provided the reporter with a comment that pointed to the foundation's belief in the ongoing importance of expanding participation in the arts. But the question of what these figures meant was a haunting one. Held raised the question of changing patterns of participation with his Wallace colleagues. What was the foundation to make of the data? Was it good or bad—or something else? What was driving the numbers? How might the foundation contribute to a better understanding of the changing character and scope of participation in the arts in the United States and thereby contribute to more informed decision making by arts organizations, policymakers, and others?

The reporter was right on two counts. The Wallace Foundation had been, and remains, an important source of support for projects designed to increase attendance at nonprofit cultural organizations, and to build an understanding of how to improve it. And the reporter was right to ask whether the NEA's most recent SPPA survey suggested that both the character and quantity of arts participation was in transition. Emerging indicators might point to changes that did not bode well for the museums, orchestras, theater, and dance companies that derived half of annual revenue from admissions. These organizations harbored the expectation that young audiences would step up to fill galleries and performance halls as older audiences declined. Unstated by the reporter was a question of whether new technologies, new patterns of cultural distribution, and new priorities of emerging arts consumers were converging to cloud the future of America's cultural institutions.

Made possible with the support of The Wallace Foundation and independently researched and edited by the Curb Center at Vanderbilt University, this volume is an attempt to address the question of how to better understand the changing landscape of cultural participation. By bringing the perspectives of multiple scholars and experts to the table, we hope to establish both a sense of how Americans participate in the arts today as well as to gain an understanding of those forces of technology and commerce that will likely shape the character of participation in the arts for the remainder of the century. A fresh look at the National Endowment for the Arts (NEA) Survey of Public Participation in the Arts—the most widely used and long-standing survey of its kind—is an appropriate starting point for this discussion.

However, as the chapter by Steven J. Tepper and Yang Gao discusses, the SPPA has by choice, and from its inception, focused on attendance at the activities of the kinds of organizations that typically interact with the Arts Endowment—cultural nonprofits. The NEA's survey never adequately tracked serious musicianship, filmmaking, graphic design, self-published collections of poetry, or the multitude of other activities that enable Americans to connect with art and art making. Today, in fact, given anecdotal evidence of growing amateur practice and the obvious increase in online participation in both the creation and consumption of art, the divergence between the SPPA and the breadth of everyday art engagement in the United States may be more pronounced than when the survey was implemented twenty-five years ago.

Because of the character of the SPPA, it was inevitable that once the process was set in motion, our conversations with experts and the essays in this volume would move beyond survey findings and beyond attendance patterns at nonprofit museums and performing arts organizations to look at broadcasting, online art making, and choice in cultural consumption. In short, although this volume began as a look back at the SPPA, it has evolved to be a first step in an effort to gain a fresh perspective on how an active connection with the arts shapes quality of life in our American democracy.

* * * * * *

In 1909, 364,545 pianos were manufactured and sold in the United States—an impressive total in a country with a population of less than 100 million.[1] A robust piano industry at the turn of the last century should surprise no one. Through much of the nineteenth century, the piano had served as the nation's archetypal cultural hearth, and images of a family sing or an informal after-dinner performance of a classical piece by a young music student were staples of American domesticity. Then, the ability to sing or play music and, for that matter, drawing and the writing and recitation of poetry were considered everyday skills, integrated into family life as thoroughly as sewing or the canning of autumn garden produce. In a review of a 2006 exhibition of drawing instruction books, *New York Times* critic Michael Kimmelman noted that between 1820 and 1860, nearly 150,000 drawing manuals were published: "Before box cameras became universal a century or so ago, people drew for pleasure but also because it was the best way to preserve a cherished sight, a memory, just as people played an instrument or sang if they wanted to hear music at home because there were no record players or radios. Amateurism was a virtue, and the time and effort entailed in learning to draw, as with playing the piano, enhanced its desirability" (2006 p. 1).

From our contemporary perspective, we can see that drawing, after-dinner theatricals, homemade music, and the very character of participation in the arts were about to undergo a dramatic and permanent change. In fact, 1909 was in some ways a high-water mark of cultural engagement in the manner of nineteenth century; more pianos were sold in the United States in that twelve-month period than would ever again be sold in a single year. By 1923, the year my mother began lessons,

piano sales had slipped to 347,589, and by 1933, sales had plunged to just over 34,000 instruments.[2]

The Great Depression contributed to this decline, but it was more than a crippled economy that pushed piano sales to their twentieth-century low point. By the early 1930s, America's new cultural industries were well on the way to transforming the way citizens engaged culture, thereby reconfiguring our definition of *participation* in art and culture. In 1909, even as piano sales peaked, nearly 350,000 phonographs were sold, a remarkable total for an emerging industry that had at the time produced only a handful of disc and cylinder releases to play on the new machines. And as piano sales began to decline, the boom in records and radio actually accelerated. In 1919, 2.2 million phonographs were sold; even more remarkably, 4 million radios were sold in 1929, just before the Great Crash. The radio, or the radio–phonograph, often dressed up in handsome cabinetry, emerged as the new cultural center of American homes; it was the introduction of our electronic hearth. The piano would never regain its dominant position in domestic artistry. And the revolution in technologies and business models reshaped art across the board. During the same period in which radio and recordings emerged, movies became a national obsession. By 1920, there were 20,000 silent movie theaters operating across the United States; the Roxy, which opened in New York City in 1927, could accommodate a movie audience of 6,000.

It was inevitable that this new era of cultural consumption—an era of radio, records, and film unimagined in the nineteenth century—would subvert old notions of participation. As *The Etude*, the magazine of amateur pianists, opined in its 1933 fiftieth-anniversary special edition, "Many parents were deceived by the radio bugbear and came to the unfortunate and unwarranted conclusion that, now that well-rendered programs to suit any taste could be introduced into the home with no more effort than the turning of a button, it would not be worth while for their children to study music" (1933, p. 646).

In its own way music education embraced the trend, following the rush toward cultural consumption by shifting its attention away from teaching young people to make music, mostly through ensemble singing, toward an alternative that could be best described as the intelligent enjoyment of music—that is, what came to be known as music (or art for that matter) appreciation. It is the field of art appreciation that has

advanced the notion of literacy in or fluency with the history, practices, standards, and personalities of different art forms as a distinct form of participation. Henceforth, the requirement to draw, sing, act, recite, play, or otherwise perform in the arts would be replaced by some form of consumption—consumption that might be as casual as the purchase of a new jazz record or the twist of a radio dial or as schooled as a guided museum tour or narrated young peoples' concert. If we think of our expressive life as divided between culture we create and culture we take in, the commoditization of art pumped up consumption—the taking in of art—while simultaneously undermining art making.

By the middle of the last century, with arts industry products and art appreciation solidly established, the original dictionary definition of *participate*—"to take part"—had been replaced by the second, more passive meaning, "to have a part or share of something" (1986, p. 858). By the early 1960s, when American foundations began to address the notion of cultural vibrancy by making available matching grants designed to increase the capacity and reach of nonprofit arts organizations, the concept of participation had already been reshaped to be about audiences and consumption through attendance at nonprofit events. Grant programs were an investment in culture that in an egalitarian, democratic spirit encouraged more Americans to have a share. Because of these investments, more Americans, especially those living outside of major cities, had better access than ever before to the fine arts.

Late in the last century, when nonprofit grant makers, and later the NEA, began to measure the health of the fine arts, it was natural that attendance at nonprofit cultural events would be a key marker of vitality. And as symphony orchestras, art museums, and dance and opera companies were encouraged by public and private funders to connect their work with audiences of all ages, ethnicities, nationalities, and races, it became important to go beyond attendance alone to measure the quality of attendance: Who was coming; where did they live; were they rich, poor, black, or white? Audience assessment became an important facet of the policies that shaped nonprofit programming.

The shared assumption that participation means attendance and intelligent consumption (appreciation) went hand in hand with the belief that attendance at fine arts events, the benchmark art forms, constitutes a special realm of cultural consumption, one that is qualitatively distinct from activities like attending movies, watching TV, or listening to live

music in a neighborhood bar. This distinction—as discussed by Richard Peterson and Gabriel Rossman in chapter 13 of this volume—has historically helped to justify the support of both public agencies and private philanthropy. In part, this focus on nonprofit arts organizations is embedded in the portfolio of the NEA, the agency that created and maintains the SPPA. It was, and remains, important for the NEA to track the health of its partners: the orchestras, museums, and nonprofit literary publishers who receive NEA grants. But the scope of the SPPA also enshrines long-held beliefs about the superiority of the fine arts: Art with a capital A. Despite the development of programs in folk arts and jazz, the NEA never moved far from its fine arts roots.

During my tenure as NEA chair, we worked with the Record Industry Association of America (RIAA) to develop an in-school program on American popular music, bringing free Internet-streamed audio and supporting print materials on historical recordings into classrooms all over the country. The Songs of the Century was unabashedly about American popular music and the project was viewed suspiciously by at least half of the NEA programming staff. One senior staff member explained it this way: "Why should we be helping students learn about old rock 'n' roll, that's the music we're working against?" And it was a fact that the NEA had always been ambivalent about its role, asserting at times that the agency was determined to increase the overall vitality of the American cultural scene, while simultaneously acting as though its mission were to sustain and advance the nonprofit fine arts. In practice, the agency has tilted toward the latter role; as the NEA's current slogan attests, "A Great Nation Deserves Great Art." It's about art that we need, not art that we want.

The SPPA's more narrow focus on the nonprofit arts gives the survey its strength. The survey provides an essential overview of the changing relationship between citizens and the work of nonprofit arts institutions. Are citizens attending performances and exhibitions? Are young people engaged by museums, opera companies, and symphony orchestras? Are certain demographic groups—the well educated, the poor, women, rural residents—participating more or less than a decade ago? Answers to these questions can be central to the health of America's cultural institutions.

Thus, the SPPA can be viewed as a kind of Nielsen rating service for museums, orchestras, and nonprofit theater companies, a service that

measures popularity by counting how many Americans attend. Even better, unlike Nielsen, the SPPA today provides information gathered over a quarter century, enabling researchers and arts professionals to search out trends and, it is hoped, to craft policies and practices that respond to changes in the economy, technology, cultural consumption, and audience demographics. The past twenty-five years have witnessed startling changes in America's arts system. After all, when the SPPA was initiated in 1982, Sony and Polygram were still struggling to introduce a new technology: the compact disc. The Internet was only a gleam in the eye of a few scientists, and Microsoft was little more than a Pacific-coast start-up. The NEA wisely decided that it was more important to track one set of trends than to constantly change the survey instrument to reflect changing social and cultural circumstances. As a result, we have reliable trend information. But the trade-off means that our most comprehensive source of participation data has not effectively engaged the changing backdrop of powerful forces that require nonprofits to continually adjust their operations.

Using the SPPA as a starting point, this volume engages the idea of participation by advancing two broad themes. First is the obvious question raised by the character of the survey itself: How have technological, cultural, and demographic changes affected nonprofits, and how might they respond to contemporary challenges? The second question moves beyond the well-being of institutions to consider the relationship among citizens, art, and creativity. It asks how we can best conceptualize participation to make art, art making, and connections with arts organizations part of a high quality of life for all Americans. Both questions are important, and both are timely.

The SPPA results of 2002 that alerted the *Chicago Tribune* to the possibility that the fine arts audience in America was shrinking and growing older were delivering a kind of long-range cultural weather forecast, mapping some of the multiple challenges facing the nonprofit arts. For example, over the past decade, the nonprofit arts have not only experienced bumpy attendance patterns but have also been devalued as a destination for philanthropy—the giving part of participation. Americans for the Arts reports that private giving to the arts was 5.2 percent of total philanthropy in 2005, down from 8.4 percent in 1992. Although 67 percent of U.S. households give to nonprofit organizations, only 8 percent contribute to the arts, well behind giving to such areas

as the needy, health care, education, and the environment (Americans for the Arts 2006).

Priorities in individual philanthropy are similar to those emerging within major foundations—a concentration on global health, education, and environmental concerns with special attention directed toward the interaction of these issues with groups that are seen as poor or vulnerable. Culture is dropping off the philanthropic radar screen. When the *New York Times* published a special section called "Giving" on philanthropy in November 2005, its thirty-two pages did not contain a single mention of art or culture. The Rockefeller Foundation, a pioneering investor in America's nonprofit arts organizations, eliminated its national arts program in 2006. And, simultaneously, corporate giving has become ever more strategic and dictated by business outcomes, resulting, in part, in a pullback from the arts, with giving declining by 65 percent between 2000 and 2005.

And the potential audience for nonprofits—the participation backdrop—has been transformed and will continue to change for the rest of this century. Since January 2006, a baby boomer has turned 60 every 7.7 seconds. The United States is home to growing Hispanic and Asian populations. Today, 11 percent of our nation's population is foreign born; 8 percent of families speak English less than well in the home.[3] Obviously, these percentages are significantly higher in the urban areas that are home to most cultural nonprofits. Some trends, like an aging population, might benefit the fine arts; others, like increasing ethnic minorities in cities, might make the symphony and art museum a hard sell. How will American arts organizations engage an increasingly diverse population to secure the hallmarks of participation—attendance, contributions, and comprehension?

In the 1990s, many nonprofits saw the Internet as a key point of connection with audiences. But although technology can create new paths to participation, digital media, the Internet, and handheld delivery devices are just as likely to divert consumers from traditional ways of connecting with exhibitions and performances. A recent Pew study found that 54 percent of Americans prefer to view movies at home, and the introduction of rapid-response DVD rental services and high-definition television sets will undoubtedly exacerbate this trend, as will music delivered to cell phones and iPods (Pew 2006).4 If even well-heeled multinational

arts companies are challenged to keep up with the parade of new delivery devices, what can we expect from our cultural nonprofits?

Many of the essays in this volume address the changing context in which the nonprofit arts must compete, while suggesting new ways to engage audiences. The first four chapters are intended to help the reader think carefully about the definitions and concepts employed when we talk about and do research on cultural participation. In chapter 1, Steven Tepper and Yang Gao introduce the notion that cultural participation is related to other forms of social life—in particular, political and religious participation. By seeing participation in this comparative framework, they open up the possibility for considering new indicators of cultural engagement, especially active art making.

In chapter 2, Mark Schuster adds another comparative dimension to our consideration of cultural participation by examining the United States from a global perspective. How do other countries think about and define cultural participation, and how do they use participation studies to make policy? Schuster alerts us to the complexities of measuring participation and to the great variability across countries. Nonetheless, he provides the first comprehensive league table of participation rates across more than twenty countries, offering a very rough glimpse of where and how the United States differs from other nations.

In chapter 3, Francie Ostrower continues to advance the idea that our language and our conceptual maps of participation are too narrow. In particular, through the analysis of new data collected by the Urban Institute, she demonstrates the importance of looking at personal motivations when attempting to explain participation, recognizing that the arts are not all one thing; rather, cultural attendance is heterogeneous. Not only do the same individuals give different reasons for attending a symphony versus visiting a museum, but different groups of people also give different reasons for attending the same art event. Ostrower's notion of diversity pushes us to think beyond notions of audience diversity (e.g. the ethnic, racial and economic composition of audiences) to think about diversity in terms of multiple motivations and experiences.

Finally, in chapter 4, Lynne Conner provides yet another comparative perspective, focusing on the historical shift from active to passive audiences throughout the course of the twentieth century. She sees a reversal of this shift in the twenty-first century and argues for a new

concept of participation that takes into account the increasingly interactive nature of engagement with art and culture.

Section 2 of the book takes up the challenge of widening our aperture to look at nontraditional audiences, venues, and art forms. In chapter 5, Bob Wuthnow discusses how the arts are a major part of religious life and, through survey data, demonstrates the popularity of religious venues as sites of arts engagement. By dispelling the notion that religion and the arts are antithetical, Wuthnow identifies the prospect for new collaborations and connections between cultural and religious organizations that could increase and enrich participation for both.

Like Wuthnow, Dan Cornfield and Jennifer Lena in chapter 6 investigate an understudied and underappreciated area of cultural participation: the cultural lives of immigrants. Immigrants employ or deploy culture differently from American-born citizens. Culture is more deeply integrated into their everyday lives and is a key currency for connecting them to their host countries while maintaining ties to their country of origin. Their analysis points to important challenges and opportunities facing immigrants as they attempt to sustain art forms relevant to their communities while simultaneously modifying art to reach out to U.S. citizens. Finally, in chapter 7, Henry Jenkins and Vanessa Bertozzi take us beyond ethnic enclaves and religious congregations to explore how young people are engaging with culture through new and old media. This chapter zooms in under the radar screen of mainstream cultural analysis to investigate new forms of cultural engagement—from designing video games to producing comic books to cosplay—interacting with people online around the design of original costumes often based on Japanese anime heroes. Jenkins and Bertozzi portray today's youth as taking control of their cultural lives by investing in their creative hobbies and connecting with others around amateur art making.

In section 3 of the book, the authors directly address how new technology is changing cultural participation. In chapter 8, Steven Tepper, Eszter Hargittai, and David Touve explore the ways college students find out about new music, testing the assumption that new technology is leading to a renaissance in cultural experimentation. They find that many young people are indeed searching for new cultural experiences, but rather than rely on new technology, the vast majority still depend on traditional social networks to discover music. In chapter 9, Joel Swerdlow investigates how technology changes the actual experience of cul-

ture—from multitasking to hypertext to personal media. The depth, concentration, and focus of our cultural engagement are transformed in part because new technology has opened up more cultural choices than ever before. In chapter 10, Barry Schwartz investigates the psychological and cultural consequences, both positive and negative, of our new explosion of choice. He suggests that in the future, cultural policy may need to shift from a long-standing concern with producing new art or attracting new audiences to a concern with creating diverse, discerning and engaging filters that will help make sense of the bewildering array of options.

Finally, the section on technology concludes with chapter 11, where Gabriel Rossman examines the potential dangers of using technology as a tool to track audiences. Drawing on commercial radio as a case study, Rossman shows how audience research has become more and more sophisticated over the past few decades. Such research techniques, honed by new technology, offer organizations—both for-profit and nonprofit—a tempting strategy for aligning their programming with the tastes of audiences. But Rossman suggests that such techniques may constrain creativity and artistry, eventually leading to the dissatisfaction of audiences.

The fourth section takes up one of the most prominent areas of cultural analysis for the past few decades: the relationship between cultural participation and cultural capital. In other words, to what extent do the arts, especially the fine arts, confer high status on participants? And what is the link between high socioeconomic status and participation in the benchmark art forms (i.e., ballet, opera, classical music, art museums)? In chapter 12, Paul DiMaggio and Toqir Mukhtar test a number of hypotheses, using the SPPA data, and find that high-culture arts remain an important dimension of cultural capital in the United States even if they are experiencing significant declines in attendance. But their findings also suggest that cultural capital is changing in important ways, including an increase in the importance of multiculturalism and global culture as well as new forces of competition arising from home entertainment and other forms of entertainment.

In chapter 13, Peterson and Rossman provide more evidence that the composition of cultural capital is changing. In particular, they show that high-status arts consumers are increasingly embracing a diverse and cosmopolitan array of art forms and are shunning old notions of

highbrow snobbery. More and more, people are showing signs of being omnivorous in their tastes by forcing arts organizations to rethink their programming choices and their strategies for attracting new audiences. Finally, in chapter 14, Bonnie Erickson discusses how omnivorous and multicultural consumption is creating new inequalities in cultural participation derived in large measure from changes in the economy and the work force.

Taken together, the essays in this volume constitute an important starting point for the examination of two important questions. First, early in our new century it is appropriate to consider the condition of our museums, orchestras, and nonprofit theater companies. Second, however, we must take the opportunity to examine the reemergence of homemade art—not necessarily music made around a parlor piano but creativity exercised at home computers tied to the Internet, our twenty-first-century take on the electronic hearth. Several essays in this volume address art, art making, consumption, and choice in a digital age, setting the stage for the return of a nineteenth-century definition of participation.

The Internet offers unlimited opportunities to connect with heritage, the work of other artists, and sites where new music and short films can be distributed all over the world. And, although nearly limitless choice can be daunting, the Web contains enough nooks and crannies to enable every artist to find a home for new work. Late in 2006, a mirror-covered edition of *Time* magazine proclaimed "YOU" its "Person of the Year" (Grossman 2006). *Time* argued that the modern Internet allows ordinary people to add their creative voices to the Web on sites like MySpace, YouTube, and LiveJournal. The Pew Internet and American Life Project (2005) reports that 12 million teens are actively creating new cultural content online.

Creativity, the handmaiden of hands-on arts participation, is now touted as the likely engine of America's postindustrial, postinformation economy. According to Daniel Pink, editor-at-large of *Wired* magazine, we are today entering a new age and a new economy, one that supersedes both the industrial age and the era of tech-enabled information. For Pink, leaders of the new economy will succeed through high concept and high touch, employing "the ability to create artistic and emotional beauty, to detect patterns and opportunities, to craft a satisfying narrative, and to combine seemingly unrelated ideas into a novel invention"

(Pink 2005, p. 51–52). *New York Times* columnist Thomas Friedman (2005) agrees, arguing that if one is to be a worker in the new global economy, you must "nurture your right-brain skills" (p. 309). Old-fashioned, nineteenth century-style arts participation is a powerful incubator of creativity.

And, finally, participation in the arts offers a real opportunity to enhance quality of life in our American democracy. The quest for post-consumerist definitions of *happiness* and *high-quality life* is emerging as a central public policy question facing Western democracies. Taking part in religious practice and a happy family life are both recognized sources of happiness, but neither is particularly amenable to public policy interventions. Arts participation, on the other hand, can provide citizens with a sense of accomplishment, continuity, and community, and its secular, communal character is a good fit for government programs.

This volume offers suggestive glimpses into the character and consequence of a new engagement with old-fashioned participation in the arts. The authors in this volume hint at a bright future for art and citizen art making. In a way, the two themes of this volume in the end combine as one. If we center a new commitment to arts participation in everyday art making, creativity, and quality of life, we will not only restore the lifelong pleasure of homemade art but will likely also seed a new generation of enthusiasts who will support America's signature nonprofit cultural institutions well into the future.

Bibliography

Americans for the Arts National Arts Policy Roundtable. October 2006. "The Future of Private Giving to the Arts in America." October 2006.
The Etude, October 1933, 646. Grossman, L. 2006 "Time's Person of the Year: You." *Time*, December 31, 2006.
Friedman, Thomas L. 2006. *The World Is Flat: A Brief History of the Twenty-First Century*. New York: Farrar, Straus and Giroux.
Kimmelman, Michael. 2006. "The Art of Drawing, When Amateurs Roamed the Earth." *New York Times*, July 19, 1.
New York Times, November 13, 2005. "Giving." *Webster's Nineth New Collegiate Dictionary*. 1986. Springfield, MA: Merriam-Webster, Inc.
Pew Internet and American Life Project Report. 2005. "Teen Content Creators and Consumers," November.

Pew Research Center Social Trends Report. 2006. "Increasingly, Americans Prefer Going to the Movies at Home." May.

Pink, Daniel H. 2005. *A Whole New Mind: Moving from the Information Age to the Conceptual Age*. New York: Riverhead Books.

Endnotes

1. National Piano Manufacturers Association, "U.S. Piano Sales History from 1900 to Present," http://www.bluebookofpianos.com/uspiano.htm.
2. ibid.
3. *New York Times*, Tuesday November 7, 2006.
4. James Irvine Foundation, "Critical Issues Facing the Arts in California," Working Paper, September 2006.

Section One:

Conceptualizing and Studying Cultural Participation

1 Engaging Art
What Counts?

Steven J. Tepper and Yang Gao

Introduction

Recently, the National Endowment for the Arts (NEA) released a report titled *Reading at Risk* based on a government-sponsored 2002 survey of arts participation. The report, discussed in the mainstream news and by countless pundits and Internet bloggers, found that fewer Americans today are reading poetry and literary fiction compared to a decade ago, and alarmingly, the most dramatic declines were among young people.

Readers at Risk takes its place in a long line of similar reports and news articles that document the health and vitality of the arts in the United States by measuring trends in participation for the benchmark art forms: ballet, classical music, opera, theater, museums, literary fiction, and jazz. Big arts associations, like the American Association of Museums and the American Symphony Orchestra League, have com-

missioned studies based on ticket sales, admissions, and attendance figures. The federal government tracks arts participation every five years (since 1982) through the Survey of Public Participation in the Arts (SPPA). The polling firm Louis Harris and Associates has sponsored five public polls in their Americans and the Arts series. There are dozens of other national and local participation studies.[1] The findings from these studies vary extensively as the result of differences in the wording of survey questions, the types of arts activities explored, the composition of the population surveyed, and, of course, the year of the survey (Tepper 1998). But regardless of the findings, which range from optimism to pronouncements of demise, there has been a persistent interest in the size and scope of arts participation for well more than three decades.

This chapter argues that the enduring interest in arts participation has shifted from a broad concern with democratic life to a more narrow concern with attendance at nonprofit arts institutions. These findings link cultural participation with other forms of social engagement (i.e., political and religious), drawing attention to a shared social context and trajectory. Given the similarities, we believe arts participation should be analyzed within a more coherent framework that considers multiple forms of social involvement. Furthermore, by focusing its attention almost exclusively on attendance, the arts community has largely ignored important forms of artistic practice. Interestingly, when artistic practice (i.e., making and performing the arts) is compared with more traditional measures of attendance, it is found that barriers of age, income, and education become less significant. This tentative finding implies that citizen engagement in the arts might be healthier than some would think; it also suggests that a broader view of participation can help reconnect the arts with concerns for social equality, individual expression, and participatory democracy. Before examining new analysis, the chapter traces the history of America's preoccupation with the idea of *participation*.[2]

Participation in Context

Alexis de Tocqueville, the French historian and political thinker who visited the United States in the early 1830s, produced one of the most enduring and trenchant analyses of American habits, customs, and

beliefs: *Democracy in America*. For Tocqueville, the vigorous egalitari-anism and democracy that defined the new republic emanated from, and in turn cultivated, a participatory spirit. He wrote, "No sooner do you set foot upon American ground than you are stunned by a kind of tumult. Everything is in motion around you" (Tocqueville 2004, p. 249). Galvanized by a propensity to participate, Americans started churches and attended religious services regularly; they joined in quilting circles and community sings, formed associations, and participated in local politics. This active engagement in a range of political, social, religious, and cultural affairs, Tocqueville argued, protected citizens from drift-ing toward tyranny and despotism.

Tocqueville was not alone in pointing out the association between participation and a healthy and spirited society, and over the years three forms of participation have attracted the interest of American intellec-tual and political leaders: political and civic participation, religious par-ticipation, and cultural participation. Given the historical connection among all three forms, the attempt is made to compare them systemati-cally. In particular, the chapter looks at (1) the motivations for studying participation; (2) the major indicators of participation employed in the scholarly literature; (3) the correlates of participation; and (4) trends in participation. All of these dimensions are summarized in Table 1.1.

Motivations for Studying and Tracking Participation

In general, scholars have approached religious and political partici-pation out of a concern for collective outcomes (i.e., democracy and community solidarity) and individual well-being (i.e., health and well-being). As mentioned earlier, writers have long argued that democracy requires active citizens who pursue and protect both their own interests and the interests of their communities. Obviously, political participa-tion is the most direct form of self-government, and voter turnout rates, which serve as a measure of political participation, have long been seen as a proxy for the health of democracy. More recently, as discussed fol-lowing, Robert Putnam (2000) and others have looked beyond voting to a range of other forms of civic participation, from attending political meetings to joining civic clubs.

Table 1.1 Comparing Religious, Political, and Cultural Participation: Indicators, Correlates, Motivations, and Trends

	Religious	Political (Civic)	Cultural
Motivation for Research and Policy	In general, people have studied religious participation because they see it as an indicator of community solidarity and integration as well as a source for democratic participation. In addition, religious participation is related to lower levels of criminal behavior and improved personal health and well-being.	People are interested in political participation as a general measure of the health of democracy. Self-government requires the active participation of citizens. Putnam (2000) found that active citizen engagement leads to better institutions (e.g., schools and hospitals). Moreover, like religious participation, political and civic participation increases sense of community and ties people more closely to each other.	People are interested in cultural participation primarily as a measure of the health of those benchmark art forms provided by nonprofit arts organizations in the United States (i.e., classical music, museums, theater, ballet, jazz). Therefore, the health of these institutions and the demand for the art they present are of primary concern. The other main motivation for studying arts participation comes from scholars who are interested in issues of inequality, in particular, whether high arts participation is associated with the reproduction of social class (i.e., elite status and privilege).

Major Indicators (Forms of Participation)	Institutional engagement (frequency of attendance at religious service) Personal practice and expression (frequency of prayer) Membership (congregational membership) Trust and confidence (confidence in religious officials) Giving (donations to congregations) Literacy (frequency of reading the Bible) Meaning and preference (Do you believe in God or biblical literalism?)	Institutional engagement (voting, frequency of attending political meetings, volunteering for a campaign) Personal practice and expression (writing letters to the newspaper, contacting officials, displaying buttons and signs, boycotting, talking to neighbors about politics, protesting) Membership (political parties and political and civic associations) Trust and confidence (trust in political officials) Giving (donations to candidates and campaigns) Literacy (reading and watching news) Meaning and preference (self-rating on liberal–conservative scale; attitudes toward political and social issues like abortion and drug use)	Institutional engagement (attendance at benchmark art forms, attendance at other leisure activities such as sports, historic homes, and movies) Personal practice and expression (did respondent draw or paint, do creative writing, make films or artistic photos) Membership (not consistently measured) Trust and confidence (not consistently measured) Giving (not consistently measured) Literacy (arts education past and present) Meaning and preference (likes and dislikes regarding music and book genres)

—continued

Table 1.1 (continued) Comparing Religious, Political, and Cultural Participation: Indicators, Correlates, Motivations, and Trends

	Religious	Political (Civic)	Cultural
Correlates of Participation	Attend religous service last week Some college education + (strong) Income + (weak) South + (strong) Youth – (strong) Female + (strong) White – (strong) Babies in house ∅ Big city – (weak)	Voted in last election Some college education + (strong) Income + (strong) South Youth – (strong) Femlae + (strong) White + (strong_) Babies in house ∅ Big city ∅	Attended classical music or opera in the last year Some college education + (strong) Income + (strong) South – (weak) Youth – (strong) Female + (strong) White + (strong) Babies in house _ (strong) Big city + (strong)
Trends in Participation	In general, religious membership has fallen by about 10 percent over the last forty years, whereas actual attendance and direct involvement with congregational activities has decreased between 25 and 50 percent (Putnam 2000, p. 72).	From 1968 to 2000, voter turnout rates in presidential elections have declined. Americans are roughly 10 to 15 percent less likely to voice their views (e.g., writing to Congress or newspaper); 25 percent less likely to vote; 35 percent less likely to attend a public meeting; and 40 percent less engaged in party politics and civic and political organizations (Putnam 2000).	Rates of attendance at benchmark performing arts events—theater, classical music, and ballet—declined from 1982 to 2002. The odds of attending one of these activities declined 7.5 (ballet) to 12.2 percent (classical music).

| Trends in Participation | Declines in congregation-related activities are most prominent among the youngest generations when compared with prior generations at the same age. Additionally, twice as many Americans in 2001, compared with 1990, say they have "no religious preference." On the other hand, the percentage who "believe in God" has stayed relatively steady—at around 95 percent. Also, the largest Christian denominations—mainline Protestants—have decreased by nearly 10 percent over the last decade. Evangelical denominations (e.g., Pentecostal, Churches of Christ) grew by almost 20 percent over the last decade (Lampman 2002). | These declines are most pronounced among the youngest cohorts. There has been a steady decline in the percentage of people who have signed a petition over the last three decades (35 to 25 percent) and contacted a congress member (17 to 11 percent). Although active participation has declined, there has been growth in the number of political organizations and the total amount of political contributions. Knowledge of campaigns and politics has remained relatively stable. | The odds of attending an arts or crafts fair or historic site declined even more substantially (22 percent). Literary reading declined 10 percent between 1982 and 2002. If we take into account that the population has become more educated over the last two decades, declines are even greater. In other words, college graduates are not attending as much as college graduates did two decades ago. The most pronounced declines are evident in the youngest cohorts (age eighteen to forty-seven). Among eighteen- to twenty-eight-year-olds, literary reading declined 28 percent (compared with 10 percent for the entire population). Attendance at art museums, opera, and jazz increased, with the odds of attending art museums growing by as much as 27 percent. It should be noted that attendance rose from 22 percent to 26.5 percent from 1982 to 2002. Evidence for this information can be found in chapter 12 in this volume (see also Bradshaw and Nichols 2002). |

a+, positive correlation; −, negative correlation; ∅, no correlation; strength of correlation indicated in parentheses.

As for religious participation, reformers and advocates have monitored church attendance, the growth of denominations, and the presence of religious pluralism. These measures of participation have historically been linked to democratic life as religious congregations have been important conduits for mobilizing voters and providing their congregants with skills required for political activity. Thus, democracy prospers when there are more religious institutions, representing more denominations, and serving more Americans (Putnam 2000, pp. 65–66).

In addition to concerns about self-government—and consequent fears of big government and big business—scholars have long worried about the effects of modernization on social solidarity and community. In particular, they feared that the industrial economy would lead to a breakdown of the social fabric, individual alienation, and, ultimately, a decline in people's willingness to trust each other. In this regard, declines in both religious and political participation are seen as signs of a larger social collapse.

Like religion and politics, initial concern about cultural participation also centered around the health of U.S. democracy. Tocqueville, again, believed that democracy and cultural participation were mutually reinforcing. He wrote that in America, "the taste for intellectual enjoyment will descend, step by step, even to those who, in aristocratic societies, seem to have neither time nor ability to indulge in them" (DiMaggio and Useem 1977, p. 8). Similarly, early advocates for American museums promoted widespread participation in an attempt to elevate taste and, consequently, to bring about a more enlightened citizenry. Thus, as early as the late nineteenth century, museums began to track attendance figures, in part to justify their reach and influence. Building participation in the arts also animated the work of musical progressives from the 1870s through the 1930s. These progressives, beginning with the founders of the Hull House Music School in Chicago, believed that enlarging the audience for music—through public concerts, festivals, community sings, and free music lessons—was an essential democratizing force in America (Vaillant 2003). Of course, underlying the interest in arts participation is the idea that egalitarianism, the hallmark of American democracy, requires not only equal access to material and political resources (i.e., "the opportunity to do well for yourself") but also to culture (i.e., "the opportunity to live well").

In fact, DiMaggio and Useem (1977) traced the idea for a national survey of arts participation—what became the Survey of Public Participation in the Arts or SPPA—to a concern about democracy and equitable access. Writing about national arts policy in the 1970s, they noted, "The vast increase in the level of public support for the arts has stimulated concern about the social composition of the expanding arts public. Policy makers and interest groups increasingly ask if government programs are underwriting an activity enjoyed by a large cross section of the American public; or are they backing an activity that remains the special preserve of an exclusive social elite?" (p. 180). The implication here is that the government has an interest in democratizing the arts by expanding access.

Along with an interest in participation for democracy's sake, arts leaders were interested in measuring participation for the benefit of arts institutions. Beginning in the late 1960s, America witnessed a dramatic rise in the number of arts organizations, fueled in part by grants from the Ford and Rockefeller foundations, as well as from the newly formed National Endowment for the Arts. These organizations often conducted audience surveys as a means of gauging demand, justifying requests for public support, and thinking strategically about marketing and future growth. But many of these audience surveys were poor in quality and dissimilar enough that making comparisons across organizations or compiling a national portrait of participation was virtually impossible. So, the NEA launched a national survey, the SPPA, which could help track trends in participation, thus providing arts organizations with important data for advocacy and strategic planning.

The emphasis on the health of arts organizations influenced the nature and design of the survey, as well as the indicators that track cultural participation in the United States. Most of the questions on the SPPA focus on live attendance at benchmark cultural forms that are provided mainly through nonprofit arts organizations and venues: theatre, classical music, opera, ballet and modern dance, and museums. Of course, these organizations, as well as the artists they represent, were and are the primary stakeholders for the agency, which had organized its grant making to support their activities. So, tracking attendance at these benchmark forms was one way the NEA could provide useful information to its primary clients while at the same time tracking

whether these benchmark forms were reaching a broad section of the American public and thus were serving democratic goals.

Although the National Endowment for the Arts saw its efforts to collect national participation data as meeting both goals—serving existing institutions and the public interest—the goals were not entirely compatible. Richard Orend (1977) wrote one of the early monographs that influenced the creation of the SPPA. In it, he discussed the tension that exists from trying to meet these two goals and argued that one or the other will have to drive the design of any future national survey, but not both. Ultimately, he noted that the NEA would have to decide if its role was to promote a broader range of activities, giving people what they want, or to enhance those already determined to be within its scope, preserving traditional high culture institutions. The NEA emphasized the latter goal, which makes perfect sense given that its programs were already organized around existing traditional high culture institutions. Of course, NEA programs have evolved to include a more eclectic set of arts activities, including folk arts and film, and its national survey includes some broader questions about other leisure activities and about amateur art making. But on the whole, the survey emphasizes attendance at the benchmark art forms.

In sum, it is fair to say that studies of political and religious participation are more concerned with what may properly be considered the public interest—the health and functioning of society and its citizens. Like the arts, scholars in these two areas have also been interested in the shape of institutions, such as the strength of political parties or the rise and fall of particular denominations. These concerns, however, are overshadowed by the larger question of whether citizens are becoming more or less engaged, trusting, and connected to one another. On the other hand, concern for arts participation, though once part and parcel of a historical preoccupation with the health of a participatory democracy more broadly, has become less connected to the public interest arguments and has been focused on the health of nonprofit cultural institutions, especially in the last few decades. Although there is preliminary research on the relationships between arts participation and (1) general social engagement (Stern and Seifert 1998) and (2) individual well-being (e.g., health, happiness, educational success), these studies have remained relatively local and have not been a major force motivating national studies of participation.[3]

Indicators of Participation

Participation can mean many different things. When existing studies are examined across the three domains—religion, politics, and culture—it is revealed that modes of participating fall roughly into six different areas, with some overlap between them. First, participation can involve engagement with an institution; in other words, participation is geared toward supporting or interacting with some formal organization, structure, or institution, typically in a manner that is relatively predetermined (i.e., there is a time, place, and agreed-on method of engaging). Institutional participation can involve attending events, volunteering, voting, and going to church.

A second mode of participation involves personal practice and expression, which emphasizes activities that require some personal competency and commitment and which often involve some form of individual expression. These activities can be more private and self-determined than institutional engagement (e.g., playing the guitar in one's bedroom, praying to God), or they can be collective (e.g., playing in a band, taking part in a protest event). Although there is clear overlap with institutional engagement, this form of engagement is less bound by the needs, interests, and routines of organizations and, ultimately, is more focused on the individual voices of citizens.

A third form of participation is membership and giving. In some respects, membership and giving are subsets of institutional engagement. These are included as separate forms of engagement because such activities reflect the salience of an institution to a person's identity and can therefore be distinguished from actual engagement with that institution on a day-to-day basis. So, for example, people can be members of or donors to an alumni association, church, or a local museum, without actually attending or participating in the activities sponsored by these institutions. In this respect, membership and giving, for some, can be far less active and demanding than full engagement.

A fourth form of participation involves literacy. In this context, literacy means acquiring skills and knowledge about a subject and is primarily an intellectual form of engagement. Literacy can involve reading the Bible, newspapers, or books on arts and culture, watching the news, or actually taking art classes. Like personal engagement and expression, literacy is more focused on individual empowerment, development, and capacity.

Fifth, scholars have looked at trust and confidence as a type of participation. Do citizens trust religious and political leaders and institutions? Such trust is often a precursor to more active engagement—from attending events to donating money—and might be considered a predictor of participation rather than a form of participation itself. Nonetheless, it is included here because it is of great interest to scholars and, like other forms of participation, has been tracked over time and linked to overall religious and political vitality.

Finally, researchers have collected a variety of information on people's preferences and the meaning that citizens attach to certain activities. Like trust and confidence, these factors might be better classified as dispositions rather than participation; nonetheless, they remain important indicators in the literature, and therefore they are included in this overview. Religious scholars have been interested in people's belief in God and whether they think the Bible represents the true word of God (i.e., biblical literalism). Scholars of political life examine people's self-rating on a liberal–conservative scale as well as social tolerance and opinions on a range of social issues, from abortion to drug use. Again, though not exactly participation, these indicators are critical for understanding political and religious life more generally. To the extent that participation includes emotional and intellectual commitments (e.g., forming an opinion is an active mode of engagement), then preferences and meaning—as well as literacy and trust and confidence—should be considered important dimensions of participatory life.

If cultural participation is compared with religious and political participation, many similarities are revealed, especially the interest in institutional forms of engagement, individual practice and expression, and meaning and preferences. But there are significant differences as well. First, regarding individual practice and expression, these forms of participation have received far less attention by arts scholars. Although the SPPA collects some basic information on several forms of art making, with the exception of one unpublished study, there has been almost no analysis of these data—as compared with dozens and dozens of studies on arts attendance. As for meaning and preferences, scholars of culture have published several articles about people's likes and dislikes of a variety of musical genres. However, much more could be done on the value people place on the arts, their own self-identification as creative or not, and their reactions to a range of statements about the role of art

in society. It should be noted that the 1993 culture module of the General Social Survey (GSS) did, indeed, ask several more interesting questions about people's opinions and preferences regarding art, but these questions have not been repeated since then. Also, the Louis Harris polls—Americans and the Arts—asked a range of attitudinal questions, but these questions vary from year to year.

In sum, there are some significant blind spots in terms of the indicators of cultural participation collected by arts scholars and policymakers. At a national level, for example, very little is known about people's personal memberships or about their giving patterns to the arts. And, with a few exceptions, we have not systematically, and on a regular basis, asked about trust and confidence in artists, arts professionals, and arts institutions. Finally, although we have collected information about arts education, other forms of cultural literacy have been ignored, including general knowledge about the arts, frequency of reading news and information about the arts, talking about the arts with friends and family, and learning about the arts on radio, on television, and in the movies. Arts researchers and policymakers have been primarily concerned with the indicators that measure institutional engagement, and, compared with other fields, have generally devoted far less attention to the many other ways people can and do participate. The bias toward these indicators is a result, as discussed earlier, of the primary motivation for collecting data on arts participation—securing the health of nonprofit arts institutions.

Demographic Correlates of Participation

Table 1.1 provides evidence that all three types of participation draw from a similar demographic profile—in particular, individuals with a high socioeconomic background (i.e., income and education) are much more likely to attend church, vote, and attend classical music or opera. In addition, women are more likely to participate in all three activities, and young people, ages eighteen to twenty-four, are less likely to participate.

From a cursory review of these correlations, it appears that conditions for participation are strongly tied to social context. Women participate more, perhaps, because of the nature of their social networks,

their greater involvement with their children, and their historical role as community connectors (Putnam 1996). People with higher social and economic status participate more perhaps because participation requires certain skills and confidence (i.e., ability to communicate, general literacy, and knowledge) and because participation is linked to the size of a person's social network. Educated people have both more and different social ties and thus are more likely to be asked by some of these many friends and acquaintances to join them at the voting booth, church, or a concert.

Of course, there are differences between the three forms of participation as well. In particular, though nonwhites are less likely to vote or attend the arts, they are more likely to go to church. Southerners are also more church going than the rest of the country. And, living in a city has little or no effect on political and religious participation, but it is a strong positive predictor of arts attendance. But, in general, a better understanding of why some Americans are more participatory than others requires looking at what these three forms of participation share in common and considering more general theories that explain participation rather than treating each form as a distinct mode of social life.

Trends in Participation

Finally, if trends in participation are examined, remarkable similarities are revealed across the three domains. Overall, institutional engagement (i.e., attendance, voting, volunteering) has decreased across the board over the past thirty years. This is disheartening given that education—the greatest predictor of participation—has increased substantially during the same period. Most striking is the consistent decline in participation for young people. Regardless of the form of participation, young people are doing less of it than their predecessors.

Some forms of participation have fared better than others. Individual giving and membership, for example, have held their own and, in some cases, have gone up. Membership and attendance at evangelical church activities have increased; in the arts, attendance at museums and jazz concerts has seen noticeable increases. And, even though there have been declines in terms of institutional engagement—what Putnam (1996)

referred to as social capital—there are no obvious declines in the interest and value people place on religion, politics, and culture. Arguably, people are just as religious as they were thirty years ago (e.g., the same number still believe in God); they just express their religiosity in new ways. In the political realm, people's interest in and knowledge about politics has stayed relatively constant over time. According to the Louis Harris poll, which is not reported in Table 1.1, Americans have maintained a healthy interest in and support for the arts—museums, theaters, and concert halls—with between 87 and 93 percent considering the arts to be an important aspect of a good place to live. These numbers have fluctuated over time, but on the whole Americans seem as enthusiastic about the arts in the abstract now as they were two decades ago.

With this said, Americans are having more trouble leaving their homes to attend events and to join in social activities that require them to plan and to show up at a certain time and place. Even though they report high levels of personal engagement and interest, they are still not interacting with social institutions as often. The root causes of such disengagement are highly debated, but there is general agreement that changes in work (i.e., overall increases in hours worked and the specific increase in the percentage of working women); changes in technology, especially the flowering of home entertainment centers; increases in the competition for people's nonwork time (i.e., competition for leisure); and increases in residential mobility (i.e., people move more often) all have some role to play (Putnam 1996). The other likely explanation is that participation has simply changed—not declined—and the right types of data have not been collected or analyzed here to account for these changes (e.g., participation may be increasing in online communities, blogging, and other forms of technology-mediated experiences). Again, scholars and policymakers need to work together across domains to understand the pushes and pulls of participation in the twenty-first century. To do so requires focusing less on the specific obstacles or opportunities facing the arts, religion, or politics and instead developing theories, collecting data, and testing hypotheses about root causes of participation.

Having drawn the connection between cultural participation and other forms of participation, the argument this chapter makes is now extended in two ways. First, is there empirical evidence of a participation disposition? More specifically, do people who participate more frequently in religious and political activities also participate more often

in cultural activities? And second, how would a broadened definition of cultural participation—more in line with approaches to religious and political participation—change our understanding of who participates in the arts and why?

The Participation Disposition: The "Do More Do More" Hypotheses

This chapter has argued that participating in political, religious, and cultural life is part and parcel of a broader phenomenon of social engagement. Social theorist Georg Simmel (1949) referred to this more general form as *sociability*—pointing to social interactions that are not immediately organized around economic exchange or the pursuit of narrow self-interest. People engage with one another because of the intrinsic pleasures and sense of togetherness that such amicable interaction affords. Some people are more sociable than others, and this might depend on an individual's personality as well as on his or her particular circumstances—where he or she lives, age, economic position, and social networks. Simmel's theory would predict that the same people who are active in one sphere of life (e.g., religion) are more likely to be active in other areas as well (e.g., politics and culture). Is there any evidence of such crossover?

Using the GSS, the relationships among a variety of different social activities were examined: attending church, joining civic associations, voting, attending sports events, going to see a movie, camping, attending museums, and attending performing arts events. There was a strong positive relationship among all of these items; the only exception is that people who attend church do not go camping as often (Table 1.2). So people who go to church more often also vote more often. People who go to museums are also more likely to volunteer, read the newspaper, go camping, watch movies, and go to church. The evidence supports the *do more do more* thesis where people who do more of one thing tend to do more of everything.

One reason for the overlap in participation is that certain demographic characteristics predict participation across the board. As shown in Table 1.1, people who are well educated tend to do more of just about everything. Perhaps the link among religious, political, and cultural par-

Table 1.2 Correlation Matrix for Different Participatory Activities

	Attend Church	Member, Service Association	Member, Professional Society	Total Number of Memberships	Voted 1992 Election	Attend Sports	Attend Movies	Camping	Attend Fine Arts	Personal Practice: Music, Dance, Theater
Attend Church	1.00									
Member, Service Association	0.15*	1.00								
Member, Professional Society	0.07*	0.23*	1.00							
Total Number of Memberships	0.30*	0.65*	0.47*	1.00						
Voted 1992 Election	0.18*	0.15*	0.21*	0.27*	1.00					
Attend Sports	0.09*	0.24*	0.20*	0.34*	0.14*	1.00				
Attend Movies	0.056*	0.19*	0.17*	0.22*	0.11*	0.31*	1.00			
Camping	-0.07*	0.12*	0.14*	0.18*	0.09*	0.22*	0.24*	1.00		
Attend Fine Arts	0.07*	0.24*	0.30*	0.32*	0.23*	0.25*	0.33*	0.23*	1.00	
Personal Practice: Music, Dance, Theater	0.06*	0.11*	0.10*	0.18*	0.05*	0.09*	0.11*	0.11*	0.15*	1.00

Notes: All correlations in this table are significant at the .05 level. The correlations were calculated with the following control variables: education, income, gender, age, and race.

ticipation is accounted for by education—and, to some extent, income, gender, and age. But the correlations displayed in Table 1.2 were calculated after we controlled for a range of demographic variables, including education. In other words, the findings clearly show a participation effect above and beyond core demographics. Certain people appear more likely to get off the couch, leave their house, and throw their lot in with their neighbors and fellow citizens, whereas others may prefer to stay home, read, watch TV, and spend time with family. This certainly suggests that participation may be deeply connected to Simmel's (1949) notion of sociability. But, as it turns out, participators are also more likely to do solitary things—to have personal hobbies and interests such as gardening, listening to recorded music, reading novels, or praying.

There are a variety of plausible explanations for this participation effect. First, it is possible that being active and engaged is determined in part by personality. Certain people have a disposition that favors an active lifestyle. Second, participation is almost certainly influenced by the extent of a person's social network (see chapter 14 in this volume). Some people are better networked than others, and networks are an important source of information and influence when it comes to participating in events, learning about opportunities, and developing hobbies. Third, participation, especially in group-related activities, requires certain skills: working with others, social graces, and an ability to express oneself. Therefore, the more a person participates, the greater the person's skills and resources for future participation, increasing the probability that he or she will spread talents across various forms of engagement.

Finally, it is possible that the participation effect reflects a fundamental bias in the types of questions asked in the surveys, thereby favoring the activities of certain people and not others. If asked about cooking, visiting with family, cruising the boulevard, fixing cars, playing video games, and other hobbies or activities, it is possible that the study's nonparticipants are equally active, just in a different set of activities.

Multiple possibilities aside, if it is true that participation is a generalized phenomenon, then treating cultural participation—or religious and political participation for that matter—as an independent and distinct area of research and policy may be misguided. Many scholars (e.g., Verba, Schlozman, and Brady 1995; Putnam 2000) have begun to view religious participation as an important gateway through which

many Americans become politically aware and engaged, whereas others (e.g., see chapter 5 in this volume) have found that arts activities might serve to revitalize religious faith and practice. Not only does each form of participation have positive spillover effects on the other forms, but there are also deep-rooted causes of—and barriers to—participation that cut across domains, such as the strength and diversity of social networks, personality and skills, and the structure of free time. Although there are good reasons for looking at the unique factors that might lead people to participate in one type of arts activity or another, it is also important to understand that solving the participation problem, however defined, for the arts requires addressing larger questions of citizen capacity, social engagement, and democratic participation.

Broadening the Aperture: New Approaches to Culture

As discussed already and as shown in Table 1.1, the arts community (i.e., scholars, policymakers, managers) has made institutional engagement, or attendance at institutionally sponsored events, its primary area of concern with regards to participation. There are, of course, many more possible indicators of engagement and participation, some of which show up on existing surveys but are, perhaps, underanalyzed and reported. There are questions about personal practice and art making on the SPPA (e.g., "Do you play classical music?" or "Do you write poetry or fiction?" or "Do you dance ballet?"), but these questions have not been systematically analyzed, nor have they been designed to capture the full range of ways Americans make and do art. The SPPA also asks very systematic questions about art classes, which have been categorized in Table 1.1 as indicators of literacy. But perhaps a formal arts training does not adequately capture what it means to be a culturally literate citizen. Could more direct questions be asked that measure a range of knowledge and exposure to the arts?

Alan Brown, arts researcher and consultant, has been at the forefront of thinking about a broader approach to participation. He suggests five modes of participation: (1) inventive arts participation (i.e., making original art); (2) interpretive (i.e., interpreting or performing a preexisting work of art); (3) curatorial (i.e., organizing, collecting, and displaying art); (4) observational (i.e., purposeful attendance at arts events);

and (5) ambient (i.e., unplanned arts experiences) (Brown 2004). Using Table 1.1 as a guide, items could certainly be added to Brown's list, and participation could be considered across a number of dimensions, including giving, membership, and literacy (i.e., knowing and talking about the arts). Variety seeking and influence (see chapter 8 in this volume) or the extent to which people exchange information and recommendations about the arts (i.e., maveness) might even be measured.

Participation through Personal Practice

Perhaps the most useful starting point would be to look at existing data on personal practice. This chapter's initial exploration focuses on two questions. First, how does inequality in cultural participation differ when examining personal practice compared with arts attendance? Second, are there any differences in how personal practice and attendance have changed between 1992 and 2002; in particular, over this decade are young people, ages eighteen to twenty-four, doing art any more or less than they are attending the arts? Ultimately, the goal is to know whether barriers to participation are higher or lower and whether trends are up or down when personal practice is compared with arts attendance.

Based on the literature, inequality in arts participation occurs along five major dimensions: (1) race (in general, blacks are less likely to participate than whites); (2) education (those with no college experience are less likely to participate than those who have attended college); (3) income (people with lower incomes participate less than higher-income individuals); (4) place of residency (living outside a central city decreases the chances of participating); and (5) arts education (citizens who have never taken art lessons are significantly less likely to participate than those who have had some arts training). Are these five factors more or less important for determining personal practice versus attendance? Figure 1.3 displays the odds ratio for participation across the five factors—both for personal practice (dark bars) and attendance (light bars). If the bars are close to 1 (or if the odds ratio is not significantly different than 1), then inequality is low. If the bars approach 2, that means the odds of participating for whatever the relevant category—white, higher education, income more than $60,000, city dweller, or previous arts

training—are twice as great as those without these advantages. If the bar approaches −2, then someone who attended college, for example, would be twice as unlikely to participate compared with someone who never went to college (i.e., they are not as likely as their less-educated counterparts to participate in an activity).

To simplify this analysis, the chapter reports on the following categories of activity: attending and performing jazz, attending and performing classical music, attending and performing nonmusical theatre, attending and performing ballet, and attending art museums and galleries versus drawing, painting, or doing sculpture. With the exception of jazz, socioeconomic inequality (i.e., education and income) is greater for attending the arts than for personal practice (Figures 1.1–1.6). In particular, having gone to college and having a high income prove more important for those who go to musical performances than for those who actually perform music themselves, for those who attend ballet than those who dance, for those who go to see theater than for those who act, and for those who go to museums and galleries than those who draw, paint, and sculpt. Nonwhites also begin to close the participation gap when we look at arts practice for ballet, nonmusical plays, and classical music, whereas the gap increases slightly when visual arts practice is examined. Interestingly, though many traditional demographic factors become less important when looking at personal practice, having taken arts classes becomes significantly more important in every instance, with the exception of nonmusical play. On the surface, this finding suggests interesting potential policy interventions. First, arts practice has been strongly linked to attendance (Peters and Cherbo 1992), and it appears that traditional demographic barriers are lower for arts practice than arts attendance, making it easier, perhaps, to expand participation—and to reduce inequality—in the domain of practice. Further, as evidenced by Figures 1.1–1.6, arts practice is highly influenced by arts education, which can be made more or less available depending on levels of government and foundation support. In other words, policy interventions might be most effective if they focus on teaching people to do art rather than simply exposing people to the arts.

What is revealed when trends over time in participation for arts attendance are compared with arts practice? In looking at Table 1.3 (columns 1 and 3), there are declines in the percentage of adults who participate in most art forms, whether looking at attendance or arts practice. How-

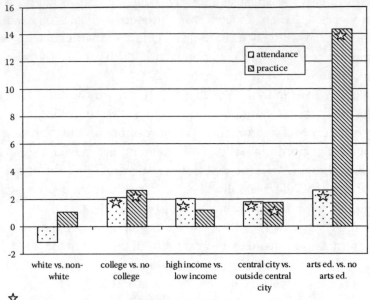

☆Indicates the odds ratio is significant at the .05 level

Figure 1.1 Comparing jass attendance and practice (odds ratios).

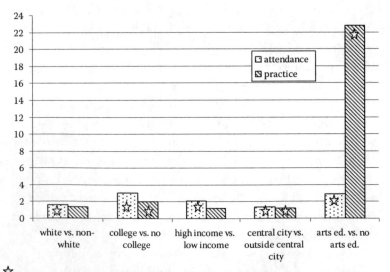

☆Indicates that the odds ratio is statistically significant at the .05 level

Figure 1.2 Comparing classical music attendance and practice (odds ratios).

Figure 1.3 Comparing music theatre attendance and practice (odds ratios).

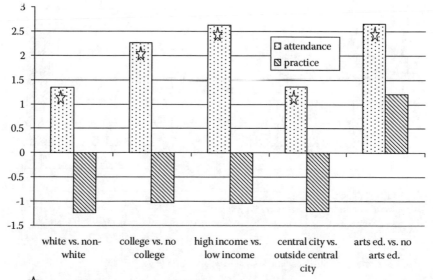

Figure 1.4 Comparing nonmusical play attendance and practice (odds ratios).

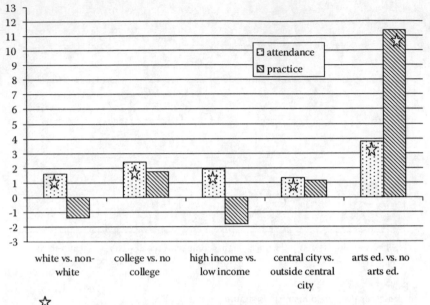

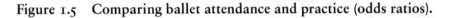

☆ Indicates that the odds ratio is significant at the .05 level

Figure 1.5 Comparing ballet attendance and practice (odds ratios).

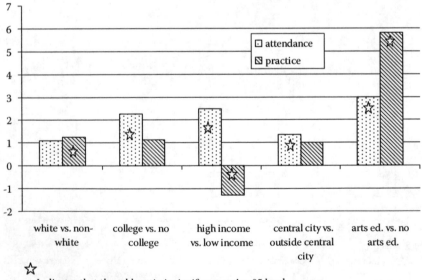

☆ Indicates that the odds ratio is significant at the .05 level

Figure 1.6 Comparing museum attendance with visual arts practice – drawing, painting, sculpture (odds ratios).

ever, the declines in arts practice are even more pronounced than those in attendance. This is particularly evident in such art forms as classical music, musical plays, and dance (i.e., nonballet). There are also significant declines in the number of Americans who weave and sew or make pottery and ceramics. It is possible that these overall trends reflect an aging population, with baby boomers less active in the arts than the generation before them (Peterson, Hull, and Kearn 2000). When examining the rising generation (ages eighteen to twenty-four), however, is there evidence that these declines will continue, or are there countervailing influences? In terms of attendance (column 2), eighteen- to twenty-four-year olds exhibit even more dramatic downward trends.

But perhaps young people are doing more art, while they are attending less. Ivey and Tepper (2006) documented the growing renaissance of personal art making and creative practices made possible by new technologies, the explosion of cultural choice, and the growth of a do-it-yourself ethos. Musical instrument sales have risen in the last decade; people are producing and editing music in their own bedrooms; and they are producing films, designing video games, and publishing poetry online. Is there any evidence of a renaissance in personal arts practice from these data? Column 4 in Table 1.3, displays the percentage change in personal practice for only those respondents between the ages of eighteen and twenty-four. In some art forms—such as ballet, musical theater, and pottery—there are some positive shifts in participation for this age group, reversing the overall downward trends in attendance and personal practice. In other areas—nonmusical theater and weaving, the youngest age group is experiencing even more pronounced declines. Overall, it is hard to argue that there has been a renaissance in art making between 1992 and 2002. Nonetheless, whereas the youngest age group is experiencing declines in every art form when it comes to attendance, this is not true for personal practice—where some forms are gaining ground over the decade. It is also possible that more visible increases would be found if the SPPA tracked the types of art forms that seem to be attracting young people—designing video games, composing and editing music, creating and curating music collections, designing home pages, making digital films, and going to clubs to see independent bands, among others.

Table 1.3 Trends in Arts Attendance versus Trends in Arts Practices for Overall Population and for Eighteen- to Twenty-Four-Year Olds

	Attendance (Column 1)			Attendance (18–24-year olds) (Column 2)			Personal Practice (Column 3)			Personal Practice (18–24-year olds) (Column 4)		
	1992	2002	Percent Change	1992	2002	Percent Change	1992	2002	Percent Change	1992	2002	Percent Change
Jazz	10.3	10.4	1.0	12.2	10.7	−12.3	1.5	1.2	−20	2.3	1.9	−17.4
Classical	12.6	11.8	−6.3	10.2	8.7	−14.7	4.3	1.9	−55.8	5.6	2.8	−50
Dance												
Ballet	4.7	3.8	−19.1	5.2	3.1	−40.4	0.2	0.4	100	0.3	1.1	266.7
Other Dance	7.2	6.6	−8.3	7.9	7.1	−10.1	8.0	4.3	−46.3	11.7	6.5	−44.4
Theater												
Musical	17.7	17.2	−2.8	15.9	15.2	−4.4	4.1	2.4	−41.5	2.5	3.0	20.0
Nonmusical	13.5	12.5	−7.4	13.2	12.2	−7.6	1.5	1.3	−13.3	2.7	1.6	−40.7
Visual Arts												
Museum, Gallery	26.4	27.1	2.7	28.3	24.8	−12.4						
Drawing, Painting							9.5	8.7	−8.4	18.3	16.3	−10.9
Crafts												
Craft Fair, Festivals	40.9	34.8	−14.9	37.6	30.8	−18.1						
Weaving, Sewing							26.9	18.2	−32.3	20.7	11.9	−42.5
Pottery, Ceramics							8.0	7.1	−11.3	7.9	10.0	26.6

Conclusion

This chapter has pursued two lines of thought, which at first glance might appear to contradict one another. On the one hand, it has argued that scholars and policy makers need to stop treating arts participation as a separate and distinct form of participation. They need to recognize the historical links between cultural participation and religious and political participation.[4] At various times in history, all three forms have been linked to notions of democracy, self-government, and community vitality. Not only do these three forms share a common intellectual history, they also share a common social context and trajectory. This chapter's evidence suggests that the demographic barriers to participation are relatively consistent across all three forms; that each form of participation, measured by a variety of indicators, is highly correlated with one another (i.e., the do more do more thesis); and that all forms of participation have shown general signs of decline over the past thirty years. This evidence points to the need to treat participation as a more generalized phenomena and to search for root causes and common barriers that might lead some people to be more sociable, leaving others more isolated from the cultural, political, and religious lives of their communities. These conclusions also suggest that there may be opportunities for cultural leaders to partner with policymakers and institutions in other sectors to facilitate more crossover—using one type of engagement (e.g., religion) as a window through which citizens can develop an interest or awareness of other forms (e.g., politics and culture).

On the other hand, this chapter's second line of thought leads us in a somewhat different direction. In the comparison with religion and politics, it was noted that the arts community has pursued a relatively narrow concept of participation, one that is more concerned with the health of existing nonprofit arts institutions than with the diverse ways that citizens engage with culture—as amateur art makers, as volunteers, as curators, as commentators, and as donors and members. Rather than treating cultural participation as a single, generalized phenomenon (e.g., attendance), this chapter suggests that future surveys, analysis, and policy focus on the multiple forms of participation.

Further, when different forms of participation are compared, such as attendance versus personal practice, significant variations are seen

in participation patterns. First, it was found that gaps in participation among different subgroups of the population—referred to here as *inequality*—tended to be smaller when examining individual practice as compared with attendance. This indicates that personal participation, or individual practice, might be a particularly fruitful area for broadening the reach of arts engagement, as traditional barriers—such as race, education, and income—seem lower. In spite of this potential, it was also noted that formal training in the arts (i.e., arts classes) is even more important for personal practice than attendance. So the opportunity to expand participation through personal practice hinges on giving citizens the necessary tools, through classes and instruction, to develop their creative hobbies, talents, and interests.

It was also found that when looking at personal practice, there are encouraging signs for potential future increases in participation rates, especially among the youngest age group, whose attendance has declined at almost all benchmark activities (see chapter 12 in this volume). Acting and singing in musicals, dancing ballet, and making pottery are all gaining ground with young people—recognizing the fact that participation rates, if improving, remain very low for these activities. By focusing more intensely on trends in personal practice—as well as other forms of participation—scholars and policymakers are less likely to fall into the doom-and-gloom scenarios discussed in the beginning of this chapter and instead see areas where arts engagement is prospering.

The participation cart should come before the cultural horse. In other words, more attention must be paid to what it means to be an engaged citizen, considering the many paths to participation. Only then can the focus be put more directly on the special challenges and opportunities facing culture. When this is done, it will be necessary to broaden the aperture and to consider the diverse ways citizens engage with the arts. A wider look will reveal a more complex and interesting set of patterns and trends, drawing attention to those places where gaps are closing and those where they are widening and where young people are flocking and where they are fleeing. Just as voting and attending church are, by themselves, inadequate indicators of the health and direction of political and religious life, attendance at the benchmark arts activities tells only part of the story of America's engagement with culture.

Bibliography

Bourdieu, Pierre. 1984. *Distinction: A Social Critique of the Judgment of Taste*. Cambridge, MA: Harvard University Press.

Bradshaw, Tom, and Bonnie Nichols. 2002. *Survey of Public Participation in the Arts*. Research Division Report 45. Washington, DC: National Endowment for the Arts.

Bradshaw, Tom, Bonnie Nichols, and Mark Bauerlein. 2004. *Reading at Risk: A Survey of Literary Reading in America*. Research Division Report 46. Washington, DC: National Endowment for the Arts.

Brown, Alan. 2004. "The Values Study: Rediscovering the Meaning and Value of Arts Participation." Hartford, CT: Connecticut Commission on Culture and Tourism.

DiMaggio, Paul, and Michael Useem. 1977. *Audience Studies of the Performing Arts and Museums*. Research Division Report 9. Washington, DC: National Endowment for the Arts.

DiMaggio, Paul, and Toquir Mukhtar. 2007. "Arts Participation as Cultural Capital in the United States, 1982–2002: Signs of Decline?" In Tepper and Ivey, *Engaging Art*, 377–421.

Erickson, Bonnie. 2007. "The Crisis in Culture and Inequality." In Tepper and Ivey, *Engaging Art*, 478–503.

Grantham, Ellen, Sunil, Iyengar, and Mark Bauerlein. 2006. *The Arts and Civic Engagement: Involved in Arts, Involved in Life*. Research Note 93. Washington, DC: National Endowment for the Arts.

Ivey, Bill, and Steven Tepper. 2006. "Cultural Renaissance or Cultural Divide?" *Chronicle of Higher Education* 52, no. 37 (May): B6–B8.

John S. and James L. Knight Foundation. 2002. *Classical Music Consumer Segmentation Study 2002: 15 Market Area Surveys*. Southport, CT: Audience Insight LLC.

Lampman, Jane. 2002. "Charting America's Religious Landscape." *Christian Science Monitor,* October 10, 12.

Miringoff, Marque-Luisa, and Sandra Opdycke. 2005. *Arts, Culture, and the Social Health of the Nation 2005*. Poughkeepsie, NY: Vassar College, Institute for Social Policy.

Nichols, Bonnie. 2007a. *Volunteering and Performing Arts Attendance: More Evidence from the SPPA*. Research Note 94. Washingotn, DC: National Endowment for the Arts.

_____. 2007b. *Volunteers with Arts or Cultural Organizations: A 2005 Profile*. Research Note 95. Washington, DC: National Endowment for the Arts.

Orend, Richard. 1977. "Developing Research on the Arts Consumer." In *Research in the Arts: Proceedings of the Conference on Policy Related Studies of the National Endowment for the Arts,* edited by David Cwi, 34–51. Baltimore: Walters Art Gallery.

Peters, Monnie, and Joni M. Cherbo. 1992. *Americans' Personal Participation in the Arts*. ERIC Document 404273. Washington, DC: National Endowment for the Arts.

Peterson, Richard, Pamela C. Hull, and Roger M. Kern. 2000. *Age and Arts Participation: 1982–1997*. Research Division Report 42. Washington, DC: National Endowment for the Arts.

Petit, Becky. 2000. "Resources for Studying Public Participation in the Arts: Inventory and Review of Available Survey Data on North Americans' Participation in and Attitudes towards the Arts." *Poetics* 27, nos. 5–6 (June): 351–95.

Putnam, Robert. 1996. "The Strange Disappearance of Civic America." *American Prospect* 7, no. 24 (December 1): 34–48.

_____. 2000. *Bowling Alone: The Collapse and Revival of American Community*. New York: Simon and Schuster.

Simmel, Georg. 1949. "Sociology of Sociability." *American Journal of Sociology* 55, no. 3: 254–61.

Stern, Mark, and Susan Seifert. 1998. "Cultural Participation and Civic Engagement in Five Philadelphia Neighborhoods." Working Paper 7. Philadelphia: University of Pennsylvania.

Tepper, Steven. 1998. "Making Sense of the Numbers: Estimating Arts Participation in America." Working Paper 4. Princeton: Princeton University Center for Arts and Cultural Policy Research.

Tepper, Steven, and Bill Ivey (Eds.). 2007. *Engaging Art: The Next Great Transformation of America's Cultural Life*. New York: Routledge Press.

Tepper, Steven, Eszter Hargittai, and David Touve. 2007. "Music, Mavens and Technology." In Tepper and Ivey, *Engaging Art*, 265–300.

Tocqueville, Alexis de. 2004. *Democracy in America*. New York: Library of America.

Vaillant, Derek. 2003. *Sounds of Reform: Progressivism and Music in Chicago, 1873–1935*. Chapel Hill: University of North Carolina Press.

Verba, S., K. L. Schlozman, and Henry Brady. 1995. *Voice and Equality: Civic Voluntarism in American Politics*. Cambridge, MA: Harvard University Press.

Wuthnow, Robert. 2007. "Faithful Audiences: The Intersection of Arts and Religion." In Tepper and Ivey, *Engaging Art*, 168–195.

Endnotes

1. See Petit (2000), Knight Foundation (2002), and Miringoff and Opdycke (2005). Additional participation surveys are available at http://www.cpanda.org.
2. Throughout the chapter, arts participation and cultural participation are used interchangeably.

3. While less relevant for policy, a significant body of research on arts partici-
pation has been motivated by a very influential theory advanced by French
sociologist Pierre Bourdieu focusing on "cultural capital," inequality, and
arts participation. In particular, scholars have been interested in the extent
to which arts participation is determined by social class (i.e., education and
income) (see chapter 12 in this volume for more background). Although
such studies are linked to concerns about equality, they have remained
largely theoretical and have not explicitly looked at how cultural participa-
tion connects with public life.

4. The NEA explored these interconnections in a three-part series that inves-
tigates the links between volunteering and the arts. See Grantham, et al.
(2006), and Nichols (2007a; 2007b).

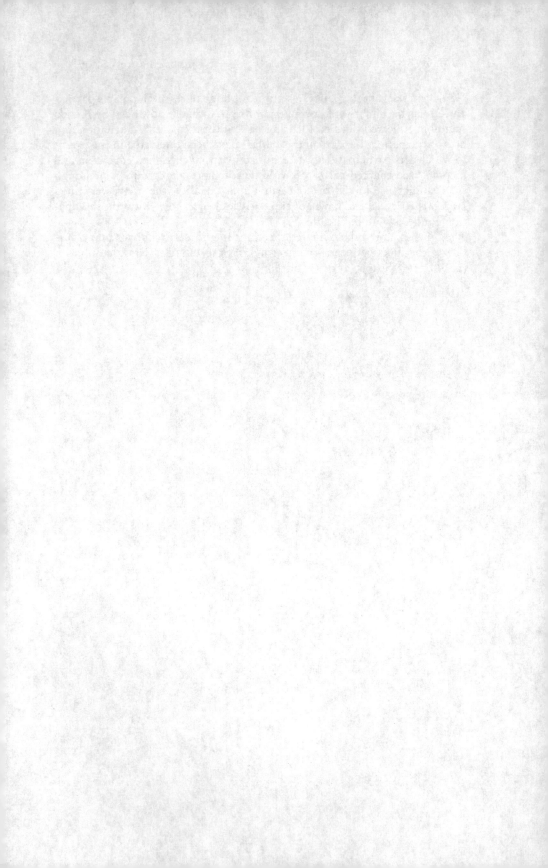

2 Comparing Participation in the Arts and Culture[1]

J. Mark Schuster

Introduction

Over the last three decades the practice of surveying a country's population to gauge participation in various arts and cultural activities has spread. The rise in participation studies is part of a broader trend: a multinational and international effort to develop a statistical base of information on the arts and culture as well as on cultural policy and its impact.[2]

The rise of government- and foundation-supported studies of participation mirrors the rationalization and quantification of culture in the broader world of arts and entertainment (see chapter 11 in this volume). Part of the impetus, no doubt, is to ensure greater accountability. The mantra of "value for money" and the call for "policy-relevant advice" have permeated cultural funding agencies, making them much more conscious of the effectiveness of the programs they oversee. The call has

gone out for hard data.[3] Perhaps no government has yet gone as far as the British government in spelling out goals for its public agencies. The Public Service Agreements between the Department of Culture, Media and Sport (DCMS) and the Treasury had, for example, stipulated a target to increase by 500,000 the number of people attending the arts by March 2004. This emphasis has emerged as cultural policy gradually shifting from a an almost exclusive focus on public funding of noncommercial cultural institutions as a sort of entitlement for their undeniable contributions to society to a more general concern with enumerating and measuring the public value that is being delivered—or not—by the arts. Some have embraced this direction; others have criticized it as an inappropriate and ultimately destructive instrumentalization of the arts.[4]

In short, the turn toward participation studies—and away from audience studies—has been accelerated by an increased government emphasis on planning, evaluation, and accountability, in other words, the rise of cultural policy itself (Huysmans, van den Broek, and de Haan 2005, p. 1). And the sheer quantity of data collected over the past few decades has inevitably led to concerns about quality, usability, and, less vocally, comparability.[5] This chapter focuses primarily on the latter. In particular, it explores differences in how countries define what it means to *participate*, how they define the arts, how they construct their questionnaires, and how each study reflect the goals and values of the sponsoring country. These differences make interpreting participation rates across countries a daunting and dangerous proposition. Nonetheless, the chapter presents a portrait of participation rates across some thirty-five countries, covering more than two dozen different art forms. The chapter concludes with observations based on the juxtaposition of these data and some thoughts about the future of cross-national comparisons in the context of larger cultural policy trends.

Comparison

Why do we want to compare cross-nationally? What do we expect to learn about others? What do we expect to learn about ourselves? What questions do we expect to answer?

We might want to compare ourselves with international benchmarks—an idea that has newly arrived in the participation literature.

But just exactly where are these benchmarks to come from: international averages; the participation rate in the country you aspire to be like; an arbitrarily set floor, or ceiling, or target? Or we might want to ascertain whether our country is an outlier, unusually high or unusually low in participation in particular art forms or cultural activities as compared with other places.

Regardless of the reasons for comparison, it pays to heed Roger Jowell's (1998) particularly useful critique of comparative research in which he urged great caution while providing a cogent summary of what would improve comparability—to the extent that that is possible.[6] He pointed out that there is a substantive difference between comparisons based on national studies and those based on studies intended to elicit equivalent measures across countries. He reminded readers that quantitative surveys depend on a sort of "principle of equivalence," yet he cited a number of cultural differences through which that equivalence breaks down (p. 170). Often, such a problem occurs when sources are not "tailor-made cross-national studies" but rather "broadly parallel data collected initially for strictly national purposes" (ibid.). For the most part, this is the situation that we confront with the accumulation of participation studies.

As this chapter shows, the task of comparing participation statistics is a considerable one. Those who have written about comparative cultural statistics are of a mixed mind concerning their utility, particularly when they turn to the implications of using such statistics in policymaking. Merkle (1991, p. 298) argued that even though comparative international data "rarely have the degree of detail needed to serve as a base for drawing up plans and formulating policies," they still have a role to play in analyzing trends "and for international comparison." Yet as Allin (2000, p. 66) pointed out, "Compiling cultural statistics for different countries on a comparable basis sounds like a contradiction: how can the cultures of one country be harmonized with those of another? The key is to identify why the comparison needs to be made." It becomes all too tempting to harmonize national cultures, if only through the device of standard statistical frameworks and definitions,[7] so that culture can be measured comparably, thereby strangely inverting the reason for conducting comparative studies in the first place.

The Challenges

Defining Participation

What is meant by participation in the arts and culture, and what are the central ideas behind each participation study?

In 1997 the Statistical Programme Committee of the European Union set up a leadership group (LEG) on cultural statistics. This group was to consider the possibility of harmonizing statistical practice concerned with the field of culture in the European Union. The leadership group arrived at the following contorted definition: "There is 'participation in cultural activities' when in any context and through any channel, with a shared general code of communication, we have senders and receivers paying much attention to forms and contents of messages to increase their own information and cultural baggage" (Eurostat, 1998, p. 171).

Although this construction may be elegantly conceptual to some, it offers little practical guidance as to how to construct a participation questionnaire. This presumably consensus view of the task force countries notwithstanding, most participation studies are much more practical in their approach to the definitional question: Participation is taken to mean all of the ways people engage with the art forms or cultural activities that are of interest to whoever has commissioned the study. This, of course, leads to considerable differences across studies.

Moreover, the meanings associated with participation vary among languages. Jean-Michel Guy (1993) nicely illustrated the problem by pointing out the discrepancies between French and English terms, demonstrating how notions of passivity and activity come into play with different words that fall under the rubric of participation. He wrote, "In both languages, the word, unless it is qualified, implies action and commitment. But the French language favours this active sense In English, when used in a 'statistical' context, the sense can often be restricted to that of frequency of attendance, whereas to a Frenchman, attendance suggests passive consumption rather than real participation" (p. 21). Thus, a logical distinction might be drawn between attendance and participation. The Dutch use a slightly different gloss by adopting a distinction between receptive participation and active participation (Huysmans, van den Broek, and de Haan 2005, p. 9). But this seems problematic: Where is reading to be categorized in such a scheme, as active or as passive? And to the extent that receptive participation

requires leaving the home and going to a performance or to make a visit, has not an active act been completed on the part of the participant?

To clarify these conceptual difficulties, the French begin with the notion of *pratiques culturelles* (cultural practices) and then divide these practices into three categories: *culture d'appartement* (culture at home), *culture de sortie* (culture outside the home), and *culture identitaire* (identity culture). This categorization has evolved as a result of three realizations: (1) a considerable amount of cultural consumption is experienced at home through various forms of the media rather than in specialized halls or buildings; (2) cultural behavior is closely linked to leisure time behavior and entertainment outside of the home and might now be more profitably construed to include cuisine, design, and cultural tourism among other cultural forms; and (3) various groups in the population—whether defined by race or ethnicity or in other ways—have their own particular cultural forms and cultural practices, ones that are not necessarily included in more traditional definitions, particularly those used by established governmental cultural agencies.

The National Endowment for the Arts (NEA) has adopted a slightly different tripartite division: participation via attendance, participation via the media,[8] and personal participation. McCarthy, Ondaatje, and Zakaras (2001, p. 27) extended this tripartite scheme and developed a two-by-two matrix of participation that takes account of both what a person is seeking through participation (i.e., entertainment or fulfillment) and the social context within which the participant prefers to participate (i.e., individually or as part of a social experience). Thus, this model distinguishes four forms of participation: participation via the media, hands-on participation, casual attendance, and attendance as an aficionado. Finally, yet another recent effort (Brown 2006) proposed a fivefold categorization of participation: inventive arts participation (artistic creation), interpretive arts participation (performance), curatorial arts participation (selecting and collecting), observational arts participation (attendance), and ambient arts participation (e.g., public art).

In addition to ex ante definitions and categorizations, how one ultimately decides to report and write about participation data also reveals quite a lot about how the issue of participation is being framed. If one chooses to write about "trends in the reach of culture," as is the case in Huysmans, van den Broek, and de Haan (2005), chances are that one

has made rather different decisions about participation and the boundary of the arts and culture than if one chooses to write about trends in the consumption of culture. Similarly, if one chooses, as does the French Ministry of Culture, to write about *la frequentation des équipements culturels* (the frequentation of cultural facilities and venues), one has bounded the inquiry in a different way.

Despite this rich theoretical debate as to how to define, to characterize, and to understand participation, most studies resort to a much more practical approach: What are the main activities that are of interest to the agency or department that has commissioned the research? It is the answer to this question that ends up determining the constituent components of participation and, therefore, the definition of participation itself. A ministry of culture or an arts council may cast a narrower net, being mostly interested, perhaps, in attendance at art museums or art exhibitions and less interested in attendance at other types of museums. An arts council that has no influence over heritage policy will be less likely to collect information on participation with respect to historic buildings, monuments, and sites. A national statistics agency, on the other hand, may arrive at participation studies through the lens of leisure time studies; as a result, the types of participation will be broadened in an attempt to catalog all of an individual's leisure time pursuits, not just those that are more narrowly deemed artistic or cultural. And an international agency that is first and foremost interested in comparability may settle for a shorter list of activities that can be agreed on by its member countries. Thus, the question of participation in the arts and culture is intimately linked to the definitional boundary constructed around them; consequently, one sees considerable variation in the coverage of various participation studies.

Defining Arts and Culture

What defines the arts and culture in any particular participation study? In public policy terms, what establishes the boundary of analysis? Participation studies vary widely across this dimension. At one end are studies that stick quite narrowly to the interests of the agency commissioning the study, incorporating only the forms of artistic and cultural practice that the agency supports with its programs. At the other

end are studies that adopt a much broader definition of artistic and cultural practice. [9]

An issue that has recently been articulated is whether the conceptual definition of the arts and culture that is held by the individuals responding to a participation survey is also the definition that is implicitly built into the survey instrument. Bridgwood and Skelton (2000) addressed this question in a pilot survey conducted for the Arts Council of England. On the one hand, they found that respondents to the pilot survey often defined the phrase *the arts* narrowly, but on the other hand, they also found that a number of the respondents were quick to point out that the survey did not include activities in which they were personally interested (e.g., visiting stately homes, gardens, or libraries). For Bridgwood and Skelton this had two implications: (1) some respondents felt judged because they did not participate in any of the listed activities; whereas (2) some interviewees tried to fit what they viewed as their own participation in the arts into the offered categories even when they were not appropriate (e.g., What is the intent of *dance classes* as a category? Does it include fitness dance or expressive dance?) In the British case, these issues led to the expansion of categories within the survey instrument and, consequently, the implicit boundary of analysis.

Further complicating the task of comparison is the fact that the appropriateness of boundaries changes over time as the policy focus of the commissioning agency and consequently of the participation study changes. This sort of expansion is easy to observe. Citro (1990), for example, pointed out that the original questionnaire for the NEA's Survey of Public Participation in the Arts (SPPA) included nothing about visits to historic locales, yet it eventually came to include, "Did you visit an historic park or monument, or tour buildings or neighborhoods for their historic or design value?" But even here the expansion was restricted by an awkward modifying phrase—"for their historic or design value"—presumably an attempt to remind the audience of the central artistic concerns of the NEA.

One might also resist the desire to expand the boundary of analysis for practical reasons: There will come a point at which the difficulty, if not the expense, of reasonable measurement becomes too high. Take, once again, the example of measuring visits to historic properties, which became a topic of considerable discussion within Eurostat's (2000, pp. 151–52) leadership group: "How does one distinguish visi-

tors with an interest in the cultural history of an old city centre from shoppers and passers-by? Has a visitor to an ancient church come to view its architecture, or out of religious conviction? The registration of visits to monuments is possible only for buildings that are open to the public, and visited mainly for cultural historical reasons. Furthermore, visitors often come not just for the monument itself …. People often visit an ancient city centre, a building or a church … without knowing that this object is a classified historical monument."

Nonetheless, there is a general tendency to subdivide artistic activity into increasingly narrow categories. This results, in part, from the inclination of arts agencies and their staffs to delimit different types of theater, different forms of dance, or different genres of music because of each office's specific policy emphases or funding priorities. But in addition to lengthening the survey and increasing nonresponse rates, increasing the number of categories runs the risk that the distinctions made by the commissioning funding body may not be comprehensible to the individual respondent. *Modern dance,* for example, was omitted from the early SPPA studies because of concerns that respondents would not interpret that phrase as the NEA staff intended.

As if these issues were not enough, it has also been demonstrated that reported participation rates actually vary according to the number of categories offered for each question. One American study double checked respondents' answers to one participation study against their answers to another study in which the respondents were asked to describe more fully the activities they had attended: 16 percent of reported opera goers, when given the opportunity to describe that attendance in more detail, actually described attending performances of musicals or operettas, 13 percent of reported jazz goers actually described attending folk or rock music performances, and 11 percent of reported classical music goers described attending rock music performances (Citro 1990). Moreover, new genres of music, visual art, and performance are constantly being invented, which leads to major changes in expressed preferences both before and after one attempts to measure them through participation studies.

Jermyn (1998) offered a nice example of what can happen to participation rates when categories are added. An apparently dramatic fall in the proportion of adults attending jazz occurred in the United Kingdom between 1991 and 1992. A likely explanation of this drop is simply that

in 1992 a rock and pop category was added to the participation survey, and respondents who once classified their attendance as *jazz* now had a more appropriate category into which to fit their concert participation. It has also been argued that the lack of a rock and pop category in the American SPPA studies—a category in which the music staff were uninterested because there was no active NEA policy in this area—may have inflated participation rates for jazz.

Participation rates will also vary by how widely or narrowly the questions cast their net. Consider reading: Most participation studies attempt to measure the percentage of the populations that might be considered readers but that do so in various ways. The NEA found broad participation for reading in general, yet when the results were scrutinized more deeply researchers found "that only 25–30 percent had read a work that might be called literature by the Literature Program and only 7–12 percent had read a contemporary work of merit [Such] narrowing occurs on the basis of subjective judgments about quality" (Research Division, NEA 1992a, p. 2). Note that the emphasis here is more on reading the type of literature that might be supported by the NEA than on reading per se.

The wording of questions can reveal a country's particular cultural interests or biases. Guy (1993, p. 23), for example, compares "Germany, whose statistics go to great lengths to measure musical behavior, making detailed distinctions between types of music, approaches to music and instruments played, and France, which is more concerned with the literary knowledge and tastes of its population."[10] Similarly, Jermyn (1998) pointed out that Americans are quite accustomed to the category *musical plays* and would easily be able to give an accurate answer as to whether or not they had attended in the previous year. But in other countries such attendance might have been classified as *plays or opera* but also as *any other performance in a theater*.

A slightly different categorization issue arises when there is a desire to distinguish attendance at professional productions from attendance at nonprofessional productions or attendance at a nonprofit artistic organization from attendance at a profit-making artistic organization. The problem is immediately apparent. One could, of course, add the desired modifiers to the survey questions; many participation studies have done so. Still, one is left wondering how completely the respondent is able to make the distinction that researchers and policymakers would

like them to make. How easy is it for a person to figure out whether he or she is attending a performance by a nonprofit theater company or a for-profit theater company, to remember that fact, and then to report it accurately later as part of a lengthy participation survey?

Recategorization and aggregation of categories occur during the processes of analysis, summary, and publication, and the intelligent reader must keep both of these issues in mind as well while constructing a meaningful comparison. How authors in various countries choose to consider and discuss their findings is quite telling. In the Netherlands, pop concerts, jazz concerts, musicals (i.e., subsets of popular music), and dance are all combined and presented as "visits to popular music events" (Huysmans, van den Broek, and de Haan 2005, pp. 54–55). This, of course, may reflect the predilections of the authors or something more profound about the way the Dutch construct and maintain the categories of cultural policy. The American SPPA studies ask a single question about attendance at "a live musical stage play or an operetta," but when the results are reported in document form they are given the simpler heading "musical play." For some consumers of these reports this difference may make little difference, but for others it could be of considerable importance.

The published results of any participation study have a certain crispness and precision that belies the difficulties and compromises entailed in their creation. But most importantly one must remember that each study is built around an implicit cultural model that defines the arts and culture as including certain domains and activities, while excluding others.

Question Wording and Survey Design

Response differences across countries also derive from how the information is gathered (Bridgwood and Skelton 2000). Some studies ask respondents to recall art forms they attended; others show the respondents a card with a printed list of art forms in which they might have participated. Response rates are much higher when prompted than when not prompted. But there are problems with the card approach if respondents think of some activities as *the arts* but they are not listed. On the one hand, respondents may underreport their extent of cultural participation, and, on the other, they may complicate the interpretation

of the forms that are listed if they feel they have to categorize their own cultural participation into one of the offered categories. One such British card shows twenty-two types of cultural participation; one might well ask whether that is too few or too many.

Another challenge for comparability is the time period within which participation rates are ascertained. The archetypical participation question asks, "During the past twelve months, have you participated in/ attended [fill in the blank]?" However, some surveys ask the question slightly differently. In Mexico, for example, the survey asks, "When was the last time you went to [fill in the blank]?" and still other countries ask, "How many times have you participated in/visited [fill in the blank] in [some specified time period]?" Depending on how the question is asked, respondents may either undercount their participation or give inflated answers.

Also, the time of year during which the study is conducted can influence participation rates. In some countries, participation is seasonal (e.g., Christmas holiday pantomimes in Great Britain, summer theater seasons); if surveys are conducted only once during the year, frequency of attendance may vary depending on the season.

Finally, the population surveyed differs across countries. Participation studies generally focus on the adult population, but there is little consistency in how *adult* is defined. In the Netherlands studies of receptive participation generally consider individuals sixteen years old or older; studies of active participation, however, generally begin at six, but some participation studies have begun at age twelve. In Italy participation studies begin at six or even three in some cases, whereas in France "Pratiques Culturelles des Français" begins at fifteen, as does New Zealand. The United States has consistently used eighteen as the starting point for the SPPA studies. Sweden begins with nine and ends with individuals age 79, whereas Luxembourg begins with fifteen and ends with 74.[11]

Looking at the Data

Table 2.1 provides the most complete compilation of relatively contemporary cross-national participation rates to date.[12] It focuses on receptive participation (attendance) rather than active participation,

Country		United States (%)	Canada (%)	Québec, Canada 1999/2004 (%)	Australia (%)
Dance	Dance/Ballet				
	Dance		6.8	13.7 / 19.0	10.9
	Professional Dance			10.6 / 13.9	
	Ballet	3.9		5.0 / 3.1	
	Contemporary/Modern Dance			5.5 / 4.4	
	Traditional/Folk Dance			2.3 / 2.6	
Opera	Opera/Operetta			4.9	
	Opera	3.2	3.0	7.5	
	Operetta			2.6	
	Opera or Musical Theatre			11.2	18.7
Theatre/	Theatre			36.9 / 31.0	18.0
Plays	Play/Drama				
	Plays, Vaudevilles and Dances				
	Professional Theatre		19.9	21.2 / 24.2	
	Theatre, Opera, Operetta, or Musical Performance				
	Musical Plays	17.1 [u]			
	Non-Musical Plays	12.3			
	Music Hall/ Variety Show/Pantomime			8.7 / 8.2	
Music	Concert		34.6 [c]	37.4	
	Classical Music Concert/Orchestral Music	11.6	8.2	11.2 / 13.7 [d]	9.0
	Non-Classical Concert				
	Choir Concert/Choral Music		6.6		
	Popular Music Performance		19.6		26.4
	Rock/Pop Music			13.1 / 13.7	
	Jazz/Blues Music	10.8 [e]		6.6 / 13.0	
	Traditional/Folk Music				
	World Music				
Other	Children's Performance		6.8		
Performing	Festival		22.6		
Arts	Culturally=Specific Festival		13.8 [t]		
	Circus			10.0 / 6.0	
	Carnival, Street Arts Event, or Circus (not animals)				
Museums/	Museum			39.0 / 41.735.4	
Exhibits	Museum or Gallery in Your Country				
	Museum or Gallery Abroad				
	Art Museum/Art Gallery [r]	26.5	29.7	30.6 / 32.6 [j]	24.9
	Other (non-art) Museums			22.8 / 26.2	25.0
	Public Art Gallery/Art Museum		22.1		
	Art Gallery		8.5	21.0 / 33.3	
	Painting Exhibition				
	Photography Exhibition				
	Craft Exhibition				
	Art/Craft Fairs and Festivals	33.4		20.8 / 21.9	
	Science, Technology, Natural Science, Natural History		12.9		
	General, Human History or Community Museum		10.9		
Outdoor	Historic Site/Monument		32.4	38.9 / 40.4	
Activities	Archaeological Site				
	Listed (Historic) Buildings				
	Visited Parks/Historic Buildings/Neighborhoods	31.6			
	Zoo/Aquarium		32.2 [q]		40.0
	Park or Gardens/Botanic Gardens		44.9 [s]		41.6
	Sports Events/Games	35.0			
Movies	Cinema/Movies	60.0	59.1	72.0 / 75.5	69.9
Reading	Read a Book	56.6	61.30	70.3	
	Read for Pleasure/Read Other Than for School or Work	46.7 [n]			
	Visited Public Library/Used Library Services		26.0	37.3 / 47.7	42.1
	Attended an Event Connected with Books or Writing			14.8[o]	
	Visited an Archive			9.3 / 11.4	
Source		2002 Survey of Public Participation in the Arts	Patterns in Culture Consumption and Participation	Enquête sur les Pratiques Culturelles au Québec (Data 1999/2004)	Arts and Culture in Australia: Statistical Overview (Data 2002)

Table 2.1a

Country		New Zealand (%)	England (%)	United Kingdom (%)	Austria (%)	Belgium (%)
Dance	Dance/Ballet			11.1	10.8	8.5
	Dance	14.0	12.0			
	Professional Dance					
	Ballet		2.0			
	Contemporary/Modern Dance		4.0			
	Traditional/Folk Dance					
Opera	Opera/Operetta		6.0	3.7	7.2	2.0
	Opera					
	Operetta					
	Opera or Musical Theatre	21.0				
Theatre/ Plays	Theatre	27.0		38.8	30.0	17.9
	Play/Drama		25.0			
	Plays, Vaudevilles and Dances					
	Professional Theatre					
	Theatre, Opera, Operetta, or Musical Performance					
	Musical Plays		26.0			
	Non-Musical Plays					
	Music Hall/Variety Show/Pantomime		14.0 [b]			
Music	Concert		39.0 [c]	33.7	28.3	21.1
	Classical Music Concert/Orchestral Music	11.0	10.0	10.1	10.2	4.7
	Non-Classical Concert					
	Choir Concert/Choral Music					
	Popular Music Performance	37.0				
	Rock/Pop Music		20.0	18.8	9.2	12.5
	Jazz/Blues Music			3.1	3.8	3.2
	Traditional/Folk Music	2.0 [f]		2.3	7.2	3.9
	World Music	2.0		1.0	3.1	2.3
Other Performing Arts	Children's Performance					
	Festival					
	Culturally=Specific Festival	18.0	8.0			
	Circus					
	Carnival, Street Arts Event, or Circus (not animals)		26.0			
Museums/ Exhibits	Museum					
	Museum or Gallery in our Country			42.0	29.3	17.1
	Museum or Gallery Abroad			21.8	16.1	17.2
	Art Museum/Art Gallery [r]	48.0	22 [l]			
	Other (non-art) Museums					
	Public Art Gallery/Art Museum					
	Art Gallery					
	Painting Exhibition					
	Photography Exhibition					
	Craft Exhibition		19.0			
	Art/Craft Fairs and Festivals					
	Science, Technology, Natural Science, Natural History					
	General, Human History or Community Museum					
Outdoor Activities	Historic Site/Monument	27.0	42.0	55.7	39.1	28.8
	Archaeological Site			12.8	14.0	7.7
	Listed (Historic) Buildings					
	Visited Parks/Historic Buildings/Neighborhoods					
	Zoo/Aquarium					
	Park or Gardens/Botanic Gardens		48.0			
	Sports Events/Games			33.1	42.4	30.4
Movies	Cinema/Movies		56.0	60.3	49.0	45.1
Reading	Read a Book			74.5	61.9	42.6
	Read for Pleasure/Read Other Than for School or Work		73.0			
	Visited Public Library/Used Library Services		44.0	49.0	17.7	23.4
	Attended an Event Connected with Books or Writing		8.0			
	Visited an Archive					
Source		A Measure of Culture (Cultural Experiences Survey 2002)	Arts in England 2003: Attendance, Participation, and Attitudes	Europeans' Participation in Cultural Activities (Data 2001)	Europeans' Participation in Cultural Activities (Data 2001)	Europeans' Participation in Cultural Activities (Data 2001)

Table 2.1b

Country		France (%)	France (%)	France (%)	Belgium (%)	Greece (%)	Belgium (%)	Belgium (%)
Dance	Dance/Ballet		809		887	789		587
	Dance			8290				
	Professional Dance	880						
	Ballet						380	
	Contemporary/Modern Dance						280	
	Traditional/Folk Dance	883					980	
Opera	Opera/Operetta		883	880	582	007		288
	Opera	380					880	
	Operetta	280						
	Opera or Musical Theatre							
Theatre/	Theatre	8880	8888	8880	3885	8880		2380
Plays	Play/Drama						3780	
	Plays, Vaudevilles and Dances							
	Professional Theatre							
	Theatre, Opera, Operetta, or Musical Performance							
	Musical Plays						2280	
	Non-Musical Plays							
	Music Hall/Variety Show/Pantomime	80880 [g]		883 [g]			3080	
Music	Concert		20800	2580	3883	8780		2882
	Classical Music Concert/Orchestral Music	980	887	780	980	288	980	382
	Non-Classical Concert							
	Choir Concert/Choral Music						780	
	Popular Music Performance			8880 [8]				
	Rock/Pop Music	980	983	580	8280	585	2280	8888
	Jazz/Blues Music	780 [e]	2888	880	282	008	8880	887
	Traditional/Folk Music		885		889	885	2880	388
	World Music		288	880	282	882		888
Other	Children's Performance							
Performing	Festival			80880				
Arts	Culturally-Specific Festival							
	Circus	8380		980				
	Carnival, Street Arts Event, or Circus (not animals)							
Museums/	Museum	3380		2980				
Exhibits	Museum or Gallery in our Country		2889		2989	8280		8949
	Museum or Gallery Abroad		988		8587	882		8280
	Art Museum/Art Gallery [r]			2880 [x]			23 [l]	
	Other (non-art) Museums							
	Public Art Gallery/Art Museum	8580						
	Art Gallery	2580						
	Painting Exhibition							
	Photography Exhibition	8580						
	Craft Exhibition							
	Art/Craft Fairs and Festivals							
	Science, Technology, Natural Science, Natural History	80880		2380				
	General, Human History or Community Museum	80880						
Outdoor	Historic Site/Monument	3080	3583	8880	8582	258		3280
Activities	Archaeological Site	8880	8089		889	8888		8380
	Listed (Historic) Buildings							
	Visited Parks/Historic Buildings/Neighborhoods							
	Zoo/Aquarium							
	Park or Gardens/Botanic Gardens							
	Sports Events/Games		2589		3880	2007		5883
Movies	Cinema/Movies	8880	5280	5280	5285	3588	5880 [8]	5780
Reading	Books	8688	7880	5788	8880	5888	8847	5788
	Public Libraries Used Library Services	3080	2280	2880	2788	788		2988
	Events Concerts or Plays or Movies or Reading						880	
Source		Les Pratiques Culturelle des Français (Data 1997)	Europeans' Participation in Cultural Activities (Data 2001)	Cultural and Sporting Participation, Insee (Data)	Europeans' Participation in Cultural Activities (Data 2001)	Europeans' Participation in Cultural Activities (Data 2001)	The Public and the Arts (Data 1994)	Europeans' Participation in Cultural Activities (Data 2001)

Table 2.1c

C⊠⊠⊠⊠⊠		Italy [a] (%)	Luxembourg (%)	The Netherlands (%)	The Netherlands (%)	Portugal (%)
⊠⊠ce	⊠⊠⊠ce⊠⊠⊠le⊠		9.2		13.3	5.2
	⊠⊠ce			9.0		
	⊠⊠⊠fessi⊠⊠⊠ ⊠⊠ce					
	⊠⊠le⊠			4.6		
	C⊠⊠⊠&⊠p⊠⊠⊠⊠⊠⊠⊠⊠e⊠ ⊠⊠ce					
	⊠⊠⊠⊠⊠⊠⊠⊠⊠⊠⊠⊠⊠ce					
⊠pe⊠⊠	⊠pe⊠⊠⊠⊠pe⊠⊠⊠⊠		3.2		2.4	0.5
	⊠pe⊠⊠					
	⊠pe⊠⊠⊠⊠⊠					
	⊠pe⊠ ⊠⊠⊠⊠sic⊠ ⊠⊠⊠⊠e					
⊠⊠⊠⊠⊠ ⊠⊠⊠s	⊠⊠⊠⊠e	17.9	30.6	26.0	33.1	8.5
	⊠⊠⊠⊠⊠⊠⊠⊠⊠					
	⊠⊠⊠-⊠⊠ ⊠⊠evilles ⊠⊠⊠ ⊠⊠ces					
	⊠⊠⊠fess⊠⊠⊠⊠&⊠⊠⊠e			14.0		
	⊠c⊠⊠⊠⊠ ⊠pe⊠⊠ ⊠pe⊠⊠c⊠⊠⊠⊠⊠⊠⊠sic⊠ ⊠⊠⊠⊠⊠⊠ce					
	⊠⊠sic⊠ ⊠⊠⊠s			16.0		
	N⊠⊠-⊠⊠sic⊠ ⊠⊠⊠s					
	⊠⊠sic H⊠⊠⊠⊠ie⊠⊠⊠⊠⊠⊠⊠⊠⊠⊠⊠e			14 [g]		
⊠⊠sic	C⊠⊠ce⊠⊠		42.2		31.5	18.2
	C⊠⊠ssic⊠⊠ ⊠⊠sic C⊠⊠ce⊠⊠⊠⊠⊠es⊠⊠⊠⊠sic	8.8 [d]	18.1	14 [d]	9.2	1.8
	N⊠⊠-C⊠⊠ssic⊠⊠ C⊠⊠ce⊠⊠	20.5				
	C⊠⊠i⊠ C⊠⊠ce⊠⊠⊠C⊠⊠⊠⊠⊠sic					
	⊠⊠p⊠⊠⊠⊠sic ⊠c⊠⊠⊠⊠⊠ce			31.0		
	⊠⊠⊠⊠p⊠⊠sic		17.5	21.0	14.6	10.6
	⊠⊠zz⊠⊠ ⊠es⊠⊠sic		4.8	4.0 [e]	3.2	0.7
	⊠⊠⊠⊠⊠⊠⊠⊠⊠⊠⊠sic		4.7		2.3	6.6
	Wo⊠⊠ Music		4.9		3.2	1.1
⊠⊠⊠&⊠ Pe⊠fo⊠⊠ing ⊠⊠⊠s	C⊠⊠⊠⊠en's Pe⊠fo⊠⊠ance					
	Fe⊠⊠ival					
	Cul⊠⊠⊠all⊠ Spec⊠⊠c Fe⊠⊠ival					
	Ci⊠cus					
	Ca⊠niva⊠ ⊠⊠⊠⊠e⊠⊠⊠⊠s Even⊠⊠⊠ Ci⊠cus⊠no⊠ani⊠als)					
Museu⊠⊠ ⊠ Ex⊠i bi⊠s	Museu⊠	28.5 [i]		38.0		
	Museu⊠ o⊠ Galle⊠y in ou⊠ Coun⊠⊠y		30.4		32.1	15.6
	Museu⊠ o⊠ Galle⊠y⊠ b⊠oa⊠		37.1		22.9	3.3
	⊠⊠⊠ Museu⊠⊠⊠⊠⊠ Gall⊠⊠y [⊠]					
	⊠⊠⊠&⊠ ⊠non-a⊠⊠⊠Museu⊠s					
	Public ⊠⊠⊠ Galle⊠y⊠⊠⊠⊠⊠Museu⊠					
	⊠⊠⊠ Galle⊠y					
	Pain⊠⊠ing Ex⊠i bi⊠ion					
	P⊠⊠⊠g⊠ap⊠y Ex⊠i bi⊠ion					
	C⊠af⊠ Ex⊠i bi⊠ion					
	⊠⊠⊠⊠C⊠af⊠ Fai⊠s an⊠ Fes⊠ivals					
	Science⊠⊠ec⊠nolo gy⊠Na⊠u⊠alScience⊠Na⊠u⊠alHis⊠o⊠y					
	Gene⊠⊠lHu⊠an His⊠o⊠yo⊠Co⊠⊠uni⊠y Museu⊠					
⊠u⊠⊠oo⊠ ⊠c⊠ivi⊠es	His⊠o⊠ic⊠i⊠e⊠Monu⊠en⊠	22.7[p]	54.2		46.0	25.1
	⊠⊠c⊠aeolo gical Si⊠e		19.3		18.2	7.8
	Lis⊠⊠⊠ His⊠o⊠ic Buil⊠⊠ngs			45.0		
	Visi⊠e⊠ Pa⊠⊠⊠ His⊠o⊠ic Buil⊠⊠ngs⊠Nei⊠⊠⊠oo⊠s					
	Zoo⊠⊠qua⊠iu⊠					
	Pa⊠⊠o⊠ Ga⊠⊠ens⊠Bo⊠anicGa⊠⊠ens					
	Spo⊠⊠sEven⊠⊠⊠ia⊠es	29.0	42.4		40.2	30.3
Movies	Cine⊠⊠Movies	48.1	53.9	57.0	48.9	35.4
Rea⊠ing	Rea⊠ a Boo⊠	41.4	65.4		63.4	32.7
	Rea⊠ fo⊠ Pleasu⊠⊠Rea⊠⊠⊠⊠ ⊠an fo⊠ Sc⊠ool o⊠ Wo⊠⊠					
	Visi⊠e⊠ Public Lib⊠⊠⊠y⊠Use⊠ Lib⊠⊠⊠ySe⊠vices		18.1	38 [m]	43.7	16.7
	⊠⊠⊠en⊠e⊠ an Even⊠⊠Connec⊠e⊠⊠⊠⊠⊠ Boo⊠s o⊠W⊠⊠⊠ing					
	Visi⊠e⊠an ⊠⊠c⊠ive			3.3		
Sou⊠ce		Aspetti della Vita Quotidiana (Data 2003/2004)	Europeans' Participation in Cultural Activities (Data 2001)	Amenities and Services Utilization Survey (AVO) (Data 2003)	Europeans' Participation in Cultural Activities (Data 2001)	Europeans' Participation in Cultural Activities (Data 2001)

Table 2.1d

Country		Spain (%)	Spain (%)	Denmark (%)	Finland (%)	Sweden (%)	Sweden (%)
Dance	Dance/Ballet	4.6	6.6	11.3	12.7		10.8
	Dance						
	Professional Dance						
	Ballet						
	Contemporary/Modern Dance						
	Traditional/Folk Dance						
Opera	Opera/Operetta		0.9	6.0	2.8		4.6
	Opera	3.0					
	Operetta						
	Opera or Musical Theatre						
Theatre/ Plays	Theatre	23.6	16.4	27.6	37.8		43.3
	Play/Drama						
	Plays, Vaudevilles and Dances						
	Professional Theatre						
	Theatre, Opera, Operetta, or Musical Performance					48.0	
	Musical Plays						
	Non-Musical Plays						
	Music Hall/Variety Show/Pantomime						
Music	Concert		26.2	38.9	30.6	58.0	42.6
	Classical Music Concert/Orchestral Music	8.5	3.0	6.8	7.6		10.0
	Non-Classical Concert	24.8					
	Choir Concert/Choral Music						
	Popular Music Performance						
	Rock/Pop Music		16.8	26.7	12.7		24.0
	Jazz/Blues Music		1.7	6.8	3.3		7.0
	Traditional/Folk Music		5.3	5.4	5.4		8.6
	World Music		1.7	1.7	1.7		0.8
Other Performing Arts	Children's Performance						
	Festival						
	Culturally=Specific Festival						
	Circus	4.8					
	Carnival, Street Arts Event, or Circus (not animals)						
Museums/ Exhibits	Museum	27.9					
	Museum or Gallery in our Country		20.0	46.1	35.4		51.1
	Museum or Gallery Abroad		3.6	25.1	14.9		25.0
	Art Museum/Art Gallery [r]					42 [j]	
	Other (non-art) Museums					44.0	
	Public Art Gallery/Art Museum						
	Art Gallery	17.7					
	Painting Exhibition						
	Photography Exhibition						
	Craft Exhibition						
	Art/Craft Fairs and Festivals						
	Science, Technology, Natural Science, Natural History						
	General, Human History or Community Museum						
Outdoor Activities	Historic Site/Monument	28.9 [p]	34.3	63.1	44.2	40.0 [p]	67.5
	Archaeological Site		13.9	18.0	8.9		11.0
	Listed (Historic) Buildings					59.0	
	Visited Parks/Historic Buildings/Neighborhoods						
	Zoo/Aquarium	11.6 / 11.3					
	Park or Gardens/Botanic Gardens	16.6					
	Sports Events/Games	20.0	32.1	39.5	43.9	55.0	50.2
Movies	Cinema/Movies	55.8	60.7	57.1	49.8	68.0	64.0
Reading	Read a Book		47.3	66.6	76.1		80.7
	Read for Pleasure/Read Other Than for School or Work	45.5				82.0	
	Visited Public Library/Used Library Services	20.0	22.2	61.0	67.6	66.0	64.7
	Attended an Event Connected with Books or Writing						
	Visited an Archive	3.5					
Source		Encuesta de Hábitos y Prácticas culturales en España (Data 2002-2003)	Europeans' Participation in Cultural Activities (Data 2001)	Europeans' Participation in Cultural Activities (Data 2001)	European's Participation in Cultural Activities (Data 2001)	Kulturbarometern in 2002	Europeans' Participation in Cultural Activities (Data 2001)

Data also collected for Norway , Bulgaria, Cyprus, Czech Republic, Estonia, Hungary, Latvia, Lithuania, Malta, Poland, Romania, Slovakia, Slovenia, Turkey, Mexico, and Japan

Table 2.1e

though many of these studies also collected data on the latter. These participation rates are drawn from nineteen participation studies, which cover thirty-five countries plus the Canadian province of Québec.[13] All but one of these studies were conducted in the past ten years, and most were conducted in the last five.

Collectively, these studies provide forty-four sets of participation rates. For several of these countries (and the province of Québec) I have chosen to include the results of two studies and, in the case of France, three studies. This is done to illustrate how results can differ from one study to another, even for the same country. For several countries the table summarizes and compares the results of studies conducted by those countries alone to a cross-national study performed by the European Union.[14] Two such cross-European studies are summarized here: "Europeans' Participation in Cultural Activities," which was conducted in 2001 for the then members of the European Union (Eurobarometer 56.0 2002), and "New Europeans and Culture," which was conducted in 2003 for a set of countries in central and eastern Europe who were under consideration for possible European Union membership (Eurobarometer 2003.1 2003). For Québec the two reported studies were done five years apart by the province itself. These results serve as one illustration of how similar—and different—the results can be when the surveys are done consistently. In France, two of the studies were conducted nationally—the well-known "Pratiques Culturelles des Français" and the more recent "Cultural and Sporting Participation" conducted by the French national statistics institute—and the third as part of the European Union's "Europeans' Participation in Cultural Activities."

It is extremely tempting to launch into comparison when confronted with such a table, despite all of the caveats discussed earlier in this chapter. Yet Guy (1993, p. 18) was on target when he insisted on distinguishing between juxtaposing such data and comparing them, which is a matter of the attitude one adopts vis-à-vis the data. Juxtaposition provides hints and suggests possibilities, whereas comparison seeks to derive facts and to establish hierarchies. The data that are currently available may be ready for juxtaposition, but for the reasons discussed already they are certainly not ripe enough for comparison. Thus, I have made every effort to constrain myself to juxtaposition. Nevertheless, a few comments on Table 2.1 do seem to be in order.

To construct this table it was necessary to make many decisions about what to include and how to include it. The categories for artistic and cultural forms were collapsed as far as seemed possible—and where this has been done, it has been carefully recognized in the notes. If this had not been done, the table would have had hundreds of rows. The resulting categorization scheme still leaves intractable interpretation problems. What are we to make of comparative participation rates at museums, for example, when so many irreconcilable definitions of museums and categories of museums are used?

It is also important to realize that Table 2.1 was not constructed from the original raw data. The study worked, almost exclusively, from published sources: reports, other documents, or tabulations posted on websites. Thus, a variety of computational and presentational decisions have already been made by the original analysts and authors. The discovery was made, for example, that some participation studies report participation rates as the percentage of attendees—to a particular art form—from among all survey respondents (including those that did not answer the question); this would appear to underestimate participation rates. Other studies report participation rates as the percentage of attendees (to a particular art from) from among only those respondents who gave a specific answer (i.e., yes or no) to the relevant question; this seems to be the preferable method, and when possible this adjustment was made to the participation rates.[15] As a consequence, some of the participation rates reported in Table 2.1 differ from those reported in each study's own documentation.

Empty cells in the table generally mean that the particular category did not appear in the original survey, but they might also indicate that the participation rates were so low as to be insignificant, that the data were simply not calculated from the original data, or that they were not published in the sources to which access was given. Conversely, many of the studies reported participation rates for other artistic or broadly cultural activities that were not included here simply because similar activities did not appear in enough of the studies to warrant juxtaposition.[16] Generally, other categories (e.g., *other dance*) were omitted when participation rates for such categories were reported.

Despite all of these cautions and caveats, it is possible to make some broad statements based on these results:

- Going to the cinema, reading, and going to sports are the cultural activities that enjoy the highest participation rates.
- Attending museums—however that has been defined and captured—and visiting historic sites generate the next highest participation rates.
- Attending musical concerts and the theater fall at the next level of participation.
- Dance in its many forms and opera and operetta enjoy the lowest participation rates.
- Participation levels are broadly similar across countries.[17]
- Participation levels appear to respond to the supply of the activity in which participation is being measured, though it may be the other way round.

Using the adjectives *highest, next highest,* and *lowest* as relative terms inevitably leads to the question of what constitutes a high level of participation in absolute terms. My view is that it is still very difficult to say something about absolute levels with respect to comparative participation rates, although many have tried.[18] These adjectives probably do have some traction when comparing global or aggregate participation rates, which combine a number of art forms and cultural practices into one participation rate. Still, it is easy to make too much out of such a number. It is my view, and that of many others who have attempted to look at participation studies comparatively, that the more interesting comparisons are often the ones that can be made for a single nation or region over time when carefully controlling for sampling error and changes in definitions and categories.

Yet it is not my intent to draw attention away from the real differences that do occur across countries in these studies. Any reader might well find particular differences compelling: The use of public libraries and the level of reading appear to be dramatically higher in the Nordic countries than elsewhere. Some countries have very high rates of attendance at historic sites or monuments, perhaps because of the natural geographic distribution of such sites or because of the degree to which interpretation and public information concerning those sites has been developed, whereas other countries have rather low levels of attendance. Luxembourg has a much higher level of participation at classical music concerts and in orchestral music than any of the other countries. West-

ern Europeans show much higher levels of visiting a museum or gallery abroad than do central or eastern Europeans, whereas the difference is much less pronounced for visiting a museum or gallery in their own country—a not unexpected result given the relative economic, and therefore mobility, positions of these populations.

Focusing on the countries in the table for which multiple participation studies are reported, two other conclusions seem apropos. First, when a survey is conducted as part of a more general study undertaken by a national statistical institute, it will make use of a broader boundary of analysis (e.g., usage of a public library, attendance at a sports match) than will a study commissioned by or conducted by the ministry of culture or its equivalent. It will also tend to use more traditional categories of artistic and cultural practices.[19] The result may well lead to more cross-national comparability because it will be more likely to conform to international statistical norms and be bound by international statistical agreements.

A careful examination of Table 2.1 displays this lowest common denominator effect that results when surveys are designed ex ante for cross-national comparison. The two EU studies tend to use broader categories for each artistic or cultural activity than the national surveys do—not unexpected when cross-national consensus has to be achieved—and fewer categories than those used by individual countries. Put another way, the pressure to develop a questionnaire that is broadly acceptable leads to a questionnaire that is constructed at a minimum level of detail so that as many countries as possible can put it into practice and consequently produce comparable indicators of cultural participation; it becomes a survey whose primary goal is comparability rather than understanding. Second, studies commissioned by cultural agencies will be much more closely tied to their own practices and agendas, thereby hampering the possibility of cross-national comparison.

These phenomena can be seen more clearly in Table 2.2, which extracts the portion of Table 2.1 that pertains to France. Several important points emerge from this side-by-side presentation of these three studies. First, even when the categories used by the studies are roughly comparable, differences in participation rates are reported. It is possible that this is due to sampling error, which is always to be expected; it is also possible that this is due to change over time; the three studies were conducted in different years. But it is difficult to explain some of

Table 2.2

Country		France (%)	France (%)	France (%)
Dance	Dance/Ballet		8.9	
	Dance			12.0
	Professional Dance	8.0		
	Ballet			
	Contemporary/Modern Dance			
	Traditional/Folk Dance			
Opera	Opera/Operetta		1.3	4.0
	Opera	3.0		
	Operetta	2.0		
	Opera or Musical Theatre			
Theatre/	Theatre	16.0	11.8	16.0
Plays	Play/Drama			
	Plays, Vaudevilles and Dances			
	Professional Theatre			
	Theatre, Opera, Operetta, or Musical Performance			
	Musical Plays			
	Non-Musical Plays			
	Music Hall/Variety Show/Pantomime	10.0 [g]		13 [g]
Music	Concert		20.4	25.0
	Classical Music Concert/Orchestral Music	9.0	4.7	7.0
	Non-Classical Concert			
	Choir Concert/Choral Music			
	Popular Music Performance			11.0 [w]
	Rock/Pop Music	9.0	9.3	5.0
	Jazz/Blues Music	7.0 [e]	2.6	4.0
	Traditional/Folk Music		1.5	
	World Music		2.6	6.0
Other	Children's Performance			
Performing	Festival			10.0
Arts	Culturally=Specific Festival			
	Circus	13.0		9.0
	Carnival, Street Arts Event, or Circus (not animals)			
Museums/	Museum	33.0		29.0
Exhibits	Museum or Gallery in our Country		21.9	
	Museum or Gallery Abroad		9.4	
	Art Museum/Art Gallery [r]			28.0 [x]
	Other (non-art) Museums			
	Public Art Gallery/Art Museum			
	Art Gallery	15.0		
	Painting Exhibition	25.0		
	Photography Exhibition	15.0		
	Craft Exhibition			
	Art/Craft Fairs and Festivals			
	Science, Technology, Natural Science, Natural History	10.0*		23.0
	General, Human History or Community Museum	14.0*		
Outdoor	Historic Site/Monument	30.0	35.3	46.0
Activities	Archaeological Site	11.0	10.9	
	Listed (Historic) Buildings			
	Visited Parks/Historic Buildings/Neighborhoods			
	Zoo/Aquarium			
	Park or Gardens/Botanic Gardens			
	Sports Events/Games		25.9	
Movies	Cinema/Movies	49.0	52.0	52.0
Reading	Read a Book	74.0	57.1	68.0
	Read for Pleasure/Read Other Than for School or Work			
	Visited Public Library/Used Library Services	31.0	22.0	21.0
	Attended an Event Connected with Books or Writing			
	Visited an Archive			

the largest differences (e.g., reading: 74, 57.1, and 68 percent) with any combination of these two explanations. Rather, it is more likely that the differences have to do with the survey context—the broader set of questions employed by each survey and its methodology—within which each individual responded.

Second, studies conducted at the European level or by an agency other than the key cultural agency will use a different set of categories. "Europeans' Participation in Cultural Activities" tends to use broad cultural categories, categories that are presumably the result of a good deal of negotiating among the European countries involved in the study. "Cultural and Sporting Participation" similarly uses broad categories but also introduces other uses of leisure time, which can lead to different answers to questions about one's personal participation. Perhaps this is why in "Cultural and Sporting Participation" a higher attendance rate at historic sites and monuments is reported. It is a result that arises from a study that is not self-consciously cultural with all of the connotations that that might impart to respondents as they are answering each question.

Third, the data concerned with attendance at various types of music may well be an illustration of an issue discussed earlier: respondents forcing their responses into improper categories when the number of categories is relatively small. To recognize this one has only to compare the participation rates in the third study in which both popular music performance and rock and pop music are offered as categories with the participation rates reported in the other two studies, which use a different set of categories.

Fourth, the categories used and the questions posed are a reflection of the primary concerns of the agency conducting, or commissioning, the study. Note the fine distinctions made with respect to museums and exhibitions in the ministry of culture's study or the attempt to distinguish among a wider set of musical forms in the European Union's study.

Finally, when there is likely to be agreement on the breadth of a category and a clear understanding among potential respondents as to what a particular category means, the participation rates are much more likely to be similar across studies. Consider, for example, attendance at the cinema, or movies: 49, 52, and 52 percent.

In Summary

Placing participation data next to one another—juxtaposing them—in a comparative table hardly makes them comparable. As we have seen, many methodological decisions are made within each study, and many of these small, incremental decisions reduce comparability step by step. But constructing league tables is much too tempting,[20] and it is all too easy to assume that differences between studies are small. Therefore, first of all, one should be wary of ex post harmonization of participation studies. One response to this warning is to force comparability from the outset. One might ask the same battery of questions across a number of countries, but then one must worry about whether the same survey instrument is perceived and interpreted in the same way in one national context as in another and whether the translations to other languages are appropriate. One must also worry about the nuance that is lost when consensual questions and categories are used.

Second, one should also be wary of ex ante harmonization. The creation of comparability may well pose methodological dilemmas: local usefulness as opposed to broad cross-national comparability;[21] depth of inquiry as opposed to degree of aggregation; depth of inquiry as opposed to cost; and timeliness as opposed to meticulousness, among others.

Seen this way, the question of comparability reduces to a question of acceptable trade-offs. Yet with sufficient investment and cleverness it is possible to create almost any degree of comparability. With an increased understanding of this particular form of survey research, participation studies are gradually being improved and their methodology refined, which brings us to the question of the use of participation studies.

Calls for regularly conducted, high-quality surveys that generate detailed, publicly available data on patterns of participation are likely to persist; the desire to benchmark local performance against performance elsewhere or as compared with another point in time is unlikely to go away. The cry for hard facts and evidence-based policy is hardly on the wane. But after his comparative survey of participation study practices for the International Federation of Arts Councils and Cultural Funding Agencies, Christopher Madden (2004, p. 11) was quick to caution, "Cross-country difference in cultural data may, therefore, be due to differences in measurement rather than to 'real' differences in cultural phenomena. Benchmarking, or drawing policy and program implica-

tions from such data should be strongly discouraged." If comparative research is to expand and have meaningful purchase in the field of cultural policy, then these data issues will have to be engaged.

The proliferation of participation studies has now spanned three decades of espoused change in cultural policy, and many claims have been made about the policy relevance of participation studies—along with the development of many other forms of cultural statistics. Unfortunately, these claims are accompanied by little robust evidence that they actually deliver such relevance.[22] What is the policy role of participation studies if all they can offer is a bird's-eye view of the terrain? Similarly, what is their research role? At the moment, the broad nature of existing questions, due to the need for relatively short surveys that remain consistent over time, does not provide the rich policy detail necessary for assessment, evaluation, and policy reform.

To give a much more detailed and nuanced view of participation and to better inform policy, longer studies with larger sample sizes and more carefully constructed questions would be required, but the necessary investment would likely prove unattractive to cultural agencies who see—and whose constituents see—their main role as providing financial support to the arts and culture rather than as supporting research. If there is an implicit agenda in this chapter, it may be to suggest that research, analysis, and understanding can also constitute forms of support. Still, it is important to remember that the interests of policymakers, researchers, cultural institutions, and the population do not naturally coincide. One exquisitely designed participation study is unlikely to satisfy them all at the same time.

Citro (1990) pointed out that the practice in a number of countries is to conduct a broader survey that includes leisure-time arts-related, educational, and recreational activities, perhaps with multiagency sponsorship. Indeed, the evidence suggests that more of a marriage is being witnessed between arts participation studies and leisure-time studies, though to date this may be more of a marriage of convenience than a marriage of mutual commitment.[23]

Nevertheless, places that vest their participation studies with their national statistical agency—or an agency with a similarly broad purview—will be better able to pursue questions outside the specific, narrow interests of the cultural agency. This is true not only because increased resources might be brought to the table (e.g., in a cost-sharing arrange-

ment with the commissioning agency) but also because a broader set of interests will have to be satisfied. If one steps further up the hierarchy of cooperation to the multinational level, however, this principle does not seem to hold true. Here the emphasis on reaching consensual definitions across multiple countries will lead to more highly aggregated concepts with a concomitant loss of detail.

Writing at a moment when a more limited set of participation studies was available, Kleberg and Skok (1993) suggested that the response of the cultural bureaucracy to participation studies has simply been to redefine the boundary of the arts and culture. From the participation data they were able to consider, they concluded that participation rates, traditionally defined, were quite stable and rather similar from country to country—for similarly defined art forms and cultural practices. Their view was that participation would not increase through the efforts of traditional cultural institutions or governmental agencies. They foresaw an era of culture without frontiers with expanding definitions of what is culture, and subsequently challenging a cultural policy world that heretofore has been dominated by elite cultural forms. [24]

One might argue that a policy concern for cultural engagement has led from an era in which participation was stressed (i.e., everyone would have their own form of actual cultural engagement) to an era in which access was stressed (i.e., everyone could choose to engage in a form of cultural engagement if they so wished) to an era in which now the definition of culture simply is enlarged. The first two policy goals have mostly been abandoned because the accumulated research suggests that policy has failed at accomplishing those goals.[25] Indeed, this research consensus might be characterized as an accomplishment of participation studies. Of course, enlarging the definition of culture is not, in and of itself, a bad thing; many would argue quite persuasively that this is the foundation on which cultural policy should have been built in the first place.

This view suggests that the relatively stable results of participation studies have led to changes in the manner in which policymakers conceive of the task of cultural policy, but it may also be the other way around: that changes in the cultural practices of the adult population necessitate changes in the methodology by which one will have to detect cultural participation. Seen in this way, the practice of participation surveys is likely to be a conservative one, struggling to keep up with

cultural participation rather than staying one step ahead of it. At the same time, the pressure from already interested parties is likely to work to maintain the status quo. If so, we might expect that old interests will persist in the face of new interests, including new ways of participating and new cultural interests of the population. Methodologically, old questions will persist in the face of new questions.

Another constraint that looms large in participation studies is the agenda of the commissioning agency. A potent combination of factors—cost, myopia, and lobbying pressure from powerful constituents—is also likely to be experienced as a conservative force, maintaining the fiction of a narrowly defined and consensual field of cultural practices.

Diary interview techniques in which respondents are asked to record all their activities for a set time period provide one possible solution. Respondents' diaries can be used to infer cultural participation, and this technique may actually introduce less bias because it asks respondents to list all their activities, not just those under the rubric of arts and culture. Analytical categories can then be formed out of the data rather than prior to the collection of the data. Diary interview techniques also do not rely on the recall of participation that may have happened nearly a year ago. The Dutch Social and Cultural Planning Office makes use of both types of studies in its analyses, conducting each on a regular basis; Italy conducts a broader leisure-time study on a regular basis and a narrower cultural participation study less often.

Lievesley (2000, p. 77), responding primarily to the issue of varying definitions of the arts and culture across countries, hinted at another approach: "Given that countries across the world have extremely diverse cultural systems and cannot really be expected to have ... a 'common cultural heritage,' does this mean that comparable data are not required internationally but only for subsets of countries which share a heritage?" In her view, comparative participation studies may only make sense if they are conducted across relatively homogeneous sets of countries, or regions. Taken together, all of these admonitions remind us that comparable data are not necessarily usable data, but, by the same token, usable data are not necessarily comparable data.

Perhaps there is a middle ground. One might envision a cross-national system that would alternate national studies with cross-national studies. At one stage in the cycle, individual countries would—or would choose not to—conduct their own studies with their own concepts, pri-

orities, and questions; at the second stage in the cycle, a cross-national study with harmonized questions and categorizations—most likely at a higher level of generality and aggregation than the approaches chosen by individual countries—would be conducted, perhaps along the lines of the current Eurobarometer studies. The cycle would then return to national studies the next time around. The current sets of studies have demonstrated that dramatic change is unlikely to be observed within the time intervals that have typically been used—though, as always, there are exceptions, the major one here being the rise of culture as mediated through the media bringing a wider range of cultural experiences into our individual homes—so perhaps there would be a willingness to give up current practice for an alternative practice of the sort suggested.

Nationalized studies would be alternated with harmonized studies, with the latter serving comparability but making trade-offs that would not have to be made in the former. Of course, it is hard to predict just what the net effect of the off-year studies might be. On the one hand, nationalized studies might exert considerable pressure toward harmonization for comparability purposes; on the other hand, harmonized studies might exert pressure in the opposite direction. Perhaps convergence would occur; if so, we would then understand better what we hope to accomplish through such studies. In any event, this suggestion notwithstanding, we should not soon expect to abandon the use of different boundaries, concepts, definitions, categories, or statistical methods because they all have meaning to those who use them.

Bibliography

Allin, Paul. 2000. "The Development of Comparable European Cultural Statistics." *Cultural Trends* 37: 64–75.

AMS Planning & Research Corp. 1995. "A Practical Guide to Arts Participation Research." Research Division Report 30. Washington, DC: National Endowment for the Arts, January.

Australian Bureau of Statistics. 2004. "Arts and Culture in Australia: A Statistical Overview." 4172.0. Canberra: Australian Bureau of Statistics.

Australia Council. 1996. *The Arts: Some Australian Data—The Australia Council's Compendium of Arts Statistics*, 5th ed. Sydney: Australia Council.

Bårdseth, Asta, and Liv Taule. 2004. "Culture Statistics 2002/Kulturstatistikk 2002." Oslo: Statistics Norway, January. http://www.ssb.no/english/subjects/07/nos_d289_en/main.html.

BBC Research & Consulting. 2004. "2002 Survey of Public Participation in the Arts." Research Division, Report 45. Washington, DC: National Endowment for the Arts, March.

Bernier, Serge, and Denise Lievesley (Eds.). 2003. *Proceedings of the International Symposium on Culture Statistics, Montréal, 21–23 October 2002.* Québec: Institut de la Statistique de Québec.

Bina, Vladimir. 2003. "Cultural Participation in the Netherlands." In Bernier and Lievesley, *Proceedings of the International Symposium on Culture Statistics, Montréal, 21–23 October 2002,* 361–380.

Bridgwood, Ann, and Adrienne Skelton. 2000. "The Arts in England: Developing a Survey of Attendance, Participation and Attitudes." *Cultural Trends* 40: 40–76.

Bridgwood, Ann, Clare Fenn, Karen Dust, Lucy Hutton, Adrienne Skelton, and Megan Skinner. 2003. "Focus on Cultural Diversity: The Arts in England—Attendance, Participation, and Attitudes." Research Report 34. London: Arts Council England, December.

Brown, Alan. 2006. "A Fresh Look at Arts Participation." Working Paper 18, newsletter of Wolf, Keens & Co., 1–2. http://wolfkeens.com/BIGPICTURE/pages/wp18.html.

Citro, Constance F. 1990. "Public Participation in the Art in Americas: A Review of Data Sources and Data Needs." Unpublished report, revised version. Washington, DC: Research Division, National Endowment for the Arts, December.

Clancy, Paula. 1997. "Arts Policies, Structures and Participation." In *From Maestro to Manager: Critical Issues in Arts and Culture Management,* edited by Marian Fitzgibbon and Anne Kelly. Dublin: Oak Tree Press.

Clancy, Paula, Martin Drury, Anne Kelly, Teresa Brannick, and Sheila Pratschke. 1994. *The Public and the Arts: A Survey of Behaviour and Attitudes in Ireland.* Dublin: The Arts Council.

CONACULTA. 2005. *Encuesta nacional de prácticas y consumo culturales.* Federal District, Mexico: Consejo Nacional para la Cultura y las Artes.

Donnat, Olivier. 1998. "Les Pratiques Culturelles des Français: Enquête 1997." Paris: La Documentation Française.

Eurobarometer 56.0. 2002. "Eurobarometer Survey on Europeans' Participation in Cultural Activities: Basic Tables." Brussels: Eurostat.

Eurobarometer 2003.1. 2003. "New Europeans and Culture, Public Opinion in the Candidate Countries." Brussels: The European Commission.

Eurostat. 2000. "Cultural Statistics in the E.U." Eurostat Working Papers, Population and Social Conditions 3/2000/E/No. 1. Final report of the LEG. Luxembourg: European Commission and Eurostat.

Feist, Andy. 1998. "Comparing the Performing Arts in Britain, the US and Germany: Making the Most of Secondary Data." *Cultural Trends* 31: 29–47.

Fenn, Clare, Ann Bridgwood, Karen Dust, Lucy Hutton, Michelle Johnson, and Megan Skinner. 2004. "Arts in England 2003: Attendance, Participation, and Attitudes." Research Report 37. London: Arts Council England, December.

Fisher, Rod, and Andreas Joh. Wiesand (Eds.). 1991. *Participation in Cultural Life: Papers Presented to the European Round Table on Cultural Research—Moscow, April 1991.* Bonn: ARCult.

Fisher, Rod, Geneviève Gentil, Jean-Michel Guy, Carl-Johan Kleberg, and Vladimir Skok (Eds.). 1993. "Cultural Participation in Europe: Trends, Strategies and Challenges: Proceedings of the European Cultural Research Round-Table, Moscow, April 1991, Preliminary Version." Paris: CIRCLE, Cultural Information and Research Centres Liaison in Europe.

_____. (Eds.). 1993. "Participation à la vie culturelle en Europe: Tendances, stratégies et defies—Table ronde de Moscou, 1991." Paris: La Documentation Française, September.

Ford Foundation. 1974. *The Finances of the Performing Arts.* Volume 2. New York: Ford Foundation.

Garon, Rosaire. 2004. "Déchiffrer la Culture au Québec: 20 Ans de Pratiques Culturelles." Sainte-Foy: Les Publications du Québec.

_____. 2005. Supplemental analyses of 2004 data for Québec. E-mail correspondence with author.

Girard, Augustin. 1992. "Cultural Indicators, Provisional Document." DECS-Cult (92) 6. Strasbourg: Council for Cultural Co-operation, Council of Europe.

Guy, Jean-Michel. 1993. "Cultural Practices in Europe: A Comparative Approach." In Fisher et al., 15–103.

Hill, Kelly. 2004. "Reading at Risk: A Survey of Literary Reading in America. Research Division, Report 46. Washington, DC: National Endowment for the Arts, March.

Huysmans, Frank, Andries van den Broek, and Jos de Haan. 2005. "Culture-Lovers and Culture-Leavers: Trends in Interest in the Arts & Cultural Heritage in the Netherlands." The Hague: Social and Cultural Planning Office, April.

Istituto Nazionale de Statistica. 2005. "Cultura, socialità et tempo libero: Indagine multiscopo sulle famiglie 'Aspetti della vita quotidiana.'" Rome: Instituto Nazionale di Statistica.

Jermyn, Helen. 1998. "Commentary 2: Arts Attendance and Participation." *Cultural Trends* 33: 107–10.

Jowell, Roger. 1998. "How Comparative Is Comparative Research?" *American Behavioral Scientist*, 42: 168–77 (October).

Kleberg, Carl-Johan, and Vladimir Skok in cooperation with Pierre Moulinier, Peter Verwey, and Vladimir Bina. 1993. "Encouraging Cultural Participation: Strategies and Methods." In Fisher et al., 105–149.

Kulturrådet/Swedish National Council for Cultural Affairs. 2003. "Kulturbarometern 2002." Kulturen i Siffror 2003:1. Stockholm: Kulturrådet.

La Novara, Pina. 2002. "Culture Participation: Does Language Make a Difference?" *Focus on Culture* 13: 1–6 (March).

Lievesley, Denise. 2000. "Commentary: Extending the Debate to Comparable Worldwide Cultural Statistics." *Cultural Trends* 37: 77–81.

_____. 2001. "Making a Difference: A Role for the Responsible International Statistician?' *Statistician* 50: 367–406.

Looseley, David. 1995. *The Politics of Fun: Cultural Policy and Debate in Contemporary France.* Oxford: Berg.

Madden, Christopher. 2002. "International Comparisons of Arts Participation Data." D'Art Report 2. Sydney, International Federation of Arts Councils and Culture Agencies, November. http://www.ifacca.org/ifacca2/en/organisation/page09_BrowseDart.asp.

_____. 2004. "Making Cross-Country Comparisons of Cultural Statistics: Problems and Solutions." Working Paper 2. Sydney, Australia Council for the Arts and the International Federation of Arts Councils and Culture Agencies, October. http://www.ozco.gov.au/arts_resources/other/working_paper_2/.

McCarthy, Kevin, and Kimberly Jinnett. 2001. *A New Framework for Building Participation in the Arts.* Santa Monica, CA: RAND.

McCarthy, Kevin, Elizabeth Ondaatje, and Laura Zakaras. 2001. "Guide to the Literature on Participation in the Arts." Draft. Santa Monica, CA: RAND, September.

McGill, Lawrence. 2005. "Forty Years of Empirical Research on Arts & Cultural Participation and Artists." Unpublished presentation made at the Social Theory, Politics, and the Arts conference, Eugene, OR, October 7.

Merkle, Kathrin. 1991. "Some Quantitative Aspects on Participation in Selected Fields of Cultural Life in Europe." In Fisher and Wiesand, *Participation in Cultural Life: Papers Presented to the European Round Table on Cultural Research—Moscow, April 1991,* 297–316.

Ministerio de Cultura. n.d. "Encuesta de Hábitos y Prácticas Culturales en España 2002–2003." http://www.mcu.es/estadisticas/MC/EHC/Presentacion.html.

Muller, Lara. 2005. "Participation culturelle et sportive: Tableaux issus de l'enquête PCV de mai 2003." F0501. Paris: Direction des Statistiques Démographiques et Sociales, Institut National de la Statistique et des Études Économiques, March.

Ogrodnik, Lucie. 2000. "Patterns in Culture Consumption and Participation." Ottawa: Culture Statistics Program, Statistics Canada, December.

Pronovost, Gilles. 2002. "Les enquétes de participation culturelle: Une comparaison France—Québec—Etats-Unis." Report submitted to the Observatoire de la culture et des communications, de l'Institut de la statistique du Québec, and the Québec Ministry of Culture and Communications, September.

Research Division, National Endowment for the Arts (NEA). 1992a. "Research on Public Participation in the Arts: December 1992 Conference—Conference Overview and Research Issues." Unpublished document, Washington, DC: National Endowment for the Arts.

_____. 1992b. "Research on Public Participation in the Arts: Summary Report on the December 1992 Conference." Unpublished document, Washington, DC: National Endowment for the Arts.

Robinson, John, Carol Keegan, Terry Hanford, and Timothy Triplett. 1985. "Public Participation in the Arts: Final Report on the 1982 Survey." Report prepared for the Research Division, National Endowment for the Arts. College Park: Survey Research Center, University of Maryland.

Schuster, J. Mark. 1987. "Making Compromises to Make Comparisons in Cross-National Arts Policy Research." *Journal of Cultural Economics* 11: 1–36, December.

_____. 1991. "The Audience for American Art Museums." Research Division Report 23. Washington, DC: Seven Locks Press.

_____. 1995. "The Public Interest in the Art Museum's Public." *In Art in Museums*, edited by Susan M. Pearce, 39–78. London: Athlone Press.

_____. 1996. "Thoughts on the Art and Practice of Comparative Cultural Research." In *Cultural Research in Europe*, edited by Ineke van Hamersveld and Niki van der Wielen, 21–40. Amsterdam: Boekmanstichting.

_____. 1997. "The Performance of Performance Indicators (in the Arts)." *Nonprofit Management & Leadership* 7: 253–69 (Spring).

_____. 2002a. *Informing Cultural Policy: The Research and Information Infrastructure*. New Brunswick, NJ: Center for Urban Policy Research.

_____. 2002b. "The Geography of Participation in the Arts and Culture: A Research Monograph Based on the 1997 Survey of Public Participation in the Arts." Research Division Report 141. Santa Ana, CA: Seven Locks Press.

Selwood, Sarah. 2002. "Measuring Culture." *Spiked*, December 30. http://www.spiked-online.co.uk/Printable/00000006DBAF.htm.

Sinnott, Richard, and David Kavanagh. 1983. "Audiences, Acquisitions and Amateurs." Dublin: The Arts Council, March.

Skaliotis, Michail. 2003. "Key Figures on Cultural Participation in the European Union." In Bernier and Lievesley, *Proceedings of the International Symposium on Culture Statistics, Montréal, 21–23 October 2002*, 448–465.

Statistics Bureau, Ministry of Internal Affairs and Communications. 2001. "2001 Survey on Time Use and Leisure Activities." http://www.stat.go.jp/english/data/shakai/2001/shuyou/zuhyou/c006.xls.

Statistics New Zealand. 2003. "A Measure of Culture: Cultural Experiences and Cultural Spending in New Zealand." Wellington: Statistics New Zealand and the Ministry for Culture and Heritage.

Tait, David. 1983. "New Zealanders and the Arts." Research Studies 3. Wellington: Queen Elizabeth II Arts Council of New Zealand.

van den Broek, Andries, and Koen Breedveld (Eds.). 2004. "Trends in Time: The Use and Organization of Time in the Netherlands, 1975–2000." The Hague: Social and Cultural Planning Office, September.

Notes for Table 2.1:

Notes: Different studies for same country are listed in separate columns. Same studies (more or less) for different years are listed in one column (e.g., Québec). Figures have been adjusted for missing values where possible. Reports that have been cited do not always remove these cases; as a result they report slightly lower participation rates than the adjusted participation rates reported here. When the definitions of the artistic or cultural activity differ only slightly across countries, the participation rates for these countries are combined into a single row in an attempt to simplify the presentation, but notes are provided to indicate the actual lexical range incorporated into each row. The categories represented by the rows are not necessarily mutually exclusive; this depends entirely on how an individual study was designed. Many entries are a subset of another entry in this table (not always the category that one might expect). When this overlap occurs, participation rates cannot be added. This table is not a complete table summarizing all of the artistic or cultural activities that were investigated in each country. Categories that appeared in only one or two countries' studies were either incorporated into another category or omitted. Some of these are discussed further in the text. All reported rates, except those for reading, are attendance rates (i.e., receptive participation rates) measured over the prior twelve months.

[a] No data are reported for Italy in the EU's summary report, "Europeans' Participation in Cultural Activities," because of discrepancies between the two reports. Thus, only a participation study for Italy itself is reported here.

[b] Pantomime only. Note that this is the British sense of *pantomime*.

[c] The Canadian participation rate refers to professional concerts or performances; the participation rate for England refers to any live musical event; and the participation rate for Norway refers to classical, contemporary, church, or choir concerts.

[d] The Québec participation rate refers to attendance at professional classical music concerts only. The Italian and Dutch participation rates refer to attendance at a classical music concert or an opera or operetta.

[e] The studies done by the United States, France, and the Netherlands on their own all refer to attendance at jazz alone without reference to the blues.

[f] Curiously, this participation rate in England refers to folk music or country and western.

[g] Dutch and French studies use a narrower definition: cabaret, music hall, or variety shows, which may just as easily be included as a category in the music section of the table (as opposed to the theatrical section). The 2003 French study by INSEE (National Institute for Statistics and Economic Studies) includes musical comedy in this category.

[h] Attendance at mainstream U.S. or British films. This study also reports a participation rate for attendance at art-house/subtitled/foreign films of 5 percent.

ⁱ Museum or exhibition.

^j Art museum or exhibition.

^k Viewing works of art.

^l Art exhibition.

^m Borrowed a book.

ⁿ Read literature—plays/poetry/novels/short stories.

^o Book fair.

^p Archaeological site or monument.

^q Includes planetariums and botanical gardens as well as zoos and aquariums.

^r The corresponding survey question is not always explicit that it is asking about an art museum or an art gallery, but if the context suggests that the question is limited to art the participation rate is recorded in this row.

^s A conservation area or nature park.

^t A cultural or heritage performance.

^u A musical or operetta.

^v The participation rate for visiting a reading room (*sala de lectura*) at least once in the last year is 8.6 percent. Perhaps this includes mostly students.

^w *Chansons, variétés françaises.*

^x The "Cultural and Sporting Participation" survey does collect data on sports participation of the French population (Muller 2005, pp. 38–40). Unfortunately, the manner in which the data have been presented to date has focused on active participation. The published reports first determine the proportion of the French adult population that engages in sports practices (including both active and passive participation); this proportion turns out to be 71 percent. These individuals are then identified as *sportifs*. In subsequent analyses the documentation then calculates the percentage of *sportifs* who engage in various activities, including a *manifestation sportive*. Of those identified as *sportifs*, 14 percent have participated in a manifestation sportive. Thus, this percentage is not directly comparable to the Eurobarometer participation rate of 25.9 percent of the French population, although it does raise the interesting question of why the attendance at sporting events would apparently be so much lower among *sportifs* than among the rest of the population.

Endnotes

1. I wish to acknowledge all those who responded to my requests for clarification on many of the participation studies discussed here, including—but not limited to—Vladimir Bina, Serge Bernier, Tom Bradshaw, Ann Bridgwood, Danielle Cliche, Jos de Haan, Olivier Donnat, Rosaire Garon, Péter Inkei, Christopher Madden, Sarah Selwood, and Michail Skaliotis. Thanks also to Steven Tepper, who read multiple drafts and provided many insightful comments. Finally, I am also indebted to May Tsubouchi, my research assistant, who performed miracles in uncovering—and occasionally translating—the many participation studies summarized in this study. This is truly an instance in which the current chapter would not have been possible without her impeccably capable assistance. In the

course of conducting the research for this chapter, information was collected on a considerable number of the most recent participation studies conducted in a wide variety of countries. In addition to the information gathered here, I have relied particularly on three earlier publications: Citro (1990) provided a rigorous consideration of the technical questions that have entered into the design of participation studies, particularly in the American context; Guy (1993) synthesized the results and develops a summary of the participation studies that were presented to the 1991 CIRCLE roundtable in Moscow; and Bridgwood and Skelton (2000) contributed an account of the decisions that go into designing a participation survey questionnaire, especially in the British context. This chapter is an abbreviated version of a longer monograph, which is under consideration for publication in its entirety. For further information, contact the author.

2. For the United States alone, Lawrence McGill, director of the CPANDA project at Princeton University, has identified eight national participation studies and twenty-seven local participation studies, which because of multiple waves over time have generated 171 participation datasets (McGill 2005).

3. For one interesting example of this, see the discussion of evidence on the website of the Museums, Libraries, and Archives Council in London: http://www.mla.gov.uk/information/evidence/ooev.asp.

4. To the extent that the focus here is actually on delivering clearly articulated public benefits and value, this is an instrumentalization of the arts. But those who worry about the trend to have the arts cast as the savior of many of society's ills use instrumentalization as a more derogatory term.

5. See Bernier and Lievesley (2003) for one compilation of papers on the development of cultural statistics.

6. I am grateful to Christopher Madden of the International Federation of Arts Councils and Culture Agencies for calling the Jowell article to my attention.

7. The harmonization of cultural statistics taken on most recently by the European Union (Eurostat 2000) and the UNESCO Institute of Statistics (Bernier and Lievesley 2003) are only the most recent efforts. See Girard (1992) for a description of the promise of comparable statistics that accompanied the Council of Europe's Program for the Evaluation of National Cultural Policies or Schuster (1997) for an account of earlier UNESCO attempts at creating a cross-national statistical framework for data on cultural expenditures.

8. England goes in a somewhat different direction, distinguishing between enjoyment of art via the media and using the media to create art.

9. For a more detailed discussion of the issue of boundary drawing in cultural policy analysis, see Schuster (1987, 1996).

10. But note that the relatively recent Eurobarometer studies are also very detailed with respect to the types of music heard in various concerts in which one might participate.

11. For an incomplete comparison of how the EU countries treated this issue and others prior to the adoption of the single Eurobarometer study, see Eurostat (2000, pp. 157–61). Of course, as long as these studies collected the actual age of the respondent rather than the individual's age in categories, one could achieve age comparability with the original datasets by deleting cases. There is always the possibility that these age limits are the result of some cultural policy consideration, but as Jowell (1998, p. 171) pointed out, it may also be the result of grafting cultural modules onto preexisting survey instruments for which the sampling frame has already been determined for a completely different set of reasons.

12. It has not been easy to collect the reports or, in some cases, the simple digital cross-tabulations and spreadsheets that summarize the extant participation studies. Occasionally, an initial contact with one government agency would indicate that no participation study existed; yet, contact with another agency would uncover a wealth of participation data. Thus, the ability to uncover such studies was a function of the nature of the network that we contacted with this study's inquiries. Thus, to some extent this summary is a measure of personal ability to locate these studies and to present them; it may be little more than a map of the present author's network. One should also remember that any attempt to summarize any body of participation studies is an attempt to present a snapshot of a constantly moving target. New reports for Québec, Mexico, and France arrived as I sat down to write the first version of this chapter. Others will doubtless arrive soon.

Finally, some studies are much better documented (in English) than others, so this summary is somewhat selective along the dimension of language. Care has been taken to translate and summarize what was uncovered, but some nuances of language may well have escaped us.

13. Detailed Québec figures for 1999 are presented in italics, and more recently released partial figures for 2004 are set in nonitalics.

14. Curiously, Eurostat does not report Eurobarometer results for Italy in its reports because the Eurobarometer results are systematically higher than a larger survey carried out by the Italian National Institute of Statistics (ISTAT). Therefore, no results for Italy from the "Europeans' Participation in Cultural Activity" study are reported in Table 2.1. Why a larger sample size would systematically result in lower participation rates is unexplained.

15. In particular, this was done for the two Eurobarometer studies, although even here it was not possible to account for situations in which a percentage was less than 1.5 and, therefore, according to Eurobarometer's attempt to recognize the likely size of sampling error, not reported in the published tables.

16. Some of the more interesting examples include the following. Fourteen percent of French respondents have attended a son et lumière in the previous twelve months; 29 percent report having attended a Spectacle du rue. The New Zealand survey pays particular attention to participation

in Maori culture: 16 percent report have attended kapa haka (Maori performing arts performances encompassing Maori song, poi and haka). The Dutch report a participation rate of 10 percent for mime in a time use survey (not reported here); Spain reports an attendance rate of 8.6 percent at bullfights, 38.0 percent at the annual Feria, and 2.4 percent for the Zarzuela; and the English study estimates participation at events with video or electronic art content at 8 percent. It is clear that these national concerns are unlikely to ever make their way into cross-national studies.

17. This result has been observed in other, more limited studies of participation studies. See, for example, Schuster (1991, 1995) and Guy (1993, p. 14).

18. For examples of published international comparisons using participation data see Sinnott and Kavanagh (1983), Tait (1983), Robinson et al. (1985), Schuster (1991), Fisher and Wiesand (1991), Fisher et al. (1993), Clancy et al. (1994), Schuster (1995), Clancy (1997), Feist (1998), Bridgwood and Skelton (2000), Pronovost (2002), Eurobarometer 56.0 (2002), Eurobarometer 2003.1 (2003), and Bina (2003).

19. This theme is further explored in Jermyn (1998).

20. For a critique of league tables as a form of comparison see Schuster (1987, 1996) or Lievesley (2001).

21. See Schuster (1987).

22. The one exception seems to be with respect to reading. National cultural agencies have evidenced concern when reading participation rates have declined and have adopted various policy responses (see, e.g., Hill 2004; Skaliotis 2003, pp. 476–77). That reading has attracted policy attention whereas other forms of artistic and cultural participation have not is not totally surprising. In the words of Gigi Bradford, then director of NEA's Literature Program, "Everyone is supposed to read and write; not everyone is supposed to be musical" (Research Division, NEA 1992b, p. 8).

23. In a similar vein, one might also pursue the option of having provincial, state, or even local arts agencies support an increase in the effective sample size in their own geographic area to have sufficient data on which to base more sophisticated statistical analysis. This was actually done once by the State of California in the context of the Survey of Public Participation in the Arts.

24. More recently, McCarthy and Jinnett (2001, p. 3) came to a similar conclusion but by looking at increasing participation through a perspective that takes more of a marketing approach.

25. On the first point, participants at the symposium on cultural statistics that helped mark the creation of the UNESCO Institute for Statistics expressed the view that the accumulated time series of participation studies and other studies clearly demonstrate that "cultural democratization policies have failed and [one should] consider that it is now more important to understand cultural participation than to measure it; in this respect, qualitative measures should be favoured" (Bernier and Lievesley 2003, p. 328).

3 Multiple Motives, Multiple Experiences

The Diversity of Cultural Participation

Francie Ostrower[1]

Introduction

Since the 1960s cultural policymakers, funders, and researchers have given increased attention to diversity (Arthurs 2000; Campbell 2000; DiMaggio 2000; DiMaggio and Ostrower 1992; Kreidler 2000; Lewis 2000; Lowell 2004; Rosenstein 2005; Wyszomirski 1999). Over this period their understanding of *diversity* has shifted and broadened. This chapter argues that a further broadening is needed—one that encompasses the diversity of motivations and experiences associated with cultural participation. Such a broadening is particularly important and timely, given that cultural policymakers and funders, who have traditionally focused on cultural producers, are increasingly shifting attention to cultural demand (McCarthy and Jinnett 2001; Wyszomirski 1999).

As the research presented in this chapter shows, people attend different types of cultural events for distinct reasons. Moreover, different groups of people exhibit a variety of reasons for their attendance. Generalizations about involvement in *culture* can therefore be very misleading. Expanding the notion of diversity to encompass motivations and experiences would strengthen our characterizations and interpretations of people's involvement in culture and help managers and policymakers craft more effective initiatives to expand it.

Shifting Understandings of Diversity and Cultural Participation

During the 1960s private and public funders launched efforts to expand access to the arts among groups they regarded as underserved. Initial attention focused on expanding geographical access. In the private sector the Ford Foundation launched a major initiative to establish and develop nonprofit arts institutions throughout the United States. In the public sector the National Endowment for the Arts (NEA) was founded in 1965 with geographical equity as a core mandate (Kammen 2000). As the number of arts institutions increased during the 1970s, geographical disparities became less of a focus. The emergence of government and large foundation arts supporters spurred greater attention to minority participation (DiMaggio and Ostrower 1992). The types of arts receiving support, however, were often fairly circumscribed, going to nonprofit institutions presenting Euro-American high culture (DiMaggio 1986; Lewis 2000) and, subsequently, prompting charges of elitism. For instance, one critic noted, "The desire to convert the masses to the joys of opera and ballet ... can be as oppressive as it is philanthropic" (Lewis 2000, p. 88).

More recently, the approach to diversity taken by policymakers, funders, and researchers has been evolving again, now to encompass a more inclusive definition of culture itself that recognizes the value of a wide range of artistic forms and traditions. Thus, "a current byword in arts policy circles is cultural pluralism (or cultural diversity), which ordinarily refers to a commitment to the value of (and, by implication, subsidies to) artists working in a variety of cultural traditions, especially those of Americans of Asian, African, and Latin American descent" (DiMaggio 2000, p. 38; see also Arthurs 2000; Brustein 2000). Many

state arts agencies, responding to populist criticisms, introduced folk arts and expansion arts grants programs targeting rural and minority ethnic communities (Lowell 2004). By the 1980s a major facet of the Ford Foundation's arts funding was its African American and Latino Art Museums program intended to encourage growth in minority arts organizations.[2]

Definitions of culture in the policy literature reflect the shift. For instance, when defining *the arts,* the American Assembly (2000) "resisted calling up the conventional dichotomies that have separated the arts into high and low, fine and folk, professional and amateur, insisting, instead, on a full spectrum concept" (p. 65). Likewise, the President's Committee on Arts and Humanities (2000) emphasizes that "by American culture, we mean both Pueblo dancers and the New York City Ballet" (p. 72). Definitions of art and culture have increasingly included activities that take place in the informal and unincorporated sector (Jackson and Herranz 2002; Wali, Severson, and Longoni 2002).[3]

This chapter argues that discussions of diversity need to be expanded yet again, this time to include the variety of motivations and experiences associated with arts participation. This is all the more important as discussions of culture increasingly include a broad and diverse array of forms and activities. All too often, "we often talk as if the 'arts' were a single thing" and assume that different types of cultural participation have similar effects (DiMaggio 2002; see also McCarthy et al. 2004). Findings from an Urban Institute survey of 1,231 American adults, to which the chapter now turns, show that this is clearly not the case.

Surveying Cultural Participation and Motivations: About the Study

This chapter is based on a national survey of cultural participation conducted by the Urban Institute and commissioned by the Wallace Foundation (see Ostrower 2004, 2005). This phone survey of a random sample of Americans age eighteen and older was conducted during June and July 2004. The 1,231 people who participated represent a response rate of 45 percent. The study was built on and extended an earlier survey of arts participation in five local communities conducted by the Urban Institute in 1998, also commissioned by the Wallace Foundation. That survey, "Reggae to Rachmaninoff," took a broad and inclusive view

of culture, highlighted the diverse venues where people attend cultural events, and demonstrated the links between cultural and civic participation (Walker and Scott-Melnyk 2002).

A major contribution of the "Reggae to Rachmaninoff" study was that it questioned people about their motivations for cultural participation. The research literature on participation has infrequently addressed that subject, focusing more often on "the who, what and how of arts participation" (McCarthy and Jinnett 2001, p. 4). The primary survey of cultural participation among Americans, the NEA Survey of Public Participation in the Arts (SPPA), is a rigorous and rich source of data but does not consider motivations. Results of the "Reggae" study revealed a variety of reasons for participation that ranged from the aesthetic to the civic and social.

Although this earlier Urban Institute study asked about motivations and a broader range of cultural activities, it resembled the SPPA and other participation surveys in that it questioned people about attendance during the previous twelve months. When it came to examining reasons for participation, the "Reggae to Rachmaninoff" study likewise asked people to characterize their reasons for cultural participation as a whole over the past year. Therefore, the data do not allow for a comparison of the importance of motivations across forms. For instance, the primary reason for participation given by respondents in that study was to get together with friends and family. What this survey cannot show, then, is whether a desire to get together with friends and family is a common reason for all attendance or has greater or lesser importance for those attending specific kinds of arts events.

This new study was designed to investigate just such questions, and data were intentionally collected that were not already available in current national surveys (Ostrower 2005). As with other surveys, people were asked about their participation during the previous twelve months. The primary innovation of the present survey was that it includes questions about respondents' most recently attended cultural event. This information provided a way to link specific types of motivations, experiences, and venues to attendance at various types of events and thus to compare their commonalities and differences. The diverse motivations and experiences prevalent among those attending different art forms turned out to be numerous indeed. Furthermore, by including questions about experiences at events and comparing them with informa-

tion about motivations, it was possible to determine whether people are getting what they seek from attendance.[4] Variations also were found in motivations and experiences among more and less frequent attendees and, in some cases, among members of various ethnic groups.

This survey represents an important but preliminary step toward analyzing the diversity of motivations and circumstances that characterize cultural participation. This study does not attempt to document the extent and nature of that diversity comprehensively. This chapter examines only live attendance and does not cover other modes of participation, such as production, participation through media, or reading. Moreover, preliminary evidence from music is presented that suggests considerable differences in motivations and experiences for attendance within genres, but more work on a larger sample would allow for more refined analyses within other genres. Finally, it is necessary to keep in mind that people may not only have diverse reasons and experiences for attending arts events; they may also have different ways of speaking about their motivations and experiences with various types of culture. Thus, it is necessary to design studies that coordinate open-ended qualitative work with broad survey results to understand and interpret more fully the different motivations that people report.

Variations in Motivations for Attendance

People attend different types of cultural events for different reasons (see Figure 3.1). For instance, most people who attend museums (65 percent) say they are strongly motivated by a desire to gain knowledge or learn something new. That is true far less often for people who attend music performances (29 percent) or plays (36 percent). For them, a primary motivation is to socialize with friends and family: 60 percent of those attending music performances and 68 percent who went to plays. Likewise, a desire to experience high-quality art is far more prevalent among those who attend art museums or galleries (56 percent) and plays (47 percent) than among those who attend music performances (37 percent) or arts and crafts fairs and festivals (26 percent). The desire to support a community organization or event ranged from a high of 37 percent for fairs and festivals to lows of just over 26 percent for museums and dance. Only 26 percent of those who went to a fair but over 40

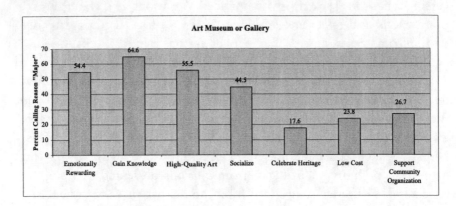

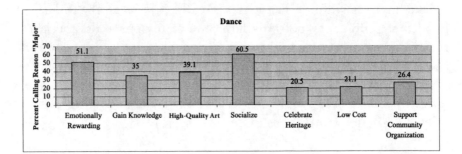

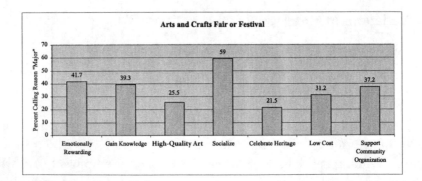

Figure 3.1a Major motivations for attending different cultural events.

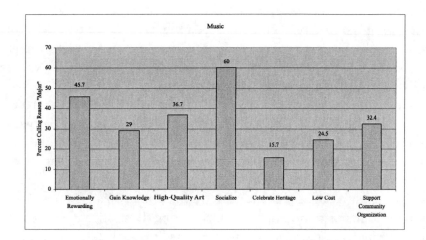

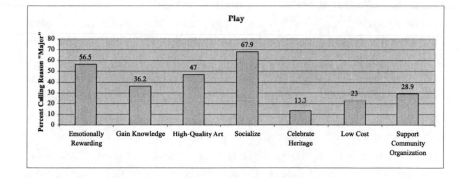

Figure 3.1b Major motivations for attending different cultural events.

percent of those who attended other events said community support did not factor in their decision.

Motivations varied even among cultural forms that tend to share audiences. For instance, respondents who had been to art museums in the previous twelve months were also more likely to have attended plays and vice versa. Yet there are striking differences in the reasons that respondents go to those events. This result reinforces the point that the same people may go to various types of cultural events for very different reasons and suggests that a desire for diverse experiences drives these individuals to attend various cultural forms.

Comparing respondents' reasons for attending their most recent event with the reasons for their total attendance during the past twelve months reinforces the point that people attend different cultural events for different reasons. Reasons that may have been major motivations for their overall attendance during the past year were often not as important for their most recent attendance. For instance, many people (38 percent) who said a major reason they attended during the past year was to support community organizations also reported that this did not influence their last event. This shows that wanting to support community organizations was a factor for some, but not all, of their attendance.

Motivations can also differ for subgenres of the same cultural form. Generally, there were too few people attending specific subgenres to allow extended analysis, but findings for the most common forms of music illustrate the point. Thus, a desire to experience high-quality art is a major motivation for attending classical music (61 percent) and jazz (47 percent), but not for rock and pop and country music (35 and 24 percent, respectively). Although a desire to learn something new is not typically a major motivation for attending music performances, it is a more important reason among those who attend performances of religious music (45 percent). A desire to celebrate one's cultural heritage was cited for attending religious music performances far more often than for other music.[5] This clarifies the previous finding by indicating that religious music attendees want to gain knowledge about their cultural heritage, of which music is a part.

Certain motivations also varied among members of different ethnic groups and among frequent and less frequent attendees. African American and Hispanic survey respondents were far more likely than white respondents to express a desire to learn about or celebrate their cultural

heritage as a major motivation: 50 percent of African Americans and 43 percent of Hispanics but only 15 percent of whites gave this response. African American and Hispanic respondents were also more likely to cite a desire to support a community organization; however, the gap was smaller.

Frequent arts attendees assert more often that their major motivations include experiencing high-quality art, supporting a community organization, gaining knowledge, learning about their cultural heritage, and having an emotionally rewarding experience. Fully 59 percent of frequent attendees (those who went to eleven or more events during the previous twelve months) claim a desire for high-quality art is a major motivation, compared with 34 percent of moderate (four to seven events), and 21 percent of infrequent attendees (one to three events). Similarly, the proportion of respondents who maintain that a major motivation for their attendance is to learn something new drops from a high of 64 percent among frequent attendees to a low of 34 percent among infrequent ones.

A clear message of these findings is that motivations matter in spurring attendance. Even after controlling for standard demographic predictors of attendance (e.g., level of education and childhood socialization), a desire to experience high-quality art remains a significant predictor of more frequent attendance.[6] Frequent attendees also have a greater number of strong motivations for going to cultural events. Note that frequent attendees not only attend more cultural events, but they also go to a greater variety of events. Taken together, the findings indicate that frequent attendees' active engagement is driven by this multiplicity and variety of positive experiences.

Experiences at Cultural Events

People overwhelmingly reported positive experiences at their most recently attended events. This was gauged by reading respondents a series of six statements about their most recent event, such as "the artistic quality was high," and asking whether they strongly agreed, agreed, disagreed, or strongly disagreed. Over 93 percent agreed or strongly agreed with four of the statements. In the other two cases, the majority also responded positively, although a greater percentage disagreed.[7]

Given that so few had negative experiences, this chapter focuses on intensity of positive experiences. Figure 3.2 accordingly shows the percentage of people who strongly agreed with each of the statements.

Although attendees commonly report positive experiences, experiences vary for different types of cultural events (Figure 3.2). For instance, those who attend museums were far more likely to agree strongly that they gained knowledge or learned something new (51 percent) than those who attended fairs (23 percent) or music performances (28 percent). People who attended plays were most likely to agree strongly that they had an enjoyable social occasion (67 percent), whereas those attending arts and crafts fairs and festivals were least likely (45 percent). Likewise, more people (approximately 55 percent each) who went to music performances, plays, and art museums strongly liked the venue than did those who attended dance performances and fairs (44 and 34 percent, respectively).

Frequent arts attendees more often reported strong positive experiences and were more likely to strongly agree that the artistic quality was high, that the event was socially enjoyable, that they learned something new, that they liked the venue, that the event was emotionally rewarding, and that they would go again. For example, 59 percent of the most frequent attendees strongly agreed that the artistic quality was high. That figure falls to 36 percent among the least frequent attendees. Likewise, 69 percent of frequent arts attendees, compared with 45 percent of infrequent attendees, strongly agreed that they had an enjoyable social occasion.[8] Taken together, the findings about frequent arts attendees show them to be individuals with a wide variety of interests and the ability to derive fulfillment from an array of activities—both cultural and otherwise. Frequent attendees not only attend more arts events and a greater variety of arts events, but they also tend to be joiners, who are more likely to engage in other civic, social, and religious activities (see chapter 1 this volume).

Comparing Motivations and Experiences: Do Arts Attendees Get What They Seek?

Most people had the experiences they hoped to have at their most recently attended event. For instance, most people who said they were

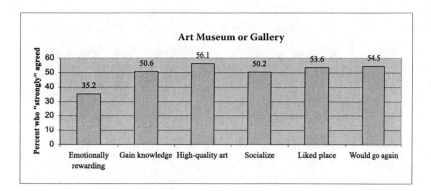

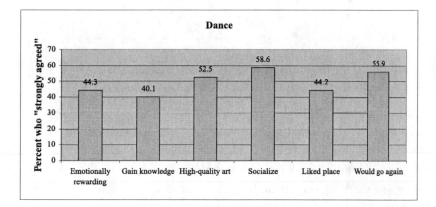

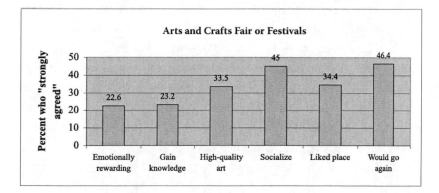

Figure 3.2a Experiences at different cultural events.

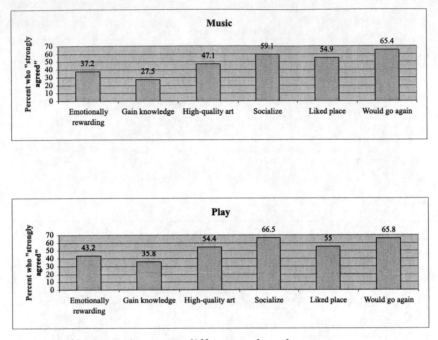

Figure 3.2b Experiences at different cultural events

strongly motivated to attend an event because they wanted to experience high-quality art agreed strongly that the artistic quality of the event had been high. However, there were important variations by type of cultural event where significant numbers said their expectations were not met.

For example, 59 percent of fair and festival attendees said a major reason they went was to socialize, but only 45 percent strongly agreed it was a socially enjoyable occasion. Of those who attended a play, 57 percent said a major reason they went was that they thought it would be emotionally rewarding, but only 43 percent strongly agreed that it was. Likewise, 65 percent of museum attendees said a major reason they attended was to gain knowledge or learn something new; however, only 52 percent strongly agreed that they had.

To understand whether people are getting the experiences they seek from a particular art form, it is critical for arts institutions to consider experiences in relation to motivations. Otherwise, it is easy to mistakenly focus participation-building efforts on improving less relevant aspects of the experience. For example, only 34 percent of those who

went to fairs strongly agreed the artistic quality was high—lower than for any other area. But only 26 percent of those who attend fairs say they are doing so out of a desire for high-quality art. What is far more relevant from the standpoint of increasing participation is that for many attendees, fairs seem to be falling short in fulfilling their major motivation of being socially enjoyable.

Implications

These survey findings have significant implications for those who study or wish to expand cultural participation. The most fundamental implication is that arts research, policy, and management should be reoriented to pay greater attention to the diversity of motivations and experiences associated with cultural participation. For researchers, this means probing more deeply into motivations and experiences, exploring variations within as well as across disciplines, and incorporating these results into theoretical explanations of participation. It is necessary to understand far more about cultural participation at levels more detailed than broad categories such as music or dance. For example, this chapter's findings for music show that aggregate figures for broad categories can obscure profound differences in cultural participation among subgenres. Recall that a desire to gain knowledge—a relatively unimportant reason for music attendees considered in the aggregate—proved a very important motivation for attending religious music.

Adding to the complexity is that motivations and experiences associated with arts attendance often depend on a context broader than the artistic event or product alone. Religious music attendees seek knowledge, but the knowledge they seek is about their cultural heritage, which they learn about and celebrate by participating in the music. Understanding the links between cultural forms and their wider social and cultural contexts is thus an important part of comprehending the heterogeneity of cultural participation.

For those seeking to expand participation, the study's findings underscore the significance of defining what type of culture they wish to attract people to and of targeting their efforts accordingly. Efforts to enlarge attendance cannot be based on why people attend culture, in a broad-brush sense, but must be rooted in information about why

people attend a specific type of cultural event, where, with whom, and the experiences they hope to have. If participation-building efforts are not based on a clear understanding of a particular cultural form and its audience, they risk trying to attract people in ways that will not work because they fail to understand those they seek to reach. Within this framework the findings also suggest other practical steps those seeking to enlarge participation might take.

Organizations seeking to attract more attendees should examine the experiences that attendees have in relation to their major motivations and should tailor their participation-building efforts accordingly. Organizations that hold—and funders that support—special events aimed at attracting people by appealing to particular motivations should not count on such strategies to build sustained participation in regular programming in the absence of a careful analysis of the full range and depth of motivations that would keep people coming back. Indeed, the fact that special events frequently produce disappointing results in terms of bringing people back to regular programs is consistent with study findings because special events likely draw people for reasons quite different from those that bring them to the regular programs.

The findings concerning racial and ethnic differences in the importance of celebrating heritage suggest that incorporating programming that speaks to African American and Hispanic heritages may be an important way to engage those communities (e.g., through new programming or new presentations of existing programming). At the same time, organizations cannot expect that merely presenting isolated events that address cultural heritage will automatically increase attendance by African Americans or Hispanics at other events. Instead, organizations need to take a multifaceted approach, built on an understanding of the audience they wish to reach and the multiple reasons that African Americans, like other groups, attend.

In short, when it comes to explaining or increasing cultural participation, one size does not fit all. Strategies based on overly broad and general concepts of culture rather than taking the diversity of motivations and experiences into account will hinder, rather than advance, efforts to understand and to promote cultural participation. Attention to diversity in policy discussions has shifted and expanded from geographic diversity to ethnic and racial diversity and to the diversity of what constitutes culture. It is time now to expand that attention as well

to the diversity of motivations and experiences associated with partici-
pation in varied forms of culture.

Bibliography

American Assembly. 2000. "The Arts and the Public Purpose." In Bradford,
 Gary, and Wallach, *The Politics of Culture: Policy Perspectives for Indi-
 viduals, Institutions and Communities*, 64–70.
Arthurs, Alberta. 2000. "Making Change: Museums and Public Life." In
 Bradford, Gary, and Wallach, *The Politics of Culture: Policy Perspectives
 for Individuals, Institutions and Communities*, 208–17.
Bradford, Gigi, Michael Gary, and Glenn Wallach (Eds.). 2000. "The Arts and
 the Public Purpose." *The Politics of Culture: Policy Perspectives for Indi-
 viduals, Institutions and Communities*. New York: New Press.
Brustein, Robert. 2000. "Coercive Philanthropy." In Bradford, Gary, and Wal-
 lach, *The Politics of Culture: Policy Perspectives for Individuals, Institu-
 tions and Communities*, 218–25.
Campbell, Mary Schmidt. 2000. "A New Mission for the NEA." In Bradford,
 Gary, and Wallach, *The Politics of Culture: Policy Perspectives for Indi-
 viduals, Institutions and Communities*, 141–46.
DiMaggio, Paul. 1986. "Support for the Arts from Independent Foundations."
 In *Nonprofit Enterprise in the Arts: Studies in Mission and Constraint*,
 edited by Paul DiMaggio. New York: Oxford University Press, 113–39.
DiMaggio, Paul. 2000. "Social Structure, Institutions, and Cultural Goods:
 The Case of the United States." In Bradford, Gary, and Wallach, *The Poli-
 tics of Culture: Policy Perspectives for Individuals, Institutions and Com-
 munities*, 38–62.
DiMaggio, Paul. 2002. "Taking the Measure of Culture." http://www.princ-
 eton.edu/~artspol/moc_prospectus.html.
DiMaggio, Paul, and Francie Ostrower. 1992. "Race, Ethnicity, and Participa-
 tion in the Arts: Patterns of Participation by Hispanics, Whites, and Afri-
 can-Americans in Selected Activities from the 1982 and 1985 Surveys of
 Public Participation in the Arts." Research Division Report 25, National
 Endowment for the Arts. Washington, DC: Seven Locks Press.
Jackson, Maria-Rosario, and Joaquin Herranz. 2002. *Culture Counts in Com-
 munities: A Framework for Measurement*. Washington, DC: Urban Institute.
Kammen, Michael. 2000. *"Culture and the State in America."* In Bradford,
 Gary, and Wallach, *The Politics of Culture: Policy Perspectives for Indi-
 viduals, Institutions and Communities*, 114–40.
Kreidler, John. 2000. *"Leverage Lost: Evolution in the Nonprofit Arts Eco-
 system."* In Bradford, Gary, and Wallach, *The Politics of Culture: Policy
 Perspectives for Individuals, Institutions and Communities*, 147–69.

Lewis, Justin. 2000. *"Designing a Cultural Policy."* In Bradford, Gary, and Wallach, *The Politics of Culture: Policy Perspectives for Individuals, Institutions and Communities,* 79–93.

Lowell, Julia. 2004. *State Arts Agencies 1965–2003: Whose Interests to Serve?* Santa Monica, CA: RAND Corporation.

McCarthy, Kevin, and Kimberly Jinnett. 2001. *A New Framework for Building Participation in the Arts.* Santa Monica, CA: RAND Corporation.

McCarthy, Kevin, Elizabeth Ondaatje, Laura Zakaras, and Arthur Brooks. 2004. *Gifts of the Muse: Reframing the Debate about the Benefits of the Arts.* Santa Monica, CA: RAND Corporation.

Ostrower, Francie. 2004. *Motivations Matter: Findings and Practical Implications of a National Survey of Arts Participation.* Washington, DC: Urban Institute.

_____. 2005. *The Diversity of Cultural Participation.* Washington, DC: Urban Institute.

Peterson, Richard A., and Albert Simkus. 1992. "How Musical Tastes Mark Occupational Status Groups." In *Cultivating Differences: Symbolic Boundaries and the Making of Inequality,* edited by Michèle Lamont and Marcel Fournier, 152–86. Chicago: University of Chicago.

Rosenstein, Carole. 2005. *Diversity and Participation in the Arts: Insights from the Bay Area.* Washington, DC: Urban Institute.

Wali, Alaka, Rebecca Severson, and Mario Longoni. 2002. *The Informal Arts: Finding Cohesion, Capacity and Other Cultural Benefits in Unexpected Places.* Chicago: Chicago Center for Arts Policy, Columbia College Chicago.

Walker, Chris, and Stephanie Scott-Melnyk with Kay Sherwood. 2002. *Reggae to Rachmaninoff: How and Why People Participate in Arts and Culture.* Washington, DC: Urban Institute.

Wyszomirski, Margaret. 1999. "Philanthropy and Culture: Patterns, Context, and Change." In *Philanthropy and the Nonprofit Sector,* edited by Charles Clotfelter and Thomas Ehrlich, 469–80. Bloomington: Indiana University.

Endnotes

1. The author is grateful to The Wallace Foundation for funding the study on which this chapter is based and to the Urban Institute for support to write this chapter. My thanks to Steven J. Tepper for his very helpful comments on this chapter.
2. See the Ford Foundation website, http://www.fordfound.org/news/more/05042000arts/index.cfm.
3. Peterson and Simkus (1992, p. 904) suggested that even cultural exclusiveness has become more inclusive when they contend that "highbrow status" has shifted from "snobbish exclusion" in tastes to "omnivorous inclusion" in which "cultural expressions of all sorts are understood in what relativists call their own terms."

4. This chapter focuses on motivations and experiences. For discussion of venues and attendance with other people, see Ostrower (2004, 2005).

5. Though cited by 32 percent of religious music attendees, the figure drops to 18 percent for jazz and blues and falls to lows of 5 percent for country and rock.

6. Findings are based on regression analysis of those who attended one or more cultural events during the past twelve months. The dependent variable was the total number of events attended. The adjusted R2 was 10. Variables described as significant predictors were significant at the .01 level or below. The finding is consistent with McCarthy et al.'s (2004) argument that a key characteristic of frequent attendees is that they experience "intrinsic benefits" from the arts.

7. Twenty-three percent disagreed that they learned something new, and 15 percent disagreed that it was emotionally rewarding.

8. The percentage who strongly believed that they learned something new dropped from 43 to 23 percent between the most and least frequent attendees, that the artistic quality was high from 59 to 36 percent, that they liked the venue from 61 to 43 percent, that it was emotionally rewarding from 49 to 27 percent, and that they would go again from 74 to 46 percent.

McCarthy et al. (2004) contended that frequent exposure to the arts is needed to derive arts' intrinsic (versus extrinsic) benefits. This chapter's findings do indicate that more frequent attendees strongly experience the intrinsic benefit of artistic quality. However, frequent attendees also more strongly experience other benefits, such as having an enjoyable social occasion.

4 In and Out of the Dark

A Theory about Audience Behavior from Sophocles to Spoken Word

Lynne Conner

It is a common understanding that sometime during the course of the twentieth century, the live arts lost touch with the popular or mass audience. Experts ranging from economists to market researchers to cultural historians have all documented a shift in consumer patterns as audiences in search of live entertainment moved from the concert hall and the playhouse to the arena, coffee shop, and nightclub. This shift occurred because the audience no longer has an interest in—or the intellectual capacity for or the cultural connections with—the arts. In theatres and symphony halls across America, it is said, the audience has left the building.

This chapter argues the opposite. American audiences are very much as they have always been: looking for similar kinds of satisfaction from their cultural sources. What has changed, however, are the arts themselves, or rather, the culture surrounding arts participation—what I label the *arts experience*. In this chapter's analysis the traditional arts industry has abandoned responsibility for providing—or even acknowl-

edging—the importance of larger opportunities for engagement with arts events, particularly those that encourage an interpretive relationship. The result is an ever-widening interest gap between passive forms of high culture (e.g., orchestral music, theatre, and concert dance) and more active types of entertainment (e.g., music concerts, spoken word, slam poetry, and interactive theatre) that are either inherently participatory or are connected to opportunities that invite participation before and after the arts event. In twenty-first-century America the latter group most consistently encourages vibrant intellectual and emotional responses from audiences. To support this assertion, this chapter combines a brief history of audience behavior and an analysis of current trends in cultural participation with a theory about the psychology of contemporary adult learning and its relationship to audience engagement.[1]

From Seeing Place to Hearing Place

In the performing and fine arts, the term *audience* is used to signify a group of people assembled together to experience a live performance, demonstration, or exhibit. The word *audience* connotes the action of hearing and is derived from the Latin *auditorium*, or hearing place. To *give audience* literally means to give ear, but figuratively it means to pay attention with both ears and eyes. An audience member is, by definition and by current standards of appropriate behavior, a person who looks, listens, and feels at a distance. An audience member is expected to be a passive participant.

This has not always been true. Until the end of the nineteenth century, Western audiences of all economic classes and from a wide variety of places were expected to participate actively before, during, and after an arts event. Few conceived of the arts event as existing independently of its audience—not the artists nor the producers nor the audiences themselves. In fact, the historical record suggests that the audience's presence was fundamental to the very definition of the arts event itself. Going to the theatre—or the ballet, the opera, the symphony, or the museum—was usually a long day and evening out in which the arts event was a critical part of the experience but certainly not its sum total. People came to the arena, the playhouse, the concert hall, or the

gallery, and they talked to each other—before the show began, while the show was on, and after the show ended. They came to look, watch, eat, make deals, talk, flirt, learn, debate, emote, and engage with their fellow citizens.

This was certainly the case in classical Athens, a significant origin site for Western cultural practices—and hence, a good place to begin this historical sketch.[2] The assembly of male citizens, slaves, foreigners, and children who attended the drama competition at the Theatre of Dionysus in Athens in 425 BCE. (the year that *Oedipus Rex* competed) came to a *theatron* (seeing place) to participate in the City Dionysus, an annual religious and civic festival that included purification ceremonies, civic proclamations, community feasts, and a three-day competition for the best tragedy. Plays were commissioned and produced through civic mandate, financed both publicly (through taxation) and privately (by wealthy citizens appointed to pay for costuming or the training of the chorus), and performed mostly by amateur members of the community. At the end of the three-day competition, the community fulfilled its collective duty—through a panel of judges selected from the audience—by voting for the best tragedy. It would be folly to assume that 15,000 or so audience members sat quietly all day, heard and understood every word of the tragedies under consideration for the prize, or had an agreed-on set of criteria for judging them. Instead, Athenians disagreed with playwrights and with each other over the aesthetic, social, and political issues embedded in the tragedies. The historical record shows that they were extremely vocal in their opinions during the performance and afterward in the ongoing civic debate that followed. The Athenian audience was a sovereign entity in terms of measuring and evaluating the arts event.[3]

The Active Environment

We are accustomed—and conditioned—to treating the arts environment, whether it is a concert hall, a playhouse, or an art gallery, as a kind of sacred place where there is no touching and no talking. But the *theatron* of the ancient Greeks was an active place in all senses—physically, intellectually, and emotionally. So, too, were the amphitheatres built by the Romans, the Elizabethan Public (outdoor) Theatres

of Shakespeare's day, the first proscenium-style grand opera halls of Renaissance Italy and France, and the entertainment emporiums of nineteenth-century America. In all of these sites, an active auditorium was an essential aspect of the live performance itself. Merchants came to do business; the aristocracy came to see and be seen; the laborers came to talk, drink, and exchange information; and on occasion, the king, czar, or president came to preside. Among the most telling extant period illustrations of a Renaissance performance, for example, is the famous rendering of *Ballet Comique de La Reine* in Paris in 1581. The illustration vividly captures the performance conditions of the first ballet, including the placement of the king, who is seated literally on the stage floor among the scenery. From the spectator-illustrator's perspective, the king was an important aspect of the performance.[4]

Extant period documents flesh out the active nature of the auditorium.[5] It was a common practice in England and France until about 1770, for instance, to place seats literally on the stage during the performance: These were either reserved for courtiers or sold at high prices. Since chairs were not routinely bolted down until well into the nineteenth century, even those relegated to the auditorium proper had a great deal of control over where they sat and how they oriented their sightlines. In the boxes (for the province of the upper class) as well as in the pit and galleries (for the working-class sections), audience members conducted all manner of social transactions, from the mundane (e.g., sharing tea and cake) to the profane (e.g., prostitutes selling their wares behind the upper galleries during the performances). Other aspects of the real world were transformed by the liminal space of the auditorium. In most nineteenth-century English and American theatres, the distinct social hierarchy of the outside world was reconstituted through separate entrances leading to seating areas organized by social status. Nevertheless, as a newspaper commentator from 1838 complained, the auditorium was a ripe site for expressing the spirit of class warfare: "The Babel confusion and uproar, the yelling and cursing—swearing and tearing—the friendly interchange of commodities—apples, pignuts, etc., between the tenants of the [gallery] and pit, have become intolerable."[6]

Early museums were also active, eclectic environments. As early as the 1820s, the display cases of Philadelphia's Peale Museum, often labeled America's first official museum institution, contained a wide array of items—portraits, landscapes, sculpture busts, insect speci-

mens, stuffed birds, collections of shells and rocks—all democratically laid out. At Barnum's American Museum established in New York City in the 1840s, people from a variety of economic classes looked at everything from specimens of natural history and displays of fine arts objects to curiosities. They also attended lectures, watched variety acts, and saw productions of moral drama (the temperance play *The Drunkard* was a favorite), all while mingling with each other inside Barnum's grandly appointed building. Patrons at these museums lived the art space fully; they saw their presence in it as a large affair that was not confined simply to quiet, reverent spectating.

The Active Audience

Arts environments were open and unrestrained because the arts event itself was a form of community property. The arts object did not arrive with a fixed meaning; rather, it was received by the audience as an inherently interpretable commodity. This does not imply that there was regular, or even much, consensus in the process or even the protocol of interpretation, and the history of arts reception is full of vivid examples of the violent ways that artists, producers, and audiences disagreed. The function of interpretation was understood as both a cultural duty and a cultural right; that is to say, the arts event's meaning could and should only be discerned through a thorough interpretive process that by definition included the audience's perspective. Consider Sophocles, the author of *Oedipus Rex* and the winner of many prizes for best tragedy during his lifetime: As an Athenian citizen writing plays for a civic purpose, he was referred to not as *dramaturg* (playwright) but as *didaskalos*—the ancient Greek word for teacher and scholar. This is because competing tragic poets were required to appear before their audience a few days in advance of the performance to explain the themes and ideas of the plays presented. They did not expect the audience to understand their intentions solely through the presentation of the play itself. Instead, they accepted that the play was one part of a larger learning operation in which the audience's collective and individual reception would invariably shape the ascribed meaning. For the Athenian community, the tragedy was never an end in itself—and certainly not for its own sake—but

the point of departure for the exchange of ideas, opinions, and passions that are the fundamental criteria of useful civic conversation.

This essential reciprocity among artist, citizen, arts event, and artistic meaning continued to guide Western culture. During the Middle Ages, when the concept of an *artist* was as yet unformed, crafts guild workers created their own art—everything from religious cycle plays to cathedrals. They functioned as citizen-artists and both created and interpreted the world of metaphor that surrounded them—albeit under the larger authority of the Catholic Church. Even as the force of professionalization began to dominate the arts ecology of the Renaissance, the audience did not see itself in a secondary position in relationship to making meaning. Through the nineteenth century audiences controlled events on stage, frequently directing the action by clapping, stomping, hissing, and throwing objects, or they stopped the performance to demand that an actor, singer, or dancer repeat favorite passages. This behavior was not confined to populist art forms. When the city of Paris erupted in 1830 over the premiere of Victor Hugo's *Hernani* at the Comédie Française, the young esthetes of the emerging Romantic movement debated with the old-school neoclassicists over the new tragedy's dramaturgical structure, language choice, and poetic meter. A literal battle occurred outside the Astor Place Theatre in Manhattan in 1849. Over the course of a few days, 31 people were killed and 150 injured as the result of an argument about who was the better actor—American-born Edwin Forrest or English-born William Macready. In contrast to the so-called moral concerns that characterize most of today's heated public discourse on arts related topics, none of these riots were the results of charges of impropriety or obscenity.

Instead, audiences erupted over what might be labeled *cultural aesthetics*. Disagreements about word choice, poetic meter, harmonic structure, and acting styles were aesthetic concerns with inherent interest to the audience because they were part of a societal discourse on nationalism, ethnic and class identity, and cultural progress.[7]

The audience's role in making meaning was not limited to the moment of production. Public discussions on the arts routinely occurred outside of performance and museum sites, from Sophocles' presentation at the City Dionysia to the seventeenth-century French salons to the more recent era of arts appreciation clubs sponsored by schools, churches, community centers, and public libraries. In addition, written

forms of pubic discourse were steady and voluminous. Beginning in the early 1800s and through the mid-twentieth century, for example, most American cities had numerous daily newspapers that provided a range of cultural information through reviews, columns, letters to the editor, and educational articles. In light of this, an arts consumer had access to a wide variety of critical opinions and was reminded on a daily basis that even the experts disagreed, which in turn created the cultural space for the patron to disagree as well. In addition to newspapers, there were many theatre, music, dance, and fine arts journals oriented toward the audience. Arts patrons also participated in a practical manner by joining amateur production companies, by taking studio classes, and by creating public works of art, such as historical pageants, as a form of celebration and as a way to solidify and document community identity. Although recent community-building efforts have recuperated some of these practices, most notably in the form of public murals, these efforts are primarily focused on school-aged children and not, as they were historically, on adults.

One of the more interesting examples of audience sovereignty among nineteenth- and early twentieth-century Americans were audience leagues. In the United States, these organizations were created and led by professional audience members—that is, by serious patrons who organized themselves to create a platform for voicing opinions about the arts events they were attending. Often these leagues wrote, printed, and disseminated their own newsletters; efforts were rooted in a desire to maintain a sense of control over their cultural experiences.

Constructing the Passive Audience

So what happened to the active, participatory ethos that defined Western audiences for more than 2,000 years? In studies of the evolution of American culture, historians locate the emergence of the passive twentieth-century arts audience in several cultural, economic, and technological shifts.[8] This chapter focuses on two key moments of this evolution that cross genre and class lines: one purely technological and the other essentially sociopolitical.

Beginning with the sunlit outdoor Greek theatres and through the introduction of gas lighting in indoor theatres during the 1810s, the

stage areas and auditoriums were continually lit—an effect similar to the lighting arrangement in most sporting arenas today. In 1881, the Savoy Theatre in London, the home of Gilbert and Sullivan, became the first theatre fully equipped with discretely wired electric lighting on stage and in the auditorium. The benefits were myriad, from focusing attention on the actors instead of the audience (thus helping to establish the fourth-wall illusion—a deep goal of the Realist movement) to making the playhouse significantly safer and more comfortable (lighting by gas caused headaches). By the early 1890s, cities across Europe and the United States boasted of theatres with state-of-the-art electrical systems.

The other effect of controlled lighting was to move the audience into complete darkness, while at the same time placing the actors, dancers, symphony musicians, and opera singers into a more focused and determined quality of light. This adjustment transformed the playhouse or concert hall from a site of assembly—ripe for public discussion and collective action—to one of quiet reception. Audiences also went from being active to passive participants in their own entertainment, as Richard Butsch noted in *The Making of American Audiences: From Stage to Television, 1750–1990*: "Critical to any conception of public sphere and also to any potential for collective action is conversation, for the opportunity to assemble and discuss and come to consensus about what to do. Suppressing theatre audience expression therefore eliminated the theatre as a political public space. Quieting audiences privatized audience members' experiences, as each experienced the event psychologically alone, without simultaneously sharing the experience with others."[9]

A second factor in the construction of the passive arts audience is what cultural historian Lawrence Levine referred to as the *sacralization* of the arts. Toward the end of the nineteenth century, the gap between popular culture and aesthetic, or high, culture widened dramatically. As Levine demonstrated in his book *Highbrow/Lowbrow*, this shift was the result of a deliberate effort to create a cultural hierarchy in America. Informed in part by Matthew Arnold's definition of culture (versus anarchy), the ostensible goal of "raising the masses through culture" came down to a simple recipe: provide American audiences with "the best that has been thought and known in the world ... the study and pursuit of perfection" (p. 223). Arnold's theory of the high and the low was, as Levine noted, quickly and widely embraced: "The ubiquitous discussion of the meaning and nature of culture, informed by

Arnold's views, was one in which adjectives were used liberally. 'High,' 'low,' 'rude,' 'lesser,' 'higher,' 'lower,' 'beautiful,' 'modern,' 'legitimate,' 'vulgar,' 'popular,' 'true,' 'pure,' 'highbrow,' 'lowbrow' were applied to such nouns as 'arts' or 'culture' almost ad infinitum. Though plentiful, the adjectives were not random. They clustered around a congeries of values, a set of categories that defined and distinguished culture vertically, that created hierarchies which were to remain meaningful for much of this century."[10] Embedded in this new construction of the arts was an altered definition of the artist's function and social position; the artist was elevated to a position of authority that could and should not be questioned. But the inevitable problem soon revealed itself—a gap between the existing audience ethos (which assumed authority over the artist's intentions and the arts event itself) and the kind of auditorium etiquette that acknowledges this new definition of high art. Part of our evolution from a populist, mass cultural practice to segregated high, middle, and low cultural practices, then, was the necessary reeducation of American audiences in how to behave while in the presence of high cultural products. Symphony orchestras, fine arts museums, and opera houses led the way in instilling American audiences with the concept of high culture and the notion that great art needed to be received with awe and respect.[11] It is also clear that underneath this effort to raise the overall standards of American taste was the desire, among the economic elite, to segregate themselves from the mass audience using the "cloak of culture." But even if the reasons for this sacralization process were culturally complex, the public message was relatively concise: Sophisticated audiences do not interfere with great art, and unsophisticated people should confine themselves to other spaces.

Ironically, a similar message was also broadcast by other, more populist realms of the late nineteenth-century American arts industry. In the 1880s, for example, an entrepreneur by the name of Benjamin Franklin Keith reinvented the largely male province of the burlesque and variety theatres by sanitizing the material and relabeling it *vaudeville*. He added to the allure of an emerging, family-friendly theatre experience by building new playhouses where middle- and working-class families could afford to spend a few hours in luxurious surroundings. However, the shift from burlesque to vaudeville demanded new standards of appropriate behavior. Inside the Keith-Albee vaudeville palaces audiences found the following instructions: "Gentlemen will kindly avoid the stamping

of feet and pounding of canes on the floor …. All applause is best shown by clapping of hands." And "Please don't talk during acts, as it annoys those about you, and prevents a perfect hearing of the entertainment."

Such etiquette lessons soon became standard in theatre playbills and programs, as did wall placards instructing patrons on how to behave inside galleries and museums. Audiences learned that physical responses—outside of applause—and verbal feedback were no longer welcome. By default, they also learned that any cognitive processing of their viewing experience had to be achieved in silence and in private. Eventually the combination of environmental forces (i.e., the dark auditorium and mandated etiquette) and the growing gap between the societal position of the artist and the arts patron effectively quieted the audience. By the early twentieth century people of all social classes were expected to treat arts events as private experiences. They were to sit still, to refrain from talking, and to keep their opinions to themselves. In the process opportunities for public discourse about the arts and the attendant opportunity for formulating and exchanging sets of opinions about the arts event itself were, for the most part, lost.[12]

Silencing Twentieth-Century Audiences

The sacralization of the arts in America can be viewed as a Gilded Age project—an effort to reshape cultural interaction at a time when class lines were being drawn to fit late nineteenth-century economic interests. In a similar manner the so-called democratization of the arts that characterizes the twentieth century was a byproduct of Progressive Era reforms: the introduction of public and charitable support into what had formerly been a privately funded sector. These include the tax laws allowing for deductions based on charitable gifts to cultural organizations (1917), the artist employment projects of the Works Progress Administration (1935–1943), the institutionalization of a new model of foundational support with the Ford Foundation's arts program (1957), the first legislation to sustain direct government subsidy through the implementation of the National Endowment for the Arts (1965), and the proliferation of state and municipal arts councils (beginning in the late 1960s).[13]

The reconstitution of the *noncommercial arts* into the *nonprofit arts* engendered unparalleled changes in the cultural life of American communities. With the support of public funds, resident theatres, orchestras, ballet troupes, modern dance companies, and museums were established in regional sites, helping to decentralize the industry and offering many more opportunities for professional-quality production and consumption of fine arts at a local level. This new context for local art making nourished the idea of the professional arts as a normative part of a community's social fabric, and booms in art production occurred all over the United States. It also provoked material changes, most notably the construction of new concert halls and playhouses and in many cities, centralized performing arts centers servicing a variety of genres and organizations. Not surprisingly, arts organizations grew to meet the demand, taking on capital responsibilities, adding more support staff, creating departments focused on arts education and community development, and beginning in the 1990s, absorbing corporate business strategies, particularly in marketing and development.[14]

By the late 1960s, then, legitimate theatre, concert dance, orchestral music, art and history museums—now relabeled the *serious arts*—had become the property of the nonprofit arts industry. This significant cultural shift could have had a leveling effect on the power dynamic between arts makers and audiences. But despite the rhetoric of democracy implied by terms like *public theatre* and *civic orchestra,* the high–low binary that emerged in the late nineteenth century was not erased, just reassigned. From the perspective of audience sovereignty, public funding did not desacralize the arts. Instead, the cloak of culture once worn by wealthy audience patrons was draped over the shoulders of the professionals at the helm of publicly funded institutions: the artists, arts administrators, and board members. Although words like *high* and *pure* were abandoned—especially after the advent of multiculturalism—the operating assumption among nonprofit organizations continued to advance the Arnoldian principle of raising the masses through culture. The idea of taking into account the audience's opinions on arts events—so formative to the shaping of the Western arts tradition—morphed into a distasteful compromise of artistic integrity to pander to public tastes.[15] Curiously, although the advent of postmodernism has encouraged artists and arts institutions to dismantle the distinction among high, middle, and low when it comes to defining appropriate material content

or structure, postmodernism has not attempted to redefine appropriate audience behavior. This attitude has led to a kind of double objectification of the audience: They are being asked to buy a product over which they cannot ever expect to have any control. Ironically, after forty years of public art paid for twice by its audience—through tax-based subsidies and ticket sales—the intellectual and emotional distance between public arts producers and the average cultural consumer has never been greater.

Into the Light: A New Era of Active Audiences

Most working artists and arts producers acknowledge that what occurs in the concert hall or the gallery or on the playhouse stage is a complex interaction of intention and reception that no one person or institution can forecast or contain. They learn—sometimes by design and often through failure—that a meaningful definition of art does not originate solely from knowledge of the art object or from understanding the artist's intention. Instead, a meaningful definition of a production of *Oedipus Rex*, whether it is staged in 420 BCE or in 2007 acknowledges the active and engaged interplay of all constituent elements of the creative act, from production to reception and beyond. This changing relationship is the calculus of an arts experience.[16] The *Oxford English Dictionary* gives the following definitions of the word experience: "the fact of being consciously the subject of a state or condition, or of being consciously affected by an event; personal knowledge; to feel; to undergo" (Simpson and Weiner 1989, p. 563). I am most interested in the last term—to *undergo*. Experience implies undergoing a cognitive journey from receiver to perceiver—from a passive to an active state—from a neutral condition to an opinionated stance. But to realize the full potential of experiencing an arts event, the audience member must possess two qualities: the authority to participate in the process of coauthoring meaning; and the tools to do so effectively.

The concept of coauthorship is fundamental to many late twentieth-century methodologies for analyzing the process of encoding and decoding meaning in the arts, from reception theories to performance semiotics. Furthermore, the problem of who gets to interpret a work of art is a common one in both industry and academic circles, where it is

familiar territory in the culture wars over relativism versus dogmatism. Nevertheless, in my twenty years of working with adult arts audiences in theatres and concert halls, I have found repeatedly that audiences are unaware that they have the cultural right to coauthor the meaning of the arts event. What previous generations of arts-consumers took for granted—the sovereignty over their own cultural choices and the attendant authority to ascribe meaning in a publicly valued manner—contemporary adult arts-consumers do not even consider as a possibility. After all, they have been taught to remain quiet to keep their feelings hidden inside a calm, still body and to wait for the appropriate moment to express an opinion. Further, they have been conditioned to wait to receive meaning from the experts: the artist, the newspaper critic, the professor, and other, more sophisticated patrons who have somehow earned the right to post an opinion.[17]

This does not mean, however, that contemporary audiences are not interested in coauthoring arts events. I believe what today's potential arts audiences most want out of an arts event is the opportunity to coauthor meaning. They don't want the arts; they want the arts experience. They want the opportunity to participate—in an intelligent and responsible way—in telling the meaning of an arts event. Like their forebears in the amphitheatres of fifth-century Athens and the vaudeville palaces of nineteenth-century America, they want a real forum—or several forums—for the interplay of ideas, experience, data, and feeling that makes up the arts experience. They want to retrieve sovereignty over their arts-going by reclaiming the cultural right to formulate and exchange opinions that are valued by the community.

This thesis is supported by surveying the ways that today's consumers actually spend their leisure time and discretionary money. What characteristics connect the arts of the past to the forms of live, real-time cultural participation that enjoy the most popularity today? It is events that invite physical or intellectual freedom and provide, in tangible and socially relevant ways, opportunities to coauthor meaning and to make choices. Think of the physical freedom of the rock concert environment. Or the opportunity for ongoing verbal feedback during a jazz set. Or the intellectual stimulation of a spoken word event, a performance site where thousands of years of oral poetic expression meet the rhythms of popular culture and the tensions of contemporary life in a way that invites analysis and engagement among its young audience set.

By comparison, consider what it means to *attend* a football game. I acknowledge that sports—with their emphasis on competition and tribal affiliations—serve a set of individual and collective impulses quite distinct from those serviced by our contemporary definition of art. Though I also take the opportunity to remind the reader that *Oedipus Rex* was created in a competitive, tribal environment. Perhaps sports attendance is so high in the United States because of the felt value of participating in the sports experience rather than in simply watching the sports event itself. Sports fans are constantly invited to coauthor meaning and are regularly provided with experiential opportunities that facilitate that coauthoring process. The enormous amateur sports enterprise—enabling children and adults to participate on a physical level—supports a connection to and engagement with the professional industry. But even nonathletes can participate in significant and meaningful ways. Every day they can read in newspapers about their game of interest: its current conditions, its people, its politics. Every day they can watch and listen to expert analysis of their game on the television or the radio, and every day they can debate their own opinions with a coworker or a neighbor or make a call to radio and television talk shows. In our society, opportunities for the analysis of and debate about sporting events are so abundant, in fact, that we can be democratic in how we field those opportunities. We have the cultural space, so to speak, to listen to everyone's opinion.

The same is not true for arts lovers. People who have an interest in theatre or dance, for instance, and want to learn more about the history of the work or genre or to listen to an expert discuss a recent trend in the fine arts or to express their opinion about a chamber concert to someone who actually cares, where do they turn? Where are the opportunities to analyze, formulate, and debate works of art in the same way as sports fans? In most cities they must take some significant steps: enrolling in a university course, buying a season subscription to qualify for the postconcert discussion groups; or organizing their own play-going group.

The distinction here is obvious: We do not have the same attitude or approach to arts as to sports. We rarely carry the energy of an arts experience into our work environment, and we seldom, if ever, feel knowledgeable or empowered enough to debate the meaning or value of an arts event. Sports fans, unlike their arts counterparts, have been given

permission to express their opinions openly and the tools they need to back up those opinions. The experiences that surround the sporting event—from talk shows to twenty pages of sports writing in the daily newspaper—help the audience to prepare, to process, to analyze, and to feel a deep sense of satisfaction. As every sports fan knows, the real pleasure of the sports experience is not limited to watching the game. It is also located in talking and arguing about it the next morning. Throughout the twentieth century, the sports industry has understood its responsibility to promote opportunities for public debate and civic discourse. The arts industry has largely neglected that task, and we are paying for it now.

Redemocratizing the Arts

Although the profound social changes since Sophocles' time have certainly affected both the role and function of civic engagement, they have not altered the spectator's basic need to coauthor the meaning of an arts event. Today's consumption patterns make it clear that adult audiences—like their forebears—seek entertainment promoting the interplay of ideas, experience, information, feeling, and passion. They, too, seek the cognitive satisfaction that comes from the opportunity to formulate and express an opinion in a public context. Simply put, today's audiences are willing to spend their money and leisure time on live entertainment that puts them in the position to participate in, through and around the arts event itself.[18]

Reassembling a similar model for the live arts is an enormous challenge since our society no longer provides the same kind of infrastructure for arts assembly and public coauthorship that it did in the past. The burden for providing it, then, weighs heavily on arts institutions. Creating these opportunities will involve an institutional realignment, for even though the arts education and community outreach programs installed during the 1980s and 1990s are certainly valuable, they have been modeled on what Paolo Friere called the "banking" system of education in which knowledge is considered a gift bestowed by the "expert" teacher on the "helpless" student.[19] Preconcert lectures given from a distant podium, program notes written in discipline-specific jargon, and feedback sessions monopolized by an artist's point of view begin and end

with a one-way transfer of information and cannot, when offered as the sole audience enrichment program, meet the standards of coauthorship.

Happily, a new ethos is brewing in many facets of the nonprofit arts community—this time with the audience's interests at the center. Evidence of change can be seen in the museum industry, where many theorists, curators, and administrators are embracing the concept of an *open work*—that is, the notion that the meaning of an object can only be derived in the real-time exchange between the object, the exhibition environment, and audience.[20] The result has been a decade of innovative programming designed to suit different tastes and styles of adult learning. These include playful scavenger hunts that invite adult patrons to follow clues—loaded with information and interpretive suggestions—to trace their own path through an exhibit, signage that acknowledges multiple interpretations of the art work on display instead of a single, authoritative definition, and in-gallery activities that encourage the patron to employ the artist's strategy in making their own piece of art.

More recently, performing arts organizations have also begun to experiment with this new ethos by expanding the boundaries of their audience-centered programming. Ballet troupes are offering movement for nonmover workshops that help put visual imagery into the spectator's muscles. Modern dance presenters show video and offer pointer sessions directly before a concert to help prepare the eye of the spectator for what they are about to see—a strategy that has been proven to increase audience satisfaction.[21] Theatre companies invite their audiences to attend rehearsals and to e-mail the designers, directors, and actors with questions or comments. Opera companies hold salons run by passionate subscribers interested in debating points of view. Symphony orchestras place interpretive aids inside the concert hall, marking a significant disruption to the discipline's long-established etiquette. The Concert Companion (currently being tested by several leading orchestras), for example, is a hand-held PDA device featuring a small screen scrolling real-time interpretation of the live concert.[22] All of these organizations are exploring the world of online opinion forums by building sites that host discussions in a structured manner.

When an arts organization combines two-way interactive experiences with well-designed lectures, program notes, and other forms of information dissemination, the audience wins. They have the information and the opportunities they need to begin formulating and expressing an opin-

ion. This, then, is the practical, bottom line definition of coauthorship in the twenty-first century: a critical mass of surrounding experiences that converge in and around an arts event to provide useful information, opportunities to process that information, and, finally, a follow-through experience that allows for synthesis, analysis, debate, and—at least some of the time—consensus on the meaning of the arts event.[23]

Conclusion

It would not be possible, or desirable, to return to the nineteenth-century stage and the kind of active live arts audience behavior of the past. In the twenty-first century it is reasonable to expect a quiet auditorium during an arts event—if only because we are accustomed to this reception environment and have learned, through experience, to need silence to concentrate. Nor am I proposing that audiences become programmers, curators, or sole arbiters of taste. Building opportunities for the audience to participate in the arts event should not be confused with dumbing down the repertoire, nor should we worry that empowered audiences will interfere with the need and desire among artists and arts producers to create and program challenging work. Effective arts experiences are more likely to lead to progressive, adventurous programming because they provide audiences with the tools for looking and listening to unfamiliar art with confidence and with useful forums for coauthoring meaning.

What I am proposing is that nonprofit arts producers and their institutions look to the histories of their disciplines for examples of the arts experience—those larger, surrounding opportunities for engagement. In doing so, they must also acknowledge that the hierarchal idea of arts reception, in which great art will automatically find its true audience without mediation of any kind, is behaviorally inaccurate. As this chapter shows, there is a historical relationship between a given community's interest in attending an arts event and the opportunity to inform its meaning; it is a reciprocal status that reflects a healthy balance among the needs of artists, producers, and audiences. To compete in the cultural marketplace of the twenty-first century, the nonprofit live arts community must concede that an audience-driven cultural transformation is already under way—with or without our permission or approval. Ameri-

can audiences of the twenty-first century, especially younger patrons, are busily and happily engaged in the process of redemocratizing the arts. With their money and leisure time they are willfully undoing the sacralization of cultural experience, refusing to be influenced by out-dated definitions of respectable concert hall decorum, and eagerly engaging with new technologies that alter the very definition of art and art making in our time. If we want this newly empowered audience to follow us into our theatres and concert halls, then we must be willing to participate in this redemocratization process by encouraging the kinds of surrounding arts experiences that people are clearly seeking.

Bibliography

Allen, Robert C. 1991. *Horrible Prettiness: Burlesque and American Culture.* Chapel Hill: University of North Carolina Press.

Arian, Edward. 1989. *The Unfulfilled Promise: Public Subsidy of the Arts in America.* Philadelphia: Temple University Press.

Benedict, Stephen. 1991. *Public Money & the Muse: Essays on Government Funding for the Arts.* New York: W. W. Norton & Company.

Brooks, Van Wyck. 1934. *Three Essays on America.* New York: E.P. Dutton & Co., Inc.

Brown, Alan. 2005. "Orchestras in the Age of Edutainment." Issues Brief 5. Miami: John S. and James L. Knight Foundation.

Butsch, Richard. 2000. *The Making of American Audiences.* Cambridge: Cambridge University Press.

Cohan, Selma J. 1992. *Dance as a Theatre Art: Source Readings in Dance History from 1581 to the Present.* Hightstown, NJ: Princeton Book Company.

Conner, Lynne. 2004. "Who Gets to Tell the Meaning?" *Grantmakers in the Arts Reader* 15: 11–14.

Connolly, Paul, and Marcelle H. Cady. 2001. *Increasing Cultural Participation: An Audience Development Planning Handbook for Presenters, Producers and Their Collaborators.* Wallace–Reader's Digest Funds, Illinois State University. http://www.wallacefoundation.org/WF/KnowledgeCenter/KnowledgeTopics/ArtsParticipation/IncreasingCulturalParticipation.htm.

DiMaggio, Paul. 1984. "The Nonprofit Instrument and the Influence of the Marketplace on Policies in the Arts." In *The Arts and Public Policy in the United States*, edited by W. M. Lowry, 58–59. Englewood Cliffs, NJ: Prentice-Hall.

Florida, Richard. 2004. *The Rise of the Creative Class.* New York: Basic Books.

Friere, Paolo. 1998. *Pedagogy of Freedom: Ethics, Democracy, and Civic Courage.* Lanham, MD: Rowman and Littlefield Publishers.

Gascoigne, Bamber. 1968. *World Theatre: An Illustrated History*. Boston: Little, Brown and Company.

Green, John R. 1994. *Theatre in Ancient Greek Society*. New York: Routledge.

Grimsted, David. 1968. *Melodrama Unveiled: American Theatre and Culture, 1800–1850*. Chicago: University of Chicago Press.

Keith-Albee Theatre Playbills. The Merriman Scrapbooks, Curtis Theatre Collection, University of Pittsburgh Library.

Kriegsman, Sali A. 1998. "Meeting Each Other Half Way." *Dance/USA Journal* 9: 13–15.

Levine, Lawrence. 1988. *Highbrow/Lowbrow: The Emergence of Cultural Hierarchy in America*. Cambridge, MA: Harvard University Press.

Lowry, W. M. 1984. *The Arts & Public Policy in the United States*. Englewood Cliffs, NJ: Prentice-Hall.

Lynes, Russell. 1949. *The Tastemakers*. New York: Harper & Brothers.

McCarthy, Kevin, Elizabeth Ondaatje, Laura Zakaras, and Arthur Brooks. 2004. "Gifts of the Muse: Reframing the Debate About the Benefits of the Arts." RAND Corporation. http://www.rand.org/pubs/monographs/2005/RAND_MG218.pdf.

McConachie, Bruce A. 1992. *Melodramatic Formations: American Theatre & Society, 1820–1870*. Iowa City: University of Iowa Press.

Pickard-Cambridge, Arthur. 1988. *The Dramatic Festivals of Athens*. Oxford: Oxford University Press.

Putnam, Robert. 2000. *Bowling Alone*. New York: Simon & Schuster.

Simpson, J.A. and Weiner, S.C. 1989. *The Oxford English Dictionary – 2nd Edition*. Volume 5. Oxford: Clarendon Press.

Walker, Chris, Stephanie Scott-Melnyk, and Sherwood Kay. 2000. "From Reggae to Rachmaninoff: How and Why People Participate in Arts and Culture." Washington, DC: Urban Institute.

Wilson, Erasmus. 1898. *Standard History of Pittsburgh*. Chicago: H.R. Cornell & Co.

Endnotes

1. A portion of this chapter was originally commissioned by the Heinz Endowments' Arts & Culture Program as a policy statement for the Arts Experience Initiative—an audience enrichment laboratory involving Pittsburgh-based arts organizations. The policy statement was published under the title "Who Gets to Tell the Meaning?" *Grantmakers in the Arts Reader* 15, no. 1 (Winter 2004): 11–14.

2. For practical reasons I limit my historical survey to a discussion of the Western European trajectory of cultural practices in the United States. There are, of course, many other influences that inform contemporary American audience behavior.

3. For a discussion of Athenian cultural practices and Greek drama, see Green (1994) and Pickard-Cambridge (1988).

4. Cohan (1992, p. 19).

5. For reproductions of period illustrations depicting active auditoriums and museums, see Gascoigne (1968), Butsch (2000), and Levine (1988).

6. Quoted in Wilson (1898, p. 880).

7. Audience-led conflicts over impropriety and obscenity are good examples of cultural participation, but I divert from citing them in this chapter to make it clear that our legacy of interactivity is not reducible simply to them.

8. Butsch (2000), for example, noted that the move away from production for use toward production for exchange in the arts industry firmed up the distinction between producers/performers and consumers/audiences and elevated the artist's status while demoting the audience's. McConachie (1992) narrated the construction of discrete high and low genres for the purpose of separating respectable and unrespectable people. Other useful historical analyses of the economics of nineteenth-century leisure and cultural practices include Allen (1991) and Grimsted (1968).

9. Butsch (2000, p. 15).

10. Levine (1988, pp. 223–24).

11. See especially Levine (1988) and Butsch (2000). I also point readers to Greg Sandow's ongoing Web log commentary on the history of applause during classical music concerts: "Greg Sandow on the Future of Classical Music," http://www.artsjournal.com/sandow/.

12. The intermission is perhaps the sole remaining domain of active behavior within the real-time construct of a live arts event. Interestingly, more and more productions—especially in the theatre and dance communities—are being designed without intermissions.

13. For a discussion of the history and policy surrounding public funding for the arts in the United States, see Benedict (1991), Lowry (1984), and Arian (1989).

14. The latter adjustment became increasingly necessary because, as Paul DiMaggio (1984, pp. 58–59) first pointed out more than twenty years ago, American arts organizations are "nonprofit" but not "nonmarket" institutions. They are required, in most cases, to earn at least 50 percent of their operating budgets and thus must compete in the arts marketplace. This has proven to be an awkward situation because the "arts marketplace consists of firms that ... steadfastly refuse to maximize profits." In other words, by definition the nonprofit arts organization sell a constantly changing, unknown, and unproven product.

15. It might even be argued that today the only sovereignty left within our nonprofit arts ecology is that of the publicly funded artist, who maintains the right to create along individual rather than collective desires.

16. My use of the phrase arts experience is distinctly different from its use in current arts education and cultural participation literature. See, for example, varying usages in McCarthy et al. (2004), Connolly and Cady (2001), and Walker, Scott-Melnyk, and Kay (2000).

17. As chapter 10 in this volume illuminates, an audience member left to interpret an unfamiliar and uncomfortable arts event without support will most likely choose to exit rather than to voice an opinion. Even sophisticated adult audience members have problems absorbing unfamiliar art forms. Open learning is a risky undertaking for most adults because the process underscores what we do not know and, as such, exposes our weakness.

18. Although some current studies observe a trend away from cultural participation among overworked Americans of all economic classes, these findings do not entirely square with the significant amounts of money and time being spent on events that clearly satisfy an essential need to convene and interact in a public setting. One reason why book clubs and restaurants are currently enjoying so much success, for instance, is that they allow Americans to participate in their own entertainment.

19. Obviously, Friere's revolutionary thesis on the role of power abuse in *Pedagogy of the Oppressed* was distilled from his experiences among impoverished and abused peoples. Still, it seems to me that the idea of a powerful expert bestowing a gift of information on a helpless audience is a reasonable analogy for some attitudes within our contemporary high culture environment.

20. In her essay "Performing Openness: Learning with Our Audiences and Changing Ourselves," Jessica Gogan describes a wide range of experiential programming at the Andy Warhol Museum based on the theory of an open work and notes that the concept "suggests a new model of curatorial synthesis that is open to creating/curating together with audiences and communities and amongst museum staff. Here, the museum plays a critical role in galvanizing energies and promoting the sharing of knowledge that in turn builds trust and relationships within communities and within the institution. An 'open' museum ultimately offers richer and more meaningful possibilities for learning and experience and an expanded sense of a museum's civic role and place in community." (Contact GoganJ@Warhol.Org)

21. For an interesting description of the effectiveness of pre-performance education in terms of enhancing the audience's enjoyment, see Kriegsman (1998), which outlines the history of Jacob's Pillow's experimental audience enrichment programming inaugurated in 1996.

22. For a full description of the Concert Companion and other innovative audience-centered programming in the orchestra field, see Brown (2005).

23. If there are no opportunities for public talk about the arts, then a sense of cultural isolation and class segmentation sets in. In American life, this cultural isolation and fragmentation has been the focus of much aca-

demic and popular analysis since at least 1915, when Van Wyck Brooks (1934) first published his theory of the high–low binary of American culture. Notable mid-century analyses include Russell Lynes (1949), wherein the concept of the middlebrow gets a thorough treatment. Most recently Robert Putnam (2000) argued that as a nation our social capital has plummeted. He used the bowling alone metaphor literally, claiming that recent statistics show that even though more Americans bowl now than ever before, we do so by ourselves rather than in leagues or social groups, as in the past. Another recent study, Richard Florida (2004), redefined the term creative as an economic indicator by telling us that people who are paid to think for a living—doctors, lawyers, engineers, programmers—are drawn to arts-infused communities because this empowered, emerging creative class seeks fulfillment through stimulating leisure, not just work. In my own reading of these last two texts, the compelling common idea is the demonstration of an ongoing psychological desire among Americans of all classes for civic engagement and the opportunity for meaningful public assembly.

Section Two:

Getting off the Beaten Path:
Investigating Non-Traditional
Audiences, Places, and Art Forms

5 Faithful Audiences

The Intersection of Art and Religion

Robert Wuthnow

Introduction

Religion plays a huge role in American life. Even those who claim no interest in it can hardly deny its importance. There are approximately 340,000 congregations in the United States—more than twenty times the number of performing arts organizations. Annually, Americans make an estimated total of three billion visits to their places of worship—at least three times the number made to art museums, plays, musical performances, historical sites, and arts and craft fairs combined.[1] Giving to religious organizations—amounting to $88 billion in 2004—constitutes the largest category of individual philanthropy.[2] Religious orientations influence partisan politics and attitudes toward numerous social and moral issues. For many people faith is the source of meaning and purpose, the basis of morality, and the answer to life's enduring questions.

The prominence of religion in American society means that it cannot be ignored in discussions of the arts. Although it is sometimes viewed as a competitor, religion inspired the arts throughout history. It continues to sponsor certain kinds of art, including congregational singing. Recent developments also suggest that the relationship between religion and the arts may be growing closer. For instance, the Christian music industry is flourishing, megachurches are making greater use of contemporary music and the visual arts, and major motion pictures such as Mel Gibson's *The Passion of the Christ* (2004) feature religious themes.

Surprisingly, researchers have paid relatively little attention to the relationship between religion and the arts. This neglect has been particularly acute among social scientists. In 2004, the Social Science Citation Index (SSCI) included more than 16,000 journal articles with *religion* in their titles or abstracts and more than 5,600 with *arts*. Yet only thirty-one articles include both *religion* and *arts,* and of these, only two were empirical studies involving the United States. Anecdotal evidence, though, suggests that religion and the arts currently interact in increasingly interesting ways. Painters, sculptors, musicians, and writers describe a close relationship between their art and spirituality, and contrary to the stereotype that most are flaming atheists, a large majority express a religious preference, believe the Bible to be divinely inspired, and pray.[3] Art museums increasingly include religious objects and exhibitions representing the religious traditions of ethnic groups. A large church in Dallas sponsors its own symphony orchestra, whereas a church in Mississippi sends a ballet company on national tours. Smaller churches hold arts festivals and craft fairs, and religious leaders sometimes stage protests about art they consider offensive.

To learn more systematically how religion and the arts are interacting, I initiated a five-year research project in 1998 with primary funding from the Lilly Endowment and supplemental funding from the Luce Foundation. My project included a nationally representative survey of the American public, conducted in 1999, and in-depth interviews with approximately 100 professional artists, 100 leaders of large metropolitan arts or religious organizations, 60 randomly selected clergy, and more than 300 lay leaders involved in church music and other aspects of the performing and visual arts. In addition, more than 100 people participated in focus groups. The Luce grant also permitted questions about the arts to be included in the General Social Survey (GSS) and a national

study of congregations. Detailed results of this research have been pub-lished elsewhere,[4] but here, I summarize some of the key findings.

Religious Organizations as Venues

A walk through almost any major art museum leaves the impres-sion that religion and the arts were closely connected in the distant past but no longer are. In the exhibitions about archaic societies through the Middle Ages, religious artifacts are clearly present. Renaissance art reflects the shift away from church patronage of the arts, and by the contemporary period, there is hardly any evidence of religion at all. In social science terminology the gradual separation of art from religion is an example of institutional differentiation. Art extricated itself from the grasp of religion with difficulty, as modern societies became more complex and secular. According to this narrative, religious influences hampered the development of the visual arts in the United States until well into the nineteenth century. Protestant teachings about idolatry and graven images restricted opportunities for visual artists. Major museums and orchestras also had to wait until urban elites became sufficiently disenchanted with religion to patronize the arts instead of churches.

This familiar story of institutional differentiation, however, is a tale sorely in need of modification. It fails to take account of the sacramen-tal tradition in American Catholicism, which favored the visual arts and became increasingly prominent during the nineteenth and twentieth cen-turies. It also fails to acknowledge the growing place of the visual arts and artistic approaches to church architecture apparent in wealthy, urban, Protestant churches. And it especially fails to consider the role of music in nearly all American congregations. In seeking to understand the current relationships between religion and the arts, the first order of business is thus to examine how religious congregations serve as arts venues.

One path or inquiry is simply to ask members about arts activities in their congregations. Their perceptions may not always be accurate, especially if they are infrequent attendees, but awareness is an important part of the story. In the Arts and Religion Survey, the nationally repre-sentative study I conducted among 1,530 respondents, I asked members of religious congregations to indicate if their congregations had spon-sored arts activities the past year. To compare the responses of people

belonging to different religious traditions, I divided respondents into Protestants or Catholics and then further categorized the Protestants into evangelical or mainline, according to their denomination. Evangelical denominations such as Southern Baptist, Assemblies of God, Nazarenes, and Pentecostal are generally theologically conservative; they teach that the Bible is infallible and should be taken literally. Mainline Protestants—Episcopalians, Methodists, United Church of Christ, and most Presbyterians and Lutherans—are usually theologically moderate or liberal.[5] Until recently, evangelical denominations were the clearest embodiments of the earlier, plain piety tradition that viewed the arts skeptically. Yet anecdotal evidence shows that many evangelical congregations have embraced the arts in recent years as ways to attract young people and to be more culturally relevant. Mainline Protestants have historically been more affluent than evangelicals and have thus constructed more elaborate churches, taking pride in fine furnishings and music. Mainline churches have suffered serious membership losses lately, however. Finally, Catholic parishes vary considerably in size and affluence and have suffered financially at the same time that they have become more ethnically diverse.

Whatever the denomination, music remains the most common artistic expression in American congregations. Approximately three church members in four claimed that their congregations have an adult choir (Table 5.1). Choirs, these data suggest, are somewhat more common in Protestant than in Catholic churches. Three church members in five said that their congregations also have a children's choir. Again, these choirs are slightly more prevalent in Protestant churches than in Catholic ones. Neither choir is significantly more or less common in evangelical than in mainline churches. Almost half of members reported that their congregations have sponsored dramas or skits in the past year. Evangelicals staged the most theatrical productions, followed by mainline Protestants. Skits and short dramas have been popularized by nondenominational, evangelical megachurches to enliven traditional worship services and to make them more appealing to audiences used to television and movies. These data, though, indicate that dramas and skits serve other purposes as well. For instance, many congregations have long histories of sponsoring special dramatic performances or pageants at Christmas and Easter. Although nearly all congregations include music during regular worship services, evidence suggests that almost

Table 5.1 Arts Activities Sponsored by Congregations (Percentage as
Reported by Members)

	Evangelical	Mainline	Catholic	Total
Adult Choir	78	80	67	74
Children's Choir	64	63	55	61
Drama or Skit	55	46	32	45
Music Performance other than Worship	53	48	32	44
Art Festival or Craft Fair	22	37	51	36
Group Discussion of Art, Literature	12	20	26	19
Liturgical Dance	8	8	16	11
Private Music Lessons	8	11	10	10
Number	295	227	273	795

Note: Data from Arts and Religion Survey question, "Within the past year, which
of these activities has your congregation sponsored?"

half of all congregations sponsor musical performances at other times.
Again, this activity is more prominent among Evangelicals than main-
line Protestants. Performances range from church-sponsored rock con-
certs designed to attract teenagers to special concerts by the children's
choir to church space being used by outside organizations, such as a
chamber orchestra or choral group. Then, about one third of members
noted that their congregations hold art festivals or craft fairs. Unlike
the previous activities, these are more common in Catholic churches
than in Protestant churches. Anecdotal evidence reveals that art festi-
vals and craft fairs have become increasingly popular: Some churches
see them as opportunities for members to display their talents, others
to celebrate ethnic traditions or to sell objects made by craftspeople
in developing countries. A fifth of members said that their congrega-
tions sponsor groups that discuss art or literature. The most common
examples are book discussion groups. Slightly more than 10 percent of
members mentioned liturgical dance (usually incorporated into worship
services), and about the same percentage wrote that their congregations
provide private music lessons.

These numbers show clearly that congregations are important ven-
ues for the arts. Many churches have the resources and motivation. For
instance, the Dallas church that sponsors its own symphony orchestra
also has theater-style seating in its auditorium for nearly 3,000 people
and state-of-the-art equipment for national telecasts of its performances.

In addition, the congregation supports several large choirs, has a video library, and hired a renowned architect to design its sanctuary and surrounding buildings. For believers interested in the arts, it is an attractive church. With an annual budget of more than $10 million and 100 full-time employees, the church can afford to engage in the arts.

In the survey, members of medium and large congregations were more likely to mention artistic events than those of small congregations—ones that presumably lack resources.[6] But small congregations usually incorporate some aspects of the arts into their programs as well. The nearly defunct Kansas church featured in the documentary *Zenith*, for example, enlists the entire community in an annual Passion play; participants attest that the performance has brought them closer to Christ and to each other.[7] In another example, one of the smallest church buildings in Nebraska, erected a century ago for a capacity of about twenty, uses a piano during its services that stands prominently next to the altar.[8]

Despite all their artistic activity, churches differ significantly from secular venues. Churches are houses of worship, and worship is an end in itself, sometimes beautiful but not to be judged for its aesthetic value. People may learn to sing there, and their broader appreciation of art and music may be nurtured; however, the singing must be understood primarily as worship, not as artistic performance.[9] The arts may be present but may fall low on any scale of congregational priorities.

Consider, for instance, the responses of church members when asked if they would like their congregations to sponsor various activities—not limited to the arts. More than half of members would like their congregations to offer classes to help people deepen their prayer lives (Table 5.2). Over one third want more information about spiritual retreats, seminars, and conferences, and almost as many would like opportunities to examine the teachings of other world religions. In comparison, the percentage requesting arts activities was smaller. Three in ten respondents wanted their congregations to host art festivals, concerts, or poetry readings. About 25 percent said they would like worship services to feature contemporary music. Less than one fourth expressed a desire for discussion groups about music, art, or literature; sermons that included ideas from art or literature; or opportunities to explore spirituality through painting, sculpture, or dance.[10]

Table 5.2 Activities Desired in Congregations (percentage as reported by members)

	Evangelical	Mainline	Catholic	Total
Class to Deepen Prayer Life	63	56	41	53
Information about Retreats, Seminars	42	37	35	38
Examine Teachings of World Religions	24	40	34	32
Art Festivals, Concerts, Poetry Readings	22	34	35	30
Worship Service with Contemporary Music	26	32	24	27
Interest Group in Music, Art, Literature	16	28	29	24
Sermons with Ideas from Art, Literature	12	24	19	18
Spirituality through Painting, Sculpture, Dance	12	21	16	16
Number	295	227	273	795

Note: Data from Arts and Religion Survey question, "Would you like your congregation to sponsor any of these activities?"

Based on this evidence, it seems that church members are content with the outlets for art and music in their congregations. For instance, when asked to rate the music at their congregations on a five-point scale (from not satisfied to very satisfied), 78 percent of church members chose scores of 4 or 5.[11] This proportion was slightly higher than the number that rated sermons (76 percent) and fellowship (75 percent) similarly. Consider as well the results from church members who reported when during church services they felt close to God: 72 percent did so while listening to the sermon, and 71 percent while singing or listening to music. According to survey responses, church music also has powerful associations for church members. Of those polled, 57 percent recalled having favorite hymns or religious music when they were growing up—almost as many as those who had special Bibles belonging to them or their families (66 percent). In addition, 51 percent sang in a choir or ensemble at church in their youth—slightly more than sang in a choir or ensemble at school (49 percent).

Even the most faithful church members vary, of course, in whether they actually participate in or benefit from their congregations' musical and artistic activities. This issue was examined in the results of a ques-

tion included in the 1998 GSS. When asked, "Within the past 12 months, have you had any experiences with the arts at your place of worship ... activities like viewing performances or exhibits, singing in a choir, or playing an instrument?" about half of those who attended evangelical or mainline Protestant churches weekly or almost every week responded positively (52 and 51 percent, respectively), as did 29 percent of regularly attending Catholics. Among parishioners who attended less frequently, the totals ranged from 30 percent of mainline Protestants to 23 percent among evangelical Protestants to only 9 percent of Catholics.[12] On the one hand, these figures suggest caution about overestimating the role of the arts in congregations: Just because most congregations have choirs or some other form of art does not mean that churchgoers feel engaged with these activities. But on the other hand, the fact that there are 340,000 congregations in the United States attended by more than a quarter of the adult public every week means that exposure to music and art at church may be more significant for many people than the occasional visit to a museum.

A national study of congregations also indicates that the arts—or at least music—are part of most worship services.[13] Congregation leaders—usually pastors—answered a long sequence of questions about the kinds of activities that took place in their churches (Table 5.3). Almost all said congregational singing was integral to the main worship service each week. About three in four reported that services included singing by a choir and that 50 percent featured a soloist. In congregations that had musical instruments (nearly all), pianos or organs were present in about two thirds. About a quarter used drums or electric guitars. Evangelical churches were the least likely to have choirs or organs but were most likely to have soloists, pianos, drums, and electric guitars. Catholics resembled mainline Protestants in most comparisons but were more likely to use electric guitars and less likely to use pianos. At least once a year, services included dance and skits, both of which were mentioned significantly more often by leaders in this study than by lay members in the previous study. About three in ten pastors reported their buildings were sometimes used for musical or theatrical performances, and about one in nine said buildings were used for exhibits of paintings or sculptures.[14]

Table 5.3 Arts Activities of Congregations (Percentage as Reported by Leaders)

	Evangelical	Mainline	Catholic	Total
Included in Typical Worship Service				
Singing by the Congregation	99	99	98	98
Singing by a Choir	65	79	78	72
Singing by a Soloist	57	37	49	50
Piano	81	70	49	67
Organ	61	81	73	69
Drums	36	14	11	24
Electric Guitar	36	17	30	29
Included in Worship in Past Twelve Months				
Dance	25	30	30	29
Skit or Play	74	80	57	70
Building Ever Used for:				
Musical or Theatrical Works	18	43	33	29
Exhibits of Paintings, Sculpture	5	18	12	11
Number	473	311	356	1236

Notes: Data from National Congregations Survey question, "Was there ... at this [main worship] service?" Weighted by size of congregation.

Degrees of Separation

Although these studies demonstrate that religious organizations are venues for the arts, we need to remember that religious organizations are not primarily oriented to the arts, whereas arts organizations are. One kind of organization may supplement but cannot substitute for the other. This means, too, that religious groups and arts organizations attract different constituencies. Some of these discrepancies are evident in Table 5.4, which shows the proportion of weekly churchgoers compared with the proportion of gallery attendees who participated in artistic activities. In each instance, gallery attendees were significantly more likely than churchgoers to have participated in the arts. This is probably not surprising, but it does underscore the differences between the two constituencies. Gallery attendees also differ from regular churchgoers in other ways. For instance, nearly half (44 percent) had graduated from college, compared with only a quarter (27 percent) of churchgoers. Gallery attendees were also more likely to have grown up in homes where at least one parent was college educated (41 percent versus 25 percent). But when only the respondents who had at least some college training are compared, the differences between gallery attendees and churchgo-

ers are smaller in every instance. However, regular churchgoers include a larger number of African Americans and are more geographically dispersed.[15] In short, galleries—and many other formal expressions of the arts—draw a better-educated clientele, whereas religious organizations appeal to a broader cross-section of the public.

Spirituality and the Arts

Despite these differences, religious and arts constituencies have much in common. Unlike organizations that specialize in either religion or the arts, individuals often have interests in both: 89 percent of weekly churchgoers, for instance, had done at least one of the arts activities in Table 5.4, and 70 percent had done more than one. Deeply religious people do sometimes have misgivings about the arts, as this chapter considers. However, there is very little evidence to support the hypothesis that religion and the arts are mutually exclusive. Besides the fact that nearly all regular churchgoers participate in one or two artistic

Table 5.4 Comparison of Churchgoers and Gallery Attendees

	Churchgoers	Gallery Attenders	Difference	Adjusted Difference
Purchased Music on Tape or CD	66	86	20	12
Read a Novel	53	70	17	10
Read Poetry	37	66	29	12
Attended Live Concert of Opera	30	56	26	19
Purchased Painting, Sculpture, Craft Item	35	56	21	13
Made Art or Craft Objects	35	50	15	9
Went Dancing	24	44	20	15
Played Musical Instrument	22	36	14	8
Wrote Poetry	10	17	7	5
Number	(517)	(397)		

Source: Data from Arts and Religion Survey question, "Please tell me if you have done each one within the past 12 months." Churchgoers = attend services weekly. Gallery attendees = attended an art museum or gallery in past twelve months. Adjusted difference = respondents with some college or college degrees only.

activities a year, they also explicitly attest that they value the arts. Of the weekly churchgoers surveyed, 82 percent said the arts were at least fairly important when asked, "If we think of the arts as including painting, sculpture, music of all kinds, dance, theater, and creative literature, how important would you say the arts are to you in your life?" This percentage was slightly higher (by three percentage points) than among people who attended religious services less frequently.[16] Among regular churchgoers, 44 percent also said they sometimes go with church friends to plays, galleries, or concerts, and 28 percent said some of their fellow church members work as artists, musicians, or writers. These responses mean that religious participation, as has been suggested for volunteering and community involvement, sometimes serves as a form of social capital through which people meet artists or participate in arts events. Indeed, a principal conclusion is that there is considerable overlap between the American public's interest in religion or spirituality and its interest in the arts.

This overlap has probably become more significant in recent years as a result of several significant changes in American culture. Religion has increasingly become part of what Wade Clark Roof (1999) termed a *spiritual marketplace* where people seek information and ideas from a widening range of sources—not only congregations or religious leaders but also television, music, books, and independent spiritual entrepreneurs. A person may find as much, or more, spiritual inspiration from a rock band or popular writer, for instance, as from a member of the clergy. Whereas the choice was once to be religious or not, it is now increasingly common to hear people say they are "spiritual, but not religious." Of course, the majority who are deeply interested in spirituality are still involved in organized religion. Yet evidence suggests that religious authority is rooted more in personal experience rather than in church doctrines. Moreover, personal experience often centers on the emotional and the intuitive, and efforts to deepen spirituality emphasize intentionality and practice. These emphases reveal a growing affinity between current understandings of spirituality and the role played by music and the arts as a form of introspection and personal expression. At the same time, a democratization of the arts has occurred, widening public exposure to the arts through school programs, encouraging greater public involvement in community arts activities, and blurring the line between beaux arts and popular expressions such as folk art, ethnic

art, indigenous art, and crafts. If religion and art can be conceived as distinct institutions, then a kind of cultural blending of the two can be imagined through which individuals seek meaning and transcendence.

There are several indications that spirituality and the arts actually reinforce each other. One indication of intersection is that adults who express the most serious interest in spirituality are also the most likely to have been exposed to the arts while they were growing up (Table 5.5). In qualitative interviews, people recall that childhood interests in the arts sometimes posed questions they later came to associate with spirituality; in other cases, religion and art were intertwined from the beginning, and for some an early crisis of faith led them to seek spirituality through the arts. Another indication is that people who say spirituality is extremely important in their lives are the most likely to have engaged in artistic activities within the past year, such as reading or writing poetry, purchasing a painting or sculpture, making art objects, or visiting an art museum. Moreover, people who are most interested in spirituality are the most likely to say they have felt uplifted listening to music or viewing a work of art and consider music and literature as essential to their spiritual lives. In short, large segments of the public not only view the arts through an aesthetic lens but also associate the arts with a personal quest for meaning, purpose, and transcendence. Responses to these questions vary according to education, age, gender, and other factors, yet detailed analysis of the data shows that the relationships between interest in spirituality and the arts remain statistically significant.[17]

Some additional data in the Arts and Religion Survey help in interpreting what might be regarded as the spiritual functions of the arts. An earlier discussion showed that a sizable proportion of the church-going public feels close to God when listening to music during a worship service. The proportion who feels close to God when encountering the arts in other settings is much smaller, but it does represent a fraction of the public. For instance, 22 percent responded they have felt close to God when looking at a painting or sculpture, 17 percent while attending a concert, and 13 percent while reading poetry. Among those most interested in spirituality, the numbers are higher, ranging around 30 to 35 percent. The data also show that the arts play a special role for many people during times of illness, loneliness, or grief. Among the 85 percent who said they had experienced such difficulties, 70 percent said they

Table 5.5 Artistic Interests and Involvement by Interest in Spirituality

		Interest in Spirituality		
	High	Medium High	Medium Low	Low
Percentage Involved in Each While Growing Up:				
Performed in a School Play	64	55	51	45
Learned to Play a Musical Instrument	54	51	45	44
Sang in a Choir or Ensemble at Church	54	48	38	26
Sang in a Choir or Ensemble at School	53	50	44	34
Took Art Classes	48	45	46	40
Kept a Personal Diary or Wrote Poetry	48	40	35	22
Played in the Band or Orchestra	38	26	25	22
At Least Three of the Above	66	58	55	39
At Least Three Not Counting Church	61	51	48	35
Selected Activities within the Past Year:				
Read Poetry	44	30	23	17
Purchased a Painting or Sculpture	40	39	31	21
Made Art or Craft Objects	36	36	32	22
Visited an Art Museum or Gallery	30	28	24	19
Wrote Poetry	16	9	7	5
Felt Especially Uplifted:				
Listening to Music	76	70	57	62
Viewing a Work of Art	32	27	21	19
Strongly Agree:				
Art helps us experience meaning in life.	44	36	24	24
Art can help people deepen their spirituality.	60	61	55	45
Very Important Personally in Spiritual Growth:				
Music	47	31	16	12
Playing a Musical Instrument	31	14	5	6
Reading Literature or Poetry	23	12	5	3
Number	428	424	359	295

Note: Data from Arts and Religion Survey question about interest in spirituality: "Importance as an adult to grow in your spiritual life (extremely important = high; very important = medium high; fairly important = medium low; not very important or not at all important = low)."

had found music therapeutic, 67 percent turned to craft projects (e.g., woodworking, painting), and 43 percent had been helped by literature or poetry. Finally, the arts are integral to private devotional activities. Of those who pray or meditate, 38 percent reported that they sometimes listen to music or sing as they do so—larger than the proportion who read the Bible (34 percent) or a devotional guide (26 percent).

Mutual Misgivings

None of this evidence is likely to impress readers who think of the arts as cultured and religion as symptomatic of simplemindedness. There is a long history of mutual disdain, with religious leaders criticizing artists and artists taking offense. These tensions may have been muted by some of the changes noted here, but they have not disappeared. In the general public negative views of the arts vary considerably, depending on the particular issue at hand. For instance, about half of the public (49 percent) agrees that most artists nowadays will do anything to make money. The same number also believes that most music on the radio is harmful to young people. Similar proportions (56 percent) have heard a song or seen a movie preview in the past year that disgusted them. A smaller percentage of the public thinks artists are engaged in immoral or sacrilegious behavior. Twenty percent say most of the art one sees in galleries and museums dishonors God, and 16 percent agree that contemporary artists are destroying the moral fabric of our society.

Religion informs all of these opinions. People affiliated with evangelical churches are more likely than mainline Protestants or Catholics to hold these views, and people with no religious affiliations are less likely to hold them than people with religious affiliations (Table 5.6). Not all evangelicals hold negative views of artists, and some of their opinions are shared by some mainline Protestants and Catholics. Thus, it would be wrong to conclude that there is a culture war, as some have dubbed it, with orthodox believers on the one side and secular artists and other cultural leaders on the other. Nevertheless, it is important to note that one quarter of evangelicals have heard a sermon in the past year about the dangers of contemporary art or music. A majority also believe that churches should promote only Christian art or music.

Table 5.6 Attitudes by Personal Religious Orientation

| | Religious Orientation | | | |
	Evangelical	Mainline	Catholic	Nonreligious
Percentage Who Agree:				
Most artists nowadays will do anything to make money.	60	46	46	48
Most of the art one sees in galleries dishonors God.	33	19	19	13
Most music on the radio is harmful to young people.	64	50	50	40
Religious leaders should speak against contemporary art.	24	13	18	11
Contemporary artists are destroying the moral fabric.	24	13	18	8
Churches should only promote Christian art or music.	60	38	34	18
In Past Twelve Months Have You:				
Heard a song that disgusted you?	69	63	55	39
Seen a movie preview that disgusted you?	64	57	48	36
Seen a work of art that disgusted you?	31	25	21	18
Heard a sermon about dangers of contemporary art or music?	26	10	11	4
Number	205	199	273	246

Note: Data from Arts and Religion Survey regarding religious orientation based on denominational preference.

The issue of music, though, is better understood as a conflict between generations than as a struggle between religion and the arts. Simply put, young people are much more likely to enjoy contemporary rock and pop music than older people are, and older people are more likely to prefer classical, Christian, and gospel music than younger people are (Table 5.7).[18] If only those who like Christian music are considered, then

Table 5.7 Musical Tastes by Age Groups (Percentage Who Especially Like Each)

	Age Groups				
	21-29	30-39	40-45	46-64	65-97
All Respondents:					
Contemporary Rock and Pop	78	75	69	54	19
Country and Western	37	44	38	54	60
Jazz	34	40	44	37	25
Christian Music	16	24	33	41	43
Classical	35	38	44	47	43
Gospel	13	21	35	44	51
Only Those Who Like Christian Music:					
Contemporary Rock and Pop	76	67	58	48	16
Number	231	300	210	387	316

Note: Data from Arts and Religion Survey.

most of the younger people in this group also like contemporary rock and pop music, whereas even fewer of the older people do. Younger people are, in this sense, musical omnivores.

Implications

By most indications the likelihood of a continuing convergence between religion and the arts is high. The occasional controversy over Andres Serrano or Robert Mapplethorpe exhibitions notwithstanding, arts leaders and religious leaders generally regard one another as allies rather than as opponents. Churches and synagogues are sponsoring artists in residence and are making space available for performances. Having a top-flight music director, organist, and choir and sponsoring a monthly chamber orchestra concert and annual film festival is simply de rigueur. Younger people are more likely than their parents and grandparents to have gained exposure to the arts at school or through private lessons, and contemporary worship services increasingly incorporate music and the visual arts in the hopes of appealing to youthful tastes. In surveys, a large minority of the public claims their interest in spirituality is growing, and this interest, as we have seen, often coincides closely with seeking inspiration from the arts.

Whether the United States is on the cusp of a major spiritual or artistic revolution is more doubtful. Participation in organized religion has remained steady, but not grown, in recent decades, and projections about a deepening quest for spirituality are largely speculative. What seems more certain is that the capacity of religious organizations to produce art and music is both strong and potentially innovative. The establishment and popularity of the Maranatha music label, for instance, were in large measure indebted to Calvary Chapel Costa Mesa, one of the largest congregations in the United States.[19] As hundreds of Calvary Chapel offshoots have appeared, these congregations download lyrics and guitar chords for use on overhead projectors at their own services. Another example is Rick Warren's (2002) bestselling book, *The Purpose-Driven Life,* which was promoted initially through Warren's preaching at the Saddleback megachurch and word of mouth among its thousands of members. Similarly, *The Passion of the Christ* film and the *Left Behind* (Tyndale House Publishing) book series gained large followings among churchgoers.

The fact that religious organizations and religious individuals support the arts should not be interpreted as evidence that faith-based initiatives should somehow replace government funding for the arts—as has been suggested in the case of social welfare programs. Religious congregations are already hard pressed to carry out their main activities. Clergy work weeks are among the longest of any occupation. Church coffers have been diminished by scandals and by fewer young adults giving as generously as previous generations did. Some church leaders, in fact, privately express concern that philanthropic giving is being redirected away from churches toward colleges and universities, arts organizations, and political causes with more innovative fund-raising methods. Similar to campuses, however, congregations often have underused facilities that could be devoted to the arts as well as social networks to promote events.[20]

The research points most clearly to the need for better understanding between leaders of arts and religious organizations. The story of modernization told by social scientists perpetuated the notion that religion was a thing of the past, the kind of superstition one learned as a child but needed to abandon in adulthood. It suggested that art was a more worthy enterprise, expressing the highest in human possibility without bending to the false hopes purveyed by religion. But the early

results of research into the relationships between religion and the arts reveal that these normative assumptions must be set aside long enough to recognize that religion and the arts for most Americans are not mutually exclusive. The United States remains a society in which people—for many different reasons—retain an interest in spirituality and religion, and it may even be the case that religion has contributed to the flourishing of the arts.

Bibliography

American Assembly. 2004. "The Creative Campus: the Training, Sustaining, and Presenting of the Performing Arts in American Higher Education. Columbia University, New York. http://www.americanassembly.org/programs.dir/report_file.dir/CCAMPUS_report_report_file_C_Campus.pdf.pdf.

Arthurs, Alberta, and Glenn Wallach (Eds.). 2001. *Crossroads: Art and Religion in American Life*. New York: New Press.

Brown, Melissa S. (Ed.). 2004. "Giving USA 2004: The Annual Report on Philanthropy for the Year 2003." Giving USA Foundation. http://www.aafrc.org.

Chaves, Mark. 2004. *Congregations in America*. Cambridge, MA: Harvard University Press.

Chorus America. 2003. "America's Performing Art: A Study of Choruses, Choral Singers, and Their Impact." http://chorusamerica.org/files/chorstudy.pdf.

Davis, James A., Tom W. Smith, and Peter V. Marsden. 2002. "General Social Survey 2000." NORC ed. 2002. Chicago: National Opinion Research Center [producer]; Storrs, CT: The Roper Center for Public Opinion Research, University of Connecticut [distributor]. http://www.cpanda.org/data/a00032/a00032.html.

Gottlieb, Jennifer (Ed.). 2001. *The Arts, Religion, and Common Ground*. Washington, DC: Americans for the Arts Monographs.

Lewis, Gregory B., and Arthur C. Brooks. 2005. "A Question of Morality: Artists' Values and Public Funding for the Arts." *Public Administration Review* 65: 8–17.

Roof, Wade C. 1999. *Spiritual Marketplace: Baby Boomers and the Remaking of American Religion*. Princeton, NJ: Princeton University Press.

Warren, Rick. 2002. *The Purpose-Driven Life: What on Earth Am I Here For?* Grand Rapids, MI: Zondervan Publishing.

Wuthnow, Robert. 2001. *Creative Spirituality: The Way of the Artist*. Berkeley: University of California Press.

_____. 2003a. *All in Sync: How Music and Art are Revitalizing American Religion*. Berkeley: University of California Press.

_____. 2003b. "Art for the Soul." *Christian Century* 120: 24–29.

Endnotes

1. The estimate of total annual visits to places of worship is for adults only and is based on reports of religious attendance in the 2000 GSS, appropriately deflated to take account of possible overreporting in surveys; the estimates of performing arts organizations and visits to arts activities are from http://www.cpanda.org.
2. Brown (2004).
3. Lewis and Brooks (2005, pp. 8–17). These authors intended to show that artists are not as religious as the general public; yet their evidence belies the claim, as my analysis of the same source shows.
4. Wuthnow (2001, 2003a); see also Wuthnow (2003b) and several of the essays in Arthurs and Wallach (2001) and Gottlieb (2001).
5. Jews, other non-Christian congregations, and members who did not indicate their denominations are excluded from these comparisons because there were too few cases to provide meaningful percentages.
6. I ran logistic regression models for each of the items shown in the table, taking account of the religious tradition of the congregation and the race, gender, age, and education level of the respondent. Net of these effects, the odds-ratios of saying that one's congregation sponsored each activity were generally about twice as great among those who attended services at least once a month as for respondents who attended less often. The odds-ratios were also consistently significant and higher for respondents who attended larger congregations.
7. Producer Lesa Paulsen, Prairie Fire Films, not yet released. Further information about the film is available at http://www.zeniththemovie.org.
8. Example courtesy of Omaha photographer Sue Lawler.
9. On the broader impact of choral singing, see Chorus America (2003). This study showed that 76 percent of choral singers belong to a church or synagogue and that 73 percent regularly attend religious services. Curiously, the study did not examine whether the singers did their singing at a religious organization nor did it control for religious participation in reporting other alleged social benefits of choral singing.
10. The results of logistic regression analysis—with the same variables included as previously noted—indicate that older people and members of evangelical denominations are less likely than younger people and nonevangelicals to favor their congregations having arts festivals and concerts; better educated members and nonevangelicals are most likely to favor discussion groups concerned with the arts; and younger people who are better educated and attend frequently are most likely to favor worship services with contemporary music. These activities are also favored more by members of large congregations than by members of smaller ones.
11. The percentages were 86 for evangelicals, 81 for mainline Protestants, and 67 for Catholics.

12. This question was asked only to a subsample of respondents in the GSS and thus included too few black Protestants, Jews, and people of other faiths for meaningful percentages.

13. The National Congregations study was designed by Mark Chaves (2004) and conducted in 1998 by the National Opinion Research Center at the University of Chicago in conjunction with the GSS; churchgoers in the survey were asked to identify the particular congregation they attended, and then follow-up interviews were conducted with the pastors at those congregations; data are available online from the American Religion Data Archive (http://www.thearda.com).

14. Too few African American and non-Christian congregations were included in the survey to yield reliable percentages. Other than the differences between evangelicals and mainline Protestants and between Protestants and Catholics, the main differences in the presence of these activities were between larger congregations and smaller congregations.

15. Of weekly churchgoers, 14 percent were African American, compared with 8 percent of gallery attendees (Hispanics and Asian Americans did not differ between the two); 47 percent of gallery attendees lived on the East or West coast, compared with 39 percent of churchgoers.

16. Nor was there any evidence that people who never attend religious services value the arts more than those who attend every week (76 percent of never attendees said the arts were fairly important; only 16 percent said the arts were extremely important to them, compared with 21 percent among weekly church attendees).

17. Wuthnow (2003a, see especially the appendix).

18. The age categories in Table 5.7 are ones I developed for use in testing other hypotheses about cohort differences in religious attitudes and behavior. Respondents ages forty-six through sixty-four correspond roughly to the boomer generation; those older are sometimes called builders, and the three younger categories permit comparisons among younger adults. Respondents eighteen through twenty are excluded here; accurately reflecting this age group is difficult because of variations in residential patterns among college students and among young adults living with their parents.

19. For further information see http://www.maranathamusic.com.

20. See, for instance, American Assembly (2004).

6 Immigrant Arts Participation

A Pilot Study of Nashville Artists

Jennifer C. Lena and Daniel B. Cornfield

This chapter examines arts participation and audience composition for immigrant arts and speculates on the future of both in the United States. This pilot study draws on in-depth interviews with four artists located in Nashville, Tennessee, a rapidly globalizing interior city. From these interviews and supporting survey data and archival research, strategies are explored by which immigrant artists and their communities engage with one another. These strategies represent the motivations and relationships artists have with their art and communities as well as the tensions and dynamics of art that intends to appeal both to coethnics and native-born Americans. The strategies presented here lead us to project three potential pathways for immigrant art participation in the future and to identify what we believe are the primary factors influencing these pathways.

Immigrants are growing as a demographic group. The percentage of U.S. residents who were foreign born increased from 4.7 percent to 12.0 percent between 1970 and 2004 (U.S. Census Bureau 2003, 2004). These new American residents have distinctive cultural traditions and artistic

practices. Percolating throughout America—in temples, mosques, and churches, in community centers and schools, in private homes, on local access television and low-frequency radio—are forms of dance and music, culturally specific media and broadcasts, and styles of visual art, book making, and jewelry, among others. Like American-born artists, immigrant artists often earn their primary income from nonartistic occupations, primarily in the service sector. Unlike native-born artists, immigrants have little access to institutional and foundation support. They may be extremely talented artists—professionals in their home countries but working in the United States as committed amateurs. To practice their art and to pass along their artistic and cultural heritage to a new generation and to a broader audience, these artists act as leaders and brokers in their communities, using social networks to secure the resources—often quite meager—to keep their artistic passions alive.

Arts participation has both instrumental and intrinsic value for both immigrants and native-born Americans. Participation may be viewed as intrinsically valuable by participants, analogous to religious practice. It has instrumental benefits as well. Individuals may view arts participation as a way to promote physical or mental health or as a venue or mechanism for producing or affirming social and economic relationships. Art can function as the public face of an immigrant group, and if artistic participation is open to native-born Americans, it may function as an introduction to another cultural tradition. Arts participation, particularly in language classes and traditional dance styles, may be seen as a tool to maintain cultural traditions and thus may be viewed as both an intrinsically and instrumentally valuable practice. In fact, the boundary between the two is often fuzzy at best.

The city of Nashville affords the opportunity to discover how immigrant artistic expression reflects, reproduces, and caters to a range of emerging intergroup relations and identities. Nashville is emblematic of the recent and rapid immigration into the new destination communities and gateways of the interior region of the nation (Farris 2005). During the 1990s the number of foreign-born residents tripled, raising the percentage to 10 percent, the average for all U.S. cities (Cornfield et al. 2003). A wide socioeconomic range of immigrants and political refugees are attracted to Nashville because of its robust service economy and moderate cost of living. Some 60 percent of Nashville's foreign born are low-wage economic migrants from Mexico and Central America,

and the other 40 percent are professionals, businesspeople, and manual laborers from Africa, Eastern Europe, the Middle East, and South and East Asia, including the largest Kurdish community outside of Kurdistan (Cornfield et al. 2003; Farris 2005). This chapter explores the context of immigrant experiences to learn more about immigrant arts participation and its reach to a broader public. It is impossible to understand or predict changes in how Americans engage with art and culture without taking account of the experience of our newest arrivals.

Interviews

This study employed a qualitative, interview-based approach for generating hypotheses and categories of analysis for future scientists working in these fields. The purposive and snowball-generated sample consisted of a Somali visual artist, a Kurdish musician, a Korean dance instructor, and an Indian dance instructor.[1]

The focus of the study is on established artists who have started or run organizations. Their professional identity provides them with a framework for understanding the field of arts participation and sense-making concepts that can form the foundation for later empirical work on immigrant arts communities, including nonprofessionals. These professionals also have a community-wide perspective on the evolution of interethnic and immigrant native-born relations.

Using semistructured interviews respondents were asked to describe their artistic work, the nature of their collaborations, and the reception of their work among both coethnics and native-born audiences. Inquiries were made into the constraints and opportunities for arts participation—both for professionals and audience members.

As the subjects describe their personal and professional experiences with immigration and the context for arts creation and reception in Nashville, it can help in beginning to understand participation in immigrant arts among Nashvillians. This pilot study is necessarily both inductive and speculative. The expectation of this work is to open avenues for research by addressing arts participation in an exceptional context that is likely emblematic of the future of immigration in America. The intention is to open a conversation among public policy scholars, community groups, activists, and sociologists of culture and immigration.

Context of Reception: Art and Community

The context of assimilation—the hospitality of the native-born community—impacts the characteristics of immigrant arts, just as they affect the entire immigration experience. Alejandro Portes and Rubén Rumbaut (2006) offered the concept of *modes of incorporation* to capture the dynamics influencing immigrants in their transition to a new context. Modes of incorporation are affected by the policies of the host government (i.e., receptive, indifferent, or hostile); characteristics of the coethnic community; and forms of social reception faced by immigrants (see Portes and Rumbaut 2006). The last of these, social reception, can range in quality from prejudice to tolerance to celebration. Prejudice and discrimination within the host community lead to the isolation of immigrant communities and their arts. In contrast, an ethos of diversity and assimilationism contribute to a celebration of ethnic and artistic diversity.

Research on immigrant, folk, or informal arts in Silicon Valley and Chicago suggests that the context of assimilation impacts the immigrant arts community in specific ways. In Chicago the arts were a hidden social asset, whereas they were publicly celebrated in California. This result may be attributed to the longer and more tension-filled history of ethnicity in Chicago and its domination by larger groups of whites and blacks, whereas the California groups are smaller and there are many more of them (Moriarty 2004, p. 53). In addition, researchers have found that Chicago immigrant arts communities were not integrated across ethnic and racial boundaries despite the fact that they bridged social capital across occupational, age, and gender groups. In contrast, in Silicon Valley, over half of the groups "operate inter-ethnically to various degrees, although their core members may belong primarily to one ethnic-language group" (ibid.).

The four immigrant ethnic communities examined here—Somali, Kurdish, Southeast Asian Indian, and Korean—have experienced distinct pathways of incorporation, and these appear to correlate with four distinctive approaches these artists have taken in their engagement with audiences. The following four sections examine this correlation by reviewing how artists perceive and serve both immigrant and native-born American audience members. A range of responses is found—from an exclusive emphasis on traditional practices to the hybridization of traditional

practices with alternative artistic traditions. Through these differences insight is gained into the characteristics of the immigrant experience and the host community that affect immigrant arts participation.

Somali Immigrants and Participatory Arts

Of the four immigrant ethnic communities discussed here, the Somali community has experienced the most hostile local reception and has had the more tenuous incorporation into Nashville society. According to the 2000 census analysis cited in the final report of the 2002–2003 Immigrant Community Assessment of Nashville (ICA), the Somalis are the most residentially segregated of all immigrant ethnic groups in Nashville. Furthermore, the ICA immigrant focus group discussions indicate that Somalis are often geographically and linguistically isolated from human services, are culturally excluded in schools and workplaces, and are unemployed or underemployed in the secondary labor market, compared with the business and professional positions they held in Somalia (Cornfield et al. 2003).

The difficult incorporation of Somalis into the Nashville community is reflected in the social and artistic strategies used by our respondent in his role as a cultural broker. The Somali visual artist interviewed for this study fled his homeland in the wake of the United Nations withdrawal of troops in the early 1990s and since that time has devoted himself to teaching both coethnics and native-born Americans about Somali culture. He explained that the educational television show he helps to produce has the purpose of depicting the Somali experience in the United States and of "show[ing] off our culture to the general population of Nashville." He also works on a talk show in the Somali language that he views as an opportunity to instruct coethnics on "how to survive in the United States; how to respect the cultures of the others while you have your own culture." However, he has faced opposition from the estimated 10 percent of Nashville's Somali population who harbor traditional Sunni Islamic values. These values require a more traditional frontal appearance for women. He explains, "For example, if I put on the TV women that have hair … they always tell me, 'Why you do that?'; it's against their tradition …. That's the only challenge I face." Although this respondent's desire to increase understanding and

tolerance leads him to translate and accommodate Somali cultural practices to attract a native-born audience, this accommodation to outsiders alienates him from some traditional members of his own community.

Similarly, he has chosen to emphasize Somali pop music in the television broadcasts to reach out to younger Somalis and to native-born audiences. Although this may be seen by some readers and older members of the Nashville Somali community as uncompromising assimilation, this respondent noted that the emphasis on Somali pop is temporary and that once he identifies a source of funding, he will seek to portray folk music on his television program. This will bring him into alignment with what he described as the older generation's desire to preserve traditional Somali folk culture "because it's what they grew up with, and they understand the words more than the new generation." Thus, the generational divide, originally attributed to musical assimilation, takes on a broader significance as a consequence of diminished language acquisition over the immigrant generations and a consequent loss of interpretative muscle.

The Somali respondent works as a cultural broker, or emergent leader, using his skill to navigate American bureaucracy, to translate linguistic and cultural material, and to sustain the interest of his audiences while also nurturing tradition. However, balancing the needs and tastes of these constituencies is not an easy task. It is hypothesized here that the Somali visual artist represents a distinctive pathway for immigrant arts: As a member of the group with the least warm reception, he uses a medium and message designed both to promote intragroup cohesion and cultural retention, while he seeks to make this culture interpretable to outsiders. Simultaneously, he endures resistance from the most traditional members of his immigrant community.

Kurdish Immigrants and Participatory Arts

According to the ICA, the Nashville Kurdish community has experienced similar problems as those of Somalis. Although the U.S. Census does not collect data for individuals of Kurdish ancestry, the ICA analysis of individuals from the Middle East region implies that Kurdish residents are almost half as residentially segregated from native-born

Americans and other immigrant groups as Somalis in Nashville (Cornfield et al. 2003).

The less-hostile reception of Kurdish immigrants is reflected in the study respondent's openness to cultural exchange with noncoethinics. The Kurdish musician was a political refugee from Iraq, fleeing repression by the Hussein government. The Kurdish musician noted that since his immigration to the United States, he has sought to fuse traditional Kurdish music—and Arabic beat patterns—with American popular music: "I made some beats myself; what I did is put Middle Eastern music to it. Like the beat would be American, but the Middle Eastern music would be in it." His acculturation to, and acceptance in, American culture is reflected in this respondent's desire to blend traditional Middle Eastern music and so-called American beats. The acceptance of his music—both in traditional and hybridized form—is evidenced in a short description he provides of his friendships with coworkers at the book plant: "I've got two friends at my work, they want to meet up with me and sit down and they want to know more about how the Kurdish music works and what kind of music I play." These coworkers are interested in the music itself and in adapting its elements to their own musical performances—of more mainstream, or American, music. The Kurdish musician noted the reciprocity of these relationships with native-born artists: They help him with recording technology, while he adds aesthetic value to the relationship. This artist is able to offer performances that draw on traditional elements and to fuse them with alternative cultural traditions.

Korean Immigrants and Participatory Arts

In contrast to both the Somali and Kurdish communities, the Korean community is highly integrated into local society. According to the 2000 census, approximately 900 of the residents in this community are Korea-born immigrants, 90 percent of whom are women. Two thirds of these women arrived in the United States between 1975 and 1989. The census does not indicate how many of these women are married to American career-military husbands, but this study's interview with the Korean dance instructor suggests that this is very common.

Perhaps ironically, the high integration of these Korean women into local society is reflected in the presentation of traditional Korean arts to the exclusion of any hybrid forms, as is demonstrated in the Korean dance instructor's experience. Most of the clients at the dance academy she owns are adult, female, immigrant Korean women brought to middle Tennessee by their husbands' careers in the military and the children of these unions. The Korean dance instructor noted the importance of her performances and classes as a mechanism to teach and preserve customs. In particular, she noted the importance of her lessons as a means for mixed-parentage children to learn about and identify with their Korean heritage: "Not many Korean people here, [and most have] mixed-marriage children. They love it [the dancing]. Also Korean people look at them They're not full Korean, but they learn about Korean They love Korean dance." Clearly, the strain between full Koreans and those with mixed parentage is addressed, in this respondent's mind, through a mutual appreciation of traditional culture. This is encouraged through participation in the arts.

Though the Korean dance classes are held privately and the respondent does not mention any regular public performances for her students, professional dancers do perform for holiday celebrations or when hosting a traveling group of artists. These audiences are likely to include non-Koreans, particularly city or government officials. Like the Indian dance instructor (see following section), the Korean dance instructor has participated in outreach programs hosted by local public schools. A Korean American association sends her to these schools to teach traditional Korean dance. In fact, her comments suggest that she perceives hostility or simply a disinterest in anything other than traditional dance. She explained new, even culturally hybridized, pieces are greatly valued in her native Korea, but "here in the USA they don't understand that dance, so here we do only traditional dance." In response to a lack of comprehension on the part of native-born audiences, this respondent noted a retrenchment in traditional forms rather than the hybridization practiced and celebrated by the Kurdish and Somali respondents. Perhaps this is a consequence of high local integration in combination with the strain of exogamy, one that is notably absent in the testimonies of the Kurdish and Somali respondents.

Indian Immigrants and Participatory Arts

Individuals of Indian ancestry in Nashville constitute a middle-class community. According to the Census Bureau's American FactFinder profile for Nashville, there were 2,607 Nashville residents of Indian ancestry in 2000. Of these residents, roughly three fourths were foreign born; 45 percent had at least a bachelor's degree (compared with 30 percent for all Nashvillians), and the median value of their family incomes exceeded that of Nashvillians by 23 percent. Born to Anglo-American parents in Asia, the Indian dance instructor interviewed for this study teaches classes in Indian dance at a private studio and a local university. She also regularly gives lectures and performances at a variety of multicultural events, at a large Hindu temple, and in public schools around the Nashville area. Most of the students in the Indian dance instructor's classes are second-generation Indian students, although she does have a few first-generation young women who learned dance in India but find themselves at a local university pursuing a degree. She noted that her classes provide second-generation Indian students with "an avenue for understanding their culture and their religion, and this is a very easy way to get kids to know something about traditional Indian culture and Hinduism." Native born students are attracted to these classes as well, often because they are "neighbors and best friends of the Indian kids, and they look at it and think it's cool, and they start to learn."

However, not all Indian students embrace the art form as a way to be both connected to their Indian heritage and to be attractively distinct from their peers (from different backgrounds): "I have some students who resist ... performing outside the Indian community And so we talk about it I view [these conversations] as a way to help them come to terms with this double identity that they have. Their home life is very Indian because most of their parents have an accent and they have Indian food at home and Indian values and way of living. And then they go to school and they're Americans. Some of them do go through a difficult process trying to adjust with these two identities, and I think that the dance form helps."

Like the Korean children, these Indian dancers experience a strain between traditional values and the American culture in which they seek membership. Unlike the Kurdish and Somali children, the relatively high integration of these immigrant groups into the local context, and

the friendliness of that context to their cultural traditions, may encourage generational tensions over assimilation.

This study's examination of how the context of reception influences participation in immigrant arts has served to offer some emblematic ways immigrant artists engage with their art form and their community. These patterns suggest that audience diversity and artistic links to native-born communities are associated with the incorporation challenges facing immigrant groups. Immigrant artists of highly integrated ethnic communities express their artwork primarily in an effort to preserve homeland culture and intraethnic ties, or bonding social capital (Putnam 2000, p. 22; Rumbaut and Portes 2001). Immigrants of less integrated ethnic communities express their artwork for broader audiences, not only helping their own community to bond but also building bridges with other communities to promote awareness, tolerance, sensitivity, and support within the general community for their ethnic community.

Future of Immigrant Arts Participation in the United States

Given the importance of immigrant arts for both immigrant and native-born communities, what does the future hold for immigrant arts in the United States? What impact will demographic changes bring as technology and economic circumstances provide more opportunities for niche markets? As elite, native-born audiences develop more cosmopolitan tastes? As boundaries between art forms break down? Will these artistic forms become more or less widely embraced? Will they remain marginalized, or will they have a broader influence on the cultural life of America? This section examines several possible—even probable—scenarios.

First, it is possible that immigrant arts will remain basically invisible for most Americans, while such art forms continue to animate immigrant communities and neighborhoods. From the aforementioned cases, it is clear that immigrant arts are at the heart of the incorporation process. Arts participation is often the locus of ethnic and American identity reformulation. As parents and children struggle to maintain cultural traditions or to assimilate into their new home, arts are likely to become the focus of attention. Immigrants commonly experience

cultural dislocation or culture shock, and their experience of loss typically results in an intensified investment in culturally specific groups, symbols, and activities (Moriarty 2004, p. 13). This investment is likely made in practices communally identified with tradition and is articulated against the diluting consequences of culturally hybridized forms of art and artistic participation. Resistance to cultural hybridization also comes from a wariness of commercial, or Westernized, culture. There is a common perception that "traditional arts ... serve as a powerful means for the preservation of cultural autonomy against the accelerating homogenization of culture" (Peterson 1996, p. 51). All respondents of the study spoke to this concern within their communities, although each reacted differently to this perception of a threat. The Kurdish respondent rejected the opposition of tradition and innovation in his fusion of Kurdish and American pop music, whereas the Korean dance instructor grieved over the loss of innovation and new compositions in her performances. The Somali justified a focus on hybrid pop music and less traditional female appearance by identifying hybridization as a pathway to tradition, and the Indian dance instructor described traditional practice as a counterbalance to other, strong forces drawing second-generation children toward American culture. In these differing responses, the dynamic impact of the context of assimilation on particular immigrant groups can be seen. This dynamism is demonstrated to produce particular modes of incorporation in general, but particularly in the immigrant artist's perception of the balance and value of traditionalism and hybridization.

Immigrant arts have, and will likely continue to face, diminishing coethinic audiences as second- and third-generation immigrants assimilate to American culture and lose interest or involvement in ethnically specific cultural practices. Immigration scholars find that one primary anxiety in immigrant families is the cultural tension surrounding assimilation, particularly that between new immigrant parents and their Americanized, or second-generation, children (Cornfield et al. 2003; Rumbaut and Portes 2001; Singer 2004). The emphasis placed on the importance of the education of children in traditional cultural practices was evident in each respondent's testimony.

If traditional practices and the education of coethinics is emphasized and the expansion of arts participation to native-born audiences is deemphasized or made difficult, then this outcome is likely. Immigrant arts

will remain largely invisible for most Americans and will continue to remain at the heart of immigrant identity and community life. As immigrants' children assimilate into the larger community, this may drain audience members for immigrant arts. However, narratives of identity may slow diminishing audience size, and new digital technologies like podcasts, low-frequency radio, and blogs may animate immigrant arts. These media may allow many immigrants—particularly those with middle-class lifestyles and access to advanced digital technologies—to develop virtual affinity groups with coethinics across the globe. These affinity groups may allow them to create a large enough audience to sustain art forms. Differential access to technology will impact the spread of these art forms to spatially dispersed coethinics and noncoethinics.

Particularly given the projected increase of immigrant and minority cohorts in the United States in the coming years and the increasing ubiquity and low cost of digital recording and performance technologies, it is possible that audiences for immigrant arts will attract the sponsorship of mainstream media outlets. The arts industry may then cater to their specific cultural needs and preferences. This has two potential outcomes.

First, corporate and nonprofit mainstream arts organizations may engage in market segmentation, leading to the ghettoization of immigrant arts, artists, and audiences. Davila (2001) and Porter (2003) noted this phenomenon in the Spanish-language entertainment industry. Second, the commodification of immigrant arts could lead to hybridization with mainstream, or popular, art forms, which in turn promotes the exposure of these art forms to new audiences. We might look to the recent popularity of reggaeton, a type of Puerto Rican dance music that sounds like a cross between techno and ska music and has become popular in Los Angeles (Caramanica 2005). This study produced evidence of the influence of cultural hybridization on artists in the two least warmly received immigrant communities: the Kurds and Somalis.

These pathways are arrayed on a spectrum with respect to the likelihood that immigrant arts will impact native-born audiences. The confinement of immigrant arts to immigrant communities—even if they are spatially dispersed—represents a future in which the art form serves mainly to reinforce cultural identity, traditions, and practices within immigrant communities. This investment in bonding social capital, to the exclusion of bridging social capital, has positive and negative consequences for both immigrants and host communities. Intraethnic

arts participation can diminish the negative effects of culture shock and intergenerational tensions and can contribute to a sense of cultural pride, critical in the face of a hostile context of incorporation. On the other hand, excluding—intentionally or by default—nonimmigrant audiences can be seen as missed opportunities for immigrants to draw on the resources offered by bridging social capital, including access to occupational and social mobility, enhanced language proficiency, fresh aesthetic material, and enhanced health, confidence, and a sense of control (Erickson 2003). Moreover, as the public face of an immigrant group, arts can enhance understanding and tolerance, easing the incorporation of present and future immigrants. This tolerance pays dividends in job and housing markets, social networks, and many other realms of community life.

The nature of this pilot study leads us toward broad generalizations from particular cases. We can only speculate on variations within these blocs of audience members: immigrant and native-born Nashvillians. Consistent with arguments put forth elsewhere in this volume, we have good reason to hypothesize that immigrant arts in the United States may only impact a segment of the native-born audience—a segment others have called cultural omnivores and who represent a new cultural elite (Peterson and Rossman, chapter 13, this volume). As our colleagues in this volume note, there is an increasing cultural divide between a new cultural elite, who have the access, resources, time, and inclination to navigate a sea of cultural possibilities, and a new cultural underclass, who are increasingly corralled into large portals owned by consolidated media. The new cultural elite—the omnivores—are likely to find immigrant art—whether or not it is distributed by mainstream arts organizations—and to incorporate it into their diverse portfolios of cultural consumption. Conversely, the cultural underclass will likely not be exposed to immigrant arts, unless media giants like AOL/Time-Warner, Clear Channel, and Wal-Mart record and distribute it. Although these projections, like all speculation, are necessarily exaggerated, this study seeks to illuminate the connections between the future of immigrant arts in America and the future of arts participation—the subject of this volume.

When evaluating the likelihood of these pathways, consideration must be given to the social context in which such evolutions might take place. These contextual factors may impact the long-term survival or

incorporation of immigrant art into the mainstream and the health and vibrancy of both immigrant and host communities. The following section examines the six factors most likely to impact which of the pathways previously described are followed by particular immigrant arts communities in the United States.

Influences on the Future of Immigrant Arts

The likelihood of these outcomes for immigrant arts is influenced by six factors: (1) currents in immigrant communities; (2) economic pressures; (3) artistic networks; (4) organizational capacity; (5) grantor support; and (6) artistic medium.

Currents in Immigrant Communities

The size and isolation of immigrant communities, and the pressures within an immigrant community to resist assimilation and to keep cultural traditions pure of native-born American influence, impact the likelihood that they will engage in hybridization or commercialization—both of which are linked with the increasing size and diversity of immigrant art audiences. As discussed already, scholars have found that arts participation is a locus for intergenerational and community tensions around the costs and benefits of assimilation. Artistic participation with coethinics can be particularly critical in affirming the living heritage of a community and encouraging intergenerational exchange.

All of the study's respondents spoke to the issue of cultural preservation and the importance of educating second-generation children in the traditional art forms of the community. This is perhaps best summarized in the emphasis the Somali respondent placed on educating coethinic children; he explained this education "is very important because in this world you have to leave something back for your family that they can carry on. So if I get all, they would be the one who teach the other generation, so it's very important to leave something that they know about."

However, it was artists living within the most geographically and socially isolated immigrant communities that engaged the most frequently in collaboration with artists from other cultural traditions. These communities are less directly threatened by assimilation and appear to

be least hostile to it. Interestingly, these are the groups most likely to attempt to gain support from the host community for the broad-based distribution of and participation in their artistic practices. However, the oldest immigrant groups, and those facing the least hostile reception, appear to be most resistant to hybridization and most welcomed by native-born audiences and artists, as shown in the example of the Korean and Indian dance instructors.

Economic Pressures and Technology Impact Immigrant Arts

Technology—the availability and use of recording and broadcast or display technologies by immigrant artists and audience members—affects the breadth and quality of distribution to coethinics and native-born audiences. Digital technologies will permit the evolution of national and transnational affinity groups and their ability to communicate in real time. These technologies may also pose lower barriers to entry for non-ethnics who are interested in immigrant arts. For example, the increased reach of Somali culture in Nashville has already been noted: Cultural participation can take place by simply watching TV, which is less labor intensive and less expensive than attending a live performance.

However, there is a difference between digital distribution using local access television, low-frequency radio, and online streaming video and music and the mainstream media. This study has projected that immigrant arts communities must achieve and maintain a critical mass for corporate actors to see these arts as a viable investment opportunity.

Supportive Social Networks between Native-Born and Immigrant Artists and Hybridization

The experiences of the Kurdish musician and Indian dance instructor suggest that native-born Nashville artists are open to collaboration and exchange with some immigrant artists. In cases like these, where artistic networks are relatively open across ethnic divides, the evolution of more hybridization might be noted. Conversely, where artistic networks are more closed, which they appear to be for Korean artists, more traditional programming should be expected. It should also be speculated that a return to more traditional art forms may be an unintended consequence of more hybridization as the latter builds interest in and

openness to unfamiliar immigrant art forms. The Somali's suggestion that he will use pop music as a means for introducing traditional folk music to young immigrant audience members reveals an awareness that this may come to pass.

The Organizational Capacity of Immigrant Arts

Audience size and composition are clearly affected by access and visibility. The language and site of advertising for immigrant arts impact the likelihood of immigrant or native-born community members attending the event. If these events are advertised in a language other than English or only in immigrant news channels or are located in difficult-to-find or poorer neighborhoods, majority group members may not attend. For example, the Korean respondent noted that advertising for her dance troupe's performances takes place almost exclusively in Korean-language newsletters, unless the event is sponsored by the local Korean association. The association places English-language announcements of these events in regional and local newspapers and on local radio stations. The Somali respondent emphasized that coethnic artists "need to be trained how to sell their [unintelligible] to the general public, but what they do now is just go through the Somalis. It's so easy, they just put some posters [in] the community. They tell each other, call each other" If word-of-mouth or linguistically or physically circumscribed advertisements are the main mechanism of attracting an audience, this limits potential diversity among audience members.

Access to particular spaces for display, performance, and practice can be a critical factor in the composition of immigrant arts audiences. Having civic spaces that commonly and explicitly welcome ethnic participatory arts engenders a standing openness to nurturing the incorporation of immigrant arts as a civic priority. Convention centers, community centers, parks, streets, and parade grounds can encourage interethnic and host interaction. These public sites of arts participation can contribute to community cohesion and broad audiences by casting a positive light on ethnic events and cultures, by easing access for nonethnics, and by explicitly framing the event as an opportunity for building bridges between immigrants and native-born Americans.

However, research has found that immigrant arts participation is much more likely to occur outside institutional settings or as a part

of other aspects of community life, organizational agendas, or calendars (Peterson 1996, p. 50). Nontraditional, or arts, organizations may already provide space or encouragement to immigrant artists, like hotel ballrooms, local shops, community rooms in housing complexes, churches, coffee shops, and playgrounds (Bye 2004). When asked about institutional support for Somali musicians, the study's respondent noted that there are relatively no economic barriers to performance—that there are spaces available at no cost, although most "people don't like places like that. They want to go to Sheraton" or other hotels with ballroom spaces. These locations vary in the extent to which they may be accessible to, and comfortable for, nonethnic arts participants. Moreover, members of the community may not view these locations as probable sites for arts participation and so may not be aware of the events held there.

Evidence has already been presented about the important role that churches and temples, community centers, ethnic coalitions, and libraries play in generating interest in the immigrant arts and sustaining it over time. However, difficulties may arise in these relationships. For example, the Indian dance instructor noted a number of public performances in which artists were unpaid or were paid very little. She also noted the importance of compatibilities of size and expertise: "I do everything myself. From choreography to teaching to publicity to finances to designing the costumes to designing the lighting So when you're working with an organization like the Nashville Ballet which has specialized people in these roles who expect to deal with another professional I don't know how such a thing would work." Incompatabilities of size, expertise, and institutional logics limit institutional collaborations between ethnic arts organizations and other institutions; these factors may trap ethnic arts organizations in a participatory ghetto. Here, lack of organizational capacity on the part of an immigrant artist points to the difficulties of building networks that span immigrant and native-born artistic communities.

The role of coordinating, or hub, organizations is evident in the interviews with immigrant artists. Immigrant artists and arts participation are embedded in an ecology of small organizations and informal groups that include commercial and nonprofit arts, cultural, and community organizations. As noted already, both the Korean and Indian dance instructors have participated in outreach programs hosted

by local public schools. In both cases community or community arts organizations brokered the relationship between artist and school. The Indian dancer is often called on by a local, international cultural center to go to schools and talk about India, its art forms, and culture: "The point is to try to erase misconceptions and make American children, all children, familiar with the cultures that are here in Nashville and to have an authentic understanding of those cultures and to not be afraid of them or look down upon them." Whether these are ethnically specific or panethnic organizations, and whether their focus is broad or solely on artists, these hub organizations can help to expand the audience for immigrant arts, while articulating and emphasizing the culturally specific meanings of their content.

Grants Agency Support

Grantors often ignore the nonarts organizations that host ethnic arts participation and are limited in their support of small groups by 501(c)3 regulations, leading many advocates for immigrant arts to recommend suspending or adapting these constraints for immigrant artists and organizations (Bye 2004; Peterson 1996; Staub 2003).

Grant monies are typically not available for nurturing the web of institutional relationships described in the previous section. Immigrants have expressed an interest in individual and organizational coalitions so that expertise and resources can be exchanged on a barter basis or for a fee. These service hubs, sponsor organizations, and coalitions can also collaborate to develop an incubator model for new immigrant arts groups to help them gain business training, develop an organizational infrastructure, access resources, and cultivate peer-to-peer networks. These organizational and individual networks can encourage links across the arts within a single ethnic community and links across organizations and individuals that span ethnic divides.

Some artists do receive grant support for interethnic cooperation and institution or skills acquisition. For example, the Somali television producer collaborates with coethnics in other cities but also with leaders in other immigrant communities in Nashville. In particular, he described the role he played in training members of the Iraqi and Kurdish communities as they built their own television programs for public television, The Iraqi House and the Nashville Kurdish Forum: "The Iraqis and

Kurdish, if they have a program they call me and I go and pick up their program and we edit together." These programs were funded by a grant to the Somali community to facilitate this training. He looks forward to the opportunity to work with the Sudanese, as they plan to produce a show for public television on their culture.

Grantors often restrict the definition of artistic activity to traditional arts, eliminating the possibility of funding for many immigrant artists and groups (Bye 2004, p. 7). Though the Indian dance instructor is proud of fundraising efforts undertaken by community arts organizations, the response from one funding agency to a local international cultural center's request for funds to support scholarship in an after-school and summer multicultural arts camp was as follows: "These are not art forms—what we teach: Indian dance, Native American dance—these are not art forms, these are hobbies, these are activities. So funding agencies definitely view art differently. Ballet, symphony—those are art forms. What we do is—I think the word they used is 'folk' art—so we fall into a different category for funding. We're not folk artists We are full-fledged classical performing artists! We have to get funding through these other categories, for which funding is much less. And then all of us are competing for the same pool of limited funds."

Arts funding agencies may expect potential grantees to use grant language and to produce and document short-term results, whereas immigrant artists may have the ability or desire to do neither. When immigrant artists or arts organizations do apply for grant support, they often have needs below the minimum funding threshold or need funding for activities or supplies not covered under traditional guidelines—for art supplies, space, or transportation for audience members.

Nature of the Work Itself

Participatory forms of culture—those traditions where audience members are expected to, for example, sing, dance, or design a costume or float—may be less likely to bridge over into mainstream culture than music and film, for example. As a matter of course, mainstream arts typically do not demand participation from audience members (see the evolution of this practice in theater in chapter 4 in this volume), and so this requirement may discourage native-born audience members and may limit their attendance at such events. On the other hand, if we are

witnessing the rise of a new participatory culture (see chapter 7 in this volume) then immigrant art forms may offer the types of experiences that are attractive to young, native-born audiences.

Conclusion

The task facing scholars of immigrant arts participation is immense. Immigrant populations are difficult to identify, sample, and interview. Arts participation is difficult to define and measure; many forms of engagement with the arts take place in private spaces and oftentimes are not seen by participants as arts participation at all (e.g., cooking, gardening, quilting). However, the answers we seek to gain from a study of immigrant arts participation drive directly at the central questions of our disciplines: How healthy are America's artistic communities? How open are these communities to new media and new participants? What does the future hold for arts participation in America, and where do minority or immigrant populations fit into that future?

The goals, features, and futures of immigrant arts seem to depend greatly on the warmth of what is denoted here as the immigrant *context of reception*. Groups that faced a cooler context appeared to be more eager to find ways to cooperate with native-born artists in the production of art. In contrast, immigrant groups who were more warmly welcomed appear to be most invested in the production of traditional artistic performances. However, the context of reception is not the only—or perhaps even the most important—factor influencing immigrant arts. Like any other art world, immigrant artists must mobilize economic, political, and human resources. As this chapter argues, immigrant artists face particular difficulties accessing and using the same forms of support that have benefited the high arts for the last century. The residential and social segregation of immigrant artists into ethnic enclave communities complicates efforts to draw native-born audiences to events. Yet this physical and social segregation may be offset by the opportunity presented by mass media technologies to build despatialized communities of support and participation. We see a future in which the mass distribution of immigrant arts is plausible, even likely. However, unless consolidated media giants see profit in these niche markets, the mass consumption of immigrant arts by native-born Americans will

likely be confined to cultural omnivores—those with the time and desire to find immigrant art.

We recognize that this study of arts participation in Nashville is only a small step toward providing answers to these questions. This pilot study used a purposive and snowball-generated sample to provide deep, if narrow, insights into the experience of immigrant artists in Nashville. The results of this pilot study are offered in the hope that other scholars will pick up these questions and will ask them of other immigrant groups, in other cities, and of immigrant art participants who are not committed amateur or professional artists.

Bibliography

Blacking, J. 1995. *Music, Culture and Experience.* Chicago: University of Chicago Press.

Born, G., and D. Hesmondhalgh. 2000. "On Difference, Representation, and Appropriation in Music." In *Western Music and Its Others,* edited by G. Born and D. Hesmondhalgh, 1–58. Berkeley: University of California Press.

Bye, Carolyn. 2004. "Brave New World: Nurturing the Arts in New Immigrant and Refugee Communities." Issues in Folk Arts and Traditional Culture. Working Paper Series 2. The Fund for Folk Culture, The National Endowment for the Arts. http://www.folkculture.org/pdfs/bye_working_paper_02.pdf.

Caramanica, Jon. 2005. "The Conquest of America (North And South)."*New York Times,* December 4, Section 2, pg. 1.

Cohen, S. 1999. "Scenes." In *Key Terms in Popular Music and Culture,* edited by B. Horner and T. Swiss, 239–50. Malden, MA: Blackwell.

Cornfield, Daniel, Angela Arzubiaga, Rhonda BeLue, Susan Brooks, Tony Brown, Oscar Miller, Douglas Perkins, Peggy Thoits, and Lynn Walker. 2003. "Final Report of the Immigrant Community Assessment." Prepared under Contract 14830 for Metropolitan Government of Nashville and Davidson County, Tennessee, August. ftp://ftp.nashville.gov/web/finance/immigrant-community-assessment-nashville.pdf.

Davila, Arlene. 2001. *Latinos Inc.: The Marketing and Making of a People.* Berkeley: University of California Press.

DeNora, Tia. 2000. *Music and Everyday Life.* Cambridge, UK: Cambridge University Press.

Erickson, Bonnie. 2003. "Social Networks: The Value of Variety." *Contexts* 2, no. 1: 25–31.

Farris, Anne. 2005. "New Immigrants in New Places: America's Growing 'Global Interior.'" *Carnegie Reporter* 3 (Fall). http://www.carnegie.org/reporter/11/newimmigrants/index.html.

Frith, Simon. 1996. "Music and Identity." In *Questions of Cultural Identity*, edited by S. Hall and P. du Gay, 108–27. London: Sage.

Hebdige, Dick. 1979. *Subculture: The Meaning of Style*. New York: Routledge.

Hobbs, Richard, (Ed.). 2000. "Bridging Borders in Silicon Valley: Summit on Immigrant Needs and Contributions." Santa Clara County's (CA) Office of Human Relations, Citizenship and Immigrant Services Program, December.

Lena, Jennifer C. 2005. "Racial Tourism in Rap: Voyeurism and Authenticity." Paper presented at the Experience Music Project Pop Conference, Seattle, WA, April 15.

Lewis, G. 1991. "Who Do You Love?" In *Popular Music and Communication*, edited by J. Lull, 134–51. Newbury Park, CA: Sage.

Moriarty, Pia. 2004. "Immigrant Participatory Arts: An Insight into Community-Building in Silicon Valley." Inquiries into Culture Series, Cultural Initiatives Silicon Valley. http://www.ci-sv.org/pdf/Immigrant_Arts_LR.pdf.

Negus, Keith. 1999. *Music Genres and Corporate Cultures*. London: Routledge.

Negus, Keith, and P. Roman Velazquez. 2002. "Belonging and Detachment: Musical Experience and the Limits of Identity." *Poetics* 30: 133–45.

Peterson, Elizabeth. 1996. "The Changing Faces of Tradition: A Report on the Folk and Traditional Arts in the United States." Research Division Report 38, National Endowment for the Arts.

Peterson, Richard A. 1997. *Creating Country Music: Fabricating Authenticity*. Chicago: University of Chicago Press.

Porter, Tim. 2003. "Dismantling the Language Barrier: In an Effort to Crack the Burgeoning Hispanic Market, Major Newspaper Companies Are Investing in New and Expanded Spanish-Language Editions." *American Journalism Review* 25 (October–November): http://www.ajr.org/Article.asp?id=3415.

Portes, Alejandro, and Rubén Rumbaut. 2006. *Immigrant America: A Portrait*. 3rd ed. Berkeley: University of California Press.

Putnam, Robert D. 2000. *Bowling Alone: The Collapse and Revival of American Community*. New York: Simon & Schuster.

Putnam, Robert D., and Lewis Feldstein. 2003. *Better Together: Restoring the American Community*. New York: Simon and Schuster.

Rumbaut, Rubén, and Alejandro Portes. 2001. *Ethnicities: Children of Immigrants in America*. Berkeley: University of California Press.

Quintero-Rivera, A. 2002. "Migration and Worldview in Salsa Music." *Latin American Music Review* 24, no. 2: 210–32.

Singer, Audrey. 2004. "The Rise of New Immigrant Gateways." The Living Cities Census Series, Center on Urban and Metropolitan Policy. Washington, DC: Brookings Institution.

Staub, Shalom. 2003. "Small Organizations in the Folk and Traditional Arts: Strategies for Support." Issues in Folk Arts and Traditional Culture, Working Paper Series 1. Fund for Folk Culture, National Endowment for the Arts.

Stokes, M. 1994. "Introduction." In *Ethnicity, Identity and Music*, edited by M. Stokes, 1–27. Oxford: Berg.

Straw, W. 1991. Systems of Articulation, Logics of Change. *Cultural Studies* 5, no. 3: 368–88.

Thornton, Sarah. 1996. *Club Cultures: Music, Media and Subcultural Capital*. Middleton, CT: Wesleyan University Press.

U.S. Census Bureau. 2003. "Statistical Abstract of the United States: 2003, Mini-Historical Statistics, Table HS-10," p. 17. http://www.census.gov/statab/hist/HS-10.pdf.

U.S. Census Bureau. 2004. "2004 American Community Survey, Multi-Year Profile, Selected Social Characteristics." http://www.census.gov/acs/www/.

Wali, Alaka, Rebecca Severson, and Mario Longoni. 2002. "Informal Arts: Finding Cohesion, Capacity and Other Cultural Benefits in Unexpected Places." Columbia College, Chicago Center for Arts Policy, June.

Willis, Paul. 1990. "The Golden Age." In *On Record,* edited by S. Frith and A. Goodwin, 43–55. New York: Pantheon.

Endnotes

1. These subjects were identified through referrals from the social networks generated by the 2002–2003 Immigrant Community Assessment of Nashville, a study of the social well-being of Arabic, Kurdish, Laotian, Latino, Somali, and Vietnamese immigrants that was commissioned by the mayor (Cornfield et al. 2003). The study's interviews extended over the summer of 2005. Each audiotaped, confidential interview lasted approximately two hours. U.S. Census data were also consulted to understand better the size and composition of each immigrant group.

7 Artistic Expression in the Age of Participatory Culture

How and Why Young People Create

Henry Jenkins and Vanessa Bertozzi

Introduction

Chloe, a seventeen-year-old girl living in western Massachusetts, has taken on the responsibility of translating the lyrics of her favorite Japanese rock songs and making them available on the Web.[1] Chloe, a tall thin girl with long, dirty-blonde hair, enjoys cosplay, that is, creating costumes based on characters from her favorite anime series or J-rock bands, dressing up and often performing these roles in public. Young people in Tokyo and across Japan gather on Sunday afternoons in the local parks, parading their costumes and connecting with other young fans.[2] Their images and personal narratives flow across the World Wide Web, and young people like Chloe feel an emotional link to these Japanese fans through their mutual interests in media properties and their

shared participation in the same cultural practices. She interacts with local cosplay kids through science fiction conventions, and she shares images of her costumes via the Web.[3]

Chloe has been inspired by her participation in cosplay to learn more about Japan. Frustrated by the limits of her own high school, she now takes Japanese conversation classes at Smith College. She can speak at length about traditional Japanese poetry and fiction. While discussing how the lead singer of her favorite band, Dir en grey (who happens to be male), often writes from a female point of view, she muses on the literary implications. "They'll often write from a female perspective because a lot of the great Japanese authors are female. I don't know if you know too much about Japanese literature, but Murasaki Shikibu was the author of the first recorded novel, *Tale of Genji, Genji Monogatari*. Yes, she's a woman."[4] Chloe's knowledge and passion for all things Japanese is truly impressive: She has moved outward from her initial interest in popular culture to embrace traditional literary and artistic practices. She has in the process moved from being a consumer to an active participant, shaping the flow of these materials and educating other Westerners about Japanese culture.

This chapter offers glimpses into the art worlds of Chloe and six other young people, ages thirteen to twenty-eight. This chapter refers throughout to a series of interviews—conducted face to face, with video, and over instant messaging, e-mail, and phone—with seven young artists. Besides Chloe, we talked with Josh Meeter, a *Star Wars* fan and animator; TheSidDog, a gamer and machinima maker; Ariel, an independent comics creator; Ed, a musician and composer; Petey, a multimedia artist; and Antonia, a costumer and performance artist.[5] The question of whether or not these young people are, in fact, artists is an interesting one. Let us leave aside for the moment whether making media is the same thing as making art. At one time, Western culture would have drawn a sharp line between amateurs and professionals and would have reserved the word *artist* for someone who produced art—if not for a living than as a significant part of their lives. We have all met waiters at local coffee houses who claimed to be poets even though they had not yet written a poem, or we have heard a cab driver grumble, "What I really want to do is direct." In fact, these young people are already doing what they want to do. Today, these distinctions between amateur and professional, hobbyist and artist are blurring:

These young people are getting their work in front of a public at a much earlier age, are developing reputations within a larger community, and are defining their identities to no small degree through what they create. The young people interviewed for this study were at various stages of development—some, such as Ariel, are already veterans with national reputations, whereas others are just at the very beginnings of their journeys—yet all of them would see making media (and, perhaps, making art) as a vital part of their lives.

What these young artists have accomplished is impressive, all the more so because few of these activities took place in schools. Indeed, many of these kids have had frustrating experiences in school: Some are home schooled; some have dropped out; and others chose to graduate early to have more time to pursue their dreams. They developed much of their skill and knowledge through their participation in the informal learning communities of fans and gamers. School, if anything, served as a stage for subversive acts, such as Antonia cosplaying *Harry Potter* school uniforms at a public school, and Ariel passing around mini-comics about coming out as a lesbian. These young artists exploited a range of new media tools to do their work and tapped large-scale networks to help circulate and publicize what they had done. They operate outside traditional arts institutions. They have not been sanctioned by the critical establishment.

In any given period there are exceptional individuals who break all the rules and enjoy off-the-chart success. But these kids are perhaps less exceptional than one might at first imagine. According to a 2005 study conducted by the Pew Internet & American Life Project, more than half of all American teens—and 57 percent of teens who use the Internet—could be considered media creators.[6] For the purpose of the Pew study, a media creator was defined as someone who "created a blog or webpage, posted original artwork, photography, stories or videos online or remixed online content into their own new creations" (p. 1). Most have done two or more of these activities. Thirty-three percent of teens share what they create online with others. Twenty-two percent have their own home pages. Nineteen percent blog, and 19 percent remix content they found online.

Contrary to popular stereotypes, these activities are not restricted to white suburban males. In fact, urban kids (40 percent) are somewhat more likely than their suburban (28 percent) or rural (38 percent) coun-

terparts to be media creators. Older girls (27 percent) are more likely than boys their age (17 percent) to be involved with blogging or other social activities online. The Pew researchers did not find significant differences in terms of race.

If anything, the Pew study underestimates the number of American young people who are embracing the new participatory culture. The Pew study did not consider newer forms of expression such as podcasting, game modding, or machinima; they also did not count other forms of creative expression and appropriation (e.g., music sampling in the hip-hop community) that are highly technological but that use other tools and tap other networks for their production and distribution.[7] The study does not account for even more widespread practices (e.g., computer or video gaming) that may require a great deal of time and effort focused on constructing and performing fictional personas.

What this chapter describes is a new participatory culture. A participatory culture might be defined as one where there are relatively low barriers to artistic expression and civic engagement, where there is strong support for creating and sharing what one creates with others, and where there is some kind of informal mentorship whereby what is known by the most experienced is passed along to novices. It is also a culture where members feel that their contributions matter and where they feel some degree of social connection with each other at least to the degree to which they care what other people think about what they have created. Not every member needs to contribute, but all need to feel that they are free to contribute when they are ready and that what they contribute will be appropriately valued. In such a world, many will only dabble, some will dig deeper, and still others will master the skills that are most valued within the community. But the community itself provides strong incentives for creative expression and active participation.

What this chapter refers to as participatory culture has a long history.[8] What is different now? For one thing, there are now channels of distribution that make it possible for young people to circulate what they make more readily. These amateur works move along similar and often identical circuits as commercially produced works. Amateur media makers may reach publics at least as large as those who embrace the avant-garde artists typically celebrated by arts institutions. Home movies were once shown in the home; now they can be downloaded and watched by thousands, even millions, of people on the Web.[9] As these

art works become more visible, they provide models for other young artists who are similarly inspired to make media. These communities exchange advice and offer critiques. The result is grassroots creativity operating on a scope and scale that would have been unimaginable at earlier moments.

These experiences may be reshaping what is meant by art and by participation in the twenty-first century. Much of this volume's discussion has defined participation in terms of attending concerts or museums, that is, as a form of consumption. But the new media landscape has broadened access to tools for media production, and thus participation may now include involvement in the development and circulation of grassroots media. In such a world, art is integrated into people's everyday lives and is not necessarily a special event like a concert or sanctified space such as a museum or opera house. Arts educators and museum curators often see themselves as being at war with popular culture for the hearts and minds of their students. Yet it is quite the opposite. Popular culture motivates students to do research, read, write, learn, and create. Young people are not disconnecting from the arts; they are connecting to art in new and unpredicted ways. The hope in this chapter is to help arts policymakers and institutions better understand the implications of these new forms of participatory culture. Arts institutions cannot rely on tried and true methods to connect with these young people; they need to understand the worlds within which these young artists create and consume media.

Unlike many of the other chapters in this book, the approach here is qualitative and not quantitative. Interviews with young artists are used to map a still-emerging set of cultural practices and to understand what they mean for the people involved. The recent Pew study previously cited provides some benchmarks: Everything learned so far suggests that these trends are impacting a sizable percentage of people of high school and college age. These cultural practices are so new that they have not yet registered on the radar of quantitative social scientists; there are only fragmented data that might allow us to measure how widespread they are across this age cohort. There are no longitudinal studies to show how long young people are likely to participate in these creative communities or how their participation may shape their attitudes and relations to the arts as they become adults. The hope for this chapter is that it will provoke researchers to reframe how they define

participation in the arts and to explore more fully the implications of this new participatory culture.

Rethinking Participation

More young people are producing media than ever before, yet policymakers complain about a lack of participation in the arts. What is wrong with this picture? Historically, arts policymakers and scholars have defined participation in terms of attending so-called high art concerts or museums. Currently, there is a growing concern that members of the younger generation do not seem to have much interest in these forms. This chapter argues something different: Youth are very interested in participating, just not necessarily in the arts as they have been traditionally defined. This is not to say that today's young people do not respect artists who have devoted their lives to becoming masters or that over time they may not emerge as active audiences for traditional arts events. Often, young people come away with a new appreciation of such works once they have had a chance to make their own media. They do object to the mystification of art—to an attitude that demands quiet contemplation and distanced admiration. The culture in the United States is moving away from a world where a few gifted artists produced works that would be consumed and admired by many to a world where many are producing works that can be circulated among smaller niche publics. Art institutions need to keep up with these changes or they will be left behind.

Think of a youth on a field trip being told to sit quietly to a symphony to which they have no personal connection. They sit, distracted, squirming in their seats, glancing about the room. Asked to share their impressions, they shrug defensively. Now think of a youth playing a computer game. Listen to the passion with which they contrast different works in the same genre or talk about what constitutes good and bad work within a still-emerging genre. Indeed, listen to them debate among themselves whether or not games can or should be considered art. Listen to their pride when they show each other their own efforts to adapt games to tell their own stories—the scrapbooks of images they have captured of their own game play, their efforts to modify the game

levels or create new "skins" of the game character, their first attempts to create short animated films using the games engine as a platform.

These young people are passionate about emerging forms of expression, which allow no fixed hierarchy, no standardized criteria for evaluation, and little inherited canon. They are dubious about being told what artworks matter. They have grown up in a world where tools for media making have been widely available: Why should they sit and watch when they can roll up their sleeves and make something? They are entering spaces where there are no established masters and where it is possible to grab some spotlight for themselves—if the community values what they make.

These young people have a seemingly unprecedented access to the means of cultural production and distribution. They are driven to express themselves and to share those expressions with the world, and they are learning how to tap networks to get their work in front of the public at surprisingly young ages. Take, for example, Ariel Schrag, a twenty-something woman with dark, cropped hair, who grew up in the San Francisco Bay area. Ariel used the medium of underground comics to come out as a lesbian to her high school audience. Ariel was talented and persistent enough to get the attention of Slave Labor Graphics. The publishing company first released Ariel's comic books while she was still in high school. Her books, *Awkward*, *Potential*, and *Definition*, have been distributed in comic book shops around the world and are, in turn, inspiring another generation of young people to create and distribute their own autobiographical comics.[10] How did she do it? As she puts it, "You've gotta schmooze schmooze schmooze!" Her hobby took her places she never would have anticipated: "I started this project that completely took over my entire life and I've never been the same. I mean no one is ever the same after high school, but for me it was this really specific thing where the entire focus of my life changed. I sort of look at it and every single thing in my life relates back to the comic in some way." Today, Schrag is a professional comic book artist—if such a thing is possible in a world where relatively few comic book creators earn enough to support themselves from their work. Indeed, Schrag is going into classrooms to instruct young people how to make compelling work and get noticed.

We might think of the emergence of this do-it-yourself aesthetic as a revitalization of folk culture. As scholars have long noted, folk art was

participatory: Many people would participate in square dances, sing-alongs, or quilting bees who would never regard themselves to be professional artists. They learned from each other, and much of what they made became community property. The twentieth century's efforts to industrialize and professionalize artistic production could be viewed as a strange chapter in the history of creativity. In the future, the arts may once again be more participatory, but the traditional high arts will have to operate alongside and often in dialogue with modern mass culture. At the same time, the mass media is being forced to become more responsive to audience demands for greater participation. As anthropologist and consultant Grant McCracken (1997) explained, "Corporations will allow the public to participate in the construction and representation of its creations or they will, eventually, compromise the commercial value of their properties. The new consumers will help create value or they will refuse it" (p. 34). The same could be said for art institutions.

Ironically, despite all of the publicity about law suits against young downloaders, the commercial sector may be more welcoming to young media makers than most art institutions. This is especially true of new media firms, such as games publishers, who have come to accept audience participation as a central aspect of their business plan. Games might have once been talked about as interactive media; today, games are going further, embracing what industry commentator Tim O'Reilly (2005, p. 2) likes to call "an architecture of participation." Less and less game content is coming from commercial designers—more and more from consumers. Top-selling games are often valued as much for the design tools they provide to users as for the actual games themselves. In addition, movements have emerged around amateur filmmaking projects that make use of the digital assets created for games.

Peter, a homeschooled, California teen who goes by *TheSidDog* online, creates machinima clips using the movie-making software packaged with *The Sims 2,* the bestselling computer game of all time. Machinima turns game engines into a platform for the generation of computer animation in real time.[11] Machinima is close to puppetry, where players are able to use their control over the game characters to improvise scenarios. In this case, players do not directly control the Sims characters: They make suggestions, which influence but do not determine how the Sims behave. The Sims are actually controlled by a structured set of priorities, sometimes responding promptly, sometimes

refusing to obey. TheSidDog works around these constraints. As he explains, "Unlike human and CG actors, Sims don't know they're in a movie so to speak, so the trick is getting them to interact with their peers and shoot at the right second. Really, the camera is just there to record. There is no mode to get them to follow your commands exactly as you want. One could be recording the perfect scene only to have his/her Sim pee on the floor at the last second, killing that perfect shot …. Think of shooting Sims like shooting animals—they have no idea they're on the camera." TheSidDog has taught himself how to stage performances, to edit his footage, and to choose musical tracks to express his own perspective. In one of his pieces, a Sims character appears in an eerie white space, with an ominous soundtrack. TheSid-Dog shows him reading a Sims newspaper. Miming the characteristic anguished gestures of an upset Sims character, TheSidDog's figure undergoes a tongue-in-cheek existential crisis as he reads the headline that he has been deleted from the game.

People are so used to thinking of these young artists as trespassers on other people's intellectual property that it may be surprising to learn that the legitimate rights owners in this case actively encourage this use of their materials. TheSidDog posts his movies on a fan site owned by Electronic Arts, *The Sims's* parent company; the company's head designer, Will Wright, recommended TheSidDog to us, having identified him through one of the contests for amateur filmmakers that the company sponsors. Wright intentionally creates computer games that invite the user to generate original content. Wright predicts that ultimately more than half of the game content will come from amateurs rather than from his commercial team. As Wright explained, "We are competing with other properties for these creative individuals …. Whichever game attracts the best community will enjoy the most success."[12] Wright's embrace of user-generated content gives Electronic Arts a competitive advantage over other games companies. The Sims model also works to the company's advantage: User-generated content begets more users. Some argue it is the key to the record-breaking success of *The Sims* franchise. This push to give consumers the tools to make their own games is spreading across the games industry.

Redefining Art

Again, it should be asked what is wrong with this picture: Media companies—not all of them certainly but many of them—are embracing young artists, celebrating their ability to use their tools and resources to create new works, whereas many art institutions and policymakers are looking down their noses at what these young people are creating and then wondering why they are not showing up for their docent tours. Just as it is necessary to reconsider what is meant by participation, it is necessary to rethink what is meant by art. As TheSidDog says, "Games have been used since the start of mankind as a way to learn and grow—games like *The Sims* ... are also doing that. They inspire, they provoke thought, they have meaning and thus are art." This sounds like a pretty good definition of art to us.

The idea of artistic originality has become much more complicated. In the fine arts as well as the popular arts, remixing has emerged as a significant aspect of creative expression—in part because of cheap and accessible digital tools and in part because of the emergence of a postmodern aesthetic that values appropriation and transformations of previously circulated materials. Journalists talk about the Napster generation, and corporations blame young people for piracy and illegal downloads of other people's music. Yet they have also already emerged as a generation of media makers. For example, take a look at Young Composers, a website that uses MP3 technologies to allow young musicians to share their own compositions and get feedback from their peers.[13] Web sites for fan fiction—original stories written about characters drawn from popular media—may include thousands of works, many of them by teen authors.[14]

In some cases, young artists are making media from scratch. In other cases, they are producing media that appropriates and transforms existing media content. These kinds of appropriation should not be understood simply as plagiarism. Appropriation involves a complex negotiation between the self and the larger culture—an absorption and transformation of shared resources into the raw materials of one's own collective and personal expression. The digital remixing of media content makes visible the degree to which all cultural expression builds on what has come before. Many of the forms of expression that are most important to American youth accent this sampling and remixing pro-

cess, in part because digitization makes it much easier to combine and repurpose media content than ever before. Jazz, for example, evolved through improvisation around familiar themes and standard songs, yet the digital remixing of actual sounds that occurs in techno or hip-hop music has raised much greater alarm among those who would insist on strong protections of copyright.

Fourteen-year-old Antonia takes cosplay, a form of media appropriation, a bit further: She wears a different look to school every day. She is growing up in a reenacting household; her family engages regularly in vintage dance, civil war reenacting, and other activities that involve sewing reproductions of antique clothing. Her love for the *Harry Potter* books led to a major Hogwarts phase. For an entire year, she wore British school uniforms to her Massachusetts public school. Now Antonia reads the webcomic *Megatokyo* and uses its imagery for her patterns.[15] Though she has become more active in meeting people with common interests online and at conventions, her main outlet is high school. Antonia finds the jeers and dirty looks of her classmates amusing and enjoys playing with people's expectations in an environment that often defines people through their external appearances. Because of her level of self-reflection, one could see her activity as performance art. Though her costumes mark her as strange at her school, they also represent her membership in a subcultural community—one that expands beyond the local community or even national boundaries. This process of self-fashioning starts with a phase of research. Antonia goes online to learn more about periods, genres, or media properties that she wants to emulate through her work. She wants to master every detail of these imaginary worlds, and as she does so, she moves from the specific details—the colors of a herald, the buttons on a coat, the Japanese droopy socks—toward a larger understanding of the cultural traditions that shaped those details.

Many adults worry that these kids are copying preexisting media content rather than creating their own original works. This is the wrong way to think about what is going on here. Their appropriations from commercial media are a kind of apprenticeship phase. They learn what they can from the stories and images that are most familiar to them— just as previous generations of artists and storytellers sought inspiration from the Bible or from folk traditions. Building their first efforts on existing cultural materials allows them to focus their energies on

mastering their craft, perfecting their skills, and communicating their ideas. We often mystify the process of creation—focusing on the act of original invention and personal expression while denying the degree to which all art builds on what has come before. The 2005 Pew study suggests something more: Young people who create and circulate their own media are more apt to respect the intellectual property rights of others because they feel a greater stake in the cultural economy.

People often want to know how much of the work these young people are generating is any good, and the answer is more than we might think. For one thing, young creative artists are exploring new modes of expression: digital cinema, machinima, claymation, and self-fashioning as performance art, mashups, and webzines.[16] As with any emerging artistic practice, much of the work is experimental, and many experiments fail. Yet there is something engaging about watching people transforming emerging technologies into tools for artistic expression and about the emergence of new communities of artists and supporters who are developing new standards for evaluating works that do not fit comfortably into existing artistic categories. In addition to online message boards and other feedback forums, online communities often convene offline at conventions, concerts, or events where a community of peers holds contests, teaches workshops, and appraises each other's work. On the other hand, asking if any of this stuff is good may be wrong-headed. When discussing teaching young people how to write poetry or make pottery, creativity is emphasized as a process; the question of what percentage of them go on to become professional poets or potters is not asked. We should think in the same ways about youth creativity in the new media environment.

Rather than trying to evaluate new media by old standards, the focus should be more on what it means to live in a world where a large number of people—including many young people—have access to new tools for expressing themselves, new distribution channels to share what they have made with others, and new publics ready to appreciate and respond to their art. For example, Ed recorded an entire original album on his Mac computer in his bedroom in Greenpoint, Brooklyn, where we interviewed him. "This is where I do all recording, in this room. I tend to use almost anything I can find in here. Like one of the first songs I ever did I used a belt buckle and a glass ashtray and made just like a clinking sound. My mom is an elementary school music teacher so she gave me children's instruments, like a recorder and little sand-blocks

you scrape together to make percussion sounds …. I use those, and for a couple songs I made a noise off my desk," Ed says as he bangs on his desk. "I used that and sampled it to create some sort of percussion type thing …. I do love using my computer." Ed uses the simple set-up of a microphone attached to his Mac running an audio editing program called ProTools.[17] By circulating MP3s with his iPod and on the Web, he eventually got signed and has now toured the United States under the band name Grizzly Bear.[18]

In this chapter this type of activity is called *grassroots convergence*.[19] Right now, the media industries are embracing convergence as a way of expanding the potential market for their properties. In this culture, any significant story, sound, image, brand, or relationship will play itself across the maximum possible range of media. Right now, convergence is being shaped by decisions being made in corporate boardrooms as media conglomerates demonstrate their mastery over all different kinds of distribution channels. But convergence is also taking shape through decisions being made in teenagers' bedrooms. Young people are demanding the right to access the media they want, when and where they want it. Simultaneously, these young people assert their ability to transmit the media they have made across a range of different distribution channels. A commercial song might spread from a concert performance to an album to a music video to a film soundtrack to an advertisement, gaining new listeners and acquiring new meanings along the way. An amateur song, at the same time, might move from a friend's computer into a podcast, might surface on someone's entry on MySpace, Friendster, or another social software, might get downloaded through peer-to-peer technology, and, as in the case of Grizzly Bear, might find its way into the hands of a recording industry executive. The flow of media does not simply gush forth as a river but flows in many different interconnecting tributaries and estuaries.

Some of these youth see themselves as future participants in commercial media, some as entering the world of high art, and some will no doubt remain amateurs. Regardless, the lines between these spheres of cultural production are breaking down. In such a world, making, consuming, and sharing media is integrated into people's everyday lives and not necessarily always set apart as a special event, with a definite time and place. Take, for example, Petey—a quirky thirteen-year-old artist whose Web site hosts a variety of his creations: flash-animated

shorts, comics, writings, games, original and remixed music.[20] Much of his fan base springs from *The Best Show with Tom Scharpling*, which airs on WFMU, a listener-supported, free-form radio station in East Orange, New Jersey.[21] "A year after the Tom Scharpling show started on WFMU I started calling up and I was kind of a jerk back then. I was kind of a prank caller back then and Tom used to hate me. But eventually we became friends and I started helping out on the show and entering contests and stuff. I became a frequent caller and do skits on the air sometimes." During Petey's average day, he might post a new flash animation to his Web site, e-mail online with fans of his Web site and other artists, and call into the WFMU radio show on which he has become a regular personality. In this way, his various activities support each other: He makes media because he can. He shares media because other people seem to like what he makes.

Redesigning Art Worlds

James Paul Gee (2004) used the term *affinity spaces* to refer to the new creative and learning communities that have emerged online. He argued that such communities often function more effectively than formal education in supporting the growth and development of their participants. For one thing, they consist of artists at different stages of development so that each individual can learn from others in their affinity space and at the same time; each can pass along what they know to those in need. Such affiliations surface often in the stories we heard from young artists: One way that young people have been able to break out of their bedrooms has been by networking within art worlds. For example, Flickr (http://www.flickr.com), the socially networked photo sharing Web site, extends and connects a global virtual community of amateur photographers. These art worlds expose young people to other amateur works. They provide encouragement for them to produce their own works, a context for them to share those works with others, and feedback that helps these artists grow and develop.

Many such transactions occur in digital space: Young people can reach out and connect with others who share their interests around the world. Chloe, the young fan of Japanese rock music and anime, follows her interests across cyberspace, learning about groups and artists whose

work might be obscure even in a Japanese context. But she also gathers together with like-minded people in physical spaces, such as science fiction conventions at local hotels: "The biggest payoff of cosplay is to go to the conventions where there are other people who know who you are dressed as and can appreciate your effort. At the first convention I ever went to, I must have had fifty people take my picture and at least ten of them came up and hugged me. It's almost like whoever you dress up as, you become that person for a day People put the pictures up on their Web sites after the con. So after a con, you can search for pictures of yourself and if you are lucky, you will find five or ten." At the conventions, she can compare notes with others who share her investment in cosplay; she can learn new techniques, discover new inspirations, and meet new people. She gets recognition for what she has accomplished. Impressions of these face-to-face contacts spread back to the Web, where her work draws attention from an even larger community of fellow fans. Rather than focusing only on what we can do to get young people to support existing arts institutions, maybe policymakers need spend more time thinking about what they can do to support affinity spaces and how real-life and virtual spaces interconnect. Maybe they should stop thinking in terms of archives and start thinking in terms of networks.

The idea that information wants to be free has been a recurring refrain among digital revolutionaries. Maybe the same thing can be said about art: No longer locked up in museums and galleries, art, like information, flows across networks, passing from one person to another at the click of a mouse. Young people take pride in their roles as tastemakers and influencers. They love to straddle between different creative communities and to facilitate the circulation of amateur work from one public to another. For the past several decades, media scholars have written about the cultural productivity of fan cultures, celebrating the ways that they turn mass culture back into participatory culture. Fans tap existing media texts for raw materials that they can remake to serve their own fantasies, as resources for their own artistic production. Fans, we are told, create stories, make videos, construct costumes, stage performances, and compose songs, which speak to their relationship to the content of mass media. Yet for all of the glee with which we have written about these new forms of grassroots cultural production, fan researchers missed a big part of the story. In the old days, fan communities, for example, existed to signal their support for commercial media proper-

ties. Increasingly, young people are seeking out fan communities because they represent the best networks for getting their own works seen.

Take Josh Meeter, an earnest, driven, and aspiring young film director. In his last year of high school in Nevada, he made a claymation piece, *The Award Showdown* (2000).[22] It spoofs the many films of Meeter's favorite directors, George Lucas and Steven Spielberg. As he explains, "I'm going out there as a filmmaker, nobody knows who I am. There are so many people who want to make movies and get out there. It's really hard to make a short film and get a whole lot of people to actually see it and like it. It's challenging to be able to draw people in. So I figured if I took Spielberg and Lucas, people are already familiar with them, know their history, where they came from and what films they've made, you know *Star Wars*, *Jaws*, *E.T.*" Josh is a fan himself, and so for him it was natural to make a movie starring his favorite directors. But he also knew that there would be people out there who wanted to see a film on this topic. Meeter negotiated with composer John Williams for the rights to use excerpts from his film scores. He networked and was able to get the film seen by Steven Spielberg, and ultimately it was featured on a DreamWorks-owned Web site:

> I was searching through movie Web sites and I found Counting-down.com. They were hosting a Web cam on the set of *AI*. I think it was in the canteen area, where you could talk with the stars. They could come up and chat with the fans. I thought, "Oh this is pretty cool." I just started getting on the message boards there and spreading the word about my movie. It was already online so people could access it. That's the really cool thing about the Web. I just started posting a bunch of messages. I was pretty annoying—"Look, it's pretty cool! Just go see it!" I was asking for Spielberg to see it The next morning I woke up and checked my e-mail and "Congratulations! Steven Spielberg saw your film and he wants to recompress it and put it on his Web site."

This story no doubt underscores the role of luck involved in reaching the upper echelons of Hollywood, but it also demonstrates the degree to which youth are able to navigate the maze of transmedia tributaries. At last count, there were more than 400 amateur *Star Wars* films in circulation on the Web, many of them made by high school or college

students, who see this as a chance to rehearse and perfect skills that will be applied in subsequent productions.[23]

One of the first skills these young artists master is how to target an audience. They are pushing the limits of technology to get their work out there, but at the same time they tap into combinations of virtual and real-life social networks. Josh pointedly went for the Lucas–Spielberg fan base. Ariel felt that distributing her art face to face is a meaningful stage for young artists to go through. Ed brought his iPod around and burned CDs of his music until he got a record deal, and TheSid-Dog used *The Sims* contest promotion to draw attention to his animation. Such strategies work because more people are responding to amateur media makers. Spielberg and DreamWorks were willing to put *The Award Showdown* on their Web site. Will Wright and Maxis are committed to building up their market by empowering fans. The record company executive was willing to listen to Grizzly Bear's demos, and Slave Labor Graphics was willing to publish and distribute Ariel's work. In that sense, the shifts are not simply technological (i.e., new networks for distribution) but also cultural (i.e., a new openness to do-it-yourself media and grassroots expression).

Reconsidering the Digital

Digital media have a role to play in every story recounted here—sometimes a positive role, sometimes a more ambiguous one—but what these young artists create cannot be reduced to digital culture. In many cases they are reacting against this preoccupation with the digital and seeking to return organic materials and processes to the center of their artistic expression. Chloe may seek inspiration for her costumes by surfing the Web, but in the end, she admires people who can sew their own clothes and even make their own buttons. Ed must reverse engineer his computer music to be played before a live audience, and Petey's audience for his Web site and flash animations grew out of his participation in a live, local show at WFMU. Ariel Schrag has little use for a purely digital culture, dismissing blogs as making it too easy to throw up half-processed work without regard to audience expectation. Her advice to young women interested in making comics is to try self-publishing and selling their comics face to face, hand to hand, "because there's some-

thing about that mode of self-promotion and getting-it-out-there that I think is a really important part of the whole process. It's a really great experience because you're connecting with your fans. The whole point of writing anything is to connect with people There's always this drive to get it published, which obviously in my experience after a while is important because you want more people to read it, but I think you don't want to skip over this phase of actually selling your own work."[24]

At every step along the way—from research to production to distribution to community—a high degree of hybridity has been observed. These artists pull from all available resources, use all available tools, and get their work in front of targeted audiences, both online and offline. Their talents start with being able to organize clusters of information, to draw inspiration across various media, and to translate what they learn into their chosen medium. New media mean more options, thus more decisions, more boundaries to play with. There is a push and pull between high-tech and lo-fi modes of production wherein young artists struggle to formulate and articulate their own philosophies.[25] Josh wants his art to look clean and professional more than anything else. Ariel gripes about how the color—as opposed to black-and-white—cover of her first published comic connotes professionalized editorial distancing. Ed loves his computer and yet doesn't want it on stage when performing because he does not want "that laptop image." Most of the young artists see production as a process through which they learn skills and come to a sharper understanding of their subject. Yet the emergence of new media forms presents more challenges in negotiating the meaning of such new modes of expression.

Remaking Art Institutions

After reading these stories of how young artists are learning to make and distribute art on their own, outside of formal classes, without help from arts institutions, policymakers may wonder what, if anything, young people need from established artists and curators. Consider two key roles they might play: (1) as mentors helping young people master professional ethics and navigate the risks of breaking into the art world; and (2) as enablers ensuring that all young people have access to the

skills and experiences needed to be full participants in this new realm of cultural production.

Fischman et al. (2004) discusses how young journalists learn about the ethical norms which will define their future professional practice. They acquired their skills most often by writing for high school newspapers. For the most part, the authors suggest, student journalists worked in highly cohesive and insulated settings. Their work was supervised—for better or worse—by a range of adult authorities, some interested in promoting the qualities of good journalism, and some concerned with protecting the reputation of the school community. Their work was free of commercial constraints and sheltered from outside exposure. The ethical norms and professional practices they acquired were well understood by the adults around them. This might be broadened to consider the role of school plays, literary magazines, band concerts, and art exhibits in shaping the development of young artists, all of which operate according to similar principles. Historically, local art institutions were the places young people went to learn how to be artists, though their focus was often on issues of craftsmanship and expression and not on networking and professional development.

Now, consider how different the context is for the emerging participatory cultures. In a world with a blurred line between consumers and producers, young people find themselves in situations that no one would have anticipated a decade or two ago. Their creative work is much more open to the public and can have more far-reaching consequences. Young people are creating new modes of expression, which adults around them poorly understand, and so they receive little to no guidance or supervision. The ethical implications of these emerging practices are fuzzy and ill-defined, and young people are discovering that information they put online to share with their friends can bring unwelcome attention from strangers.

Many of the young artists interviewed for this study told stories of adults who claimed to want to help them but who in reality sought to exploit them. Going online is the best way to reach a larger public and jump start their artistic careers, but it also comes with considerable risks. The young artists interviewed benefited from having supportive adults around them to help them sort through choices and potential consequences. Many had parents or siblings who helped to foster their talent and protect their interests. Petey comes from a family of artists, and Ariel's mother backed her when she decided to self-publish. Yet,

eventually, these artists have had to step beyond those safety nets and take some social risks as they enter into a predominantly adult sphere of activity. Art institutions could help them make that transition, by brokering mentorships with more-established artists in the same media. Such mentorships take on central roles at a time when more and more young people are producing works for public circulation rather than purely for personal expression.

In returning to the 2005 Pew study with which the chapter began, remember that 57 percent of teens who use the Internet might be considered media makers, but what of the other 43 percent? Throughout the 1990s, enormous energy went into combating the digital divide, which was defined around questions of technological access. Considerable success has been seen in ensuring that most American kids have at least minimal access to networked computers at school or public libraries. But as a 2005 report on children's online experience in the United Kingdom concluded, "No longer are children and young people only or even mainly divided by those with or without access, though 'access' is a moving target in terms of speed, location, quality and support, and inequalities in access do persist. Increasingly, children and young people are divided into those for whom the internet is an increasingly rich, diverse, engaging and stimulating resource of growing importance in their lives and those for whom it remains a narrow, un-engaging, if occasionally useful, resource of rather less significance."[26] All of these young artists had more than simply public access, though in some cases limits in bandwidth still shaped their participation. What these kids can do at home is very different from what kids can do when they only have shared, limited, and public access to computers, which often lack the possibility to store or upload media content.[27]

This participation gap creates a real challenge. On the one hand, schools are effectively deskilling the most media-savvy kids, cutting them off from their best ways of learning and denying them access to the tools with which they can most fully express themselves. On the other hand, schools are leaving behind those kids who have little or no access to the resources these young artists tapped to do their work. After-school programs at arts institutions could play an important role in expanding access not simply to the tools and technologies needed to sustain artistic production in the digital age but also to the kinds of

knowledge, skills, and experiences required to participate effectively in these emerging cultural practices.

Educators have long talked about cultural participation as a kind of hidden curriculum. Indeed, Ostrower (2007) found that those who regularly participated in cultural events were also more likely to vote, to belong to social organizations, to conduct charitable work, and to attend religious services. More research is needed to determine if those same traits extend to those who participate in online communities or who create and share media in digital environments. Historically, those kids who had access to books or classical recordings in their homes, whose parents took them on outings to concerts or museum exhibits or theatrical performance, and who engaged in dinnertime discussions of current events developed—almost without conscious consideration— skills that helped them perform well in school. Those experiences, which were widespread among the middle class and rare among the working class, became a kind of class distinction, which shaped how teachers perceived students. These new forms of cultural participation may be playing a similar role. These activities shape what skills and knowledge students bring into the classroom and, in this fashion, determine how teachers and peers perceive these students.

The young artists discussed here learned and grew outside of the formal education system. But care should be taken in pushing that insight too far. At a time when funding for the arts education is endangered, we reject the idea that arts education is not needed because kids can do it on their own at home. Rather, the present research points toward an even greater need for arts and media literacy education that can help bridge the participation gap and can reengage these bright kids with schooling. These stories should be used not to dissolve formal education but to reform it.

This research suggests that young people remain actively interested in the arts, if by the arts we mean the full range of human expression. This research reveals that young people are participating in the arts to an unanticipated degree, if by participation we mean not simply consuming public performances and exhibitions but rather making and distributing their own media works. What can art institutions do to assist this process? They can provide classes to help young people acquire skills in these new modes of expression. They can offer Web sites and exhibitions that showcase the best works that are produced and in this

way can call greater public attention to the creative expression of this emerging generation of artists. They can foster networks that broker relationships between emerging and established artists. They can provide a physical space where young artists can gather and interact face to face. Art institutions do not necessarily need to curate, but they can certainly facilitate the production and exchange of artworks in the digital age. In the process, they may blur the lines between high art and popular culture, creating a more inviting space for young people to experiment and explore artistic expressions of all kinds. Some of this they can do online, but much of it they can do the old-fashioned way: opening their doors and inviting young people to congregate inside. This chapter urges arts policymakers and institutions to reappraise how their physical spaces (e.g., art museums, concerts halls) might serve as a much-needed nexus for the real-life community, no matter how much cyberspace has reconfigured how communities are conceived of. After several decades of research, it is now clear that the virtual communities that survive over time and sustain the lives of their participants are those that get renewed from time to time by face-to-face contact among at least some significant portion of their members. Do not think of this as simply part of a youth outreach program. This is not a temporary fix that channels young people into traditional arts institutions and practices. If participatory culture changes the way people engage with art, then art institutions will have to shift how they operate. Young people are the center of this change, to be sure, but these shifts are going to impact all strata of society, one way or another.

Art institutions can become an active part of this process, or they can watch media flows route around them. Young people are not making the same kind of distinctions between high and low culture, between digital and nondigital expression, that policymakers are. As sociologists in this anthology note, Americans are becoming cultural omnivores. Consequently, they are increasingly wary of the ways cultural institutions police the borders between different forms of expression, deciding what art matters—and, implicitly, what art does not—rather than seeking to further expand who gets to make art and to broaden what counts as expression. Art institutions need to rethink their traditional roles as curators of the arts and instead embrace a new and potentially unfamiliar role as facilitators of participatory culture.

Bibliography

Douglas, Susan. 1989. *Inventing American Broadcasting, 1899–1922.* Baltimore: Johns Hopkins University Press.

Duncombe, Stephen. 1997. *Notes from the Underground: Zines and the Politics of Alternative Culture.* London: Verso.

———. 2002. "'I'm a Loser, Baby': Zines and the Creation of Underground Identity." In Jenkins, McPherson, and Shattuc, *Hop on Pop: The Politics and Pleasures of Popular Culture,* 227–50.

Fischman, Wendy, Becca Solomon, Deborah Greenspan, and Howard Gardner. 2004. *Making Good: How Young People Cope with Moral Dilemmas at Work.* Cambridge, MA: Harvard University Press.

Gee, James P. 2004. *Situated Knowledge and Learning: A Critique of Traditional Schooling.* New York: Routledge.

Grajeda, Tony. 2002. "The Sound of Disaffection." In Jenkins, McPherson, and Shattuc, *Hop on Pop: The Politics and Pleasures of Popular Culture,* 357–75.

Jenkins, Henry. 1992. *Textual Poachers: Television Fan and Participatory Culture.* London: Routledge.

———. 2003. "Quentin Tarantino's Star Wars: Digital Cinema, Media Convergence, and Participatory Culture." In *Rethinking Media Change: The Aesthetics of Transition,* edited by David Thorburn and Henry Jenkins, 281–314. Cambridge, MA: MIT Press.

———. 2006a. *Convergence Culture: Where Old and New Media Intersect.* New York: New York University Press.

———. 2006b. "Pop Cosmopolitanism: Mapping Culture Flows in an Age of Media Convergence." In *Fans, Bloggers and Gamers: Exploring Participatory Culture,* edited by Henry Jenkins. New York: New York University Press.

Jenkins, Henry, Tara McPherson, and Jane Shattuc (Eds.). 2002. *Hop on Pop: The Politics and Pleasures of Popular Culture.* Durham, NC: Duke University Press.

Lenhart, Amanda, and Mary Madden. 2005. *Teen Content Creators and Consumers.* Washington, DC: Pew Internet & American Life Project.

Livingstone, Sonia, and Maureen Bober. 2005. "UK Children Go Online," Economic and Social Research Council, p. 12. http://personal.lse.ac.uk/bober/UKCGOfinalReport.pdf.

McCracken, Grant. 1997. *Plenitude.* Toronto: Periph. Fluide.

O'Reilly, Tim. 2005. "What Is Web 2.0?" O'Reilly Media, Inc., September 30. http://www.oreillynet.com/pub/a/oreilly/tim/news/2005/09/30/what-is-web-20.html.

Ostrower, Francie. 2007. "Multiple Motives, Multiple Experiences: The Diversity of Cultural Participation. In *Engaging Art: The Next Great Transformation of America's Cultural Life,* edited by B. Ivey and S. Tepper. New ork: Routledge.

Petrik, Paula. 1992. "The Youngest Fourth Estate: The Novelty Toy Printing Press and Adolescence, 1870–1886." In *Small Worlds: Children and Adolescents in America, 1850–1950*, edited by Elliot West and Paula Petrik, 125–142. Lawrence: University of Kansas Press.

Schrag, Ariel. 1997. *Definition*. San Jose: Slave Labor Graphics.

———. 1999. *Awkward*. San Jose: Slave Labor Graphics.

———. 2000. *Potential*. San Jose: Slave Labor Graphics.

Wartella, Ellen, Barbara O'Keefe, and Ronda Scantlin. 2000. "Children and Interactive Media—A Compendium of Current Research and Directions for the Future." Markle Foundation, p. 8. http://www.markle.org/downloadable_assets/cimcompendium.pdf.

Zimmerman, Patricia. 1995. *Reel Families: A Social History of Amateur Film*. Bloomington: Indiana University Press.

Endnotes

1. Chloe X, "This is Not Greatest Site." http://www.notgreatestsite.net/.

2. Henry Jenkins, "Media Literacy—Who Needs It?" New Media Literacy, 2005, http://projectnml.org/yoyogi.

3. For example, Chloe uses CosplayLab.com (http://www.cosplaylab.com/).

4. Dir en grey's official website is http://www.direngrey.co.jp/.

5. More information can be found at Jenkins and Vanessa Bertozzi, "Young Artists," Media Studies Program, Massachusetts Institute of Technology, http://vanessabertozzi.com/youngartists/. In this chapter, all quotes from these young artists come from interviews and correspondence with them, conducted between August 2004 and May 2006. Interviews were conducted via e-mail, instant message, phone, and face to face with notes, video, and audio recordings. In some cases, the young artists preferred to not have their last names used.

6. Lenhart and Madden (2005).

7. Podcasting refers to the distribution of audio or video files over the Internet for listening on mobile devices or computers. Modding technically refers to any effort to modify existing software but is most often used to refer to modifying computer games. Mods could range from simple adjustments to the mechanics of the game to totally replacing all of the assets used in the game, transforming a fantasy landscape into one set in a specific historical period, or introducing new missions and situations. Machinima refers to the use of game engines and in-game cameras to create forms of digital animation. Often, these tools allow one to animate a sequence in real time and thus to dramatically lower the time and cost of production.

8. Petrik (1992), Douglas (1989), and Duncombe (1997).

9. Zimmerman (1995).

10. Schrag (1997, 1999, 2000).
11. See "Making Movies in Virtual Reality" (http://www.machinimacom/) for more information.
12. Will Wright (personal interview with Henry Jenkins, summer 2003). More information on Maxis's policies can be found in Henry Jenkins (2006a).
13. Young Composers (http://www.youngcomposers.com/).
14. Fan fiction involves the appropriation of characters or situations from an existing media property for the purpose of constructing original stories produced by impassioned amateurs. For more, see Jenkins (1992).
15. Fred Gallagher, Megatokyo, http://www.megatokyo.com/.
16. Claymation refers to stop-action animation created using molded clay figures. Mashups are a form of expression that involves combination of two or more media properties, most often two or more pieces of music.
17. DigiDesign puts out ProTools, a powerful multitrack audio editing and mixing application, which became very popular among amateur and professional music and radio producers. In part, its popularity was due to the fact that the company made a free trial download available via their Web site (http://www.digidesign.com/).
18. Ed Droste, Grizzly Bear the band (http://grizzly-bear.net/).
19. For more on convergence, see Jenkins (2006a, 2006b).
20. Petey X, Suburbanal Cuts (http://suburbanalcuts.com).
21. Tom Scharpling, Friends of Tom (http://www.friendsoftom.com/).
22. Joshua Meeter, MeeterVision Entertainment (http://www.meetervision.com).
23. For more on the Star Wars fan cinema movement, see Jenkins (2003).
24. Duncombe (2002).
25. For more information on the lo-fi music movement, see Grajeda (2002).
26. Livingstone and Bober (2005, p. 12).
27. Wartella, O'Keefe, and Scantlin (2000, p. 8).

Section Three:

New Technology and Cultural Change

8 Music, Mavens, and Technology

Steven Tepper, Eszter Hargittai, and David Touve

Introduction

Changes in culture are intricately connected to changes in technology (Carey 1988). In fact, the footprint of technology is found on the doorstep of every epochal change in how art and entertainment is produced and consumed. In many cases, new inventions in the way sounds, images, and texts are produced and captured have changed the way that artists and writers work, leading to new styles (e.g., dime novels, Impressionism, talkies, rock and roll) and forms (e.g., photography, synthesized music, new media art). But perhaps even more far reaching, new technologies have dramatically changed the market for art, typically leading to expanded audiences with access to more diverse cultural fare. In short, technology has been the handmaiden for both the expansion and diffusion of culture—more material made available to more people.

But, of course, technology is subject to social, cultural, and political forces; therefore, its impact on culture is not always straightforward

(Neuman 1991; Starr 2004). Throughout history, technology has also been used to censor and restrict art, and technology gave birth to the cultural industries and the mass production of art and entertainment, often replacing diverse, locally based culture with national, homogenous fare. So we cannot assume that technology and culture move along a single path. Every case of technological change requires careful analysis and observation to determine its unique consequences.

This chapter examines the impact of new digital technology on music consumption, a subject that has drawn considerable attention from pundits, scholars, legal experts, and the music industry. The terrain is contested, messy, and difficult to sort out. Traditional social and economic arrangements surrounding intellectual property are breaking down. Business models are shifting daily, and markets are becoming more consolidated. Consumers are facing a mind-boggling array of gadgets and services that allow them to access and enjoy art and entertainment in novel ways. In the face of such a daunting set of issues, this chapter focuses on a much smaller part of the puzzle: How do college students go about finding new music in a digital age?

Why do we care about the discovery of new music? Is there an a priori reason to favor discovery in art? Should we care if people prefer to listen to the same Beatles album day after day or to a country music station that plays the same fifteen songs every three hours? There are two reasons why a healthy art system requires its audiences and consumers to seek out new artists and new sounds. First, innovation and creativity require churn. If demand is sated, and audiences are complacent, then there is little room for new artists and styles to break through. Second, ever since British economist Nassau Senior (1854, p. 14) introduced the Law of Variety, arguing that "our desires do not aim so much at quantity as diversity," economists and psychologists have explored variety-seeking behavior in consumers. They have concluded that pleasure is derived from the act of stimulating choice and discovering something new that satisfies one's preferences. Musicologists and music theorists, of course, have long argued that variety, surprise, and the resolution of the unfamiliar are critical for enjoyment and deep appreciation of music. Therefore, it is safe to assume that there are positive benefits—for artists, for audiences, and for the larger society—when people sample and explore new art.

Of course, it is difficult to generalize from college students to the rest of the population, but they are a decent weathervane for larger currents in the world of music. Music labels have mostly targeted college students as prime suspects in the illegal downloading of music. College radio stations play an important role in promoting diverse and alternative music. College students are frequent early adopters of new technology, as evidenced by the flood of iPods on today's campuses. Finally, music is a particularly important source of identity and social currency for young adults. In short, if new technologies are influencing patterns of musical consumption, college students would be expected to be at the forefront of such changes.

The chapter begins with a brief overview of the historical relationship among technology, diversity, consumers, and art. Then, several theories are outlined about audience behavior, focusing on the use of technology, the effects of the mass media, and the role of taste makers. The chapter concludes with a discussion of the results of a recently administered survey on the musical tastes and habits of college students, and some implications for future research and policy are drawn.

History of Technology and Cultural Change

Scholars have long been interested in how technology has influenced patterns of cultural production and consumption. Sociologist Paul Starr (2004) wrote eloquently about the process by which new technology led to the expansion of readers in the early nineteenth century. He argued that new technology allows cultural goods to be produced more cheaply, leading to a reduction in price and a consequent expansion in the size and diversity of audiences. For example, the inventions of the power-driven cylinder press, stereotyping, and cheap paper all led to an explosion of publishing and reading, including the rise of the dime novel, pulp fiction, specialty newspapers, and other literary forms. More citizens took up reading, niche markets arose, and books became a source of amusement rather than just a means of religious, practical, or political communication.

As books and periodicals flooded private homes, urban night life emerged with the invention of widespread lighting in the late nineteenth and early twentieth centuries. As urban streets were illuminated by the new technology of gas and electric lamps, respectable, middle-class

people, including women, emptied out into the streets at night to enjoy such urban places of entertainment as dance halls and clubs. These early amusements created the demand and the urban context that ultimately led to the proliferation of movie theaters.

Around the same time, Thomas Edison invented the phonograph and changed forever the way Americans consumed music. Instead of gathering on the porch or around the piano for sing-alongs, music lovers hovered over music boxes and listened to the professional voices of new recording stars, like John McCormack, the Irish Tenor, or Nora Bayes, the vaudeville singer turned celebrity. Suddenly, Americans were exposed to more artists and types of music than they ever knew existed.

Since the turn of the twentieth century, technological innovation has continued to reshape the way people experience music. The invention of the LP (long-playing, high-fidelity disc) and FM radio led to what the founder of Elektra Records refers to as "an unprecedented flowering of musical styles and sonic experimentation" after World War II (Karr 2002, p. 2). Suddenly major record producers had excess press capacity—each press run could produce four to six songs per album instead of one—and started renting their presses to independent record labels. According to Karr (2002), music fans started new labels to reflect their own tastes and interests, and by the 1950s there were more than 500 different labels. Music lovers would be confronted with every type of music imaginable at their local music store. With the rise of FM radio, which doubled the number of stations, there was plenty of air time to go around. As this brief historical account makes clear, the introduction of new technologies in the early twentieth century was associated with the flowering of new and diverse art forms, expanded choice for consumers, and experimentation.

More, More, and Then Something Extra: The Shifting Landscape of Cultural Consumption

Today, many observers look out over the sea of digital technologies and anticipate similar tectonic shifts in the way people consume art and entertainment. In the realm of distribution and retail, technology has shifted inventories of music, books, and videos first from expensive physical shelf space in local stores to cheap space in national ware-

houses and then to virtual shelf space in the online world. In the purely physical world, the average Wal-Mart store offers around 4,000 CD titles, and the average music superstore offers 40,000 (Anderson 2004). Online retailers such as Amazon.com, on the other hand, offer upward of 150,000 unique CDs. Digital storefronts like iTunes, Napster, Rhapsody, and MusicMatch offer upward of 3 million tracks—the equivalent of about 300,000 CDs.

There are equally dramatic changes in the ways people store and access art and entertainment. Digital technologies have made possible the storage of massive quantities of entertainment. In 1998 Diamond Multimedia released the Rio portable MP3 player, which could store about three music albums worth of compressed audio. In 2006, Apple's iPod offered 60 GB of storage and the potential for 15,000 songs on a portable music player small enough to fit into a shirt pocket. Some media players can also handle video and will soon be offering more than 100 GB of storage capacity.

Access to radio and film is also exploding, thanks to technology. In the 1990s two exclusive licenses for satellite radio broadcasters—Sat-Casters—were issued in the United States, resulting in the creation of Sirius and XM satellite radio. Consequently, more than 200 additional, commercial-free audio programming channels were made available in the United States to those willing to pay the monthly subscription fees. Singular audio channels accessible across the contiguous nation now offer everything from classical music to talk radio, with channel names like "Backspin," "Area 63," and "Boneyard."

Online, the domain of programmed audio and video channels, or webcasts, is continually expanding. There is no reliable estimate of the total number of webcast stations available at any one time, but it is not unreasonable to place the number in excess of 100,000. Live365, one provider of webcasting services to individuals, has approximately 5,000 unique stations. Music@Netscape, a division of AOLMusic, offers more than 1,000 music videos, and online video providers like iFilm and AtomFilms provide access to thousands of short- and long-format digital films.

Beyond this cache of webcasters is a category of content programmers labeled *broadcatchers,* since the audio and video content available can be downloaded and caught. An example of broadcatching is podcasting, whereby user-created audio programming—with subjects

from popular music to science fiction—have been made available for download from sites such as Odeo, Podshow, or PodcastAlley and for playback on popular portable media players such as the iPod. In other words, audience members themselves are curating the musical experiences of other listeners.

Though the rental of films, in VHS or DVD, has been a popular market category in the United States for decades, copyright law did not provide such preformatted potential for music. Recently however, renting music has been made possible by the availability of subscription licenses and services. Music services, including MusicMatch, Rhapsody, Napster, MusicNow, VirginDigital, and OD2, provide subscribers access to large catalogs of music, often more than 2 million tracks, for a monthly fee. The available catalogs for these services continue to grow. Music subscription services are not the only offerings, however, as companies such as NetFlix, Blockbuster, and Greencine provide the subscription-based availability of films on DVD, via the postal system, whereas online film services distribute digital films through the Internet.

Perhaps the most controversial vehicle through which the average netizen has gained access to an ever-expanding percentage of the world's entertainment has been peer-to-peer (P2P) network development, or file sharing. In 2004, Jupiter research found that 42 percent of eighteen- to twenty-four-year olds surveyed had traded music by file sharing (Jupiter Research 2004). By enabling any individual to search and download from the hard drives of their peers easily, these services make millions of unique recordings available to users of P2P services at any one time. Although the Supreme Court ruling in the case of *Metro-Goldwyn-Mayer Studios Inc. v. Grokster, Ltd.* may have slowed the growth of unlicensed peer networks, they continue to function, and file sharing persists.

Blurring the edges of P2P and webcasting are applications like Mercora, a service that converts the music collections of connected individuals into peer-based audio streams organized according to the limits of legal webcasting standards. This system allows individuals to webcast with their connected peers directly or to convert the contents of the music collections of myriad connected individuals into a unique programming experience for each listener. Similarly, upcoming portable media players from Microsoft, under the Zune brand name, will enable the streaming of music in local spaces from one portable media player to another.

The development of massive online communities, whether formed around general social networks or user-generated media, has been one of the fastest-growing categories of new cultural consumption, creation, and discussion. In this environment, sites like MySpace, Bebo, and Facebook have grown to include tens of millions of active users. During the month of July 2006, MySpace reported adding 230,000 new registered users each day (Francisco 2006). These social network sites seemingly become so influential that larger media companies now consider these channels crucial to marketing products. Additionally, video-specific sites like YouTube, Revver, and GoogleVideo, along with music-focused sites like Garageband.com and PureVolume, are growing to provide not only the media consumer with a host of options but also the producer with a wider collection of channels through which to develop an audience.

Beyond differentiation, the ability to customize and personalize the entertainment experience is continually improving. Most visitors to Amazon.com are now familiar with the recommendations provided by the company's collaborative filtering system: "people who have purchased this book, have also purchased..." This system relates a buyer with other consumers of similar goods in order to make recommendations for other products. This filtering system provides a simple example of how machines can use human behavior to connect people to new products—even if these new products are similar to ones they have tried before. Internet radio providers, such as LaunchCast, a division of Yahoo! Music, permit the customization of audio programming based on the preselected genres and artists chosen by a listener as well as the ongoing rating of music programmed for each user. Audio providers like Last.fm and Pandora create custom radio programming based on each user's music collection, listening behavior, or individual ratings similarity to a collective of user ratings.

Similar to the trends described in the first half of the twentieth century, the cultural universe is expanding, and technology is allowing consumers and artists to navigate this system better, creating communities of expertise and shared interest, bigger and more accessible catalogues, more personalized services, and more efficient ways of matching preferences to new choices. Chris Anderson, author of "The Long Tail" (2004, p. 2) boldly asserted, "Unlimited selection is revealing truths about what consumers want People are going deep into the catalog, down the long, long list of available titles ... and the more they find,

the more they like. As they wander further from the beaten path, they discover their taste is not as mainstream as they thought."

However, not everyone agrees that technology is driving us toward more enlightened consumption. In fact, some scholars raise concerns about many of the customization and personalization devices mentioned already (Negroponte 1995; Sunstein 2001; Turow 1998, 2006). Marketing and advertising are taking advantage of new technologies and methods of gathering and cross-referencing data to create increasingly targeted campaigns. Consumers will soon see advertisements on their televisions, computers, and PDAs that are narrowly tailored to appeal to some predetermined taste category. One person might see ads for foreign films in her edition of the *New York Times*; another will only see ads for romantic comedies in his. This reflects the notion of the "Daily Me," where people increasingly put together very specific portfolios of news, information, and culture that reinforce their existing preferences and views while filtering out everything else (Negroponte 1995).

Thus, collaborative filtering technology, like that used by Amazon, could serve to expand cultural choice, offering people reliable recommendations and reducing the risk of trying new books and music. But if these filters become too precise and customized, they more likely will create ever-more narrow bandwidths of choice, leading people down the "Daily Me" path.

In short, technological innovations could lead to either more or less experimentation and sampling. Of course, there have always been opportunities to sample new cultural goods: Libraries make books available for free, and trendsetters identify novel products and promote them to their friends (e.g., copying records, making mix tapes, dragging friends to see films or music). But very little is known about how these social dynamics work and how they might be changing as the result of new technologies. There is a dearth of empirical research examining the ways consumers sample new books, films, and music. On whom do they rely? To what sources do they go to learn about new artists? What type of person is more likely to experiment? The next section reports on a pilot study of 300 college students that explores how they find new music, how they interact with new technologies, and how they respond to opportunities to wander from the beaten path.

Pathways through which We Find the New

Scholars offer three general explanations for the behavior and strategies of audiences and consumers. First, as noted already, technology is seen as a tool for users to navigate ever-expanding cultural catalogues. Technology is supposed to lead to greater and more diverse cultural consumption in two ways. First, catalogues of books, music, and film have become much bigger, more diverse, and expansive. Some scholars and pundits adhere to the notion that the sheer size of the new virtual catalogues will incite people to experiment and discover new things. Economists agree that technology leads to new patterns of experimentation, but they focus more narrowly on the new electronic marketplace (Bakos 1998). Accordingly, they point out that technology has reduced the cost of searching and browsing by enabling consumers to sample, or rent, music and books for a short period of time at relatively low cost. No longer do consumers have to buy a whole album only to find out that they like just one song. As Cory Doctorow, former Grateful Dead drummer, proclaimed, "The whole point of digital music is the risk-free grazing" (Doctorow 2003). Based on these arguments, the expectation is that technology is a primary tool for students as they seek out new music.

On the other hand, there is a long tradition of scholarship that focuses on the role of social networks for helping individuals find information and make purchasing decisions. Social networks disseminate news about jobs, health services, politics, and culture (DiMaggio and Louch 1998; Granovetter 1995). People regularly rely on friends and acquaintances for recommendations and reviews. In the area of art, culture, and media, *opinion leaders, mavens,* and *trendsetters* play a prominent role in the circulation of information about new products (Katz and Lazarsfeld 1955; Rogers 1995). In the 1950s, Paul Lazarsfeld first pointed out the important role that leaders in a community play in redacting information and often changing citizen preferences. More recently, Malcom Gladwell (2000) wrote about the role of mavens in the diffusion of new cultural trends— for example, a handful of trendsetters in the lower east side in New York City in instigating the widespread adoption of Hush Puppies in the late 1990s. Corporations are increasingly hiring *cool hunters* and mavens to spread the word and to create buzz around new products. Consequently, a second working hypoth-

esis is that social networks and face-to-face exchange remain important avenues for exploring new music.

Of course, consumers continue to be influenced by mass media and advertising. Approximately 150 billion dollars are spent each year by the U.S. advertising industry under the assumption that the mass media are a source of influence and information for consumers. Beginning in the 1950s, psychologists were enlisted by ad agencies to perfect the science of persuasion—convincing American consumers to buy new cars, to try new whiskey or cigarettes, and to switch cleaning detergents. In recent years, there has been a reaction against the idea that consumers are dupes and passive media consumers, as scholars show how audiences actively navigate the marketplace, resist dominant media messages, and take advantage of empowering technologies. But these claims might be overstated and exceedingly optimistic. W. Russell Neuman (1991) found that the development of cable television and the explosion of cultural choice did not lead to interactive consumers who used the medium to try new channels and programming. Instead, he discovered that audiences are habit bound and that cultural practices, like watching TV, labor under heavy inertia. People resist new technologies if they challenge existing media habits. He also found that audiences are quite passive when it comes to cultural consumption; they do not want to work hard for their entertainment. Consequently, network television stations maintained a large share of the market even in the face of a proliferating number of cable programs. Neuman's work suggests that it is possible that new digital technologies will be slow to take hold and that cultural consumers will continue to rely on traditional mass media (e.g., radio, television, newspapers, films) as important sources for the discovery of new music.

College Students' Music-Finding Behavior

To test empirically these theories, a survey was conducted of how college students learn about new music. A paper-and-pencil questionnaire was administered to 292 students on three different college campuses across the United States: one in the Northeast, the Midwest, and the South. Students were asked to report on the ways they find music

that is new to them. Following are presented some of the findings from the study's preliminary analyses.

First, as expected, college students consume a great deal of music (Figures 8.1 and 8.2). When asked how many artists are in their *jukebox*— that is, the number of different artists they listen to in a given week—89 percent reported that they listen to at least five different artists a week, and 53 percent listen to more than fifteen different artists. Students also

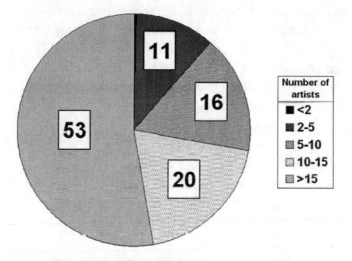

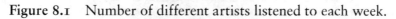

Figure 8.1 Number of different artists listened to each week.

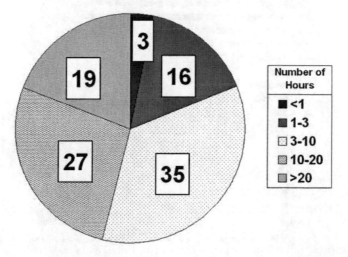

Figure 8.2 Number of hours of music listened to each week.

listen to music often, with almost half listening to at least ten hours a week and one fifth more than twenty hours weekly. Most of this music listening revolves around four major genres: pop music, rock (including classic rock), alternative and hard rock (including punk), and rap and hip-hop (Figure 8.3). Consistent with findings from the National Endowment for the Arts National Survey of Arts Participation, young people are much less interested in classical music, with only 10 percent reporting that classical music is among the top three genres of music to which they like to listen—and only 3.5 percent selecting it as their top choice.

When examining variety-seeking behavior, a central concern of this chapter, the sample of students were almost evenly divided between two statements: 48 percent chose "I generally stick to music I like and know well and will try new things if others recommend them to me, but I do not actively look for new things"; 45 percent chose "I generally stick to music I like and know well, but I am actively looking for new things to try also" (Figure 8.4). These two groups might be characterized as those who are open to variety and those who seek out variety. Very few students (2 percent) shun variety entirely ("always stick to music I like and know well"), and very few (5 percent) are always experimenting and trying new things.

Figure 8.3 Music preferences by genre.

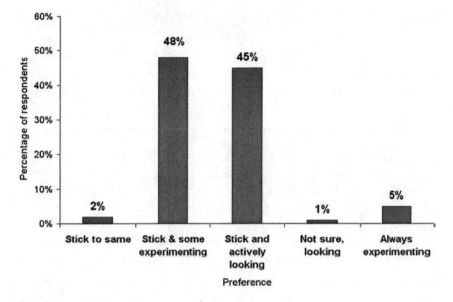

Figure 8.4 Disposition toward experimentation

What are the pathways through which students find out about new music? Do they use new technology, rely on trusted friends and acquaintances, or discover new music through the mass media? Table 8.1 shows the top ten pathways or search strategies. The top ways involve social networks, with personal acquaintances playing and recommending new songs as two of the most frequent pathways for finding new music (54 percent and 36 percent of the students, respectively, choose these as one of their top three strategies). Also, mass media remain an important source—though not as important as social networks. Watching MTV (28 percent) and listening to the radio (40 percent) were among the top four strategies. In general, new technology played a more minor role than expected. Use of P2P technologies (22 percent) was the most popular strategy in this group, followed by browsing a subscription library (9 percent), but both of these were far less popular than discovering new music through friends and acquaintances. The data collected for this study are a few years old, and it is possible that technology has become a more popular search strategy in the intervening years. Nonetheless, recent discussions with students affirm the premise that finding new music remains primarily a social process, and when technology is used, it is often in combination with social networks, as when a friend sends another friend an e-mail with a link to a new artist or album.

Table 8.1 Top Ten of Twenty-Four Total Search Strategies

Strategy	Total Strategies(%)
A personal acquaintance played me the song/album/artist.	54
Listening to a radio station (offline) that I frequently listen to.	40
A personal acquaintance recommended the song/album/artist to me.	36
Watching a music video on television (e.g., MTV).	28
Using a P2P file-sharing network.	22
Watching a film in which the song/artist was featured as part of the sound track.	20
Browsing through multiple radio stations (offline).	18
A personal acquaintance sent me the songs via the Internet.	14
A personal acquaintance made me a CD/tape compilation.	12
Browsing a subscription music library online (e.g., Rhapsody or iTunes).	9

Although most students do not rely exclusively on new technologies to find new music, new technologies still play an important role. How are users of new technologies different from their peers? Figure 8.5 compares technology users with those who do not use technology to find new music. The bars represent two types of technology users: (1) those who use technology, but not as their first choice; and (2) those who use technology as their first choice for discovering new music. Both are compared with the baseline of people (no bars shown in this case) who did not choose new technology (various online services) as one of the three top ways for learning about new music. The bars in Figure 8.5 represent the odds that a new technology user will do any of the five activities listed along the bottom, compared with someone who does not use new technology. So, for example, people who use new technology to discover music are more likely to listen to a greater number of different artists in a given week than nontechnology users (almost twice as likely); they also listen to a greater number of hours of music in a given week (again, almost twice as likely to do so).

In terms of their willingness to experiment and move beyond typical listening habits, technology users are more likely to say that they actively look for new things. Interestingly, technology users are not necessarily the ones who are the trendsetters. In other words, technology users are not more likely to consider themselves mavens (i.e., people who frequently make recommendations regarding new music to their

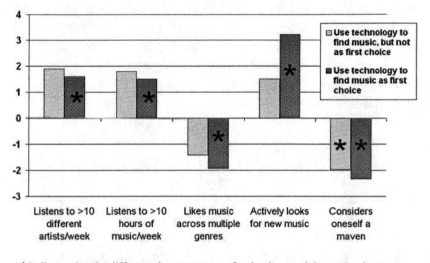

★Indicates that the difference between users of technology and those who do not use technology is statistically significant (at the .10 level), when comparing respondents by the 5 items at bottom of the chart.
Control variables include gender, whether respondent went to a private high school, whether they grew up in an urban area, and the amount of time they spend each week online (logged).
The vertical axis represents "odds"

Figure 8.5 Comparing technology and nontechnology searchers.

friends); in fact, they are twice as likely not to be mavens. Moreover, although technology users say they are more likely to be variety seekers, they are actually less likely to move out of their comfort zones and consume music across multiple genres.

Figure 8.5 shows that people who use technology as their first choice for discovering new music are almost twice as likely not to list their favorite styles of music across multiple genres (e.g., instead of listing classic punk, jazz, and hip-hop, they might list classic punk, mod punk, and new wave). Thus, initial evidence suggests that college students who use new technology to find new music most likely dig deeper in familiar territory—perhaps looking for artists or albums that are new to them but similar to styles they know well—rather than looking for music that would stretch their knowledge and tastes. Technology users act more like connoisseurs rather than true experimenters.

As discussed already, the study's evidence strongly suggests that social contact remains a key strategy for college students. Not only is

social exchange important, but much of this exchange also takes places through key influencers: 32 percent of all college students consider themselves mavens, and the vast majority (95 percent) rely on mavens for their own musical choices. Given the importance of mavens, it is important to try to understand their characteristics. Table 8.2 compares mavens and nonmavens in the study's sample. Mavens are more likely to be men, higher in socioeconomic status (measured by private high school attendance), and slightly more urban. They listen to more music than nonmavens in a given week and to a greater number of different artists. They are also more likely to seek out new music (76 percent of mavens are variety seekers compared to only 37 percent of nonmavens) and slightly more likely to cross over multiple genres.

However, counterintuitively, mavens are less likely to use technology to find new music (Figure 8.5), and they are more likely to rely on professional sources such as critics and journalists: 19 percent of mavens rely often or always on professional sources compared with 12 percent of nonmavens. When they do use new technology, they tend to browse the Internet, whereas nonmavens are more likely to use subscription services like Rhapsody or iTunes, which often have recommendations and staff-picks built into the service. In summary, mavens are important cultural brokers who value novelty. They use a diverse mix of search strategies—

Table 8.2 Comparing Mavens and Nonmavens

	Maven (%)	Nonmaven (%)
Rely on recommendations from professional sources (critics, journalists) when choosing to listen to recorded popular music (often or always)	19	12.4
Listens to more than ten hours of music per week	64	38
Listens to more than ten different artists per week	75	70
Male	54	40
Grew up in urban setting	27	18
Likes to experiment or look for new music and artists	76	37
Went to a private high school	33	20
Likes music across multiple genres	71	65

Note: Mavens are defined as "people who frequently make recommendations to others regarding new music." Of the sample 32 percent identified themselves as mavens.

as do nonmavens—including reaching beyond their own social circles to find music recommended by professional critics, watching music videos, and passing on recommendations that they have received from others.

Overall, the search strategies of mavens and nonmavens are remarkably similar. In general, mavens are not operating in some parallel universe of cultural choice and consumption, connecting their friends to treasures far away. The only significant difference between the two is that mavens are more likely to stretch their tastes further and to share their discoveries more often.

Implications: A Dynamic Model of Cultural Preference Formation

This study's data describe a dynamic community of listeners interacting with new technology, with established media (e.g., MTV), and with each other. This picture differs dramatically from the idea of the individual consumer who has relatively stable preferences and who is influenced primarily by traditional media. Figure 8.6 presents a schematic of such an individual, where marketers can either appeal to existing preferences—an individual's portfolio of favorite artists and genres—or they can try to induce an individual to try something new. Although this model allows room for some experimentation (i.e., trying something new), it conceives of the individual in a relatively bounded social and cultural space. The model does not acknowledge changing social dynamics (e.g., new friendships, new social networks) and how these changes might influence an individual's cultural preferences.

Figure 8.7 presents an alternative way to think about cultural consumption. Here, individuals are not isolated, individual consumers; rather, they are part of an overlapping network of cultural exchange. Each individual still has a set of preferences—likes and dislikes—but many of these preferences are determined by other individuals, especially mavens: those friends and acquaintances who are actively searching for and sharing new music, books, and films.

In this model new culture enters through multiple points—sometimes through traditional media, like *Rolling Stone* magazine, radio, or MTV—and other times through word of mouth. New culture is also actively discovered rather than being acquired by relatively passive indi-

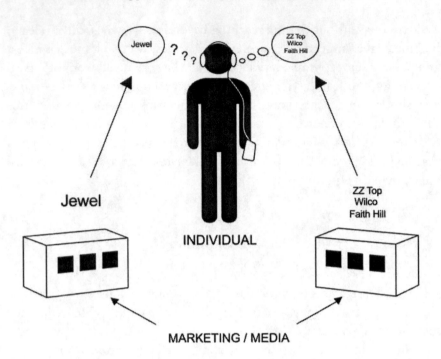

Figure 8.6 Old model: Individuals have stable preferences. Cultural producers must either target existing preferences (e.g., ZZ Top, Wilco, or Faith Hill) or try to create a new preference (e.g., Jewel).

viduals who are the targets of media and outreach campaigns. It is also clear that such an interactive model is highly dynamic. If preferences are connected through a series of overlapping network ties, then as the social world changes (e.g., new friendships, changing relationships, new ways of sharing information), cultural choices and interests will take a variety of shapes and forms. Imagine a popular children's toy, a Hoberman Transforming Sphere, made up of multiple interlocking rings. As one end of the sphere is pushed on, the entire sphere grows, shrinks, or changes shape. Small changes to the sphere can have large consequences. This idea is very much in line with the scholarship on social networks and the diffusion of innovation. An idea introduced in one part of a social network can easily influence the entire network. This alternative model suggests that cultural preferences and choices are socially contingent, relatively malleable, and formed through active search strategies and social exchange.

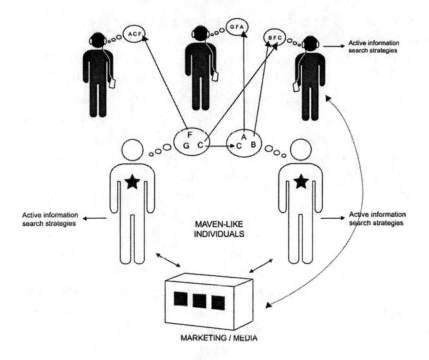

Figure 8.7 Alternative model: Individuals have shifting preferences, which are determined in large part by social networks and the influence of other mavens. (Note: Letters "A," "B," "C," etc. represent cultural preferences or choices e.g., a particular artist, CD, style, or music genre.)

Conclusion

This chapter has explored how college students find new music, but the larger goal is to shed some light on the process of discovery in cultural consumption. To date, leaders who care about arts participation have focused on issues of literacy and access. Can we give people, especially young people, the skills and knowledge to appreciate certain types of art and culture—painting, classical music, theater, and dance? And, assuming a basic foundation of literacy and knowledge, can we ensure access to these benchmark art forms? But this focus has largely ignored the process of discovery. Yet we know from economists and social psychologists that part of the meaning and enjoyment of consuming goods involves wandering off the beaten path.

This research suggests that many young people actively seek new avenues when it comes to listening to music and that many others rely on friends and acquaintances to suggest new paths to them. What encourages this type of discovery, and what tools help young people find new music? It was expected that new technology would be a critically important tool in this process because the number of devices that help people search for, experience, and exchange culture has grown exponentially in recent years. In theory, new technologies should be launching a renaissance of cultural experimentation. Surprisingly, however, new technology is far less important than social networks in connecting young people to new music. Furthermore, traditional media (e.g., newspapers, radio, MTV) remain important sources of information.

It is quite possible that new technology will become more important over time, especially as prices drop and as consumers shift to an increasingly all-digital world. But as with older technologies (e.g., automobiles, the telephone, television), these new technologies are expected to be shaped by the customs, habits, and needs of individual citizens. Discovering new music, books, films, and other forms of entertainment is a social process. It is social both because our friends and acquaintances provide us with valuable information as we navigate a crowded marketplace in search of "the stuff we like best" and because our connection to others is forged, in part, by discovering culture together.

It is suspected that new technology will increasingly make it easier for people to discover art and culture. As this pilot study demonstrates, people who rely heavily on new technology seem more inclined to seek out new music and artists actively, but they are less likely to seek out new formats and genres. Users of new technology, at present, are also less likely to be mavens, meaning they are potentially less invested in sharing their discoveries with others. These last two findings suggest that there may be more evidence for the "Daily Me" argument than the notion of widespread cultural grazing. So, new technology is not a silver bullet, either for consumers or producers of art and entertainment. Policymakers who want to elicit more variety seeking and discovery should invest in or work with those technologies that facilitate social exchange—like P2P networks or social networking sites like MySpace. In addition, they should pay special attention to networks that connect people across different social worlds, thereby increasing the chance

that cultural discovery will cut across boundaries rather than servicing existing preferences and tastes.

From the standpoint of those who produce or present art and entertainment, investing in new technology is only one approach to reaching new audiences. Creating electronic mailing lists, streaming content, or producing podcasts are strategies that may increase reach or facilitate the delivery of content. But these strategies alone are not likely to influence, to a great extent, the behavior of individual consumers and participants. Instead, such efforts must be linked to the social process by which people discover new culture. Producers must identify and work through mavens, and they must facilitate the sharing of content—rather than erecting roadblocks through tighter control over intellectual property. In short, enriching cultural participation means stimulating the many synapses by which culture flows between individuals—exchanges that are essential for discovery and experimentation. Technology can create more synapses and can stimulate those that already exist, but ultimately, we wander off the beaten path holding hands with others.

Bibliography

Anderson, Chris. 2004. "The Long Tail." *Wired* 12.10. http://www.wired.com/wired/archive/12.10/tail.html.

Bakos, Y. 1998. "The Emerging Role of Electronic Marketplaces on the Internet." *Communications of the ACM* 41: 35–42.

Carey, J. 1988. *Communication as Culture.* New York: Routledge.

DiMaggio, Paul, and Hugh Louch. 1998. "Socially Embedded Consumer Transactions: For What Kinds of Purchases Do People Most Often Use Networks?" *American Sociological Review* 63: 619–37.

Doctorow, Cory. 2003. "eMusic Turns into a Steaming Pile." BoingBoing. http://www.boingboing.net/2003/10/09/emusic_turns_into_a_.html.

Francisco, Bambi. 2006. "MySpace in Its Own Space." MarketWatch. http://www.marketwatch.com.

Gladwell, Malcolm. 2000. *The Tipping Point: How Little Things Can Make a Big Difference.* Boston: Little, Brown and Company.

Granovetter, Mark. 1995. *Getting a Job: A Study of Contacts and Careers.* Chicago: University of Chicago Press.

Jupiter Research. 2004. "Market Forecast Report: Music, 2004 to 2009." New York: Jupiter Research.

Karr, Rick. 2002. "TechnoPop: The Secret History of Technology and Pop Music." National Public Radio. http://www.npr.org/programs/morning/features/2002/technopop/index.html.

Katz, Elihu, and Paul Lazarsfeld. 1955. *Personal Influence: The Part Played by People in the Flow of Mass Communications*. Glencoe, IL: Free Press.

Negroponte, Nicholas. 1995. *Being Digital*. New York: Knopf.

Neuman, W. Russell. 1991. *The Future of the Mass Audience*. New York: Cambridge University Press.

Rogers, E. 1995. *Diffusion of Innovations*. New York: Free Press.

Senior, Nassau W. 1854. *Political Economy: Library of Economics and Liberty*. London: Richard Griffin and Company.

Starr, Paul. 2004. *The Creation of the Media: Political Origins of Modern Communications*. New York: Basic Books.

Sunstein, Cass. 2001. *Republic.com*. Princeton, NJ: Princeton University Press.

Turow, Joseph. 1998. *Breaking Up America: Advertisers and the New Media World*. Chicago: University of Chicago Press.

_____. 2006. *Niche Envy*. Cambridge, MA: MIT Press.

9 Audiences for the Arts in the Age of Electronics

Joel L. Swerdlow

Introduction

The shopping mall security guard, who says her name is Laura and describes herself as "tall with reddish blond hair," sits all day in front of images from security cameras, so she tries to break the boredom. Some days, she uses the cameras to follow the activities of a young shoplifter who has some very effective routines; another time, she leaves the windowless security office to retrieve a wallet that a man had just dropped in the parking lot. Examining its contents, she begins to imagine what his life must be like. She also connects the security cameras to a Web site and allows people to actually control the security cameras, choosing what areas to monitor and what angles to use. Talking to its visitors via computer, she sometimes wears high-heeled shoes that click as she paces back and forth. The security cameras are real, and visitors to the Web site can indeed control them, but they are at the Vancouver

Art Gallery, and Laura, her shoplifter, and all other individuals in her life, do not exist. It is all a work of art, blending imagination and reality and using new technology to engage viewers. After spending time with Laura, simply going to a museum and looking at works of art that just stay on the wall, unmoving and untouchable, will never seem the same again.

The Vancouver exhibit is only one example of how new technologies are transforming the arts and the way we experience them. Four young GIs in Iraq decided to give folks back home a taste of life and death in Iraq. They wrote hip-hop music and lyrics, improvised a recording studio, and between combat missions produced a CD titled "Live from Iraq," with song titles like "Hate Me" and lyrics that captured deep emotions. Still in Iraq, the GIs use a Web site (http://www.4th25.com) to sell their CD and to discuss the war with customers.

Such changes in artistic expression and production as well as in audience participation and expectations are fundamental, continuing, and—to a large degree—generationally defined. Those who finance and manage the arts know that to attract younger people they must adjust to this new reality and that each new generation will be increasingly comfortable with and skilled in new technologies. This chapter argues that electronics, or new technology more generally, has the potential to transform cultural engagement in at least four ways: (1) creating environments where multitasking is common and connectivity is continuous; (2) influencing the depth, concentration, and focus of engagement; (3) allowing for more interactive experiences with art and entertainment; and (4) facilitating the personalization and customization of media and art.

This is the most recent major technology-driven change in the arts since the beginning of recorded history. One of the earliest came with the written word and mass literacy. From at least the time of Homer to the medieval ballads of *Beowulf* and beyond, the format and delivery of these poems remained essentially the same. Then sometime before the birth of the modern world in the sixteenth and seventeenth centuries, both the poets and the ballads disappeared.[1] A second technology-induced change came with urbanization and industrialization. In 1800 poet William Wordsworth (1800, p. xviii-xix) already recognized the growing demand for art, news, and entertainment, noting the "increasing accumulation of men [people] in cities, where the uniformity of their

occupations produces a craving for extraordinary incident, which the rapid communication of intelligence hourly gratified." Throughout the rest of the 1800s, as historian Lawrence W. Levine (1984) documented, the rise of industry created new middle and upper-middle classes that were armed with disposable income and provided a growing audience for the arts. At the same time, as Robert Putnam (2000, p. 377) noted in *Bowling Alone*, "ordinary men and women [began] forsaking participation for spectatorship ..." Putnam quoted sociologist Robert Park, who wrote in 1918, "... We are represented now by proxies where formerly we participated in person. All the forms of communal and cultural activity in which we ... formerly shared have been taken over by professionals and the great man of men [and women] are no longer actors, but spectators" (ibid., p. 377–378).

The most recent change emerges from growing intimacy with and dependency on electronics, including, but not limited to, televisions, satellites, computers, and various types of telephones. A vast and growing body of empirical literature documents both the time spent with these machines and their impact on citizens. Take simply one demographic group: children. According to a 2005 Kaiser Family Foundation study, the average child in America is exposed to 8.5 hours of television, DVDs, computers, video games, and other electronic devices every day; more than one quarter of all children under age two in the United States have a television in their bedroom.[2]

The Always-On Generation

Mobile, wireless equipment is erasing what would otherwise be natural limits on the amount of time people can devote to electronics—and is spawning new forms of narrative art. Cellevision programs, one-minute episodes of specially produced segments, are now available on cell phones, and entire network and cable programs are available for download to MP3 devices like an iPod: "[You can] take your personal entertainment experience with you everywhere you go," explains one industry executive (Robischon 2005, p. E4).

The portability of media, entertainment, and communication devices means that people, especially young people, are increasingly connected at all times. The current decade marks the rise of the "always-on"

generation. Sixty-six percent of all high school juniors and seniors own their own cell phones, and fully two thirds of those younger cell phone owners report that they always have their cell phone on (Pew Internet and American Life Project Survey 2005). A walk across a college campus forcefully brings home the point. Ten years ago, between classes students would walk together in groups, talking to each other, exchanging glances, and enjoying seeing and being seen. Today, students are more likely to be found either on their cell phones or entranced by the music on their iPods. The presence of these new devices is dramatic.

Adults and children alike—armed with cell phones, computers, iPods, and channel changers—have an increasing capacity to multitask, monitoring more than one stream of information at the same time. There is even a new expression to describe this: *continuous partial attention*. One culprit of this trend is instant messaging, a technology that allows a person to hold a conversation with a friend or colleague in real time over his or her computer screen. Close to 70 percent of online teens use instant messaging, and, more revealing, 45 percent of them are typically engaged in multiple conversations at the same time (Pew Internet and American Life Project Survey 2005).

Clearly, attracting and keeping audiences in the future will require tapping into this world where ebbs of information and entertainment flow from every direction. Some may regret the distractions caused by this constant connectivity. In this respect it is harder to sustain the type of focused and deep engagement that might characterize traditional notions of an art experiences (e.g., listening, uninterrupted, to Beethoven's Ninth Symphony). On the other hand, perhaps the ability to process information from multiple sources simultaneously might give audiences new tools and new strategies for deep engagement (see Johnson's [2005] arguments about television and video, referenced following).

Today's events parallel the advances of visual perception that historian Michael Baxandall (1988) wrote about regarding fifteenth-century Italy. He argued that the experience of viewing a painting or fresco in the fifteenth century was much more complex and multidimensional than in earlier times. Because of changes in education and cognition, fifteenth-century viewers brought with them a new sense of three-dimensional perspective, a deeper understanding of religious symbolism, and a knowledge and familiarity with the laws of proportion. Baxandall referred to these new skills of perception as the *period eye* and sug-

gested that the experience of viewing a painting during the Renaissance changed fundamentally. Perhaps electronic media is our new period eye, and it is the task of artists and presenters to better understand how to enable and activate this new skill to more fully engage their audiences.

The new era, characterized by multiple stimuli and ever-present media, has, of course, brought changes to the traditional arts. Electronics pervade performances in large part because of what audiences expect and want to be able to do. At performances of opera, orchestras, and ballet, for example, huge screens are onstage to provide audience members with more intimacy, allowing them to look—as they choose—at close-ups of the performers' faces and to monitor many parts of the same performance at the same time. This is another form of multitasking or simultaneity. Thus, a press release from the Houston Symphony boasts that "cameras, screens, projectors, and support equipment [give] audience members close-up images of the conductor and musicians, a perspective generally only available to performers on stage."[3] One camera is even mounted on the conductor's podium. Likewise, new opera houses in Milan, Venice, London, Barcelona, and other cities are equipped with huge screens that show close-ups of the stage and orchestra. Some have gone so far as to proclaim that their performances incorporate MTV-style video and projections.

Such video enhancement offers new opportunities for creativity. A recent dance production, for example, had a photographer onstage and a screen that instantly showed the pictures she took (Kinetz 2005). Thus, the screens have become a new art form unto themselves, and decisions about what to show and how to show it demand a new range of skills and sensitivities (Kasparov 2005). It is not surprising, therefore, that video design has become one of the most important credits in many performances.[4]

Use of screens as part of artistic performances is somewhat new but is now built into people's expectations when they see something that is live. Those who attend events such as rock concerts, for example, now assume that the performance will have huge screens. This even extends to academic, intellectual events such as the National Endowment for the Humanities (NEH) annual Thomas Jefferson Lecture in Washington, D.C. Since 1972, the NEH has invited a leading scholar to lecture on the "great idea" of his or her choice. Thousands of leading government officials and invited guests gather for an old-fashioned event during which

someone stands in front of them and talks. But now, above the speaker's head, is a 40-foot screen.

One particular type of screen, showing a written version of what the singers are saying, has transformed the experience of opera. In Mozart's *The Magic Flute*, Papageno says he prefers wine to wisdom "just like most people in the world." Audience members laugh, even though he sings in German and none of them speaks German. The singer who plays Papageno continues, playing to the crowd that is watching English translations projected onto a screen above the stage. Now such surtitles—also called supertitles—are available even when the opera is sung in English.

Some purists protest that such electronic intervention adversely affects the quality of performances and distracts the audience. The former director of productions for the English National Opera in London called supertitles "a celluloid condom insert between the audience and the immediate gratification of understanding" (Tommasini 2005). He even charged that they make audiences passive because they rely on the titles rather than focusing on the songs. Nonetheless, some companies are going even further. They are experimenting with handheld devices that provide the audience with information that explains and expands on what is happening onstage (John S. and James L. Knight Foundation 2004). More and more museums are also offering handheld computers with which visitors can design their own tours.

Changes in Cognition and Attention

Dependency on electronics is so intense and so unshakeable that some experts have now hypothesized that it is addictive. The eyes of even very young infants fixate on electronic screens, and many adults become anxious and preoccupied if deprived of their computer or cell phone. Based on analysis of dopamine and other neurotransmitters inside the human brain, a small but growing literature discusses the potential to become dependent on new forms of media, including the Internet.

Whether or not it elicits addictive behavior, the use of electronics has brought—and increasingly brings—profound cognitive and behavioral changes. Much of the best evidence can be found in medical literature. A recent article in *Pediatrics*, for example, concludes that "early

television exposure is associated with attention problems at age seven" (Christakis et al. 2004, p. 708). And a frequent lament from educators is that students have increasingly short attention spans, often attributed to television and video games.

But there remains a great deal of debate about the negative consequences of new media on attention spans and cognitive abilities. The media-effects literature is notoriously riddled with holes, and critics contend that no reliable studies consistently find long-term negative effects from media exposure. More recently, author Steven Johnson (2005) advanced a very compelling argument that suggests an opposite trend might be at work: Television, video games, and the multitasking entertainment might actually be making people smarter and more focused. He showed how the plot devices and story lines of television shows (e.g., *Hill Street Blues)* and movies (e.g., *The Matrix)* have become more complex and sophisticated over the past few decades, requiring viewers to process and synthesize more information and to form hypotheses, to make inferences, to recognize patterns, and to perform other complex tasks. He also demonstrated how video games require users to master complex algorithms, to learn through trial and error, and to store and use thousands of bits of information to advance and solve the main puzzles of games.

Malcolm Gladwell (2005, p. 89) wrote, "Video games are not games in the sense of those pastimes—like Monopoly or gin rummy or chess—which most of us grew up with. They don't have a set of unambiguous rules to be learned and then followed during the course of play. This is why modern video games are often baffling: players are not used to being in a situation where they have to figure out what to do. They think they only have to learn to press the buttons faster. But, these games do not work without critical information input from the player. Players have to explore and sort through hypotheses in order to make sense of the game's environment, which is why a modern video game can take 40 hours to complete."

The average video game requires a continuous sequence of decisions by the player or players, which is what primarily distinguishes the games from other forms of electronic entertainment, such as watching a movie or television program. In the game version of *The Godfather*, for example, players step into the familiar narrative of the Corleone crime family but then decide—based, of course, on choices provided by the

game's programmers—who lives or dies and who prevails in the end (Schiesel 2005). More in-depth participation comes from open-world games that someone plays online and in the real world, often actually meeting fellow players in person. As a result, gaming experiences are no longer limited—if they ever were—to a small group of social misfits. Industry studies indicate that 75 percent of the heads of households in the United States play them, and annual sales now seem to exceed $6.5 billion in the United States alone. Both figures continue to increase. [5]

Interactivity and a Do-It-Yourself Ethos

At the most basic level, electronics have encouraged and enabled people to engage in artistic self-expression. A Pew Internet & American Life Project study (2004, p. 3) found suggestions "that up to 10 million Americans earn at least some money from their performances, songs, paintings, videos, sculptures, photos or creative writing" and more than 90 million Americans "pursue some kind of artistic endeavor."[6]

Perhaps the most pervasive is taking photographs. As comments from survivors of the flooding of New Orleans due to Hurricane Katrina demonstrate, even the poorest of people have cameras and take pictures and home movies—many of which were circulated on blogs or were used in television broadcasts. Among other things, this has led to less reliance on professionals and to the emergence of new authenticity in artistic expression. After the attacks on the World Trade Center, for example, a Spring Street storefront gallery began to display photographs that people had taken of what they saw and experienced. The result is a book and a traveling exhibition, *Here Is New York: A Democracy of Photographs*, which combines the work of so-called ordinary people with some of the world's leading professional photographers. As an exhibition of these photographs travels across the United States and other countries, joining it are often "drawings, paintings, prints and sculptures" that are the creations of local people.[7]

Most noteworthy is how common such behavior, and the need for self-expression that it drives, has become. An estimated 10 million in the United States alone now maintain their own blogs—a means of expression that did not even exist ten years ago—a phenomena that scholars have begun to refer to as *participatory journalism*. A research

consulting firm estimates that as of April 2006, 70,000 new blogs were being created daily, many of which include original stories, interviews, and photographs; direct contributions to mainstream news outlets; and comments about stories. Scrambling to embrace and join this new phenomenon, newspapers have been allowing staff members to start their own blogs and are inviting people to write blogs that are incorporated into the newspaper's official Web sites. "Our hope is to convert the paper, through its Web site ... into a virtual town square, where citizens have a say in the news and where every reader is a reporter," proclaims one newspaper (Seelye 2005, p. C1).

Closely related to participatory journalism is what might be called *participatory scholarship.* Wikipedia, the online encyclopedia that invites everyone to contribute, now has nearly two million articles written by more than 50,000 people. And, even though study after study documents that people are reading less, the desire to write is increasing. A 2002 survey by the National Endowment for the Arts (NEA 2004) found that 7 percent of the United States, about 14 million people, said that they wrote creative works during the survey year[8] and that creative writing is most common among those under twenty-five.[9] The report went on to note that "contrary to the decline in literary reading, the number of people doing creative writing—of any genre, not exclusively literary works—increased substantially between 1982 and 2003.[10]

On a more mundane level, Current TV, a new cable television channel designed for eighteen- to thirty-four-year olds, offers VC2, which stands for "viewer-contributed content." Current's president of programming, David Neuman, described the various subject categories and then added the following:

> We produce pieces ourselves for every one of those categories, but we also leave the door open for the audience to produce pieces for them...we're about what's going on for young adults, and ... we want to show this in their own voice, and from their point of view We're hoping to get to 50 percent viewer-contributed content pretty soon Viewer-contributed content is essential to our mission, which is about democratizing television We're going to give our viewers the resources to create better and better content. We just launched a training module online, free, and available for everyone. We're also going to make other resources

available online—graphics, music, and more—in order to help you to make your pieces better."[11]

Current's Web site invites viewers to preview VC2 and to vote on what video clips are good enough quality to be broadcast. Whether such programs will attract an audience and prove successful as a business model remains to be seen. History indicates that all such ventures, even those that succeed, evolve, but Current's efforts clearly tap into something significant.

In *Everything Bad Is Good For You*, Johnson (2005, p. 119) noted, "A decade ago Douglas Rushkoff coined the phrase 'screenagers' to describe the first generation that grew up with the assumption that the images on television were supposed to be manipulated; that they weren't just there for passive consumption. The next generation is carrying that logic to a new extreme: the screen is not just something you manipulate, but something you project your identity onto, a place to work through the story of your life as it unfolds." Desire and ability to be part of the art includes making ourselves its subject. Critic Susan Sontag (2004, p. 28) noted, for example, that for generations people have believed that "to live is to be photographed, to have a record of one's life." There is, she says, "the deep satisfaction of being photographed" (ibid., p. 28) and "the distinction between photograph and reality can easily evaporate" (ibid, p. 42).

Being photographed has risen to an entirely new level on virtual sites like MySpace, where young people post photographs of themselves, keep journals, share music, and list hobbies. As of spring 2006, MySpace had 78 million users, with membership growing by 5 million per month.

Inactivity also involves giving audiences a more active role in decision making. The 2005 Kaiser Family Foundation study on the use of electronics in America makes the distinction between a passive and an active screen; computers are active and televisions are passive. But this is clearly too limited, as demonstrated by another growing phenomenon: audience feedback via telephone or to digital cable. On *American Idol*, viewers telephone a designated number to vote on what happens next week, and the super-popular crime series *Law & Order: Criminal Intent* series recently asked viewers to vote on whether a particular character should escape or be killed.[12]

The *Today Show* has sponsored its annual "Throws a Wedding" since 1999. Viewers vote for which of four couples will have their wedding broadcast live and then vote on major aspects of the wedding from the site to rings, dress, and honeymoon. Some of these selections stimulate nearly half a million votes. All of this, of course, affects far more than the arts and entertainment. Physicians have lost much of their status as authority figures and must adjust to treating patients who gather data on the Internet, ask questions, and question decisions. And politics have changed. When presidential candidates debate, television viewers now call in or go online to register their reactions, and tallies of their opinions runs as a scroll under the candidates' images while the debate is still under way. As these typical examples show, people have new expectations about participation: They are less passive and increasingly want to make choices, express their views, and control what they consume.

Desire to maximize participation by employing interactive exhibits has led to what some experts call the *Disneyfication of museums*. A recent *New York Times* article titled "Child-Friendly or Child-Frenzied? Turn Down the Interactivity, Please!" reported that "these days, many museums seem less like temples of culture and science and more like multimedia amusement parks" (Galant 2004, p. G16).

Thus, London's new Churchill Museum has numerous electronic displays because, in the words of one official, "contemplation is less important than interaction" (Rothstein 2005, p. B31). In other words, walking around, choosing what to look at, talking, and thinking is not active enough. People need—or at least seem to want—electronics. A recent study concludes, "Museum visitors will interact in an almost endless variety of ways with the exhibitions and with each other. In a contemporary exhibition of any discipline, it is not uncommon to find an introductory film; a collection of objects for viewing; elements to manipulate; labels and text panels to read (and sometimes even a reading area with books and comfortable chairs); photos, maps and other graphics; a learning center with Internet stations and computers; embedded films and video loops ... and an adjacent gift shop"(McLean 1999, p. 193).

Participation as Personalization

Looking at screens, reading surtitles, and punching questions into handheld devices are a new kind of participation that is, in turn, the product of electronic innovations. More traditionally, as defined in the RAND Corporation study *Gifts of the Muse*, participation is something like attending a live performance or visiting a museum (McCarthy et al. 2004). In a narrow sense, this is true. To go to the opera or a theatrical performance and to sit in the audience is participatory to the degree that people leave their homes. However, it is not participatory in the same sense as going to a museum. In a museum, people walk around, looking at what they choose, for as long as they choose, often while talking to other people. From this perspective, attending an opera and sitting in front of a television have much in common: Both are, or have been until now, passive. Indeed, one could argue that watching television is more participatory because people usually talk to each other, in one form or another, about what they are seeing.

But now, sitting at home has changed; the creation of more pathways of participation is so pervasive that they have changed people's expectations about other arts. Few people passively consume television anymore. Nearly 90 percent of people in the United States live in homes that can receive up to several hundred channels; a recent Federal Communications Commission study (2004) found that most households regularly watch an average of seventeen channels. Most homes in America now have at least one television with a remote control that makes channel changing effortless.[13] As recently as the early 1980s, virtually no home in the United States had a VCR on which to play tapes; now more than 94 percent of the homes have some recording device. And about 80 percent of the homes in America have a DVD player.[14] Such recording equipment allows viewers to time-shift, choosing when they want to watch a particular television program. Even more audience choices come from TiVo, or DVRs, a new technology that scans all channels and records programs that the owner has preselected, even from special services such as pay per view.

Such media allow viewers to personalize their cultural portfolios leading to the emergence of what Bill Ivey and Steven Tepper (2006, p. B7) referred to as the "curatorial me." With iPods, TiVo, and other time-shifting, editing, and reorganizing devices, citizens are increasingly

able to curate their own cultural experiences—exploring new types of culture and choosing when and how they want to experience art and entertainment. Although not necessarily producing art themselves, citizens have developed the skills and the expertise to be connoisseurs and mavens, organizing their cultural lives to reflect their lifestyles, habits, tastes, and identity.

Technological Determinism versus Determining Technology

The ultimate issue, of course, is the degree to which citizens control their reaction to and use of electronic technologies. Looking at technology of the 1830s, Ralph Waldo Emerson wrote, "Things are in the saddle and ride mankind"[15] (Emerson 1899). With the recent rate of technological change, this sentiment certainly resonates today. But scholars have shown time and again that people have choices when confronting new technologies, and therefore its effects can not be predetermined (Fisher 1994).

Historian David Nye (1997, p. 125) made this point when he argued that technologies are social constructions and that "machines are not meteors that come unbidden from the outside and have an 'impact.' Rather, human beings make choices when inventing, marketing, and using a new device."

Thus, as cultural leaders and cultural participants, citizens might see the revolution of electronics as disruptive to business as usual. They may lament the fact that our audiences are harder to control—both in terms of getting them to theaters, museums, and concert halls in the first place or getting them to focus on the message or experience as it was conceived and programmed. They also may regret the increased competition from electronic media and from the vast and growing media empires. But they must resist being deterministic about the actual consequences for art and audiences.

A good example of growing pessimism relates to recent concerns about reading, which some argue is in steady decline. Twice as many movies are rented each day in the United States than books taken out of public libraries. According to a recent Carnegie Corporation study, "Baby Boomers read newspapers one third less than their parents; and the Gen-Xers read newspapers another one-third less than the Boom-

ers" (Brown 2005). Likewise, a recent survey of reading habits in the United States by the NEA (2004, p. vii) reported, "For the first time in modern history, less than half of the adult population now reads literature." Not hiding despair, the NEA lamented that "literary reading in America is not only declining among all groups [including those with the most education], but the rate of decline has accelerated, especially among the young" because "literature now competes with an enormous array of electronic media."

Those who write, and who make their living from the published word, know that the best future lies not in complaints but in the hard work necessary to understanding how the written word—which has, after all, endured for more than 5,000 years—can flourish in this new environment. Perhaps the short story, serial fiction, autobiography, or other forms of reading and writing (not yet invented) will flourish and lead to a different type of literary revival. The proliferation of journal entries, poetry, and blogging that teens are already doing online should give the NEA and other concerned citizens a reason to reconsider their pessimism.

The fate of reading is particularly salient for those most worried about the effects of new technology because books represent an ideal sanctuary, where readers can lose themselves to the ideas and aesthetic pleasures offered by the author. Many are concerned that the pervasiveness of the electronic media will make it harder for the arts to offer such spaces of quiet contemplation and authentic experience. Scientist turned essayist Alan Lightman (2005, p. 2) captured this sentiment when he wrote, "I can remember a time when I did not live this way. I can remember those days when I would walk home from school by myself and take long detours through the woods. With the silence broken only by the sound of my own footsteps, I would sit on the banks of Cornfield Point and waste hours watching tadpoles in the shallows or the saw of the water grasses in the wind. My mind meandered. I thought about what I wanted for dinner that night, whether God was a man or a woman, whether tadpoles knew they were destined to be frogs, what it would feel like to be dead"

Whatever their relationship to electronics, citizens can all still do this, and they can have art that helps us do it. And they can still enjoy the company of their fellow human beings and have art that help them do this, too. It is possible that artists and audiences will look to the arts as a way to resist the dominance of electronic media, gathering together around

culture to meet face to face or to find opportunities for quiet reflection. Perhaps enterprising and reform-minded artists and organizations will use electronic media to deepen engagement, to expand opportunities to interact with art, and to create new ways of seeing and experiencing art that are as authentic and meaningful as older forms of engagement.

So the age of electronics is still ours to define. The challenge for arts organizations and artists is to use technology and electronics to deepen engagement and enrich experiences. At a recent arts convening in Pittsburgh, a young filmmaker discussed a new approach to give audiences greater insight into the creative process. The filmmaker documented rehearsals of a new dance, producing a short film that features one of the lead dancers struggling with a particular jump. Before the performance, audiences previewed the film, which heightened the drama and the suspense of the live dance, with audiences wondering whether the dancer would make the jump.

Similarly, if an arts experience demands the ability to reflect and synthesize information during a performance or presentation, then perhaps the use of electronics to pause, rewind, or replay a segment of a performance makes sense—or handheld devices that allow audiences to retrieve additional information, biographical notes, and artistic commentary while watching a performance might enhance reflection. In another respect, if an arts experience demands the juxtaposition of different ideas and content, then electronics can facilitate this experience, as in the case of the photographer, mentioned earlier, whose onstage photographs appeared in real time on the screen behind the dancers. Similarly, many new media exhibitions use technology to overlay images, to create collage, or to otherwise force the audience to interact with contrasting media, images, or sound. Finally, if an experience requires quiet, uninterrupted contemplation, electronics might either be used as a foil against which a contemplative space can emerge, or artists and presenters can purposefully avoid the use of electronics altogether. The larger point is that as artists have long known, and as philosopher John Dewey described so passionately, the experience matters—electronics are just one tool, among many, that creative people can use to enrich, expand, and enliven the experience of audiences (Dewey, 1934).

Based on the research and artistic creations reported in this chapter, there is no question that audiences' expectations have changed and that those who present art need to be aware of this when designing

programs, marketing, or doing outreach. Clearly, using engaging electronics to help connect with audiences, especially young audiences, will be a necessary feature of future arts strategies. But, of course, pushing back against expectations is also an important part of art making. After building trust and interest with young audiences around new media, organizations will have the opportunity to go backward and forward—challenging expectations by introducing or reintroducing cultural forms that are unmediated by new technology as well as using technology to push audiences to unfamiliar places.

Bibliography

Baxandall, Michael. 1988. *Painting and Experience in Fifteenth Century Italy: A Primer in the Social History of Pictorial Style*. Oxford: Oxford University Press.

Belson, Ken. 2005. "Talking Loudly to the TV Set, and Maybe Getting a Response." *New York Times*, April 4, p. C6.

Brown, Merrill. 2005. "Abandoning the News." *Carnegie Reporter* 3, no. 2 (Spring). http://www.carnegie.org/reporter/10/news/.

Christakis, Dimitri A., Frederick J. Zimmerman, David L. DiGiuseppe, Carolyn A. McCarthy. 2004. "Early Television Exposure and Subsequent Attentional Problems in Children." *Pediatrics* 113, no. 4 (April): 708–713.

Dewey, John. 1934. *Art as Experience*. New York: Minton, Balch and Company.

Emerson, Ralph Waldo. 1899. "Ode to William H. Channing." In *Early Poems of Ralph Waldo Emerson*. New York: Crowell and Company.

Entertainment Software Association. 2005. "Essential Facts about the Computer and Videogame Industry." May 18. http://www.theesa.com/files/2005EssentialFacts.pdf.

Federal Communications Commission (FCC). 2004. "Report on 'Cable A La Carte Pricing Model.'" November 19. http://hraunfoss.fcc.gov/edocs_public/attachmatch/DOC-254443A1.pdf.

Fisher, Claude S. 1994. *America Calling: A Social History of the Telephone to 1940*. Berkley: University of California Press.

Galant, Debra. 2004. "Child-Friendly or Child-Frenzied? Turn Down the Interactivity, Please!" *New York Times*, March 31, G p. 16.

Gladwell, Malcolm. 2005. "Brain Candy." *New Yorker*, May 16. Vol. 81, 155 13. 88–89.

Gross, Michael J. 2004. "Vote on Plot Raises Ire of 'Law & Order' Fans." *New York Times,* October 26, p. E3.

Henry J. Kaiser Foundation. 2003. "Zero to Six: Electronic Media in the Lives of Infants, Toddlers, and Preschoolers." Fall. http://www.kaisernetwork. org/health_cast/uploaded_files/102803_ktf_kids_report.pdf.

Ivey, Bill, and Steven J. Tepper. 2006. "Cultural Renaissance or Cultural Divide." *Chronicle of Higher Education*, May 19. B6–B8.

Johnson, Steven. 2005. *Everything Bad Is Good For You*. New York: Riverhead Books.

Kasparov, Garry. 2005. "The Great Game." *Wall Street Journal*, March 14, p. A16.

Kinetz, Erika. 2005. "O.K., Great, Just Hold That Pose and Smile." *New York Times*, April 24, ARTS, p. 25.

John S. and James L. Knight Foundation. 2004. "Smart Concerts: Orchestras in the Age of Edutainment." Issues Brief 5, December. http://www. knightfdn.org/music/pdf/Knight_MoM_brief5.pdf.

Levine, Lawrence W. 1984. "William Shakespeare and the American People: A Study in Cultural Transformation." *American Historical Review* 89, no. 1 (February): 34–66.

Lightman, Alan. 2002. "The World Is Too Much with Me: Finding Private Space in the Wired World." The Hart House Lecture. http://www.harthouselecture.ca/resources/Lightman_2002.pdf.

McCarthy, Kevin F., Elizabeth H. Ondaatje, Laura Zakaras, and Arthur Brooks. 2004. *Gifts of the Muse: Reframing the Debate about Benefits of the Arts*. Santa Monica, CA: RAND Corporation.

McLean, Kathleeen. 1999. "Museum Exhibitions and Dynamics of Dialogue." *Daedalus*. 128 no. 3 (summer). 83–108.

National Endowment for the Arts (NEA). 2004. "Report: Reading at Risk—A Survey of Literary Reading in America." June. www.arts.gov/pub/readingatrisk.pdf.

Nye, David. 1997. "Shaping Communication Networks: Telegraph, Telephone and Computer." In *Technology and the Rest of Culture*, edited by Arien Mack, 125–149. Columbus: Ohio State University Press.

Pew Internet & American Life Project. 2004. "Artists, Musicians, and the Internet." December 4. http://www.pewinternet.org/pdfs/PIP_Artists. Musicians_Report.pdf.

_____. 2005. "Teens & Technology." http://www.pewinternet.org/pdfs/PIP_ Teens_Tech_July2005web.pdf.

Putnam, Robert D. 2000. *Bowling Alone: The Collapse and Revival of American Community*. New York: Simon & Schuster.

Robischon, Noah. 2005. "Thanks to Cellphones, TV Screens Get Smaller." *New York Times*, February 15. E1–E4.

Rothstein, Edward. 2005. "Churchill at a Touch of a Screen." *New York Times*, February 11, p. B31.

Rushkoff, Douglas. 1999. *Playing the Future*. New York: Riverhead.

Schiesel, Seth. 2005. "How to Be Your Own Godfather." *New York Times*, July 10, section 2, p. 1ff.

Seelye, Katharine Q. 2005. "Hands-On Readers: Why Newspapers Are Betting on Audience Participation." *New York Times,* July 4, section C, p. 1.

Sontag, Susan. 2004. "The Photographs Are Us." *New York Times Magazine,* May 23, pp. 24–29, 42.

Tommasini, Anthony. 2005. "Choice Words in Protest of Spelling It All Out." *New York Times,* July 3, 2.26.

Wordsworth, William, and Samuel Taylor Coleridge. 1800. "Preface." In *Lyrical Ballads, with Other Poems. In Two Volumes.* Second Edition. Volume 1(of 2). London: Biggs and Company.

Endnotes

1. Of course, nothing ever entirely goes away. Today rap songs, especially the longer versions, have many elements of storytelling poems.
2. Of children between age six months and two, 59 percent watch television on a typical day (Henry J. Kaiser Foundation 2003, p. 6).
3. See http://www.houstonsymphony.org/about/press/detail.aspx?id=6.
4. Other examples come from instant replay at sports events including the fall 2004 controversial play at Yankee Stadium. See "In the Park, but in the Dark: Fans Call Home for Replays," *Wall Street Journal,* October 26, 2004, p. B1.
5. Entertainment Software Association (2005).
6. Pew Internet & American Life Project (2004, p. 3).
7. See "About," Here Is New York, 2004, http://hereisnewyork.org/about/.
8. p. 18.
9. ibid. (p. 19).
10. ibid. (p. 22).
11. Tracy Swedlow, "Tracy Swedlow's itvt News Blog." http://blog.itvt.com/my_weblog/2005/08/_current_a_tv_c.html
12. Gross (2004, p. E3). An increasing number of television commercials urge viewers to go to a particular Web site. A closely related activity is how Major League Baseball allows fans to vote—as often as they wish—for members of the All-Star teams.
13. Already in the test stage is new technology that allows people to ignore the remote and simply tell the television to change channels (Belson 2005, p. C6).
14. "Slowing DVD Sales Hit Studio Shares," Financial Times, July 12, 2005, 19.

10 Can There Ever Be Too Many Flowers Blooming?

Barry Schwartz

Introduction

Fifty years of psychological research have confirmed the obvious: Freedom and autonomy are essential to human well-being. Unless people can exert significant control over the events in their lives, they are diminished; indeed, they are candidates for clinical depression (Seligman 1975). At the level of entire societies, there is evidence that democratic political organization, including the protection of civil liberties, has a bigger effect on life satisfaction than does material affluence—at least among those whose material circumstances meet subsistence needs.

The operational sign of freedom and autonomy is choice. To be free and autonomous is to be able to make choices. This means that no one compels us to do anything and that there are real options. Freedom of choice by statute or ideological commitment is empty if our world affords us few alternative courses of action. Thus, we have a kind of syl-

logism: The more autonomous people are, the better off they are, and the more choices people have, the more autonomous they are. Thus, the more choices people have, the better off they are.

This line of reasoning comports nicely with ideological defenses of the free market as the ideal institution for the production and distribution of goods and services. A central aim of public policy in a democratic society should be improving the welfare of its citizens. Even when resources are plentiful, this is an extremely challenging task because of the difficulty of determining what comprises *welfare*. Beyond basic necessities, there is great individual variation in what people want out of life. This is true with respect to material goods, and it is also true with respect to what people want from their work, their medical care, their educational opportunities, their relationships with others, their public institutions, the arts, and just about everything else. So any specific commitment of public resources (to, e.g., the arts, improved science curricula, green spaces, medical facilities) is likely to please some people and to displease others.

The way to solve this problem, we are often told, is to provide a wide range of opportunities and to let people determine what promotes their personal welfare. Since each individual is in the best position to judge his or her welfare, this solution to the social welfare problem cannot be improved on. This idea has been the central dogma of neoclassical economics from its inception. To improve welfare, one must increase freedom of choice—not necessarily because increased choice is intrinsically good (though it is) but because it increases the chances that each individual will be able to find something that serves his or her interests.

In short, if some choice is good, then more choice is better. Adding options is what economists call Pareto efficient: It makes no one worse off (because those who are satisfied with the options that are already available can ignore the new ones) and is bound to make someone (who is not satisfied with existing options) better off.

Though this line of argument is normally applied to the world of material goods, it seems even more applicable to culture. In addition to the fact that choice enables each individual to participate in cultural forms that suit his or her own tastes and preferences, a proliferation of cultural forms and objects will also have positive externalities. People who would not normally listen to hip-hop music nonetheless benefit from its immediacy on those occasions when they are exposed to it. Peo-

ple who are not turned on by abstract expressionism can still have their conception of visual art expanded when they see it. The proliferation of cultural forms enlivens the imagination of all members of a society. It enriches our sense of human possibility. It may even empower people to be producers as well as consumers of culture—to find their own, unique mode of self-expression. Those who are offended by abstract expressionism or hip-hop can always choose to stay away from them. So in culture, as in supermarkets, if some choice is good, then more choice is better. Indeed, the profusion of options may be as good a sign as there is of the health and vibrancy of culture.

If this is true, then all signs point to an American culture that has never been in better health. A new work of fiction is published in the United States every thirty seconds. The year 2003 saw the publication of 175,000 books, a jump of almost 20 percent from the year before (Miller 2004). There are now literally hundreds of TV stations; satellite radio, now in its infancy, offers hundreds of radio stations as well. Nonprofit arts organizations have grown vastly in the last generation. At the Toronto Film Festival in 2004, 300 films were presented—thirty a day—far more than even the most exuberant filmgoer could see. New modes of distribution are making it easier and easier for us to access this cultural diversity. Amazon puts the "world's largest bookstore" in each of our homes. TiVo lets us watch whatever TV shows we want, whenever we want. The Internet allows us to sample and then download all the music there is. Indeed, the Internet allows an unmediated relation between producers of culture and consumers. We can read thousands of blogs, written by people who have not been able to, or have not bothered to, find publishers. We can listen to the music of countless bands that have not yet secured record deals. We can see the paintings of hundreds of artists who are not represented by galleries. And each of these new forms of distribution permits us to personalize our cultural consumption to meet our tastes and preferences. Amazon does this for us, using our previous purchases—or mouse clicks—to suggest future purchases. So does satellite radio, with programming to meet every imaginable taste. Developments like TiVo and the increasingly omnipresent iPod allow us to edit out every cultural object or event that does not suit us. This may not be the best of all possible cultural worlds, but it certainly seems to be the best of all actual cultural worlds. Naysayers may complain that because of commercial pressure, there is actually less cultural diversity

than meets the eye and that what exists is mostly garbage ("fifty-seven channels and nothing on," as Bruce Springsteen sang). But even if this is partly true, the Internet has so dramatically reduced barriers to entry to the world of culture that the enterprising consumer can now step around the commercial behemoths and find productions that may not have enough mass-market appeal to make them viable.

The Psychologic of Choice

The logic behind the presumption that "if some choice is good, more choice is better" seems compelling. But what might be called the psychologic of choice tells us something different. In the last decade evidence has shown that there can be too much of a good thing—that a point can be reached at which options paralyze rather than liberate (Schwartz 2004). When there are too many choices, two things can happen. First, satisfaction with whatever is chosen diminishes, and second, people choose not to choose at all.

The first demonstration of what I call the *paradox of choice* was a study by psychologists Sheena Iyengar and Mark Lepper (2000) in which shoppers at a gourmet food store were confronted with a display that offered samples of a high-quality, imported jam. On one day six flavors were on display and on another day twenty-four. Shoppers who stopped by the display and tried the jam were given a coupon that saved them a dollar on any jam they bought. Iyengar and Lepper found that the large display attracted more customers than the small display. But when the time came to buy, shoppers who had seen the large display were ten times less likely to buy as the shoppers who had seen the small display.

And it is not just about jam. Subsequent studies have shown the following.

- Students given a large number of topics from which to choose were less likely to write an extra-credit essay than those given a small number of topics. When they did choose to write from the larger list, they wrote essays of lower quality (Iyengar and Lepper 2000).
- When owners of convenience stores were convinced to reduce the variety of soft drinks and snacks they had available, sales

volume increased, as did customer satisfaction (Broniarczyk, Hoyer, and McAlister 1998).

- Young adults made more matches in an evening of speed dating when they met eight potential partners than when they met twenty (Fisman et al. 2006).

- When employees are offered a variety of different funds in which to put voluntary 401(k) retirement contributions, the more funds that are available, the less likely they are to invest in any at all. For every ten funds offered, the rate of participation decreases 2 percent. This occurs despite the fact that in many cases, by failing to participate, employees are passing up significant sums of matching money from employers (Iyengar and Jiang 2004).

There are several reasons why increased options can lead to decreased choices. As the number of options increases, the costs, in time and effort, of gathering the information needed to make a sound choice also increase. The level of certainty people have about their choice decreases, and the anticipation that they will regret their choice increases. All of these factors can lead to decision paralysis. If and when people finally do choose, they will likely be less satisfied with the results than they would have been had there been fewer options. My colleagues and I have identified several reasons why increasing options can lead to decreased satisfaction with the chosen option (Schwartz et al. 2002; also see Schwartz 2004). Among them are the following:

- Regret: To the extent that the chosen option is less than perfect—as all chosen options inevitably are—it is easier to regret a choice if the alternatives were plentiful than if they were scarce, especially if the alternatives were so plentiful that not all of them could be investigated. Then, one can only imagine how good some neglected alternatives must have been. This regret subtracts from satisfaction with the decision.

- Missed opportunities: Even if the chosen option is wonderful, it is extremely likely that many rejected options will also have had at least some wonderful features that the chooser had to forego. As more options are considered, these missed opportunities accumulate and diminish satisfaction with the chosen alternative.

- The curse of high expectations: With many options to choose from, it is hard to resist the expectation that what one finally

chooses will be perfect, or at least extraordinary. We know from a great deal of research that the satisfaction people get from their experiences has more to do with whether the experiences meet or exceed expectations than with the absolute quality of the experiences themselves.

- Self-blame: In a world of limited choice, a disappointing result can be blamed on the paucity of possibilities. In a world of unlimited choice, it is hard to avoid blaming oneself for disappointment. There is just no excuse for failure.

Let us apply each of these psychological processes to a cultural example: selecting a movie to see in a twenty-screen multiplex. First, deciding which movie to see may be so hard that you do not go at all. You can easily imagine regretting whatever choice you make. But if you do go, and the movie is less than perfect (a little too violent, too glitzy, or too superficial), you will regret not having made a different choice, and you will blame yourself for having made the choice you did (one of the other movies must have been better). Finally, your assessment of the movie you see will almost certainly be affected by your expectation that with twenty movies to choose from, surely one of them had to have been better than the one you saw.

Is Culture Different?

Virtually all the research that has been done on what might be called *choice overload* has involved goods and services. Though choice overload is not restricted to the material domain—it also permeates decisions about careers, romantic relationships, religious commitments, and even personal identity—it is important to ask whether there is something about the world of culture that makes it different. Is it possible, in other words, that when it comes to culture, more choice is always better? There are reasons to regard culture as a special domain, and I think that the profusion of cultural options has positive externalities that make it good for society even if, at the same time, it adds to the frustration and confusion faced by individuals.

Unlike decisions in the material domain, culture is usually not an either–or option. As you try to decide whether to buy the new Philip

Roth or the new Stephen King for your flight across the country, you realize that you can read both. The same is true of movies, theater, TV shows, music, museums, and galleries. We all have limits of time and financial resources, but cultural objects and events are not substitutes for one another to the same degree that ordinary material objects are. Perhaps because culture is an experienced good, participating in cultural events may whet the appetite for more participation. Doing culture may stimulate demand for more culture. This may be enough, in and of itself, to make choice in the domain of culture an unalloyed blessing.

But perhaps more important are the multiple benefits to society as a whole. The great variety of cultural objects and events presents us with multiple perspectives, life experiences, and views of the world. American society has always contained multiple worldviews, but most of them have not been accessible to the culture at large. Instead, the tastemakers and gatekeepers, constrained by both ideologies and economic realities, made decisions for everyone about what would be available. The result was a pinched view of how people could, should, and actually did live, along with a set of cultural productions (e.g., books, magazines, music) in which the voices of most Americans were insignificant, if not invisible. Now almost everyone can become culturally enfranchised, at least in theory. I say *in theory* because the growth of media consolidation threatens cultural diversity in practice. What could be better for a vibrant democratic society? If it makes life a little more difficult for us as we make our cultural choices, this is a price that is well worth paying—or is it?

The Paradoxes of Choice Overload in Culture

I am a huge fan of Amazon. I once heard a guest on a radio talk show say that if Amazon could not figure out a way to be profitable, he would be more than happy to pay an annual fee to keep it going as a national resource. I agree completely. But why is it that I, and many others, love Amazon? As I was writing my book about how people are plagued by choices, my enthusiasm for Amazon nagged at the back of my mind as a dramatic counterexample. If the arguments in my book were correct, people should not love Amazon; they should be tortured by it. I had not resolved my puzzlement when a study appeared by Alexander Chernev

(2003), which showed that large choice sets are preferred to small ones when people know what they like and thus know what they are looking for: *preference articulation,* he called it. If you know what you like or what you want, then you just keep searching until you find it, and the larger the set of possibilities is, the more likely that one of those possibilities will match your preferences. It might take time and effort to sort through all that is out there, but at least you will not experience conflict and bewilderment. Moreover, a larger choice set increases the chances that what you are looking for actually exists. Finally, technology (essentially instantaneous Web search engines) has enabled us to cull large sets about as rapidly as small ones. As I read Chernev's article, I realized that my own behavior with Amazon virtually always fit this pattern. I knew exactly what I was looking for, and Amazon, the "world's largest bookstore," always seemed to have it. That is why I liked Amazon so much. No matter how arcane my interest, the book was there, in some virtual reality, ready to be shipped: no more hunting in store after store—no more special ordering with lengthy delay.

Beyond the endless inventory, Amazon also had an algorithm that suggested other titles that were similar to the one I asked for. The algorithm was not perfect, but it was surprisingly good. The combination of my prespecified goals and the Amazon algorithm reduced dramatically the set of choices I actually faced. Indeed, most of the time, the only choice I faced was to buy or not to buy. So if I knew exactly what I wanted, or if I was willing to let Amazon filter the possibilities for me, the potential choice overload problem went away.

If I am right about what makes Amazon a blessing and not a curse, we face a paradox of choice in the domain of culture that is unique with regard to the potential contribution that the diversity of cultural offerings makes to creating and sustaining a vibrant, pluralistic, democratic culture. Think about what "knowing what you want" means. It means that you are not so open to cultural diversity or serendipity. Instead, you put blinders on and walk straight ahead until you find what you are looking for. Indeed, in the Amazon world you may be even more resistant to fortuitous discovery than in a world offering more modest variety. Once you open yourself up to all that is possible, where does it end? Better to stay focused on the task at hand. And think about what the Amazon algorithm does. If you value Amazon's suggestions, then you are in effect using it to be your filter—your professional shopper.

It will suggest possibilities that are similar to things you have already purchased. Its aim is the opposite of diversity.

So the availability of culture providers like Amazon may mean greater interindividual diversity but less intraindividual diversity. Each of us will shop at our own, private bookstore within a bookstore. We will make less contact with literature that is different from what we already know we like than we would in the neighborhood bookstores of yesteryear, in which limited offerings made browsing feasible. I write about Amazon in detail not because it is unique but because it is a vivid example. The twin phenomena of buying only the culture that we want or relying on filters to tell us what we should want is becoming pervasive—a response, I believe, to overwhelming choice in the world of culture. There are now so many magazines narrowly tailored to particular interests that there is no need, ever, to read about something that lies outside our existing worldview. The same is true of broadcast and cable news sources. Political conservatives never have to encounter a fact or opinion that will make them uncomfortable—nor, though to a lesser extent, do liberals. Is it any wonder that the United States is as divided politically as it is? There is ample evidence from the psychological literature that even when confronted with balanced information, people are capable of distorting or discounting information they disagree with and bolstering views they already have. But at least in such a world people are exposed to the disagreeable information, and some of it, sometimes, for some folks, gets through. In the modern world, there is no reason for people to subject themselves to such exposure (Sunstein 2001).

The prominence of filtering driven by extraordinary amounts of choice tells us something important. Our cultural experiences will only be as diverse as the filters we use. With all that is available to us, unmediated browsing is impossible. Therefore, an honest appraisal of cultural variety as experienced requires an assessment of filters. There is great potential for diversity among filters: best-seller lists, local book clubs, arts and cultural organizations, museums, broadcast and print book reviews. But unless people are deliberate about the filters they use, their own cultural experiences will be anything but diverse. Given how paralyzing unlimited choice can be, my suspicion is that in the realm of culture, the more options there are, the more driven most people will be to settle on the most choice-simplifying filters they can find.

There is an additional point to be made about the potential paradoxical effects of choice on the cultural life of the nation. When choice becomes overwhelming, it can turn choosers into pickers. The distinction between the two lies in how active and engaged people are as they make their decisions. Choosers are active: They interrogate their own goals and critically evaluate how well the various options enable them to meet those goals. Choosing takes time, attention, and effort, but it bears fruit: Real depth of involvement with the options leads to the occasional discovery that none of the options is appropriate, and that we will have to invent our own. Picking is much more passive. We lie on our couch as options come by on a metaphorical conveyor belt, and we select one that appeals to us. Pickers will not be interrogating their goals. They will not be saying "none of the above" to the options they are presented with. We are all pickers some of the time, but my fear is that overwhelming options turn all of us into pickers most of the time. If so, it is having an effect that is the opposite of engagement with the life of our society. The paradox is that the more diverse and vibrant cultural offerings become, the more passive and stereotyped the selectors of those offerings become.

A recent laboratory study illustrates how increased choice can induce people to choose less and pick more. Atre and Katz (2005) exposed participants to choices among five or twenty-five thirty-minute television shows. Participants were to choose two shows to watch. With the larger choice set, fewer participants chose to watch news shows than with the small choice set. In addition, among those confronted with the large choice set, there was more genre rigidity in the second show they chose to watch—that is, an increase in show availability resulted in a decrease in the diversity of show selection. When the choice set was expanded, the kind of self-scrutiny that might characterize a chooser (e.g., "What do I want to experience now?") was often replaced by inertia. To buttress this empirical evidence, Nagler (2005) made a theoretical case that as the number of Internet options grows, people will increasingly rely on "branding" (i.e., the presence of the Internet outlet in another medium, for example CNN or ESPN) to help them make selections, so that the Internet will, in effect, become an echo of other media rather than an independent alternative to them. With so many possibilities available, a truly informed selection becomes difficult if not impossible. Consum-

ers fall back on a variety of labor-saving heuristics that solve the choice problem by making them much more passive decision makers.

Perhaps more troubling, this passivity can carry over into the ways people interact with what they have chosen. The distinction Richard Peterson and Gabriel Rossman (see chapter 13 in this volume) make between *highbrow* and *lowbrow* nicely captures this dynamic. As they suggest, the real force of the highbrow–lowbrow distinction lies less in the kinds of cultural objects people choose than in the orientation people take to those objects. Lowbrow patrons are passive consumers of culture, whether it be the symphony or a sitcom. They sit in their seats and say, "Entertain me." Highbrow patrons are actively engaged with the culture they experience. They think about it, feel it, talk about it, bond with one another over it, interpret it, and are changed by it. To the extent that culture has positive effects on a society, it is surely only when people bring a highbrow orientation to it.

To illustrate the consequences of this distinction, I discovered several years ago that the extremely thoughtful, critical students I teach at Swarthmore had a striking tendency to shut all that critical engagement down when they went to the movies. Commercial movies were meant to be a diversion—a break from the hard work of critical analysis that they did in their classes. Even as my colleagues and I were struggling to help our students to be thoughtful about the world, powerful conceptions of human nature and social life slipped into their heads while their guards were down. So with a colleague I taught a course that included a mainstream commercial movie every week to nurture the habit in students of bringing the same critical attitude to the things they encountered when they were recreating as they did when they were studying. This exercise worked, at least for the duration of the semester, but I fear that it cannot work when people are faced with the cultural variety that now confronts us every day. Passive choice heuristics will feed into passive engagement with the experiences that have been chosen.

To summarize the paradoxes of choice overload in culture, when people are overloaded they will (1) opt for the known entity as a way to avoid facing unlimited options; (2) rely on filters; and (3) become more passive in their participation in cultural life. In addition, if the characteristics of choice in the material domain hold true for culture as well, people will also get less satisfaction out of the cultural choices they make, and they will increasingly opt out altogether.

How Many Cultures?

None of these claims is good news, but I think there is even worse news. I fear that the explosion of cultural diversity threatens what culture is for. Culture is the language of Habermas's (1989) *public sphere*. For it to be an effective language, all participants in the public sphere must speak it. But the rampant diversity now available means that no one has to speak a language he or she does not like. We can respond to dissatisfaction with exit—abandon this TV station, magazine, newspaper, or musician and patronize another instead (an especially significant recent example is the development of a Christian entertainment industry that is quickly extending to all popular media). A more compelling and useful response to dissatisfaction is voice rather than exit. We speak up in an effort to change the cultural institutions we do not like. Conner (see chapter 4 in this volume) makes the illuminating point that in ancient Greece, patrons responded to theater (what we would now call high culture) in the way modern Americans respond to sporting events: Audience participation was the norm. Giving literal voice was what a theatergoer did.

Voice takes much more work than exit but contains the seeds of cultural transformation. Will people be willing to do the work? When cultural possibilities are limited, there is not much alternative to voice because there are not infinitely many options we can select instead of one we find unsatisfying. But when the options are bountiful, exit becomes much more attractive.

Distinguished economic historian Albert Hirschman (1970) initially made this distinction between exit and voice almost forty years ago. His point argued that the characteristic response to dissatisfaction in the marketplace is exit, whereas the characteristic response to dissatisfaction in the public sphere is voice—expressed as political or cultural participation. By creating cultural variety, we are turning culture into a market commodity. Rather than being an instrument of political and social engagement, it is becoming an item of consumption. For example, when there were three television networks, parents who were dismayed at the quality and quantity of programming available for children had to organize to demand something better. Now, each family can make independent decisions about which of dozens of stations just for kids are acceptable. Children's television is no longer a political issue.

I have a second, related fear. A significant function of cultural objects and events is to make people uncomfortable, as Pierre Bourdieu (1984) observed. People can become uncomfortable with the way they are living their lives, with the way others are living, with what is taught to their children in the schools, with what their government is doing in their name, and so on. But few are masochistic enough to seek out discomfort. We experience it because we cannot avoid it, and it changes us—or we change the things that caused it. But nowadays, we can avoid discomfort. We need never confront a disagreeable fact, an unsettling image, a challenging piece of music, or an angry dramatic representation of the world we live in. Each of us can find our own, individually tailored version of Aldous Huxley's soma. This is another facet of the distinction between exit and voice, and it threatens to make culture a very blunt instrument indeed—for providing insight into ourselves, for broadening our insight into others, and for energizing us to promote social change. And this is the ultimate paradox: Cultural pluralism leading to individual isolation, and cultural energy leading to individual passivity.

So How Many Flowers, and Who Decides?

In light of these arguments, we should be thinking about how to limit the range of cultural possibilities, in the service both of individual empowerment and collective democratic participation. The very possibility of limitation raises two questions: How much and by whom? The latter question is especially troubling; it is one thing to limit the number of cereals available for purchase—though why would one bother? But when it comes to culture—to First Amendment activities—everyone gets (appropriately) nervous. Nonetheless, I think this is an issue that has to be faced.

I can dispense with the first question—how many choices—quickly. No one knows. The only way to know we have enough is to experience too much. We now experience too much. A novel every thirty seconds is too much; 300 TV channels is too much. In both cases, and in virtually all others, less is more. But there is certainly no magic number of cultural options that will bring us all the benefits of cultural diversity with none of the costs.

The second question—who decides—is much thornier. At the moment, with respect to mass culture, we seem to have only a single decision maker: the market. The market has some virtues. It is, at least potentially, an expression of the popular will. But the market has only a single criterion for its filtering—profitability—and even if that is a legitimate criterion, it should not be the only one. Further, as we have seen in the decades since the Ronald Reagan deregulation revolution, now reaching its apotheosis in the reign of George W. Bush, without state intervention, massive power to control culture rests in very few hands. The market is an efficient mechanism for providing some of society's goods, but not all of them. Culture is one domain that needs to be—at least partially—protected from the market rather than provided by it.

With respect to elite culture, there are alternatives to the market, in the form of nonprofit arts organizations, universities, museums, libraries, community book clubs, theater groups, and the like. Such institutions can provide diverse and helpful sets of filters, and they require and deserve significant public support. But two questions arise with respect to these mediating cultural institutions: (1) Can they participate more actively in filtering the mainstream cultural productions that have been left entirely to the market? and (2) Do they need to change the way that they filter to accommodate the modern explosion of choice?

I have nothing useful or optimistic to say about the first question—about whether and how nonprofit arts institutions that are already struggling to pay the bills can take on the market behemoth. On the contrary, I think the powerlessness of nonprofit institutions in the face of the market has led many to make decisions about their own programming that exacerbate the choice problem rather than ameliorate it. Under financial pressure to put backsides in the seats, longer seasons, with programs that aim to appeal to everybody, have become the trend. Taking on the market in the world of popular culture is, at best, a question for long-term consideration.

The second question, however, can benefit from reflection in the short term. Nonprofit cultural institutions have always been sources of cultural diversity and filters of that diversity. Although they have taken both of these roles quite seriously, the emphasis in these institutions, in recent years, has been on promoting diversity—a refreshing change from their historic, stodgy past. For example, nonprofit theaters pre-

fer premieres to second productions (Tepper, personal communication), and funders prefer supporting something new to continuing what they have sponsored in the past. But in response to the choice problem, the time has come for the pendulum to swing back again and for these institutions to step up as our guides in the overwhelming cultural landscape by focusing more on filtering diversity than on creating it. They should concentrate what they offer rather than diluting it. They should put a lower value on novelty for its own sake. They should reach out to one another and pool resources to create fewer but grander cultural productions that capture the attention of a larger public. Finally they should encourage their patrons to be choosers rather than pickers by including patrons in the programming process.

The university is instructive here. In the big battles over the canon that marked the peak of the culture wars almost thirty years ago, the university was forced to liberalize its filters and to admit a broader range of possibilities into its club. Although it was never true, despite the hysterical complaints of cultural conservatives, that everything went, it was true—at least in my view—that too much went. In certain corners of the university, people lost Walker Percy's (1975) distinction between *knowledge* and *news,* and universities became repositories of the latest thing. Lately, there has been considerable self-correction. The curriculum has recovered some structure, there is some continuity from one year to the next, attention is paid to the staying power of texts and other cultural phenomena, and students have a better sense of where the things they study fit into the global cultural landscape. I assume (and hope) that we will not go back to the stultifying days of old, but we seem to be regaining some cultural equilibrium.

The university has corrected itself, but not without help. It was the target of massive criticism. Citizens voiced their concerns and forced the university to reevaluate what it was doing. This voice was—and still is—essential for helping institutions to develop in promising ways. This is why I see the potential substitution of exit for voice in our modern cultural profusion as so troubling.

So whereas it is extremely important for universities and other cultural institutions to be open to novelty and innovation, it is just as essential that they take their responsibilities as filters—as selectors—very seriously. It is important that each of us reads different books so that we can educate one another. But it is also important that we read at least

some books in common, so that the process of education has a platform from which to begin.

This conclusion may seem self-evident, but it suggests a shift of focus that is not so obvious in a world of endless choice. Philosopher Daniel Dennett (1975, p. 169) wrote that "it takes two to create anything." He meant that creativity requires both someone to generate novelty and someone to select from that novelty the bits that are actually worthwhile. This model of creativity is based on the way creativity happens in nature: natural selection. Random genetic recombination and mutation generate novelty, and reproductive effectiveness selects from that novelty.

Society has its generators and its selectors, people who seem to specialize in one component of creativity or the other. But in truth, both the generator and the selector live in each of our heads, dividing the labor. Dennett (1975) asked which of these components of creativity is the real creator, and his answer was that it depends: When novelty is scarce, most of the heavy lifting is done by the generator, but when novelty is pervasive, the burden falls on the selector. We most often think of creativity as the generation of novelty. The selectors (e.g., the editors, critics, program directors, creators of syllabi) are the enemies of creativity. I think, with Dennett, that this is a mistaken view in general, but I think it is especially mistaken in the modern world. Cultural creativity crucially relies on the process of selection. It depends on diverse, discerning, and engaged filters. In the modern world, all of our cultural experiences will have to be mediated by someone or something, and if we want a vibrant and creative culture, we need to cultivate vibrant and creative filters. Now, the process of selection is where the key to creativity lies.

Acknowledgment

I wish to acknowledge the invaluable editorial suggestions of Steven Tepper, who (I hope) prevented me from embarrassing myself as a complete neophyte to the issues that face the arts and culture in modern society. I also wish to thank several colleagues in the arts, literature, and social sciences at Swarthmore College who heard me give an informal presentation of my ideas in preparation for writing this chapter and

made several valuable suggestions I have tried to incorporate into the finished product.

Bibliography

Atre, J. and E. Katz. 2005. "What's Killing Television News?: Experimentally Assessing the Effects of Multiple Channels on Media Choice." International Communication Association. Annual Meeting. New York, New York.

Bourdieu, P. 1984. *Distinction: A Social Critique of the Judgment of Taste.* Trans. Richard Nice. Cambridge: Harvard University Press.

Broniarczyk, S. M., W. D. Hoyer, and L. McAlister. (1998) "Consumers' Perceptions of the Assortment Offered in a Grocery Category: The Impact of Item Reduction." *Journal of Marketing Research* 35: 166–176.

Chernev, A. 2003. "Product Assortment and Individual Decision Processes." *Journal of Personality and Social Psychology* 85: 151–162.

Conner, L. 2006. "In and out of the dark: A history of audience behavior from Sophocles to spoken word."

Dennett, D. 1975. "Why the Law of Effect Will Not Go Away." *Journal of the Theory of Social Behavior* 5: 169–187.

DiMaggio, P. and T. Mukhtar 2007. "Arts Participation as Cultural Capital in the United States." Chap. 12 in *Engaging Art: The Next Great Transformation of America's Cultural Life.* New York: Routledge.

Fisman, R., S.S. Iyengar, E. Kamenica, and I. Simenson, 2006. "Gender Differences in Mate Selection: Evidence from a Speed Dating Experiment." *Quarterly Journal of Economics* 121: 671–697.

Habermas, J. 1989. *The Structural Transformation of the Public Sphere: An Inquiry into a Category of Bourgeois Society.* Trans. Thomas Burger with Asst. Frederick Lawrence. Cambridge, MA: MIT Press.

Hirschman, A. O. 1970. *Exit, Voice, and Loyalty: Responses to Decline in Firms, Organizations, and States.* Cambridge: Harvard University Press.

Iyengar, S.S., W. Jiang, and G. Huberman, 2004. "How Much Choice Is Too Much: Determinants of Individual Contributions in 401 Retirement Plans." In O.S. Mitchell and S. Utkus (eds.), *Pension Design and Structure: New Lessons from Behavioral Finance.* 83–95. Oxford: Oxford University Press.

Iyengar, S. and M. Lepper. 2000. "When Choice Is Demotivating: Can One Desire Too Much of a Good Thing?" *Journal of Personality and Social Psychology* 79: 995–1006.

Miller, L. 2004. "How Many Books Are Too Many?" *New York Times Book Review*, p.23.

Nagler, M.G. *When Too Much Is Not Enough: Choice, the Internet, and Media Ownership Rules.* Unpublished manuscript, May 2005.

Ostrower, F. 2007. Multiple Motives, Multiple Experiences: The Diversity of Cultural Participation. In *Engaging Art: The Next Great Transformation of America's Cultural Life*, edited by B. Ivey and S. Tepper. New York: Routledge.

Percy, W. 1975. "The message in the bottle." *The Message in the Bottle: How Queer Man Is, How Queer Language Is, and What One Has to Do with the Other.* New York: Farrar, Strauss and Giroux.

Peterson, R. A. and G. Rossman. 2006. "Changing Arts Audiences: Capitalizing on Omniverousness." Chap. 13 in *Engaging Art: The Next Great Transformation of America's Cultural Life*. New York: Routledge.

Schwartz, B., A. Ward, J. Monterosso, S. Lyubomirsky, K. White, and D. R. Lehman. 2002. "Maximizing versus Satisfying: Happiness Is a Matter of Choice." *Journal of Personality and Social Psychology* 83: 1178–1197.

Schwartz, B. 2004. *The Paradox of Choice: Why More Is Less*. New York: Ecco.

Seligman, M. E. P. 1975. *Helplessness*. San Francisco: W.H. Freeman.

Sunstein, C. 2001. *Republic.com*. Princeton, NJ: Princeton University Press.

11 By the Numbers

Lessons from Radio

Gabriel Rossman

Introduction

In 1935 at Ohio State University, Frank Stanton defended his dissertation in psychology, "A Critique of Present Methods and a New Plan for Studying Radio Listening Behavior." The word *methods* is as important as *radio,* for the thesis was less about substantive facts of the medium than about systematic and rational approaches for investigating those facts. CBS immediately brought Stanton to New York to work in its research department. There he collaborated with the Princeton Office of Radio Research, where an emblematic achievement was the Stanton-Lazarsfeld Program Analyzer. The Analyzer, or "Little Annie," was a dial or set of buttons that a test audience member could manipulate to record her response to particular parts of a program. This device was one of the first examples of modern market research.[1]

Although previous research had established audience sizes as early as 1929 for radio and 1914 for print, Little Annie measured not just the quantity of audience members but also the quality of their experience. Before, one could do little more than set advertising rates, but thanks to Little Annie, one could edit programming to maximize audience appeal. For instance, one can remove from a program dialogue, scenes, or entire characters that fail to resonate. The technique is still used today, not only in radio but also in television and film, especially for comedies. CBS was so impressed by this line of research that in 1946 Bill Paley promoted Stanton to serve as president of CBS, a position he held until 1973.

Stanton's personal ascendancy and the continued prominence of techniques he developed represent a triumph of social science in the culture industries. One can conceive of two basic ways to program a cultural enterprise. The most obvious way is to choose content according to aesthetic criteria, an approach that draws from—or at least parallels—the humanities: art history, literature, musicology, or whatever the relevant discipline may be. The other approach is to base one's decisions on data. Although it is rarely taken so far, in principle this approach could be used to choose content without ever personally viewing or listening to it. Like a bookie who knows probability but not sports, a radio programmer could conceivably decide to broadcast a song based only on the song's rising sales, airplay on peer stations, and strong appeal to survey respondents.

This procedure is characteristic of rationality. A producer need not have any special inspiration but merely apply rules toward an established goal. This aspect helps to explain why rationality has such affinity for bureaucracy in that it subsumes the individual to his or her role and makes that individual's output consistent and predictable. Rationalization is to the production of culture what machine tools are to the production of tangible commodities.

Note the contrast with the romantic, in which output is an expression of the producer's personality and humanity. This is the dominant ideology of the arts. Most of us are glad that civil engineers and aircraft mechanics follow strict rules rather than express their souls through their work. However, when a songwriter or sculptor dogmatically follows rules of genre and medium without idiosyncratic flourishes, we deride such a person as a hack. Nonetheless, many art forms

are actually organized along lines more reminiscent of industrial production than of inspired genius. In radio, the romantic conception is reflected by the myth of the disc jockey. Listening to pop radio, one sometimes gets the impression that the disc jockey is choosing records based on his or her own taste. This is accurate for college stations but has not been true at most commercial stations for decades. At present, disc jockeys are tightly constrained and usually given an exact script created by station management, or programmers, of what songs to play at what times. In fact, radio tends to be among the most rationalized of the culture industries. Rationalization in radio is achieved through the production and analysis of market research data to guide decisions systematically about artistic production.

This chapter attempts to answer three broad questions. The first is simply what sorts of data exist? There is a wide variety of data available, but in general it can be divided into data about listeners and data about songs. The second question is who uses these data and how? Finally, I attempt to draw explicit parallels between contemporary uses of radio and the ways systematic research may be used by, and in turn may change, other cultural fields. The case of public radio stations shows how rationalization is not limited to commercial, lowbrow fields but extends to nonprofit, highbrow fields as well. To the extent that other culture industries are adopting this path, this chapter proves suggestive for the future of other cultural fields.

Radio Data

Advertising-supported media such as radio need an understanding of who and how large their audiences are to function. Therefore, it is not surprising that aside from Federal Communications Commission engineering files, listener data is the oldest and most important form of radio data, dating back to 1929 (Napoli 2003). Arbitron is a consulting and research firm whose core business is collecting radio ratings. Arbitron primarily collects these ratings by distributing paper diaries to large panels of listeners who record what radio station, if any, they listened to each quarter hour of the day.

This data is presented in several ways. *Average quarter hour* (AQH) shows the percentage of people listening during the average quarter

hour. Ratings are available not only on average but also for specific *day-parts,* or times of the day. *Cume* is the cumulative number of persons who listened, however briefly, to a given radio station in a given week. Finally, *time spent listening* (TSL) measures the amount of time listeners spent on the station. A station with large numbers of casual listeners will have high cume and low TSL, whereas a station with a small but intense cult following will have a low cume and a high TSL. As AQH represents a compromise between the two concepts, both hypothetical stations will have moderate AQH numbers.

Further cuts in the data are available as well. The most popular cut is to see these ratings statistics not just for the population as a whole but also for specific demographic groups. Scarborough, Arbitron's partnership with Nielsen, combines detailed media consumption data with detailed data on buying habits and political behavior, allowing one to see how often cell phone owners listen to the radio or whether independent registered voters in a given city are best reached through television or radio.

Radio stations also generate qualitative research about their listeners. The most popular qualitative technique is the focus group, in which a group of listeners or potential listeners have a discussion led by station personnel or their consultants. This type of data tends to explore listeners' feelings about music, the radio station, and other intersections of identity and consumption. Such data are primarily useful for developing promotional campaigns, but can also be used for deciding whether to make drastic changes, such as flipping to a new format. Not only are there data on listeners, but a growing amount of data on songs. There are three types of data on songs: what is being sold, what is being played, and what ought to be played.

The oldest type of data on songs relates to record sales. In various forms, *Billboard* magazine has been publishing data on the popularity of songs since 1913. The current methodology dates to 1991 when Soundscan, now a division of Nielsen, introduced a computerized inventory system that tracked sales at a large portion of all the record stores in the country (Anand and Peterson 2000). Whereas before 1991, data on record sales suffered from considerable bias and corruption, at the present we have very accurate figures.

Monitored airplay data track what songs are being played. It is collected by computers that automatically recognize and track which

songs were played every minute of the day by large samples of radio stations. This technique is preferable to the old technique of having stations report which songs they were playing, since station management would falsely report playing songs to collect bribes. Three firms collect and distribute monitored airplay data. Mediabase is owned by radio giant Clear Channel and is the basis for charts in *Radio and Records* magazine.[2] Broadcast Data Systems (BDS) is owned by Nielsen and is used by *Billboard* magazine. A recent market entrant is Mediaguide, which is based on the American Society of Composers, Authors and Publishers (ASCAP) royalty data. The magazines' airplay charts are still subject to manipulation as record labels will sometimes buy radio advertising time in the middle of the night and will use it to play their songs repeatedly. Even though no listeners requested the song and no radio programmers selected the song, Mediabase and BDS computers detect the increased airplay, and it shows up as a hit in the charts.[4] Nonetheless, computer monitoring has made the charts reflect actual airplay even if they do not accurately reflect the disinterested judgment of radio programmers. At the very least, this distinction has made corruption more expensive.

There is also considerable data on what songs ought to be played. As described already, auditorium testing was invented in 1937 by the two men who largely invented market research: Stanton, a psychologist and CBS executive, and Paul Lazarsfeld, a sociologist. In this procedure a sample of the relevant population is gathered in a room and exposed to media content, such as clips of songs. A similar technique is callout testing. This involves assembling a panel of listeners who are required to make a phone call to the researcher's computer once a week. The computer plays five- to ten-second clips of songs to the listener, who then uses his or her phone's touch pad to express approval or disapproval of the song. The percentage of listeners who disapprove of a song is the *burn rate*. A central finding of callout research is that listeners have much higher tolerance for repetition than programmers intuitively expected. Accordingly, this research has reduced turnover and has shortened playlists.

Although auditorium and callout testing are generally accurate, they tend to underestimate the popularity of extremely innovative content that defies expectations and thus is an acquired taste. People's usual reaction to novelty is dislike, but some might like it on a second or third

try. Likewise, social desirability bias may lead people to describe not what they like but what they think they ought to like. Perhaps most seriously, an inappropriately designed test may give results that are reliable but not valid. That is, the test may consistently measure something, just not the appropriate thing. Extremely rationalized tests are particularly prone to this sort of error. The most notorious example was the 1985 "New Coke" debacle. The reformulated soda was extremely popular in sip tests, but these tests decontextualized the sip from drinking an entire glass and from the more intangible factor of nostalgia (Gladwell 2005). Such narrowly targeted research can ultimately prove misleading, and thus other aspects of market research focus are much more qualitative and holistic. Instead of asking the subject to rate a sip of soda on a scale of one to ten, such research would ask the subject how they feel about soda. This research may have fewer validity problems, but it is also a much less concrete guide to action.

Arbitron is releasing a new technology—the portable people meter (PPM)—which should make many current research methods obsolete. The PPM is a gadget about the size of a deck of cards that a sample of radio listeners carry with them throughout the day. The PPM listens to the radio along with its human host and passively records to what station the listener is tuned every minute of the day. This technique should be more accurate than paper diaries in measuring ratings as it does not rely on fallible human memory and diligence. A less widely recognized implication is that it can replace callout and auditorium research since PPM observes which songs cause the listener to turn off the radio in a real-world setting. Furthermore, the PPM is designed to address convergence among the media. Although it was initially a tool for studying radio consumption, the PPM has the potential to monitor any media with an audio channel, including television and Muzak.

This new research technique may, however, create new pathologies. First, unlike paper diaries, it is too expensive to be used on a scale sufficiently large to generate statistically sound results about small demographics. Second, unlike callout research, the PPM will be biased toward short songs since most programmers lack the statistical sophistication to properly account for the baseline probability per second that listeners will turn off the radio for reasons unrelated to the song. Thus, even such an impressive methodological improvement as the PPM cannot perfect research.

Data Use

Radio stations, their corporate owners, and consultants use every kind of radio data. As the data are used in similar ways and to similar ends regardless of whether these data are analyzed within the station, by corporate superiors, or by independent consultants, I discuss them together. However, it is worth noting that most of the aforementioned sorts of data can be generated in house, commissioned, or bought off the shelf. For instance, if a radio station is interested in callout research, it can use numbers provided by its corporate parent, it can hire a pollster to collect the data, or it can simply read the callout results published in *Radio and Records*. Though producing original data is much more expensive, this approach has the advantage that one can customize the data to fit one's particular programming strategy and local market, whereas ready-made data are usually national in scope and designed for generic formats.

Regardless of the origin of the data, radio stations use data to answer specific questions. One of the most routine questions is what songs to play. This is further divided into two questions: what songs one ought to *add,* and when one ought to *drop a song.* Soundscan and *Billboard* data tell radio stations what records are selling well and thus ought to be considered for airplay. Monitored airplay data—either in raw form or redacted to the trade journals' charts—shows what one's peers are playing and thus can also suggest songs that a radio station should add. Radio stations test candidate songs with auditorium testing. Finally, callout and PPM data show burn and tuneout rates, respectively, both of which indicate when stations should drop songs from their playlists.

Although their basic practice consists of playing songs or providing other content, most radio stations are ultimately in the business of selling advertising. They use Arbitron ratings to set their advertising rates. Though advertising is sold by time, the rate per second is usually based on cost per thousand (CPM) listeners. CPM is not a constant; one intervening factor is demographics. Though the needs of advertisers vary, in general, affluent, young, white, male audiences demand a premium CPM. Furthermore, both for prestige and to avoid reaching the same people twice, advertisers prefer to advertise with one large program rather than several small programs; thus, popular programming can also demand a premium CPM.

Radio stations face not only the immediate problems of programming and ad sales but also the long-term problem of promoting an image. Focus groups are useful for assessing the feelings of one's audience and using this to develop and test brand images and promotional campaigns that will resonate with one's audience.

Finally, the biggest question a radio station faces is whether it is fundamentally on the right track. The most important source of information for this purpose is Arbitron ratings numbers. Stations interpret low numbers as a sign that they need to change their programming, promotion, or air staff. In extreme cases a station's management will decide to sell the station or to flip the station to an entirely new format. This decision is also shaped by data on peers within a market. For instance, if a classic rock station has very low ratings, it may notice that it is competing with another local classic rock station. But the market contains a very successful country station; thus, the failing station should flip from classic rock to country.

Advertisers also use Arbitron data to estimate the size and quality of the audience. Probably the most important piece of information is audience size, but its composition is also significant. Advertisers are often only interested in specific demographics. Though the summary tables found in the trades do not go into much detail, Arbitron data can tell advertisers where to find white men ages eighteen to thirty-five or black women ages eighteen to fifty-five. Furthermore, Scarborough data can tell advertisers about the relationships between consumption, politics, and media consumption in considerable detail. For instance, if Alamo rental cars wanted information about where to find their customers and potential customers, Scarborough data could identify frequent travelers from specific airports and could show whether these people are best reached through radio, broadcast television, cable television, magazines, or newspapers.

Scarborough's planned successor, "Apollo," has even more detail capability, in large part through its use of PPM. Apollo will collect data not only on media and commodities but on programs and brands as well. This will allow direct, causal testing of ad campaign efficacy and will help unify the advertising market across media.

Implications for the Future and Other Cultural Fields

Aside from radio's intrinsic interest as a major medium, it is useful as an example of what rationalization does to a cultural field. This section discusses implications for cultural fields. In particular, it notes how rationalization changes fields and how this almost inevitably involves conflict.

Rationalization involves changes to both the structure of an organization and its creative output. The most important organizational change is that it requires a shift to professional labor. Many arts organizations are traditionally characterized by either self-subsidizing labor or outright volunteer labor. Since these volunteer or quasi-volunteer workers are primarily working to achieve aesthetic ends and require relatively little money to do it, the paying audience becomes largely superfluous. The organization's output is then aligned with what interests labor rather than what interests audiences. In the language of political economy, these organizations have been captured by artists with an *arts for art's sake* orientation. Their artistic output will often tend toward avant-gardism and other practices that please creative workers but alienate some audiences.

Rationalization makes more intensive demands of skill and commitment and thus shifts the organization toward full-time, highly skilled, professional labor. A volunteer has neither the time nor the skill to accomplish what rationalization demands. This new labor force might very well find its work fulfilling, but it is usually less willing to self-subsidize than a traditional artistic labor force. This, then, makes professional labor expensive. To meet the demands of a professional payroll, the organization must increase its revenues; therefore, rationalization tends to require growth. Likewise, professionals believe that revenues or circulation reflect the organization's merit. This pushes the organization toward more accessible and popular content.

A good illustration of the effects of rationalization in a nonprofit cultural field is public radio. Since the 1980s, public radio stations have been restructuring to resemble commercial radio stations, complete with sophisticated use of Arbitron and other data (Stavitsky 1995).[3] Most of the responsibility for this change goes to a team of Corporation for Public Broadcasting (CPB) market researchers led by David Giovannoni, who produced a set of research reports that revolutionized public radio.[4]

The 1989 CPB manifesto, "Programming Economics," argues that the social worth of a program can be measured by the revenue it attracts, and thus radio programmers should replace low-revenue programming with—often more expensive—high-revenue programming. Research consistently shows that news programming attracted both more dollars and more listeners than classical music, lectures, and other high-culture programming. Based on the belief that popularity is meritorious, CPB encouraged public radio stations to replace music with news. This was a drastic change not only in content but also in organization. News usually involves syndicated talk programming from National Public Radio (NPR) produced in Washington, D.C., by professional journalists, whereas the typical music program has a local disc jockey earning a low wage. These changes have garnered tremendous resentment from radio incumbents and fans of music programming, but to little effect (Stavitsky 1995).

Furthermore, as news is much more expensive than music, this change requires a greater reliance on corporate underwriting, a genteel form of advertising, but not so genteel as to be indifferent to the size and demographics of the audience it reaches. Hence, Arbitron numbers allow public radio to satisfy both an internal belief that a public service mission requires a large audience and an external constraint that their advertisers demand large, and affluent, audiences. Public radio stations also collect data on the revenue brought in by each program from all sources, including listener pledges, both for practical fundraising reasons and also for the more idealistic reason that they treat revenue as a metric of listener utility.

A similar pattern occurred in a rather distinct subset of public radio. Pacifica is a nonprofit chain of five small radio stations that receive CPB funding but do not use NPR syndicated programming. Pacifica stations are traditionally characterized by far-left political content and an organizational structure reminiscent of college radio, with tremendous autonomy for a volunteer labor force. In the late 1990s, following mainstream public radio, Pacifica management tried to professionalize the chain, and the staff and their sympathizers fiercely resisted the process, which they called "NPR-ization." The conflict involved a series of lockouts, protests, and lawsuits. However, unlike mainstream public radio, resistance was successful, and Pacifica ultimately reached a legal settle-

ment in which management largely capitulated to the staff's opposition to change.

Rationalization has been opposed not only by classical music fans and radical talk show hosts but also by Fox television (Bianco and Grover 2004). The fact that rationalization has been opposed across such different circumstances and by such different stakeholders suggests that it is not a win–win situation but that it can involve trade-offs that leave some parties aggrieved. Thus, it poses a challenge for arts organizations who wish to retain their character. Specifically, how does the organization ensure that rationalization supports rather than challenges its mission?

Sociologists refer to pressure to conform to rationalization as isomorphism, which comes in three major forms. Mimetic isomorphism is the tendency to imitate successful organizations, whereas normative isomorphism refers to the practices professionals bring with them to an organization. Although easier said than done, to a large extent, these pressures can be resisted by management that has sufficient determination and structural autonomy to focus on the organization's mission. Rationalization pushes one toward maximizing the organization's size, but the key is to recognize that this is a value judgment. To the extent that attracting audiences, pleasing artists, and achieving the managers' own aesthetic ends are conflicting goals, managers should realize that this is a matter of values to be answered by themselves and not of evidence to be answered by data. Looking admiringly to the largest organizations in one's field or uncritically taking the advice of those with a master's of business administration or a master's of public administration can lead an arts organization to define success as growth. However, if this is accomplished through pandering, then the tail is wagging the dog.

A more blunt challenge is posed by coercive isomorphism, wherein those on whom the organization is dependent for resources can dictate its practices. In practice, these forces all push toward rational bureaucracy that sees maximizing audiences as its goal. A major reason that public radio adopted Giovannoni's reforms was the drive to seek out increased listener and corporate funding as a hedge against the threat that first the Reagan administration and later the Newt Gingrich Congress would cut the CPB budget. Admission, subscriptions, and listener pledges are the most obvious ways resources are tied to audience size. However, corporate arts funding, which is glorified advertising, and government

funding, which is increasingly framed as an investment, both demand rational metrics for the results of their arts funding (Caust 2003).

These demands have led to a series of utilitarian arguments for the arts, most recently the creative class theory of urban development, which argues that yuppies move to artsy cities, but also an innumerable series of fiscal impact studies, which usually argue that arts organizations attract tourist dollars or raise property values (Florida 2002). However much temporary success utilitarian arguments may have, they are ultimately untenable because on a dollar-for-dollar basis the arts almost always have less economic benefit than more mundane initiatives like expanding the airport, tax incentives, or buying new math textbooks. That these studies continue to be produced is primarily a result of policymakers' preference for having proposals before them leveled to a common utilitarian metric.

This suggests that rationalization inexorably squeezes the arts. Indeed in his definitive works on rationality, Max Weber (1968) wrote that it forms an iron cage that destroys the charismatic. However, the prospect is not entirely dismal. Although it has strong utilitarian presumptions, rationality is a means and not an end. Even coercive isomorphism can be overcome. For instance, despite a decreasing supply of soft money, art museums have done a good job of maintaining their values, in part by skillfully playing various pots of hard money against each other (Alexander 1996).

Assuming that the organization's goal is not limited to maximizing audiences but includes more lofty aesthetic or social ends, rationality can be used, but carefully. Managers can have strong a priori conceptions of meritorious art and can use research to find out which audiences are most receptive to it or how best to recruit audiences for it. For instance, chapter 13 in this volume draws extensively on the Survey for Public Participation in the Arts, which contains detailed data on demographics, fine arts consumption, and popular consumption. By using these data the authors identify an audience segment that may be receptive to properly framed fine arts. On a more mundane level, these data allow one to see the relationship between live arts participation and arts participation through the mass media. Such data are valuable for identifying and recruiting new audiences. These data are free, although proper analysis requires skilled labor and specialized software. Custom

data can be even more expensive, but it is relatively cheap and easy to survey one's subscribers.

There are also extensive data on grants. One major source is the Urban Institute's Guidestar database, which contains detailed and exhaustive files on nonprofits and grants. Their grant explorer tool allows grants to be searched. Although grants do not grow on trees, knowledge of which ones are available makes it more likely that a grant can be found that matches the programs rather than having to conform the programs to match the grants. As mentioned above, art museums are particularly effective at this.

To use data inevitably means counting something, and it is far easier to count ticket sales and grant income than it is to quantify artistic merit. So rationalization has strong, but not inevitable, tendencies toward commercialization. Paradoxically, rational means such as data analysis can be used to accomplish artistic ends, but only if the temptation is avoided to pursue growth for its own sake.

Bibliography

Alexander, Victoria D. 1996. "Pictures at an Exhibition: Conflicting Pressures in Museums and the Display of Art." *American Journal of Sociology* 101: 797–839.

Anand, N., and Richard A. Peterson. 2000. "When Market Information Constitutes Fields: Sensemaking of Markets in the Commercial Music Industry." *Organization Science* 11: 270–84.

Bianco, Anthony, and Ronald Grover. 2004. "How Nielsen Stood Up to Murdoch." *Business Week*, September 20. http://www.businessweek.com/magazine/content/04_38/b3900100_mz017.htm.

Caust, Jo. (2003). "Putting the 'Arts' Back into Arts Policy Making: How Arts Policy Has Been 'Captured' by the Economists and the Marketers." *International Journal of Cultural Policy* 9: 51–63.

Dannen, Fredric. 1990. *Hit Men: Power Brokers and Fast Money inside the Music Business.* New York: Times Books.

Ferguson, Andrew. 2004. "Radio Silence: How NPR Purged Classical Music from Its Airwaves." *Weekly Standard*, June 14, 18–24.

Florida, Richard. 2002. *Rise of the Creative Class.* New York: Basic Books.

Freedman, Samuel G. 2001. "Public Radio's Private Guru." *New York Times*, November 11, http://www.samuelfreedman.com/articles/culture/nyt11112001.html.

Gladwell, Malcolm. 2005. *Blink: The Power of Thinking without Thinking.* New York: Little, Brown and Co.

Napoli, Philip M. 2003. *Audience Economics: Media Institutions and the Audience Marketplace*. New York: Columbia University Press.

_____. 2005. "Audience Measurement and Media Policy: Audience Economics, Diversity Principle, and the Local People Meter." Communication Law and Policy 10: 349–82.

Seaman, Bruce A. 2004. "Cultural and Sports Economics: Conceptual Twins?" *Journal of Cultural Economics* 27: 81–126.

Stavitsky, Alan G. 1995. "Guys in Suits with Charts: Audience Research in U.S. Public Radio." *Journal of Broadcasting & Electronic Media* 39: 177–89.

Surowiecki, James. 2004. "Paying to Play." *New Yorker,* July 12. http://www. newyorker.com/archive/2004/07/12/040712ta_talk_surowiecki.

Weber, Max. 1968. *Economy and Society: An outline of interpretive sociology.* New York: Bedminster Press.

Zukin, Sharon. 2004. *Point of Purchase.* New York: Routledge.

Endnotes

1. Several General Motors surveys preceded the Stanton-Lazarsfeld investigations; however, these earlier efforts were much less sophisticated (Zukin 2004).

2. Surowiecki (2004, p. 42). Note that this practice is distinct from the older illegal practice of payola in which independent radio promoters (often with connections to organized crime) funnel bribes from record labels to radio personnel. Although using disclosed advertising time to manipulate charts is legal, in 2005 and 2006, the major record labels each promised to cease such practices in consent decrees with the New York Attorney General's office (Dannen 1990).

3. Audience Research Analysis has these reports on its website (http://www.aranet.com/3know/321.htm).

4. Freedman (2001, http://www.samuelfreedman.com/articles/culture/nyt11112001.html).

Section Four:

Revisiting Cultural Participation and Cultural Capital

12 Arts Participation as Cultural Capital in the United States, 1982–2002

Signs of Decline?

Paul DiMaggio and Toqir Mukhtar[1]

In *The Inheritors* (1979) and *Reproduction in Education* (1977), Pierre Bourdieu made the influential argument that in the modern economy, where the publicly held corporation had succeeded the industrial magnate's empire, a new mode of class reproduction based on formal education had replaced the old mechanism of direct inheritance. According to Bourdieu, members of the "dominant class" invested in their children's "cultural capital"—an easy familiarity with prestigious forms of culture—as a means of ensuring their success. Bourdieu argued that teachers and other gatekeepers interpreted "cultural capital" as a sign of grace, indicating that a child was gifted and worthy of attention and cultivation. Students with the proper cultural socialization, then, would excel in primary school, be admitted to the most selective institutions of higher education (which increasingly controlled access to the best opportunities), and ultimately succeed in reproducing their parents' elite status. In his empirical work, Bourdieu mustered much evidence

of high levels of class reproduction in France, as well as strong associations among family socioeconomic status, educational achievement and attainment, and cultural practices and tastes (Bourdieu 1984; Bourdieu and Passeron 1977, 1979).

Bourdieu was careful to distinguish between his general theory of capital as an analytic scheme and the institutional details of his accounts of French society, including the centrality of aesthetic taste to cultural capital. By the 1980s, however, researchers in many other countries had merged Bourdieuian reproduction theory with the methods and perspectives of the status-attainment tradition to analyze the impact of family background on cultural capital, and the impact of cultural capital on success and persistence in schooling, as well as a range of other outcome variables. Despite the complaints of critics who suggested that the potency of aesthetic culture as a sign of distinction was peculiar to France, or at least to Europe, most of these researchers used indicators of cultural capital similar to (albeit less detailed than) those Bourdieu had employed: attendance at high-culture arts events and taste for high-culture art forms.[2] For the past 20 years, scholars have been documenting strong associations between socioeconomic status and "cultural capital" thus defined (DiMaggio and Mohr 1985; Van Eijck 1997; Mohr and DiMaggio 1995; DeGraaf et al. 2000), as well as statistically significant, albeit weaker, effects of cultural capital on educational and other outcomes reviewed in DiMaggio 2001.

Artistic practices and tastes have served as useful measures of cultural capital because of their generality. It is only sensible to speak of cultural *capital* if one is referring to media of broad legitimacy. Because the arts have been deeply institutionalized by states and institutions of higher learning, they constitute the most broadly recognized forms of prestigious culture throughout Europe and the Americas (DiMaggio 1982). To be sure, in any specific status group—whether it is a local friendship circle or a nationally organized profession like medicine or computer science—there will be parochial forms of knowledge that are highly prestigious, possession of which marks a person as an insider worthy of respect. But such forms of knowledge are negotiable only within relatively narrow circles: in effect, they constitute local cultural barter systems rather than currencies for a national cultural economy. By contrast; the arts, especially the high-culture arts, have been the most *general* form of prestigious culture in the West, and thus a privi-

leged indicator of cultural capital. Consistent with this, research has demonstrated that familiarity with the high-culture arts (including attendance at arts events) appears to be the best cultural predictor of school success, exceeding the usually insignificant influence of academic knowledge about the arts or artistic practice DiMaggio 1982, 2001.

Despite the persistence of research support for the importance of the dynamics Bourdieu identified, and for the efficacy of high-culture arts attendance and appreciation as indicators of cultural capital, most observers believe that the position of the high-culture arts as cultural capital is declining, especially in the United States (DiMaggio 1991; Lamont 1992; Holt 1997). Several reasons have been posited for this.

First, commercial popular culture has become so pervasive and so finely segmented (as nichecasting has replaced broadcasting in fields as diverse as fiction publishing, cable television, the music industry, and film) as to overwhelm the ability of universities and nonprofit cultural institutions to maintain their cultural centrality (Warde et al. 1999). Notwithstanding the expansion of the nonprofit cultural field in the 1970s and 1980s, orchestras, theatres, and opera companies suffer persistent budgetary problems and in many cases perceive that their audiences are declining in the face of competition from other cultural fare and leisure activities (The Wolf Organization 1991; McCarthy et al. 2001). The problem of competition only became worse with the rise of the Internet, which offers many kinds of convenient at-home entertainment through a single telephone or cable connection.

Second, many U.S. social critics believe that high culture is crumbling from within, participating in its own de-institutionalization (DiMaggio 1987, 1991). In particular, high culture appears to be far less insulated from other cultural forms than in the past, and cultural hierarchy has been under attack not only by supporters of multiculturalism but by artists themselves. Postmodern artists in many fields have effaced boundaries between "serious" and "popular" culture; and types of art once dismissed as merely commercial are now the subject of university courses and museum exhibitions. The U.S. public stoutly rejects the proposition that high culture is inherently more valuable than folk or popular culture, and the most educated Americans (who should have the greatest stake in cultural hierarchy) are the most united in rejecting it (DiMaggio and Bryson 1995).

Third, many sociologists who study patterns of artistic taste and participation contend that prestige now accrues to the person who is familiar with many cultural forms from many parts of (what once was) the cultural hierarchy. According to Richard Peterson, the new cultural capitalists are the "omnivores," men and women who are comfortable speaking about and participating in high and popular culture and everything in between (Peterson 1997; Peterson and Kern 1996; Van Rees et al. 1999). This trend, it is argued, is supported by high levels of geographic mobility and job histories that require coworkers to work effectively with many types of people for relatively short periods. Research indicates that people with complex and heterogeneous social networks—precisely what one would expect as a result of these trends—have more heterogeneous (and "omnivorous" tastes) (Erickson 1996; Relish 1997).

These are complex arguments and detailed review of evidence bearing on the propositions they comprise is beyond the scope of this chapter. What is important for our purposes is that there are many plausible reasons to believe that the grip of high culture on the process of cultural and social reproduction in the United States (and perhaps elsewhere) may have loosened over the past several decades. This chapter is a preliminary effort to see to what extent this appears to be true. There are two ways one might go about this task. We have chosen to take a descriptive, demographic approach that permits us to examine change in rates of participation by different population groups directly. At this stage, we are more interested in illuminating trends than in testing hypotheses formally. The latter is best accomplished using more conventional regression-based methods, which enable one to inspect change in the effects of particular variables over time, and to estimate the contribution of particular mediating factors to those changes. We shall undertake such analyses in the future, but for now will focus on the preliminary step of documenting the trends.

Data and Implications

Until now, researchers who have wished to analyze trends in arts participation have been frustrated by the absence of comparable data collected at different points of time. With the release of the 2002

Survey of Public Participation in the Arts (SPPA), relatively long-term trend analysis has finally become possible. Surveys of Public Participation in the Arts were also undertaken in 1982 and 1992. Core items in the 1982 survey were repeated in 1992 and 2002. In each year, the survey was sponsored by the National Endowment for the Arts, Research Division and fielded by the U.S. Bureau of the Census.[3]

The SPPAs are household surveys. In 1982 and 1992, they were administered (to 17,254 and 12,736 persons, respectively, most of whom were interviewed by telephone, but some of whom were interviewed in person) as supplements to the National Crime Survey. Statistical weights rendered the results comparable to the full population of non-institutionalized U.S. residents 18 years of age or older.[4] In 2002, the SPPA was administered as part of the Current Population Survey and 17,135 persons responded.

We build on earlier studies of the 1982 and 1992 SPPAs by Peterson and Sherkat (1996) and by Balfe and Meyersohn (1996). Although these studies did not attempt to address the theoretical questions we pose in this paper, they did indicate that arts participation began to decline with the early baby boom generation—persons born between 1946 and 1955—and continued thereafter. With data from 2002, we are able to see if these trends persisted as the baby boomers and subsequent generations aged, and if they are present in the cohort born between 1976 and 1985, who first appear in the SPPA data in 2002.

Our strategy is to compare results from the 1982, 1992, and 2002 studies, and to ask if trends in arts participation are consistent with the view that the importance of the arts to social reproduction is declining. For the purpose of addressing this issue, we would prefer to have comparable data on trends in the impact of cultural capital on such outcomes as years of schooling, college quality, and early occupational attainment; but we do not. Absent such data, we focus on trends in arts consumption, an approach that makes sense in so far as one accepts the premises that actors are, first, knowledgeable and, second, reasonably rational. With respect to the first, we believe that most people are aware, consciously or unconsciously, of the extent to which involvement in the arts is part of the complex of prestigious cultural dispositions and practices that help people get ahead (i.e., cultural capital). With respect to the second, we assume that if the status payoff of participation in the arts declines, people will have reduced incentive to participate and will

participate less.[5] Because participation in the arts becomes intrinsically gratifying to most people once they begin to do it, we would anticipate that declines in incentives would have stronger effects on initial investments in exposure to the arts than on continuity of participation, and that they would therefore show up more sharply in differences among cohorts, than in change within cohorts over time. Even without status payoffs, the arts will continue to attract many people for other reasons. We only posit that declining incentives will produce some *net decline* in consumption.

Armed with these assumptions, what would we expect to find if the arts were declining as a form, source, and indicator of cultural capital?

Indicators of Decline

(1) If the value of the arts for social reproduction declined between 1982 and 2002, then the incentive of persons to attend arts events would have declined, causing a net decline in participation. There are many other good reasons to attend arts events than enhancing one's social status, of course. But unless there were some reason to believe that such motives were more compelling in 2002 than they were in 1982, *we would anticipate a net decline in participation* if status incentives have diminished.

(1a) Bourdieu 1973 and Bourdieu and Passeron 1979 posited that the successful inculcation of cultural capital occurred early in life, at the time of the formation of the habitus. Other scholars have rejected this emphasis on early socialization. Nonetheless, if there is any tendency for early experience to influence adult participation patterns, any decline should be more visible among younger than among older cohorts of the population. (Most observers have suggested that the hegemony of high culture began to give way in the 1960s, suggesting that trends would begin to be visible only among cohorts that came of age in that decade or later).

(1b) If the value of the high-culture arts as cultural capital has declined, then we would expect to find more marked declines in attendance at high-culture arts events (for example, symphony concerts, ballet performances, or operas) than at events with

more mass appeal (for example, craft fairs or historical sites). Pastimes that never were very prestigious have no prestige to lose, so should not be affected by a de-institutionalization of high culture. And if Peterson (Peterson and Kern 1996) is right about omnivorousness, such activities might actually gain in prestige as high-culture activities lose some of theirs. Therefore, *declines should be less visible in more popular arts activities than in high-culture events.*

(2) The best sociodemographic predictor of attendance at arts events in study after study has been years of schooling. The U.S. population has become more educated between 1982 and 2002, and rising educational levels should reduce the visibility of the incentive-reduction effect. Therefore, we anticipate that the decline in attendance will be most visible within groups defined by years of education, rather than in the population as a whole.

Moreover if arts attendance has become less associated with elite status, then *the gap between participation by the most highly educated and participation by people with less education should decline.* Some theories of postmodernity have empha-sized the increasing plasticity of identity and the importance of taste and consumption as instruments of self-definition (Harvey 1989; Featherstone 1991; Pescosolido and Rubin, 2000). In so far as this is the case, the enhanced value of arts participation as a source of identity could counteract its reduced value as a source of social status. If so, we might not see participation decline. But because the significance of arts participation for identity formation should be less skewed by social origin than is its role as cultural capital, we would anticipate that the extent to which arts participation was associated with educational attainment would decline, even if net attendance levels did not. (If new identity incentives have not emerged to offset the effects of declining status incentives, we would expect intergroup dif-ferences to decline a fortiori). As ever, one would expect such trends to be particularly notable among younger cohorts.

(3) In the U.S. at least, measures of cultural capital have always been strongly influenced by gender, with women attending more high-culture arts events than men, reading more literature,

taking more classes, and evincing more highbrow tastes Dumais, 2002. One may interpret these differences as reflecting a household division of cultural labor (descending from the "doctrine of separate spheres" [Welter 1966; Smith-Rosenberg 1985]) in which women, as mothers and as guardians of the domestic sphere, were vested with disproportionate responsibility for the inculcation of cultural capital (Collins 1992; Tepper 2000). If aesthetic cultural capital has become less important to social reproduction, then we would expect the participation of women to decline especially rapidly, relative to (the already lower) rates of participation of men. In other words, *we would expect that (within education groups) the ratio of women's to men's participation would decline over time.* (As usual, the expectation is strongest for younger cohorts.)

Results

In this chapter, we focus on what are called the SPPA's "core" items: questions about attendance at classical music concerts, jazz performances, opera, musical theatre, nonmusical theatre, ballet, visual art exhibits at museums or galleries, arts and craft fairs, historic sites, and, in 1992 and 2002 only, modern dance. For the most part, these represent "high culture" art forms, by which we mean artistic genres that are treated by critics as "serious," characterized by a tendency for evaluation to place greater priority on responses of critics and artists than on responses of the general public, represented in college and university curricula, likely to receive subvention from private patrons, foundations, or government agencies based on the perceived aesthetic value of their product, and often produced and distributed by nonprofit organizations (Becker 1982; Bourdieu 1983). Systems of artistic classification (DiMaggio 1987) have changed continuously, with a trend in the U.S. toward an expansion of high-culture institutional arenas (university curricula, serious criticism, government grant-making) during the twentieth century (DiMaggio 1992). One can distinguish among the SPPA core activities a gradation by prestige, associated with the percentage of revenue derived from commercial productions and with the recency of the art form's inclusion in university curricula, with classical music, museum art, opera, and ballet at the top, followed by theatre and modern dance,

then jazz and musical theatre, and finally art and craft fairs (with historical sites institutionally orthogonal but aimed at a broad audience).

The SPPA data are in some respects ill equipped to help us fathom the intricacies of change in the structure, composition, and distribution of cultural capital, for two reasons. First, as Bourdieu argued, cultural capital inheres less in specific behaviors than in a particular relationship to elite culture, particular modes of appropriation and appropriate discursive forms. The mere act of attending an arts event tells us relatively little in itself about the extent to which people use the arts as a form of cultural capital to define their identities and manage boundaries between status groups. Second, the SPPA data provide more reliable information about *whether* someone attends a certain type of event than about how frequently they attend it. If attendance rates at orchestra concerts decline, for example, but people who do attend are attending many more concerts, then the two trends may balance one another out, at least as far as orchestra managements are concerned.

We acknowledge these limitations but believe that looking at attendance rates is valuable nonetheless. Participation data have provided the best available proxies for cultural capital, operating effectively to disclose relationships not subject to plausible alternative explanations. We have no other individual-level data relevant to tracking change over time. Moreover, we have no particular reason to believe that the frequency with which attenders have attended arts events has changed over the past twenty years. Moreover, from a theoretical standpoint, a shift from broad participation by many high-status persons to very intensive participation by a few high-status persons would make the arts a less general form of cultural capital—which is to say, it would make the arts more like many other high-status forms of knowledge or activity that operate as currency within relatively limited networks and less like a broadly recognized form of cultural capital at all.

After presenting attendance rates in the full population for each art form for each year, we plot attendance rates for the full sample by cohort for each decade (1982, 1992, and 2002) to investigate trends with aging controlled. We then disaggregate the data, first by years of education (less than high school, high school graduate, some college, at least four complete years of college) and then by gender. To explore change in gaps between men and women and between more or less educated respondents, we use odds ratios, because these are relatively robust with

respect to differences in absolute participation rates Martin 2003. Odds ratios, r, are calculated as: $r_{jk}, = (p_j/[1-p_j]) / (p_k/[1-P_k])$, where P_j is the probability of attendance by the first of two groups and P_k is the attendance probability of the second.

Has Arts Participation Declined?

If the arts have become less central as a form of cultural capital then we would anticipate that attendance at arts events would have declined between 1982 and 2002. Furthermore, we would expect the declines to be most visible within educational groups (i.e., controlling for change over time in educational attainment), for the most prestigious arts forms (attendance at which was more firmly indicative of cultural capital), and among the youngest cohorts of the sample (those who came to age in the postmodern era).

Table 12.1 shows participation rates for the entire weighted sample in each of nine core activities for each survey year, 1982, 1992, and 2002. The last column indicates the percentage change in the odds of attendance (the attendance rate divided by the rate of nonattendance) between 1982 and 2002. The results provide little support for the notion that the arts are in decline as a form of cultural capital. In some areas attendance went up slightly, in others it declined. The greatest declines were in the most popular activities: attendance at art and craft fairs and

Table 12.1 Participation Rates

Event type	1982	1992	2002	Percentage odds
Classical music	0.130	0.125	0.116	-12.2
Jazz	0.096	0.106	0.108	14.0
Opera	0.030	0.033	0.032	6.8
Musical theatre	0.186	0.174	0.171	-9.7
Play (not musical)	0.119	0.135	0.123	3.8
Ballet	0.042	0.046	0.039	-7.4
Other dance	n/a	0.071	0.063	n/a
Art museum	0.221	0.266	0.265	27.1
Art or craft fair	0.393	0.406	0.334	-22.5
Historic site	0.372	0.344	0.316	-22.0

historic sites, odds of attending each of which declined approximately 22 percent. The greatest increase was in attendance at art museums and galleries, odds of which climbed more than 25 percent. Other changes were quite modest: classical music attendance declined slightly, jazz attendance rose a bit, and rates of attendance at the least popular activities, ballet and opera, changed marginally from already miniscule levels. Moreover, for only three activities were declines monotonic: historic sites, classical music, and musical theatre (which declined very modestly).

Because participation in many kinds of leisure activities is structured by age, it is useful to look at changes within particular age groups. Figure 12.1 depicts attendance rates by age groups for each of nine core participation activities. The darkest line (diamonds) depicts the figures for 1982; the line of medium hue (squares) represents 1992; and the light line (triangles) reports data from 2002. Again, results vary considerably from art form to art form. Let us begin by looking at the historically most prestigious art forms: classical music, opera, ballet, and the visual arts. Attendance rates at classical music concerts have declined markedly among younger cohorts since 1982 (with the worst of the decline occurring between 1982 and 1992). By contrast, attendance among older cohorts (those 47 years of age or older) increased notably between 1982 and 1992, declining only slightly in the previous decade. Similar but less consistent trends are visible for ballet and opera. Indeed, the same is true of attendance at stage plays and musical theatre productions. Attendance at all of these performing arts activities has remained stable or has grown among most cohorts of older Americans, while falling among younger audiences. This pattern is consistent with the notion that the status of these activities as cultural capital has declined.

The pattern for art museum attendance has been somewhat different. Among persons 18 to 46, attendance rose from 1982 to 1992, then fell back to 1982 levels by 2002, remaining stable throughout the period. Among older Americans, attendance continued to rise during each decade. Like the performing arts, then, art museums have fared best (relatively speaking) among persons middle-aged and older; but unlike the performing arts activities, they have held their own even among the young.

The outlier for the performing arts is attendance at jazz concerts. Here the shape of the age/attendance distribution changed markedly between 1982 and 1992, and remained stable in the decade that fol-

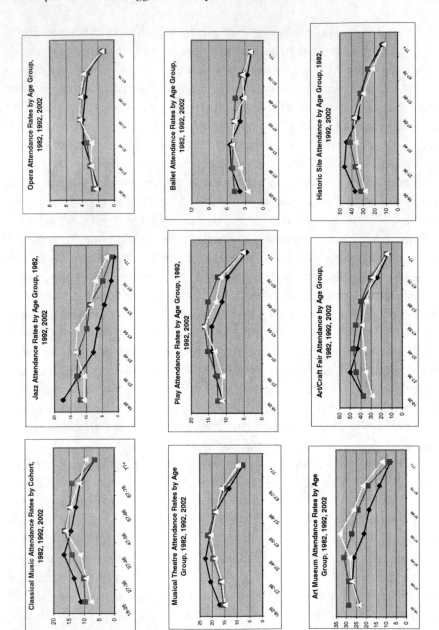

Figure 12.1 Attendance rates by age groups for full sample. Black—1982; Gray—1992; White—2002.

lowed. In 1982, jazz was a young person's music: attendance was highest among the 18–26-year-old age group; declined sharply through age 46, and continued to decline, at a slower rate, thereafter. In 1982, attendance peaked between the ages of 18 and 26; in 2002, it peaked between the ages of 37 and 46. In part, this reflects the fact that the cohort that was 18–26 retained its enthusiasm as it aged. But this is not all that was going on. In addition, declining attendance by age in 1992 and 2002 not only started later but was more modest in slope than in 1982, so that the cohort that was 27–36 years old in 1982 attended at roughly the same rate twenty years later, making the age/attendance curve for jazz rather similar to that for art museums.

Attendance at two activities—arts and craft fairs and historic sites—arguably falls outside the category of high-culture consumption as this is ordinarily understood. As we have seen, these two types of activities experienced the most marked declines between 1982 and 2002. Attendance at arts and crafts fairs held fairly constant among Americans 67 or older; peaked among respondents 37–66 in 1992 before declining in 2002; and declined monotonically among persons under 37. (Moreover, participation by members of the cohorts that were youngest in 1982 and 1992 continued to decline relative to their own earlier rates.) By contrast, most of the decline in attendance at historic sites occurred between 1982 and 1992, and was concentrated among persons aged 18 through 36.

Taken as a whole, the pattern is consistent with the notion that the traditional high-culture performing arts became less central to cultural capital during the last two decades of the twentieth century. Not only did attendance decline slightly but, more important, the decline was concentrated among the youngest cohorts in the population, suggesting a failure of these art forms to renew their audiences. On the other hand, this trend was not peculiar to the more prestigious performing arts. Musical theatre, a relatively middlebrow form, displayed the same pattern; and the most popular activities, attending arts and craft fairs and visiting historic sites, declined even more rapidly.

The two outlying activities are attendance at art museums and jazz concerts, rates of which have increased markedly among older Americans and, except for jazz attendance in the very youngest cohort, remained stable among the young. As a U.S.-bred art form with African American roots, jazz lies firmly outside the terrain of Euro-American high culture.

At the same time, as it has been annexed by university music departments, highbrow critics, private foundations, government grantmakers, and nonprofit music presenters, it has arguably undergone an institutional transformation into a form of high culture—a transformation which we may see reflected in its evolving age distribution (DiMaggio and Ostrower 1990; Peterson 1972; Lopes 2002). Art museums deviate in another way, as they are more engaged both with contemporary art and with non-Western cultures than are symphony orchestras, ballet or opera companies, and most theatre companies. Zolberg (1988) argues that art museums, with their bricolage of objects from many times and places, are quintessentially "postmodern." Consistent with the notion that museums' openness to novelty and cultural diversity is part of their appeal, DiMaggio (1996) found that U.S. art museum visitors were significantly more cosmopolitan and tolerant than nonvisitors, even after controlling for sociodemographic factors. The exception of jazz and art museum attendance, then, is consistent with the postmodern account of cultural change, with the "omnivore" story, and also with the notion that the body of prestigious arts capable of serving as cultural capital may evolve over time.

Has Arts Attendance Declined Most among the Highly Educated?

Bourdieu argues that prestigious cultural forms are effective as cultural capital only for those equipped to use them. From this perspective, although anyone may participate in the arts for intrinsic gratifications, the status value of participation will accrue primarily to the highly educated. If the value of the arts as cultural capital declines, then, we would expect this to have its greatest effect on people with college educations or more, for whom this decline would reduce an important (if ordinarily unconscious) incentive for participation.

Focusing on college graduates is also useful because it controls for much of the change in levels of educational attainment over the lifetimes of persons represented in the survey. In particular, rates of college attendance rose rapidly during the 1960s. Between 1982 and 2002, people who left the survey population through death were replaced by young persons with substantially higher levels of education. (Other things equal, this would have ensured increasing rates of arts

attendance between 1982 and 2002. Of course, we have already seen that other things were not equal). Although looking at change within age groups controls for some of the effect of increasing educational levels, it does not control for all of it, especially in comparisons over time among cohorts of the middle-aged.

Table 12.2 reports attendance rates in nine activities for 1982, 1992, and 2002, as well as the change in odds of attendance from 1982 to 2002, for respondents who had completed at least four years of higher education. Note that in every year, participation rates in all activities are substantially higher for college graduates than for the population as a whole. Note also that declines in odds of participation are more substantial for the highly educated than for the population as a whole. Indeed, the odds of a college graduate attending a classical music concert were 30 percent lower in 2002 than in 1982; for plays, the odds were 23 percent lower even though for the population as a whole they had risen slightly. Losses remained greatest among the most popular activities, with odds of attending arts and craft fairs or historic sites declining by more than 40 percent. Art museum attendance increased among college graduates, but almost imperceptibly. The only activities for which attendance trends were relatively similar for college graduates and for the population as a whole were jazz attendance (which rose almost as much for college graduates as for everyone else) and opera attendance which changed very little. Unlike the whole population, rates declined monotonically for college graduates in six of nine activities (all but jazz,

Table 12.2 Attendance Rates

Event type	1982	1992	2002	Percentage odds
Classical music	0.334	0.284	0.259	-30.3
Jazz	0.190	0.221	0.209	12.6
Opera	0.082	0.083	0.079	-4.0
Musical theatre	0.411	0.328	0.326	-30.7
Play (not musical)	0.307	0.286	0.255	-22.7
Ballet	0.107	0.102	0.090	-17.5
Art museum	0.492	0.517	0.505	5.3
Art or craft fair	0.632	0.575	0.501	-41.5
Historic site	0.674	0.568	0.530	-45.5

art museums, and opera, where they rose between 1982 and 1992 and declined between 1992 and 2002).

Figure 12.2 reports the attendance of college graduates at the nine core activities by age group for 1982, 1992, and 2002. For the performing arts, it suggests that the apparent increases in attendance among persons aged 47–66 for the population as a whole reflected the fact that those groups had considerably higher levels of education in 2002 than in 1982. For college graduates only, attendance at classical music concerts declined among all age groups but the oldest. Moreover, those cohorts entering the sample in the youngest age groups in 1982 and 1992 did not catch up with their elders; instead, their attendance rates fell further as they aged. Between 1982 and 2002, opera attendance held up better among the youngest age groups, but experienced sizable declines among college graduates 37–46 and 57–66 years of age. Ballet attendance, by contrast, declined in the three youngest age groups, with more uneven patterns for older college graduates. In 2002, college graduates under the age of 66 were attending fewer plays and musicals than their counterparts had in 1982, with the decline among persons younger than 47 especially notable for musical theatre between 1982 and 1992.

The other more popular activities suffered substantial declines among college graduates as well, with arts and craft fair attendance losing ground among every age group except persons aged 57 through 76, and historical site attendance declining across the board (mostly between 1982 and 1992). College graduates' art museum attendance rates were stable: except for a sharp rise among persons 47–56, there was little change within any age group between any of the surveys. Jazz attendance by the youngest college graduates (aged 18–26) declined between 1982 and 1992, then rebounded slightly, and rates for persons 27–36 were relatively stable. But among each age group between the ages of 37–76, rates of jazz concert attendance increased markedly between 1982 and 1992, and remained steady in the decade that followed. The resulting age/attendance curve, as compared to the distribution in 1982, reflects jazz's journey from music of the young to one of the high-culture arts.

As with evidence from the full sample, the decline in college graduates' attendance at many kinds of performing arts events (and the fact that the decline tends to have been greatest among younger cohorts), is consistent with the view that the performing arts are becoming less

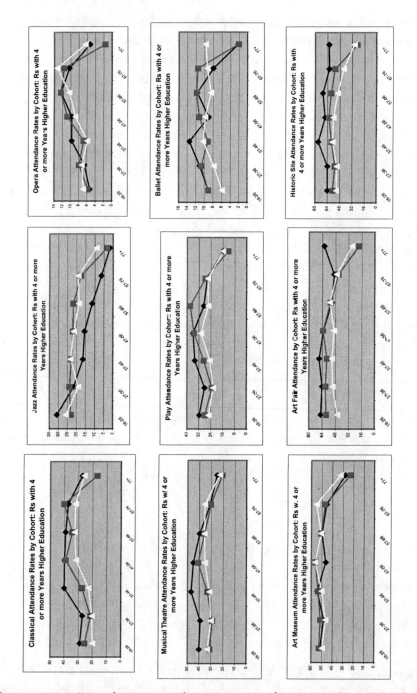

Figure 12.2 Attendance rates by age groups for respondents who had completed four or more years of higher education. Black—1982; Gray—1992; White—2002.

central parts of the status culture of highly educated Americans, whereas the visual arts are holding their own and jazz may have entered the realm of high culture. At the same time, declines in attendance at historic sites, arts and craft fairs, and musical theatre productions demonstrate that whatever trends are reducing participation in prestigious cultural forms are affecting middlebrow culture consumption as well.

Earlier we argued that if the status of the arts as cultural capital was endangered, we might expect a more rapid decline in participation among the highly educated than among other people, leading to a decline in the ratio of college graduates' to others' odds of attendance. Figure 12.3 depicts these ratios in each year for each core activity, comparing college graduates to high school graduates who had not completed additional years of education.[6] Here we see that there is no support for the expectation that the distribution of participation has become more equal over time. Indeed, the odds of high school graduates participating in arts events have declined even more quickly than the odds for college graduates. For example, between 1982 and 2002, when the classical music concert attendance rate for college graduates declined a substantial 22.5 percent (from 33.4 to 25.9 percent), the rate for high school graduates fell by more than 40 percent (from 7.6 to 4.5 percent). Declines in opera and ballet were even more disproportionate. Jazz and art museum attendance, which increased modestly among college graduates actually declined among their high school educated

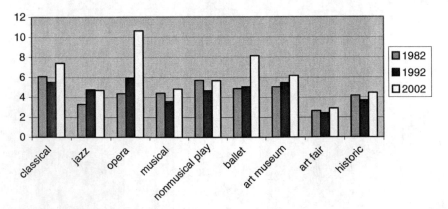

Figure 12.3 Ratio of odds of respondents with at least four years of higher education attending events to odds for high school graduates without college.

counterparts. Thus, in participation in high-culture arts events, as in many other areas of U.S. life, inequality appears to have increased during the last two decades of the twentieth century.

Taken as a whole these results suggest that the arts face substantial competition from other activities and that many live arts-and-humanities activities may be in relative decline. More popular cultural activities are declining as rapidly as the high-culture arts, and attendance has fallen faster among less-educated than among more-educated Americans. This indicates that the changes we have identified are *not* being *driven by* a dramatic deflation in the value of cultural capital. Nonetheless, a long-term erosion of participation might eventually *effect* such a devaluation of high-culture arts attendance, even if its causes are independent.

Are the High-Culture Arts Being Defeminized?

Earlier we called attention to the centrality of gender to the distribution and reproduction of cultural capital in the U.S. At least from the Victorian era onward, a domestic division of labor placed responsibility for business and political activity in the male domain, while allocating to women (who were believed better graced with virtues of sensitivity and refinement) responsibility for the household and for inculcating proper values and sensibilities in the young (Collins 1992). Research on arts participation has usually found higher rates among women than among men, with differences often wide (DiMaggio 1982; Bihagen and Katz-Gerro 2000; Tepper 2000). Some, but not all, studies have also found stronger effects of family background on arts-related measures of cultural capital for women and stronger effects of cultural capital on women's educational outcomes (Dumais 2002; but see Aschaffenburg and Maas 1997).

Persistent gender differences are also evident in Kaufman and Gabler's (2004) study of extracurricular activities, demonstrating that female high school students are more likely to take dance or music lessons, visit art museums, and engage in other arts activities than are their male counterparts; and although the results vary markedly depending on activity and outcome variable, a few of these activities have more positive payoffs for young women's college attendance than for that of young men. By contrast, Kane 2004 finds few gender differences among

students at an elite private university in arts participation (with the exception of dance), but reports that network diversity increases several types of arts participation for women but not for men. In analysis of married couples included in the SPPA, Upright 2004 finds that women's characteristics play a disproportionate role in driving households' arts participation.

Given the apparent centrality of gender and the household division of labor to the reproduction of the role of the arts as cultural capital, it stands to reason that if the arts are becoming less important as cultural capital, then the advantage of women over men in arts participation should be declining. It is also possible, of course, that women's advantage could decline because the domestic division of cultural labor was changing even if the arts status as cultural capital were *not* declining. Indeed, we might expect the gender gap to decline as a result of factors *other than* changes in the structure and composition of cultural capital. Since the 1960s, the women's movement has challenged the doctrine of separate spheres) and the practices associated with it (with some success. And, most important, middle-class women's labor-force participation has increased dramatically in the U.S. since the 1950s, a development that has reduced the discretionary time available to precisely those women who once constituted the core of the arts public.

Despite all these good reasons to expect a defeminization of arts attendance, we find no evidence that it has occurred. Table 12.3 displays attendance rates in each year for nine core activities, as well as the percentage change in odds of attending between 1982 and 2002, separately for men and women. In contrast to our expectations, for all activities but classical music and ballet, women's rates of attendance grew more or declined less than men's over the twenty-year span. (Curiously, whereas male and female rates traveled largely in tandem between 1982 and 1992, between 1992 and 2002 women's attendance rates increased while men's declined for several activities.) For most activities the differences between male and female rates of change were relatively small, but taken as a whole, the results belie the notion that the arts have been defeminized. (To be sure, the two exceptions were the two most high-cultural of the performing arts; but the differences were very small, and for other high-culture art forms, opera and the visual arts, they were reversed.)

We have already seen that aggregate trends may mask differences that emerge when one controls for age and level of educational attain-

Table 12.3 Men Versus Women Attendance Rates

Event type		1982	1992	2002	Percentage odds
Classical music	Men	0.113	0.115	0.103	-9.9
	Women	0.146	0.133	0.127	-14.9
Jazz	Men	0.103	0.119	0.107	4.3
	Women	0.090	0.094	0.108	22.4
Opera	Men	0.027	0.031	0.028	3.8
	Women	0.033	0.035	0.035	6.3
Musical theatre	Men	0.166	0.150	0.014	-18.2
	Women	0.205	0.020	0.200	-3.0
Play (not musical)	Men	0.108	0.122	0.103	-5.2
	Women	0.129	0.146	0.142	11.7
Ballet	Men	0.027	0.036	0.025	-7.6
	Women	0.056	0.056	0.051	-9.4
Art museum	Men	0.210	0.264	0.246	22.7
	Women	0.231	0.268	0.282	30.7
Art or craft fair	Men	0.331	0.353	0.270	-25.2
	Women	0.448	0.455	0.392	-20.6
Historic sites	Men	0.377	0.348	0.305	-27.5
	Women	0.368	0.341	0.325	-17.3

ment. Figures 12.4 and 12.5 plot attendance rates among college graduates by age group for each year, separately for men (Fig. 12.4) and women (Fig. 12.5). We focus our attention upon the three most youthful age groups because trends should be most evident among more recent cohorts. (And we pay little attention to the two oldest cohorts, where cell sizes are often quite small, especially in the early years.) The evidence largely defies generalization. If we compare 1982 rates to those twenty years later, we see comparable large declines for classical music, ballet, musicals and plays. Notable, if difficult to interpret, gender differences emerge in jazz, where attendance by men in the youngest age group declined markedly between 1982 and 2002, whereas attendance by women in that age group held steady, and where women in the 47–56 age group also made more notable gains than their male peers. Opera attendance declined substantially among women aged 37–46,

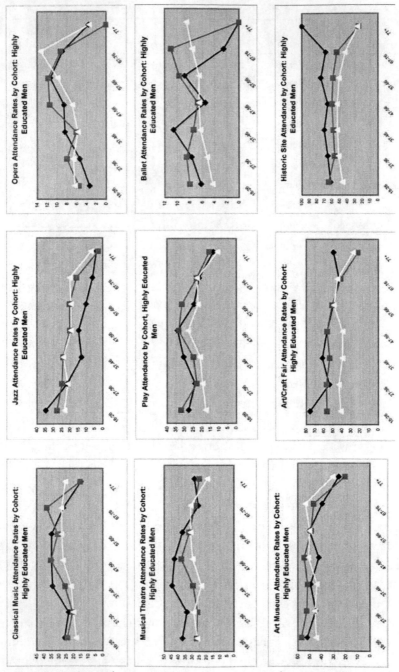

Figure 12.4 Attendance rates by age groups for men who had completed four or more years of higher education. Black—1982; Gray—1992; White—2002

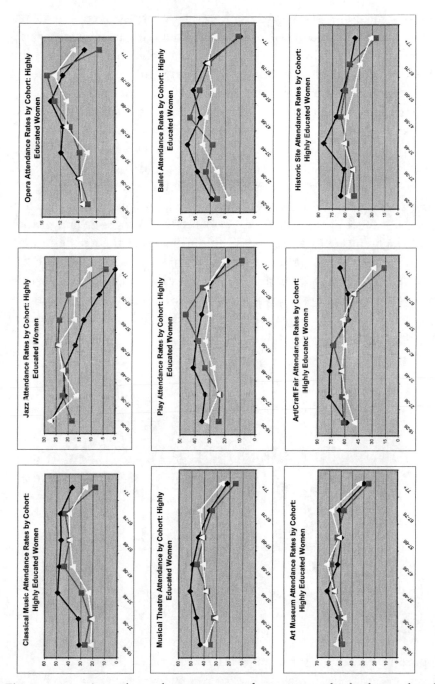

Figure 12.5 Attendance by age groups for women who had completed four or more years of higher education. Black—1982; Gray—1992; White—2002

but was steady for the younger cohorts; by contrast opera attendance rates declined for men aged 37–46, but rebounded in the most youthful cohort. Male and female college graduates also diverged in patterns of art museum visiting, with attendance rates for persons aged 18–36 declining markedly among men, but not among women.

Focusing on ratios of female to male odds of attendance (Fig. 12.6), we likewise see little pattern. For most activities (classical music, ballet, opera, jazz, visiting art museums or going to arts and craft fairs) the female advantage declined between 1982 and 1992, then increased between 1992 and 2002. In others (musical theatre, plays, visiting historic sites), women's advantage increased monotonically, but not dramatically. Once again, there is no evidence indicating a defeminization of the high-culture arts. We also analyzed change in the female-to-male odds ratios for the three youngest cohorts of men and women who had completed at least four years of higher education. These displayed the same pattern as the aggregate comparisons: a decline in the ratio of women's to men's participation odds between 1982 and 1992, followed by an increase during the following decade.

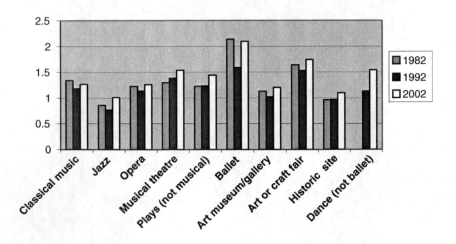

Figure 12.6 Female versus male attendance odds.

Conclusions

We examined trends in arts attendance based on data from the Surveys of Public Participation in the Arts in 1982, 1992, and 2002, and asked if trends were consistent with the widespread belief that the high-culture arts have become less central to cultural capital in the United States, as many observers have suggested. Following Bourdieu, we view "cultural capital" as comprising types of tastes, knowledge, and modes of appreciation that are institutionally supported and very broadly acknowledged to be high-status and worthy of respect (as distinguished both from passing enthusiasms that are not institutionalized and from cultural forms whose prestige is limited to particular groups). If the structure and composition of cultural capital were undergoing radical change in a way that undermined the role of the arts as cultural capital—let us call this *the meltdown scenario*—we would expect to find (a) declining rates of participation (b) concentrated among groups (college graduates, women, and, *a fortiori*, female college graduates) particularly high in cultural capital, with these trends especially visible (c) among younger cohorts and these art forms that have been institutionalized as "high culture" as opposed to more commercial or middlebrow forms.[7]

Our results demonstrate that rates of attendance at arts events in the United States declined between 1982 and 2002, although the extent of decline was obscured by a large increase in levels of schooling (the best predictor of arts attendance) among cohorts coming of age after 1960. When one disaggregates the samples by educational attainment, declines are more clearly visible, with the odds of attendance among college graduates declining by more than 20 percent for plays, musical—classical music concerts, arts and craft fairs, and historic sites. Moreover, for all forming-arts activities but jazz and opera, declines are concentrated in the three youngest age groups 8–26, 27–36, and 37–46.

The pattern of decline, however, is not entirely what we would expect if it primarily reflected developments in the high-culture arts. The trends depart from the "meltdown scenario" in several ways. First, some arts activities have held their own. The tiny opera audience has been stable, and attendance rates for jazz concerts and art museums *increased* between 1982 and 2002. Second, middlebrow activities (art or craft fairs, historic sites, musical theatre) lost their public even more quickly than the high-culture arts. Third, there was no visible trend toward

defeminization. And, fourth, attendance rates for college graduates declined at a slower pace than did rates for persons whose formal education ended with high school graduation, so that the advantage of the former over the latter actually increased for seven out of nine activities.

What do we make of these inconsistencies? First, let us consider the anomalous positives: the increased popularity of jazz and art museums in the face of declines in most of the performing arts. This development is consistent with Peterson's "omnivore thesis," which argues that status now inheres in cosmopolitanism and broadly inclusive tastes (Peterson 1997). Jazz, as a form with close ties to the African American community, and art museums, which represent artworks and objects from many cultures and traditions, stand in sharp contrast to the preponderantly Euro-American character of symphony orchestras, ballet companies, opera companies, and many theatre groups. The increase in popularity of these activities (though not necessarily the decline in attendance rates of others) is just what Peterson's work would lead us to anticipate.

Put another way, the observed patterns are consistent with the possibility that the arts remain central to cultural capital, but that change is occurring *in the composition of artistic cultural capital* in response to societal trends toward multiculturalism and greater inclusivity. In so far as attendance rates are indicators, the big losers among the high-culture arts are two art forms whose repertoires remain rooted in nineteenth-century Europe: classical music and ballet. The winners are an art form, jazz, with African American roots; and the visual and plastic arts, which may have even more appeal (following postmodernism theory) in a postmodern world of images in which visual literacy has increased as verbal literacy has declined (Jameson 1984; Lash 1990).

Second, we must consider the anomalous negatives, the fact that attendance at relatively middlebrow arts and cultural activities craft fairs, musical theatre, historic sites has declined even more quickly than attendance at more highbrow activities. The patterns suggest that all arts activities are experiencing increased competition for the public's attention, and that declines in attendance reflect these broader competitive conditions rather than the endogenous dynamics of cultural capital. Additional research is needed to identify the most important sources of competition; for example, the relative role of participatory activities (sports, *art-making*, outdoor activities) versus new or enhanced forms of home entertainment (cable, the Internet, computer games, DVDs or

MP3s). Indeed, given the proliferation of competitors for the consumer's entertainment dollar, it is surprising that public arts events have held up as well as they have.

Research is also needed to understand the specific processes accounting for declines in attendance among younger cohorts. One line of inquiry concerns interactions between attendance at live arts events and other forms of arts consumption. To what extent do declines in attendance at out-of-home arts events reflect across-the-board diminution of the arts public? To what extent might such declines be offset by increases in in-home consumption of related products? (Peterson and Sherkat 1996 present evidence suggesting that at-home consumption may have substituted for live attendance among some age groups in some disciplines between 1982 and 1992.) How has direct participation in the arts (taking arts classes, painting or drawing, taking part in theatrical productions, playing musical instruments, and so on) fared over the past two decades?

A second line of inquiry has to do with how broader kinds of social change may be influencing arts attendance. The arts boom of the 1970s and 1980s was driven both by new infusions of government investment in the arts through the National Endowment for the Arts and the state arts agencies; and by earlier public investments in higher education, which produced unprecedented numbers of new arts consumers among the generations that came of age in the 1960s and 1970s. In the past twenty years, demographic trends may have worked against the arts. Research is needed to assess the impact, if any, of three factors in particular: increased middle-class women's labor-force participation, which may reduce discretionary time for college-educated women; increases in the divorce rate; and, more recently, increases in birth rates to never-married middle-class women. Parents in general, and single parents in particular, may find it harder to seek entertainment outside the home (Peterson and Sherkat 1996; Balfe and Meyersohn 1996). Other research demonstrates (Roscigno and Ainsworth-Darnell 1999) that adolescent children living with step-parents or in single-parent households are significantly less likely to visit art, history, or science museums, and that the former are also significantly less likely to take classes in the arts outside of school. It is possible, then, that changes in family structure explain part of the reduced participation rates among the youngest cohorts.

The impression that declines in performing arts attendance reflect broad competitive forces rather than a specific delegitimation of the arts as cultural capital is consistent, as well, with two other deviations from the "meltdown scenario." First, women in general, and college-educated women in particular, continue to attend arts events at rates higher than men, even though the influence of feminist critiques of the traditional domestic division of labor and the dramatic rise in labor-force participation by middle-class married women would, other things equal, lead one to expect the female advantage to decline. Second, attendance by college graduates in most activities has declined at a slower rate than attendance by less-educated persons. Neither of these results is consistent with the notion that a decline in returns to cultural capital has reduced the incentive for women and college graduates, respectively, to maintain their investment. Rather they are consistent with the interpretation that groups with the strongest investment in high culture offer the greatest resistance, in the face of rising competition, to alternative uses of nonwork time.

So the arts share in the difficulties of a crowded marketplace for cultural and leisure activities. In coping with those difficulties, they have certain advantages. The prestige of high culture is produced by institutional processes that restrain the impact of market forces (DiMaggio 1982); market forces cannot eliminate that prestige so long as institutions that guarantee and reproduce the valuation of the arts as high culture endure. That said, there is undoubtedly a reciprocal effect of market forces and public opinion on the strength and behavior of institutions. How long high-culture art forms like classical music, theatre, and ballet can continue to lose attendance and still remain a source and indicator of cultural capital remains an open question. We suspect that if attendance continues to decline, at some point such art forms will become irrelevant to the shared culture of families and social groups whose life chances are most dependent upon their command of cultural capital. As that happens, such groups will spend less energy inculcating a love of the arts in their children, may be less willing to support government grants to nonprofit performing arts institutions, may demand fewer university courses in art history or music history, and may provide less incentive for broadcasters, record companies, and other commercial culture producers to make the arts available in digital form. In this scenario, the "high-culture arts" would not disappear; but they

would be left to fend for themselves as niche players in a vast and saturated cultural marketplace.

This is speculation to be sure. Taken together, our results suggest that, although some forms of arts activity are losing patronage in the face of competitive pressure, the decline of the arts as a form of cultural capital in the U.S. is taking place more slowly than many observers had predicted, if indeed it is taking place at all.

Bibliography

Aschaffenburg, Karen and Ineke, Maas. 1997. "Cultural Educational Careers' *American Sociological Review* 62: 573–87.

Balfe, Judith Huggins and Rolf Meyersohn. 1996. "Arts Participation of the Baby Boomers." Washington, DC: National Endowment for the Arts. Research Report #34, part 2.

Becker, Howard S. 1982. *Art Worlds.* University of California Press, Berkeley.

Bihagen, E., Katz-Gerro, T. 2000. Culture Consumption in Sweden: The Stability of Gender Differences. *Poetics* 27, 327–49.

Bourdieu, Pierre. 1973. "Cultural reproduction and social reproduction." In Brown, Richard Ed., *Knowledge, Education, and Cultural Change: Papers in the Sociology of Education.* London, Tavistock Publications, pp. 71–112.

_____. 1974. "Avenir de Classe et Causalité du Probable." *Revue Française de Sociologie 15: 3–42.*

_____. 1983. "The Field of Cultural Production, or: The Economic World Reversed." *Poetics* 12: 313–56.

_____. 1984. *Distinction: A Social Critique of the Judgment of Taste.* Cambridge, MA: Harvard University Press.

Bourdieu, Pierre and Jean-Claude Passeron, 1977. *Reproduction Education, Society, and Culture.* Beverly Hills, CA: Sage.

_____. 1979. *The Inheritors: French Students and their Relation to Culture.* Chicago: University of Chicago Press.

Collins, Randall. 1992. "Women and the Production of Status Cultures: In: Michéle Lamont, Marcel Fournier (Eds.), *Cultivating Differences*, Chicago: University of Chicago Press, pp. 213–31.

DeGraaf, Nan Dirk, Paul M. De Graaf, and Gerbert Kraaykamp. 2000. "Parental Cultural Capital and Educational Attainment in the Netherlands: A refinement of the Cultural Capital Perspective." *Sociology of Education* 73: 92–111.

DiMaggio, Paul. 1982. "Cultural Capital and School Success: The Impact of Status Culture Participation on the Grades of U.S. High School Students." *American Sociological Review* 47: 189–201.

_____. 1987. "Classification in art." *American Sociological Review* 52: 440–55.

_____. 1991. "Social Structure, Institutions, and Cultural Goods: The Case of the U.S." In Pierre Bourdieu and James Coleman, (Eds.*), Social Theory for a Changing Society*. Boulder, CO: Westview Press.

_____. 1992. "Cultural Boundaries and Structural Change: The Extension of the High-Culture Model to Theatre, Opera, and the Dance, 1900–1940." In Michêle Lamont and Marcel Fournier, (Eds.), *Cultivating Differences: Symbolic Boundaries and the Making of Inequality*. Chicago: University of Chicago Press.

_____. 1996. "Are Art-Museum Visitors Different from Other People? The Relationship between Attendance and Social and Political Attitudes in the U.S." *Journal of Empirical Research on Literature, The Media, and the Arts* special issue on *Museum Research* 24, no. 2-4: 161–80.

_____. 2001. "Social Stratification, Life Style, Social Cognition and Social Participation." In David Grusky (Ed.), *Social Stratification in Sociological Perspective*, 2nd edition, Boulder, CO: Westview Press.

DiMaggio, Paul and Bethany Bryson. 1995. "Americans' Attitudes Towards Cultural Authority and Cultural Diversity: Culture Wars, Social Closure, or Multiple Dimensions?" General Social Survey Topical Reports series, No. 27. Chicago: National Opinion Research Center.

DiMaggio, Paul and John Mohr. 1985. "Cultural Capital, Educational Attainment, and Marital Selection." *American Journal of Sociology* 90: 1231–1261.

DiMaggio, Paul and Francie Ostrower. 1990. "Participation in the Arts by Black and White Americans." *Social Forces* 68: 753–78.

Dumais, Susan A. 2002. "Cultural Capital, Gender, and School Success: The Role of Habitu." *Sociology of Education* 75: 44–68.

Erickson, Bonnie. 1996. "Culture, Class, and Connections." *American Journal of Sociology* 102: 217–251.

Featherstone, Mike. 1991. *Consumer Culture and Postmodernism*. Beverly Hills, CA: Sage.

Harvey, David. 1989. *The Condition of Postmodernity: An Enquiry into the Origins of Cultural Change*. Oxford: Basil Blackwell.

Holt, Douglas. 1997. "Distinction in America? Recovering Bourdieu's Theory of Taste from Its Critics." *Poetics* 25: 93–120.

Jameson, Frederic. 1984. "Postmodernism, or the Cultural Logic of Late Capitalism." *New Left Review* 146: 53–92.

Kane, Danielle. 2000. "Distinction Worldwide: Bourdieu's Theory of Taste in International Context. *Poetics* 31: 403–21.

_____. 2004. "A Network Approach to the Puzzle of Women's Cultural Participation." *Poetics* (special issue on gender, networks, and cultural capital).

Kaufman, Jason and Jay Gabler. 2004. "Cultural Capital and the Extracurricular Activities of Girls and Boys in the College Attainment Process." *Poetics* (special issue on gender, networks, and cultural capital).

Lamont, Michele. 1992. *Money, Morals, and Manners*. Chicago: University of Chicago Press.

Lash, Scott. 1990. *The Sociology of Postmodernism*. London: Routledge.

Lopes, Paul D. 2002. *The Rise of a Jazz Art World*. New York: Cambridge University Press.

Martin, Steven P. 2003. "Is the Digital Divide Really Closing? A Critique of Inequality Measurement in A Nation Online." IT & Society 1, 4. http://www.1tandSocieyt.org. Last accessed June 12, 2003.

McCarthy, Kevin F., Arthur Brooks, Julia Lowell, and Laura Zskars. 2001. "The Performing Arts in a New Era." Santa Monica, CA: RAND Corporation.

Mohr, John and Paul DiMaggio. 1995. "The Intergenerational Transmission of Cultural Capital." *Research in Social Stratification and Mobility* 14: 167–99.

Pescosolido, Bernice and Beth Rubin. 2000. "The Web of Group Affiliations Revisited: Social Life, Postmodernism, and Sociology." *American Sociological Review* 65: 52–76.

Peterson, Richard A. 1972. "A Process Model of the Folk, Pop, and Fine Art Phases of Jazz," Charles Nanry, *American music: From Storyville to Woodstock*. New Brunswick, NJ: Trans-Action Books and E.P. Dutton. 135–51.

_____. 1997. "The Rise and Fall of Highbrow snobbery as a Status Marker." *Poetics* 25: 75–92.

Peterson, Richard A. and Roger M. Kern. 1996. "Changing Highbrow Taste: From Snob to Omnivore." *American Sociological Review* 61: 900–907.

Peterson, Richard A., Darren E. Sherkat. 1996. "Age Factors in Arts Participation: 1982—1992." Washington DC: National Endowment for the Arts. Research Division Report #34, part 1.

Relish, Michael. 1997. "It's Not All Education: Network Measures as Sources of Cultural Competency." *Poetics* 25: 121–39.

Roscigno, Vincent J. and James W. Ainsworth-Darnell. 1999. "Race, Cultural Capital, and Educational Resources: Persistent Inequalities and Achievement Returns." *Sociology of Education* 72: 158–78.

Smith-Rosenberg, Carroll. 1985. *Disorderly Conduct: Visions of Gender in Victorian America*. New York: Knopf.

Tepper, Steven. 2000. "Fiction Reading in America: Explaining the Gender Gap?' *Poetics* 27: 255–75.

Upright, Craig. 2004. "Social Capital and Cultural Participation: Spousal Influences on Attendance at Arts Events." *Poetics* (special issue on gender, social networks, and cultural capital(.

Van Eijck, Koen. 1997. "The Impact of Family Background and Educational Attainment on Cultural Consumption: A Sibling Analysis." *Poetics* 25: 195–224.

Van Rees, Kees, J.K. Vermunt, and M. Verboord. 1999. "Cultural Classifications Under Discussion: Latent Class Analysis of Highbrow and Lowbrow Reading." *Poetics* 26, 349–365.

Warde, Alan, Lydia Martens, and Wendy Olsen. 1999. "Consumption, the Problem of Variety Cultural Omnivorousness. Social Distinction, Dining out." *Sociology 33*, 105–127.

Welter, Barbara. 1966. "The Cult of True Womanhood: 1820–1860." *American Quarterly* 18, 151–174.

The Wolf Organization, 1991. *The Financial Condition of Symphony Orchestras. Report to the American Symphony Orchestra League.* Cambridge, MA: The Wolf Organization.

Zolberg, Vera. 1988. "Postmodernism Previewed: Aesthetic Eclecticism in the Nineteenth-Century Art Museum." Paper presented at the 14th Annual Conference on Social Theory, Politics, and the Arts, Washington, DC.

Endnotes

1. This chapter is reprinted from Paul DiMaggio and Toqir Mukhtar, "Arts Participation as Cultural Capital in the U.S.," *Poetics* 32, no 2, 2004, pp. 169–94, with permission from Elsevier. Support for this research from the Andrew W. Mellon Foundation and the Pew Charitable Trusts is gratefully acknowledged, as is institutional support from Princeton University's Woodrow Wilson School and Center for Arts and Cultural Policy Studies. We are grateful for helpful advice and feedback from Tom Bradshaw, Josh Goldstein, Ying Lu, Larry McGill, John Robinson, Steven Tepper, and Craig Upright.

2. Lamont (1992) reports that U.S. middle-class men, especially men from outside the Northeast, are less likely than French men to report judging people on the basis of their aesthetic judgment. In a study of a sample of students at an elite U.S. University, Kane (2003) reports that controlling for age, academic program, gender, and family background Europeans are significantly more likely than U.S. students to attend classical-music concerts and visit art museums (but not ballet performances); but they are *not* significantly more likely than their U.S. counterparts to report that it is important to them that their friends are cultured.

3. The 1982 and 1992 surveys differed from the 2002 study in two ways. First, they were undertaken as add-on modules to the National Crime Survey, whereas the 2002 study was a module of the Current Population Survey. Second, they were year-round surveys, whereas the 2002 survey was administered in August. According to John Robinson and Tom Bradshaw (personal communication), extensive analyses have disconfirmed the hypothesis that either of these differences influenced the results in a systematic manner. (The arts-participation items we use in this chapter refer to participation during the previous 12 months, so should not be affected by the month in which the survey is administered). Surveys administered in 1985 and 1997 are less useful for our purposes, the former because it

was aborted midway for budgetary reasons and the latter because it was administered by a different survey organization and generated results that were systematically discrepant from the Census-administered studies.

4. We chose age groups to follow the usage of Peterson and Sherkat 1996. According to Sherkat (personal communication), the original data set with which they worked included a few 17-year-old respondents, whose records were ultimately eliminated as the result of further cleaning of the data.

5. It is not necessary to believe that people consciously evaluate the status payoff of arts attendance on their pocket calculators in order to decide whether or not to attend arts events. We follow Bourdieu in viewing strategic rationality as to a great extent institutionalized, with rational action reflecting the alignment of disposition and opportunity that Bourdieu (1974) calls *la causalitb du probable*.

6. We chose to compare college graduates to this group rather than to persons who had not completed high school or to persons who had completed between one and three years of college because, for most activities, this is a particularly significant gap.

7. It is possible, of course, that the arts never were part of "cultural capital" in the U.S., or that they lost that status before the coming of age of the cohorts in our sample. We do not take this conclusion seriously, however, as it is inconsistent with too many studies' findings of positive associations between cultural capital measured as participation in the arts and life chances.

13 Changing Arts Audiences
Capitalizing on Omnivorousness

Richard A. Peterson and Gabriel Rossman

> The concert hall [may] someday become a place where old men and women gather forlornly to listen to the same symphonies and concertos they first heard a half-century ago, while their children, if they are interested in classical music at all, will stay home and listen to compact discs or whatever newer marvel is destined to replace them.

> Terry Teachout (1998)

Introduction

These should be boom times for the fine arts in America. The numerous members of the baby boom generation—those born between 1946 and 1965—tend to be better educated, wealthier, more urban, and more widely traveled than their parents. Not only are these boomers

very numerous, and in many ways similar to those who have attended the arts in the past, but their participation in live arts events also should be reaching its highest level now as child-rearing activities are waning, and their incomes are waxing. However, as those in the art world know, the reality is not so rosy. Many arts organizations have experienced lower attendance, some notable organizations have failed or have been drastically reorganized, and all are finding that their audiences are aging. The graying of U.S. fine arts audiences is due primarily to the fact that the cohorts born before World War II are thinning out, and baby boomers are not as likely to participate in the fine arts as was their parents' generation. Those born since the baby boomers are dramatically less likely to participate in the arts at a comparable age.[1]

The graying of the arts audience can be seen graphically in the figures periodically collected by the U.S. Bureau of the Census for the National Endowment for the Arts (NEA). As Table 13.1 shows, in 1982 only the opera audience (shown in the second row of the table) had a higher median age[2] than that of the average of the entire sample of survey respondents. By 2002, just twenty years later, only ballet and jazz had audiences younger than the median for all respondents. The graying has been the greatest for jazz, classical music concerts, and art museums. Special circumstances may account for the rapid aging of the

Table 13.1 Median Age of Arts Attenders and of the Entire Sample

Wave	1982[a]	1992[a]	1997[a]	2002[b]	Net Gain
Entire Sample	40	42	43	44	5
Opera	43(+3)	45(+3)	45(+2)	48(+4)	5
Classical	40(0)	45(+3)	46(+3)	49(+5)	9
Theater	39(−1)	44(+2)	44(+1)	46(+2)	7
Musical	39(−1)	43(+1)	44(+1)	45(+1)	6
Ballet	37 (−3)	40(−2)	44(+1)	44(0)	7
Museum	36(−4)	40(−2)	43(0)	45(+1)	9
Jazz	29(−11)	37(−5)	41(−2)	43(−1)	14

Notes: Values in parentheses indicate years of difference from the median age of the entire sample. Gray shading indicates older on average than the average of the entire sample.

[a] Values for 1982, 1992, and 1997 taken from Peterson et al. (2000).

[b] Values for 2002 computed by the authors from SPPA data.

jazz audience,[3] but we know of no art-form specific circumstance that can explain the fact that over the twenty years in question, the median age of audiences for classical music and art museums has risen by nine years, the equivalent of 5.4 months per year. Some commentators have noted that the tragic events of 9/11 occurred within the survey year, but there is good evidence from the Survey of Public Participation in the Arts (SPPA) that refutes the speculation that the declines noted in 2002 resulted from 9/11.[4]

The 2006 NEA report on classical music radio programming and listening trends graphically illustrates the decline in classical music's popularity. In the seven short years between 1998 and 2005 the number of commercial classical music stations declined by 30 percent, and listenership was down proportionately. Over the past several decades, public radio has been the prime source of classical music programming and the number of public stations has increased dramatically, but from 1994 through 2005 the number of hours of public radio classical music programming has remained virtually the same whereas the hours of public radio news and talk programming more than doubled (NEA 2006).

As clear as these figures are about the aging and decline in arts audiences, they do not in and of themselves point to the reasons for these tectonic shifts in the behavior of potential arts participants. The reasons may be many and various, but this study uses the available SPPA data to point to a significant shift in how the fine arts are used to signal high social status. Put simply, we see a shift in how individuals, cities, and nations signal good taste. This is seen in elite status-group politics as a shift from snobbishly disdaining all base, vulgar, or mass popular culture—a pattern that is snobbish—to consuming a wide range of popular as well as highbrow art forms, which here is called *omnivorousness*. It is important for arts policy leaders to understand this general process so they can better interpret all the specific changes they see in the contemporary arts worlds and to consider how best to take advantage of these changes in promoting the arts.

This chapter explores the shift from highbrow snobbishness to omnivorousness. After identifying the origins of the highbrow standard of taste and the more recent shift toward omnivorousness, the chapter operationalizes a strict definition of highbrow status, confirms the importance of omnivorousness as seen in the 2002 SPPA data, and demonstrates a link between expressed taste and reported behavior. Then

differences in leisure activity are examined between highbrow univore snobs and omnivores. Then lowbrows are inspected to reveal a significant number who have a taste for the fine arts, and the study shows that the members of this group of lowbrows serve as excellent candidates for arts cultivation activities. Finally the chapter discusses the arts policy implications of the study's findings.

Art as a Status Marker

Art, architecture, furnishings, clothing, music, and all sorts of symbolic display were long used by royal courts to show their power and glory, and early sociologists, most notably Thorstein Veblen (1899), Georg Simmel (1904), and Erving Goffman (1951), have shown the importance of such display in claiming social status in capitalist societies. Following these early insights, Paul DiMaggio (1982) and Lawrence Levine (1988) showed that in the latter part of the nineteenth century, a determined set of cultural entrepreneurs deliberately differentiated the fine arts from popular culture. They argued that it was necessary to cultivate the fine arts and to shun all that was considered base or vulgar entertainment to affirm high social status in the United States.

The distinction between fine art and base culture was given a veneer of respectability in the mid-nineteenth century by linking it to the popular pseudoscience of phrenology, which posited that the larger the cranial cavity, the larger the brain and therefore the greater the capacity for knowledge, reasoning, aesthetic sensibility, and moral rectitude—ideas now long since refuted. Based on casual observation, phrenologists ranked whole nationalities by cranial capacity and shape from those with the highest brows to those with the lowest. One notable text of 1865 by J. Millott Severn paired a "portrait of Shakespeare" shown in profile with a large balding tête next to the skull of "A Cannibal New Zealand Chief" sketched slightly from above and suggesting no forebrain at all.[5]

Having this high-browed characteristic, phrenologists argued, conferred on the high-browed groups the obligation to rule over the lower-browed races, and English phrenologists, not unsurprisingly, found the English elite to have the greatest preponderance of highbrows, whereas those in Germany found them more often in the German elite. Over

time arts appreciation and patronage became indicators of being *high-brow* rather than the other way around, and the supposed relationship between arts appreciation and moral rectitude was strengthened as the brow-level terminology became more metaphorical, so that arts appreciation became seen as an important indicator of moral rectitude, that is highbrow (Colbert 1997). Because biological theories of racial and national superiority were used at the time to link arts appreciation and high status, those who cultivated the arts were called *highbrows*, and because they ardently distinguished themselves from the common lot of *lowbrows* and their ways, they were often called, and sometimes called themselves, *snobs* (Gould 1996; Levine 1988; Peterson 1997).

By the middle of the twentieth century, the terms highbrow and lowbrow, along with the intermediate middlebrow, were regularly used in public discourse (Lynes 1954), and lists of objects, dress, food, books, music, and dance considered to be emblematic of high- and lowbrows were regularly found in the mass-circulation middlebrow magazines of the time including *Life* and *Look*, where appreciation of the fine arts figured prominently among the signs of highbrow status. The brow-level imagery is less widely used today, but this discourse retains it because, like it or not, the idea of highbrow exclusiveness still, not infrequently, informs cultural policy discussions and planning. It is, for example, evident in the NEA's current motto: "A great nation deserves great art."

Terms such as highbrow, snob, and lowbrow are invidious. They are used here not because we want to see the classification perpetuated; quite the contrary, they are used because we believe that those interested in the arts need to understand how the invidious distinctions between popular culture and fine art generated over a century ago now befog important issues in arts policy. These distinctions were created by people who had a personal interest in promoting them. The intellectual underpinnings of highbrow snobbery were laid by British critic and moralist Matthew Arnold, who asserted passionately in *Culture and Anarchy* (1875) that the pursuit of the fine arts was a necessary bulwark against ignorance, moral decay, and eventual anarchy, and his treatise is still assigned for reading today in some university humanities departments. Over the years numerous other leading intellectuals and artists have glorified the fine arts while railing against popular culture. These include, among others, H. G. Wells, D. H. Lawrence, T. S. Elliot, Arturo Toscanini, Dwight McDonald, Clement Greenberg, Theodor Adorno,

Edward Shils, Arthur Schlesinger, Jr., Allan Bloom, Neil Postman, Hilton Kramer, Roger Kimball, Irving Kristol, and Julian Johnson.[6] Robert H. Bork is typical among such recent writers. He first established his meager knowledge of popular culture by, among other things, declaring that Nine Inch Nails is a rap group, and then he said, "Perhaps popular culture is inevitably vulgar, but today's is more vulgar than at any time in the past" (Bork 1996, pp. 127–28). Their ideas and actions must concern us today because thousands of arts organizations still implicitly use the classification scheme.

Dominant status groups regularly define popular culture in ways that fit their own interests and have worked to render harmless subordinate status group cultures (Sennett and Cobb 1972). Whereas highbrow exclusion was an effective marker of status in a relatively homogeneous and circumscribed white, Anglo-Saxon, Protestant (WASP) world, which could enforce its symbolic dominance over all others by force if necessary (Beisel 1997; Gusfield 1963), omnivorous inclusion seems better adapted to an increasingly global world managed by those who make their way, in part, by showing respect for the cultural expressions of others. As highbrow snobbishness fit the needs of the turn-of-the-twentieth-century entrepreneurial upper-middle class, there also seems to be an elective affinity between today's cosmopolitan business-administrative class and omnivorousness (Bell 1976; Briggs 1979; Brooks 2000; Florida 2002; Gouldner 1979; Kristol 1978).

In empirically exploring the changing nature of status and the arts in the United States, Peterson and Simkus (1992) found that, indeed, higher-status people were more likely to participate in the fine arts and that many older arts lovers shunned popular culture, as would be expected from the model of highbrow snob. But at the same time, many younger arts lovers fully embraced popular culture. Thus, rather than being snobs, these highbrows seemed more nearly culturally omnivorous. In the years since, numerous other studies have confirmed the presence of highbrow omnivores in the United States as well as in Canada, the United Kingdom, the Netherlands, Belgium, France, Spain, Austria, Australia, and across fifteen nations of the European Union.[7] This widespread shift from highbrow snobbery to omnivorousness is an indicator of the democratization of the arts that has been taking place in the United States since the middle of the last century, but the causes for the change are not well understood (Peterson 2005). As this chap-

ter demonstrates, the change is the result more of high-status people embracing the popular arts than of working-class people embracing what were called the fine arts.

As we understand the meaning of omnivorous taste, it is antithetical to snobbishness based fundamentally on rules of rigid exclusion (Bourdieu 1984; Murphy 1988). At the same time, it does not mean that the omnivore likes everything indiscriminately; rather, it means being open to appreciating everything. Though it is hostile to snobbish closure (Murphy 1988), omnivorousness does not imply an indifference to distinctions; rather, its emergence may signal the formulation of new rules governing symbolic status boundaries (Lamont and Fournier 1992). Classical cellist Yo Yo Ma's various musical projects with jazz, country music, Latin American, and Asian musicians represent the spirit of omnivorousness by respectfully playing in a number of quite distinct musical traditions.

Many people participate in the fine arts for the sheer enjoyment it gives. Many also patronize art because it represents moral rectitude and the best of civilization so that patronizing the fine arts uniquely affirms the high status of the individual. Rival cities and nations also get caught up in the struggle for supremacy in the fine arts. Such people, cities, and nations have felt that supporting the arts was something they ought to do whether they personally liked art or not. This view of the fine arts held sway into the latter half of the twentieth century (Peterson 1997) and is still used today by many of those promoting the arts. Nonetheless, this chapter argues, appeals to the moral imperatives of highbrow snobbery have had less and less appeal to potential recruits to the arts, especially those born since World War II.

Creating and Understanding the HUs, HOs, LUs, and LOs

We have talked of highbrow and lowbrow, snob and omnivore primarily using data from 1992 or earlier, but in 2002 the NEA replicated its SPPA, thus providing the opportunity to question, update, and elaborate the implications of the rise of omnivorousness. Music is the only creative field included in the SPPA survey in which respondents can voice their tastes for popular as well as fine art genres, so this study's measure of taste is based on music. It is also fortunate to be able to

focus on music because of all the traditional art forms, classical music is arguably having the greatest problems with declining participation. Now for the details. In the 2002 SPPA, 17,135 persons eighteen and older were interviewed (Bradshaw and Nichols 2004), of whom 16,724 answered the questions about music tastes, and of these 904 said they "don't like to listen to music."[8] In addition 565 respondents said they liked "all kinds" of music, so they were eliminated leaving a final sample of 15,255.[9]

Since we are interested in identifying those who are clearly highbrow in their music tastes, the study's criteria of inclusion as highbrow are that the respondent chose classical music or opera as their favorite kind of music, and, if they chose more than that one kind of music in addition to their favorite, they also chose classical music, opera, or jazz as another kind of music they liked.[10] The number of respondents who fit this strict definition of highbrow is 1,016 (6.7 percent of the study sample). The nonhighbrows represent 93.3 percent of the sample. The study follows the convention and calls them lowbrows, but as demonstrated following, many of them are far from the Archie Bunker–Homer Simpson sort because at least 23 percent like classical music, jazz, or opera to some degree. A later section of the chapter returns to look in more detail at these lowbrows because they are the most likely candidates for becoming more committed fine arts participants.

To be classed as a highbrow snob a respondent had to avoid popular and middlebrow music forms. But as has been known since Wilensky (1964) made his classic study, very few U.S. residents completely shun all middle- and lowbrow musics. To allow for a few choices, such as musical theater, religious music, classic rock, or choral music, highbrows who chose a total of five or fewer types of music are identified as *highbrow univores* (HUs), and *highbrow omnivores* (HOs) are those respondents defined as highbrows who said they like six or more genres. The operational definition of *lowbrow univore* (LU) is any respondent who likes three or fewer kinds of music and not classical music or opera best; *lowbrow omnivores* (LOs) are those persons defined as lowbrow who said they liked four or more kinds of music.[11] Not surprisingly, the number in the highbrow category is small relative to the number of lowbrows, whereas univores outnumber omnivores. The numbers of respondents of each of these four types is shown in Table 13.2.

Table 13.2 Distribution of the Four Taste Groups in 2002

	Brow Level	
Number of Music's Chosen	Low	High
Few Univore Name Numbers	LU 8,432 (55.3)	HU 526 (3.45)
Many Omnivore Name Numbers	LO 5,803 (38.1)	HO 490 (3.21)

Notes: Figures in parentheses are cell percentages of the entire sample. The cell percentages do not total 100 because people who said they did not like music and those who said they liked all kinds of music are omitted.

Table 13.3 Percent of Highbrows and Lowbrows with Live Attendance at Benchmark Arts Activities

	Classical Music	Opera	Jazz	Musicals	Plays	Ballet	Art Museum
Highbrow	39	14	27	32	25	10	56
Lowbrow	10	2	9	17	12	3	26

But are these good measures of brow level and omnivorousness? Some commentators have criticized the use of music taste, preferring to use reports of arts-going behavior. The present study demonstrates, however, that taste and behavior are closely aligned. Table 13.3 shows clearly that highbrows are far more likely to attend art music than are lowbrow respondents, and these differences are statistically significant for classical music, opera, and jazz. In addition, the data show that music taste is a significant predictor of attendance at nonmusical fine arts events, including theatrical plays, ballet performances, and art museum exhibits.[12] Clearly, for respondents this study identified as highbrow, active engagement in all fine art and art-related activities closely mirrors their highbrow musical tastes, thus validating the choice of musical taste as a good predictor of engagement in the fine arts.

Turning first to the musical tastes of HUs and HOs, Table 13.4 shows clearly that, as predicted, HOs are significantly more likely than HUs to like semipopular and popular kinds of music. It is also interesting to note that the highbrow omnivores are significantly more likely to like all the genres of music than is the total sample. This is true except for country music, heavy metal, and rap: In the three bottom rows of Table 13.4 the proportions of highbrow omnivores liking country music, rap, and heavy metal is roughly equivalent to the sample as a whole. This is

Table 13.4 Percent of Highbrow Univores and Highbrow Omnivores Who Like Specific Kinds of Middlebrow and Popular Music

Genre of Music	Highbrow Univores	Highbrow Omnivores	Total Sample
Musicals	10	59	15
Blues/R&B	8	71	29
Big Band/Swing	6	67	23
Bluegrass	4	50	20
Easy Listening	8	61	30
Choral Music	2	32	7
Gospel/Hymns	4	50	27
Classic Rock	13	74	51
Country Music	5	47	44
Heavy Metal	2	21	21
Rap	0	13	13

consistent with the finding that even among most omnivores, some low-status genres remain anathema (Bryson 1996, 1997).

There is another way to affirm the validity of taste differences among highbrows. Although the 2002 SPPA survey asked fewer questions about involvement in non-elite leisure activities than had the versions of 1982 and 1992, the HOs are significantly more likely that HUs to engage in all activities included in the survey: going to sports events, taking part in sports, going to theme parks, camping or hiking, doing home repairs, and tending house plants or gardening.[13]

Since television programming varies so widely in choice of content and mode of presentation, it would have been very valuable to have a question about the types of TV respondents regularly viewed.[14] As with the question about music taste, such a question would allow for a quick assessment of the tastes of respondents. Unfortunately, no such question was included in the 2002 SPPA survey. The one question about television asked about the number of hours of TV viewed in an average day. The differences between taste groups are not great, but they are in the direction expected from prior studies. Lowbrow univores report watching an average of 3.0 hours; lowbrows watch 2.8 hours; and the figures for HUs and HOs, respectively, are 2.4 and 2.6 hours a day. Taking a little closer look, 30 percent of lowbrow univores watch four or more

hours of TV daily, whereas the figures for both kinds of highbrows is 20 percent. Gone are the days when the elite largely claimed to watch little television, disdainfully calling it the "boob tube."

Summary Sketch of the Two Sorts of Highbrows

Having shown the contrasting taste patterns of the HUs and HOs, a summary can now be given of the ways these two groups are similar and different in their arts participation, and it can be shown how they differ demographically as well. These descriptions fit the typical person in each group, although individuals may vary from these typifications.

By definition both groups choose classical music or opera as their favorite form of music, but HUs say that they like few other kinds of music. The preference Hus have for art music is reflected in their likelihood of attending live art music concerts and consuming it via the media more than does the sample as a whole. Based on this study's detailed statistical analysis of the sample's demographic characteristics, it was found that HUs are the oldest taste group. They and their parents tend to be well educated, and they are likely to have been schooled in one or more art forms. They are more likely than the sample as a whole to have substantial incomes, be white or Asian,[15] have no young children, and to live in the largest metropolitan areas. In sum, they approximate the classical picture of the highbrow (Arnold 1875; Eliot 1939, 1949; Levine 1988; Peterson 1997).

By definition HOs choose classical music or opera as their favorite form of music and select a large number of other kinds of middlebrow and popular music as well. Their enjoyment of art music is reflected in their greater likelihood relative to the other taste groups of attending live art music concerts and consuming it via the media. At the same time, HOs are much more likely to take part in a wide range of popular leisure activities than are HUs. On average, HOs are older than the sample as a whole but not as old as HUs. They are as likely as HUs to be well to do and live in large metropolitan areas, though not as likely to live in the largest metropolitan areas as are HUs. Relative to HUs, they are more likely to be female, more likely to be well educated, have had some arts education,[16] and come from well-educated families, but relative to the other taste groups they are less likely to be married and living

with their spouse.[17] In sum, they have the characteristics found in other studies of highbrow omnivores (Eijck 2001; Peterson and Kern 1996).

Arts Targets among the Lowbrows

To this point the chapter has examined a great deal of evidence showing that contrary to expectations formulated in the mid-twentieth century, many highbrows like and participate in forms of popular culture. Is it possible that lowbrows have been mischaracterized as well? They comprise just over 93 percent of the SPPA sample, so it is tempting to see if any number of lowbrows say that they like fine arts activities. Of course, every lowbrow person in the population is a potential fine-arts participant, but it makes sense to focus on those who are more likely to participate. To do this the study begins by taking the 40 percent of lowbrows who seem to be open to a range of cultural experiences: those who say that they like four or more forms of music. Looking at this group, it is revealed that fully 44 percent say that they like classical music or opera. These lowbrows who have some highbrow tastes would seem to have the best prospects of becoming active fine arts participants, and because, as shown presently, many in this subset of lowbrows already do participate in the arts to some degree, the group is called *targets*. This group of targets is the focus of attention in the discussion that follows.

The Arts-Related Activity of Targets

Targets say that they like one or more of the fine art musics, but are they likely to attend arts events and enjoy the arts via the media? The SPPA survey data provide a good way of answering these questions. Table 13.5 clearly shows that a considerable number of targets already report attending live performances of the three forms of art music. Twenty-seven percent attended classical music concerts in the past year, 5 percent attended live opera, and 17 percent attended jazz concerts. These levels are well above those of other lowbrows, and they are within range of the attendance levels of highbrows at classical music and jazz concerts.

The chapter now turns to the other seven arts-related activities regularly tracked by the SPPA. As Table 13.6 shows, targets have levels of

Table 13.5 Percentage of Three Taste Groups that Have Attended Art–Music Activities

	Classical Music	Opera	Jazz
Highbrows	39	14	27
Targets	27	5	17
Other Lowbrows	7	2	8

Table 13.6 Percentage of Three Taste Groups that Have Attended Other Arts Activities

	Musicals	Plays	Ballet	Other Dance	Art Museum	Art Fair	Historical Site
Highbrows	33	25	10	11	56	48	48
Targets	32	24	9	14	49	55	55
Other Lowbrows	13	9	2	5	21	31	28

attendance well above those of other lowbrows, and when comparing targets with highbrows, it is found that the latter are more likely than targets to participate in art museum attendance. Targets have rates of attendance at musicals, plays, and ballet comparable with those of highbrows, and they have attendance rates at other dance performances, art fairs, and historical sites that are actually higher than highbrow rates. These findings show that these target lowbrows with omnivorous music tastes, like their omnivorous highbrow counterparts, are also likely to attend the full range of live arts-related activities.

In this day and age most people spend more time engaged with the arts via the media than they do attending live performances. The SPPA includes seven measures of watching via video, TV, CD, and DVD; five measures for listening to the radio; and four measures for playing recorded performances. The findings (not reported here) show that the percentage of targets who consume arts via the media is roughly as high as that of highbrows for all art forms with the exception of opera and enjoying musicals via radio or video.

Turning to the figures on reading and creative writing (not reported here), the figures for targets are comparable with that of highbrows for all six measures. And turning to the SPPA data for the six measured arts and crafts activities that range from making music to weaving (not

reported here), it is revealed that in every case targets' rates of activity are as high or higher than the rates for highbrow respondents. It is also possible to look at the music genre preferences and leisure-time preferences of targets, but this will be done when considering how best to appeal to this large group of energetic and arts-engaged people who are not highbrows but who are far from being the stereotypical lowbrow person.

Demographics of Targets

But who are these people? Do they have particular demographic characteristics? The results show that targets are more likely to be female and white than are highbrows and the other lowbrows. They are six years younger than highbrows and two years older, on average, than the other lowbrows. Of more interest, whereas highbrows are overrepresented in each age from the fifties to the eighties, targets are more likely than the sample as a whole to be in their fifties and are not as likely as highbrows to be sixty or over. Targets tend to be wealthier than the other lowbrows and somewhat less wealthy than highbrows; targets are more likely to come from middle-sized cities, whereas highbrows are more likely to come from metropolitan areas with greater than five million inhabitants. Targets are relatively well educated and are much more likely than other lowbrows and only somewhat less likely than highbrows to have a college or graduate school education. The same pattern of educational attainment holds true for the parents of respondents.

Arts Education of Targets

The findings concerning the respondents' arts education should be of special interest to all concerned with arts policy, so it is considered in greater detail than the other demographic variables. A number of studies have shown education in the arts to be related to arts appreciation and attendance, and this is found to be true in this sample. Highbrows are more likely to have had courses in art making or appreciation than have lowbrows, but there are wide variations within both groups, as can be seen in Table 13.7.

Table 13.7 shows that a lower proportion of lowbrows have had arts education than have highbrows. However, the differences between the

Table 13.7 Percentage of Each Taste Group that Has Received Arts Education

	Arts Education as a Child	Arts Education at Any Time
Highbrow Univores	41	52
Highbrow Omnivores	76	88
Targets	59	70
Other Lowbrows	27	34

two types of omnivores and two types of univores are greater than those between highbrows and lowbrows. Targets are actually more likely than highbrows to have had arts education when they were young or at some later period in their lives. This finding suggests that though most highbrows are attracted to the arts initially through their early family experience and support the fine arts as part of their social class experience, targets are more likely to be attracted to becoming involved with the arts by taking classes in arts performance or appreciation.

Music Tastes of the Targets

Remember that targets were selected for liking classical music, opera, or jazz but not for naming any of them as their favorite kind of music. Not surprisingly, given this basis of their selection, 95 percent of these lowbrows say that they like classical music, 27 percent say they like opera, and 50 percent say they like jazz. How different from other lowbrows they are is clear from the comparable figures for the other lowbrows: 6, 0, and 17 percent, respectively. In addition, a significantly greater percentage of targets like each of the other eighteen forms of music than do highbrows or the other lowbrows. Thus, they are clearly omnivorous in their tastes. When asked what their favorite kind of music is, their choices are diverse, but oldies rock is selected more than any other genre. Interestingly, targets show a striking similarity to HOs in their music tastes; for example, like HOs, their eclecticism is less likely to extend to rap, heavy metal rock, and country music.

A Summary of Findings Relevant for Arts Policy

Although the SPPA survey was not designed to learn what sorts of appeals are likely to motivate greater arts participation, nevertheless it can be used to get a better understanding of the many different kinds of people who are good candidates for greater arts participation. This study's primary findings can be summarized in five points.

- Some highbrows, called here highbrow univores, have nearly exclusive tastes for the fine arts, thus fitting the classical stereotype of the highbrow arts patron.
- Many arts participants, called here highbrow omnivores, have a primary orientation to the fine arts but also like a wide range of popular culture offerings. This finding has been substantiated by a large number of recent studies using data from the United States, Canada, Australia, Israel, and eight European countries (Peterson 2005).
- Looking across all the data collected in the SPPA survey for 2002 on the four taste groups distinguished as highbrow or lowbrow and univores or omnivores, the level of omnivorousness in tastes is now more important in predicting participation in the arts than is the brow level of taste. This is to say, liking a wide range of types of music is a better predictor of arts participation than is knowing that a person chooses classical music or opera as their favorite kind of music.
- This study's data, as well as that of others, suggest that the more often people go to arts events, the more often they engage in popular culture and civic activities as well. This contradicts the assumption of those arts marketers who see themselves in a zero-sum competition with popular culture and other arts venues. In consequence, it seems that more is to be gained by attracting people to participate in arts events through cross-promotion with other arts and popular culture activities than from fostering competition with them.[18]
- A goodly number of Lowbrows, here called targets, contrary to enduring stereotypes of lowbrows (Bloom 1987; Johnson 2002; Kristol 1978; Levine 1988), say they like fine art music. They are numerous, omnivorous in their tastes, and younger on average than highbrows. What is more, over a quarter already report

attending classical music concerts, and over half report hearing or seeing classical music via records, radio, or television. There is not direct information in the survey to test the assertion, but based on the findings of Brown (2002), Walker (2003), and Walker and Scott-Melnky (2002), this study hypothesizes that highbrows are more likely to subscribe to season tickets and annual memberships whereas targets are more likely to buy tickets on an event-by-event basis.

To this list we should add that a number of policy-oriented arts-research studies using different data report findings that support those reported here. Ostrower (chapter 3 in this volume), using a large U.S. national sample dataset, finds arts participation patterns that are omnivorous, as did Canadian team Viviana Friedman and Michèle Ollivier (2004). They found that what they called *ostentatious openness* functions as cultural capital for contemporary artsgoers. These findings should not be surprising in light of what is reported here (see also the important U.S. studies by Brown 2002; Walker 2003; Walker and Scott-Melnky 2002). Two decades ago R. F. Kelly (1987, p. 12) noted that, for his respondents, "one important tendency is ... to use the consumption of the arts and arts events as status markers rather than as a sacred experience in itself." It is likely that audiences have always had mixed motivations, but in the current reflexive economy of signs, the audience is conscious about it, and so is the art industry. Kelly concluded that it is time for arts policy experts to realize the limits to policies built around the assumption of art for art's sake.[19]

In summary, though highbrows and lowbrows have traditionally been counterpoised to each other, this study clearly shows that differences in the exclusiveness of tastes exist within each group, setting off univores from omnivores. The study also suggests that the difference between univores and omnivores is now more important than the differences between highbrows and lowbrows. This is a significant departure from a time, often characterized as the Golden Age, when having highbrow tastes was the most important factor in predicting arts participation. This shift should be an important consideration in framing twenty-first-century arts policy.

Cultural Policy in the Post Highbrow-Snob World

In discussing the dilemmas of the highbrow model of the arts audience and the importance of taking into account those who are omnivorous, this study focused in greatest detail on the field of classical music. This was done for two reasons: (1) because the measure of taste available to us had to do with music; and (2) because, of all the major arts, classical music is struggling the most with declining audiences. In focusing on policy considerations the chapter therefore also focuses primarily on classical music, though many of the issues are pertinent for other arts as well.

Over the middle half of the twentieth century, the status-seeking American patrons of classical music got very much the sort of music they wanted: a set of masterworks created by a pantheon of composers whose names they recognized as important. They also expected the music brilliantly realized by god-like virtuosi. Data on 2004–2005, the last season for which information was available at the writing of this chapter, clearly show the emphasis on old music. The American Symphony Orchestra League gathered program data for 322 orchestras, and they found that 57.2 percent of all the works performed were written by just twenty composers, who are all dead. Furthermore, 26.2 percent of all the work performed in the United States that season was created by four composers, all dead over 100 years.[20]

In a 2003 article in *Symphony,* Greg Sandow showed that all the stakeholders have played a part in creating the focus on "master works" and the dearth of new compositions. Sandow described a simple, if vicious, cycle. It is easiest for a conductor to select a work from the regular repertoire, even if one may want to schedule a new work. A new work would require more orchestra practice time than would a piece in the standard repertoire well known by the musicians. Members of the board of directors, expecting that a new work will alienate some donors and will garner lower ticket sales, and expecting that local newspaper critics will pan anything new, may understandably decide they cannot afford to schedule the new work (on this dynamic see also Teachout 2005).

Though they do not use the term, Joseph Horowitz, Terry Teachout, and Sandow are saying that the current perilous cycle of stasis is driven by the mid-twentieth-century attitude of highbrow exclusivity. As Costa and Bamossy (1995), Sandow (2003) and Teachout (2005) suggested,

there may be a large enough audience and big-donor patrons to support this orientation in a few of the major performance arts organizations in the largest East Coast U.S. cities. But this may not be the case in the rest of the country, where there is not a sufficient number of local highbrow univores, so that many orchestras and opera companies are having to program more middlebrow fare and in extreme cases to downsize or to go out of existence entirely (Adler 2006; Delacoma 2006; Rhein 2006). But, as the December 17, 1893 *New York Times* review of the debut performance of Anton Dvorak's "Symphony from the New World" made clear, the focus on virtuosic performance of old works is not inevitable. The lengthy review noted the many musical borrowings from popular songs, Negro spirituals and cowboy laments built into the tone poem about hardship and persistence in the new world. Interestingly, the quality of performance was not commented on, and the conductor's name was not even mentioned (Horowitz 2004).

Over the past two decades a range of efforts have been made to broaden the appeal of classical music, but these efforts have usually been piecemeal and not based on an understanding of the potential for a revitalized classical music. The results of the present study suggest that a part of the problem with the situation today is thinking that the bulk of the audience for classical music in America is made up of highbrow univores. But as demonstrated here, a much larger proportion of those who attend classical music concerts are omnivores—people who actively seek out a wide range of musical experiences and other popular and fine-arts activities as well. Efforts to change the current situation are many and various.

Consolidating the Status Quo

One strategy has been to manipulate ticket prices to fill more seats. This is difficult if one does not want to alienate season ticket holders who have subscribed on the understanding that by buying the season they are getting reduced prices. One of the most cynical price reductions was for the 2000 season of the London Royal Opera. In response to great concern about high ticket prices, the management cut in half the price of the most expensive seats in the house (Anonymous 2000). This cut was short lived because there was an immediate uproar about reducing prices for those most able to pay. A more sensible practice is to

lower ticket prices for categories of people who can be cast as deserving, such as students.

Dollar for dollar, it has proved easiest in recent years to get money to build concert halls, as if low attendance was caused by having poor facilities. Presently, new concert halls are being built in New York, Nashville, Miami, Costa Mesa, and Toronto. In Charlotte, North Carolina, an addition to rental-car tax is being used to build a new performing arts theater, classical art museum, modern art museum, and new Afro-American culture center (Johnson and Rubin 2006). And the Atlanta Opera is planning a move into suburban Cobb County after finding that half the lapsed ticket buyers and two thirds of donors of more than a thousand dollars live closer to the center of Cobb County than to downtown Atlanta (Ruhe 2006). The recent history of such changes is that the new facilities make for an increase in ticket sales but that, if nothing else is done to cultivate omnivores, the increases disappear as the novelty wears off.

The Mix of Music

Beyond marble and mortar, another strategy adopted by many orchestras has been to increase the amount of middlebrow and pop fare (Sandow 2003; Teachout 2005). The Nashville Symphony Orchestra provides a case in point. In its first year in its new facility, the programmers provided fourteen offerings in what they call their "Classical Music" series. In addition there were seven offerings in the "Pops Series," and the orchestra performed in eight of the "Special Event" offerings in which it backs a range of acts from a Christian music singer and a bluegrass performer to a Christmas program with Aaron Neville and a choral tribute to Martin Luther King.[21] In a number of cases the orchestra plays only parts of works. This move follows the trend over the past twenty years toward what has been called *classic lite,* in which there is a focus on selections from a relatively short list of recognizable works, and from listening to the radio, one would understand that the most common form of classical music is not concerto or symphony but *adagio* (Ferguson 2004; Peterson 1990, 1993). The 2006–2007 Nashville concert season illustrates another hazard of mixing music. During the season the orchestra accompanies two performers billed as jazz. One features vocalist Diana Reeves, and the other features trumpeter

Chris Botti, who is in a league with Kenny G. Backed by the lush sounds of the symphony orchestra, their work suggests that jazz is a kind of middle-of-the-road mood music. It seems likely that such *music lite,* middlebrow or hybrid, is likely to suggest to the curious omnivores that classical music has no great substance.

The alternative trend has been to program more new works. Ese-Pekka Salonen, the orchestra's new music director, notes that when he got to Los Angeles he found than those who go to contemporary art, dance, or art cinema "didn't see a symphony orchestra as part of the contemporary art scene. But now they have started to realize that the Philharmonic is moving into this century." As Kozinn (2006a) noted, the orchestra has adopted a number of tactics to show that classical music is an exciting modern art relevant to today's world (on this point see also Pasles 2006). Kozinn, however, believes that this model may be site specific to a large culturally innovative city with expanding wealth.

Cultivation and Facilitation

This study's data, along with those of other studies, have shown that young people today are much less likely to attend classical music concerts than were those born before World War II. But many orchestras today are renewing their mission to cultivate the appreciation of classical music. For example, the Nashville Symphony orchestra has four "Pied Piper" concerts in the 2006–2007 season. These include Camille Saint-Saens's "Carnival of the Animals," a narrated version of "Cinderella" with music by Sergei Prokofiev, and "Beethoven Lives Upstairs," in which a youth writes his uncle that a bellicose madman hammers the piano incessantly in the apartment above, and the uncle explains Beethoven's intentions. But it is also possible to get teens more actively involved. For example, having found that less than 5 percent of its audience is under thirty-five years of age, the Chamber Music Society of Lincoln Center created a Student Advisory Group of fourteen to sixteen year olds. They advised stopping the policy of giving away free youth tickets and instead charge $5 in exchange for which attendees receive snacks, an informal concert, and interaction with the performing chamber group. According to one of the young advisors other teens "think [chamber music] is a bor-

ing, outdated art form for senior citizens," and "our mission is to make them hear what we hear" (Toumani 2006, page B31).

Another tactic is to demystify the classical music experience. In a number of cities, the dress code has been made more informal, and conductors may briefly introduce unfamiliar or new works, whereas aids to understanding have been made available, such as translations of operas that scroll across the proscenium above the performers as they sing. And the New York Philharmonic Orchestra has experimented with "Concert Companions," which is a PDA that concertgoers may use to see real-time program notes that move forward as the music is played (Sandow 2004).

Changing Scale

The number of cities that could support ballet companies and visiting troupes increased greatly several decades ago when companies were formed around a group of five to eight dancers without a supporting corps de ballet or a pit orchestra. These aggregations usually create new works that are freed from the boy-meets-girl narrative tradition of ballet theater and complement the dancers' strengths. Freed of the live orchestra, works can be set to a diverse array of musical styles.

A similar process seems to be taking place now in classical music (Kozinn 2006b). Whereas the best conservatory of music students once strove to get a position with a good symphony orchestra, Heidi Waleson (2005) found that many of today's best choose to band together with classmates and young peers to form small aggregations. Some choose from the standard chamber music repertoire, but many more work to create an identity playing new music that fuses the best of the classical tradition with minimalist music, funk, heavy metal, spirituals, Asian music, jazz, and the like. Examples of such aggregations include Eighth Blackbird, Da Capo Chamber Players, Bang on a Can, Imani Winds, Ethel, Miró Quartet, Apocalyptica, Alarms Will Sound, and the Juniper Quartet. These musicians do not have the security of an orchestra chair, but they are immediately challenged to stand out, compose, and take creative control of their own careers. Since the groups usually do not play a full season, performers combine their play with other musical projects, thus constantly revitalizing their energies. Consciously breaking from chamber music performance traditions, these groups

often dress casually, interact with their audiences, give master classes, and actively cultivate college student audiences with their omnivorous approach to music.

A Value of Art Is in the Doing of It

As Levine (1988) and Butsch (2000) clearly showed, the mid-nine-teenth-century audiences were very demonstrative, loudly commenting, hissing, moving about, and clapping during performances (see also chapter 4 in this volume). But for the past eighty years American fine arts audiences have paid for their tickets, sat in their seats, and clapped only at specific prescribed times. Yet in recent arts policy parlance the term participation is applied also to these audiences who passively attend an artistic activity (cf. Connolly 2001; NEA 2004; Walker and Scott-Melnky 2002). Kevin McCarthy et al. (2004) said it is time to reform the debate about the benefits of the arts. Beyond the economic, political, and educational benefits of the arts, they want more emphasis on the intrinsic benefits by facilitating higher levels of audience engagement and the expansion of individual capacities. This does not, however, mean a return to spitting on the floor, getting drunk, and throwing fruit at the conductor. Christopher Small (1998) decried the status displays often found at classical music concerts and called for more active participa-tion, and Stephanie Pitts (2005) noted the enthusiastic response of par-ticipants at a chamber music festival. As with studies of popular music, bluegrass, and jazz festivals, she found that much of the energy comes from the total immersion in the one kind of music with other enthusias-tic fans over the course of several days (see also Fidler 2006).[22]

Classical Music and the Internet

In his article asserting that the "rumors of classical music's demise are dead wrong," Allan Kozinn (2006b) showed that the field of classi-cal music is not dying but that it is changing. Many of the most impor-tant changes involve effectively using the Internet to reach audiences, promoting specific groups, and distributing recordings, and what we have found about omnivorousness is relevant here as well. Take the case of Andante.com: This Internet Web site was established as a paying-members-only and offered a tony online magazine featuring reviews,

articles, and commentary on classical music. Andante also offered the streaming of orchestra concerts and CDs of historic concerts hitherto unavailable. After being launched with a great deal of fanfare and initial interest, the Web site languished, remaining afloat just five years. Scott Timberg (2006) and Anne Midgette (2006) both asserted that Andante.com failed because its exclusive highbrow tone was not attractive to enough contemporary classical music consumers. In Midgette's (2006) words, "Andante.com represented a traditional view of the field: it wanted to be elitist, highbrow, blue chip," and she concluded that its failure "can only be good news for those of us who love the art form that its future seems to be not only rosy but far more democratic" (p. E5).

Fortunately, there are other business plans more compatible with the omnivore mind set. In general these provide music at low cost via computers in exchange for a low level of advertising (much like Amazon.com), or they give away the music in the hopes of creating interest in the artist, or performers themselves post concerts on their own Web sites to familiarize people with their music, and they sell CDs and downloads of performances. Teachout (2006) posts classical music and jazz videos that he has received from friends via YouTube on his Web site (http://www.terry-teachout.com. This could be a model for a new system of distributing art music. There are numerous business plans being worked out, but this is a rapidly developing area so the examples given here may sound quaint and woefully incomplete in just a few years (e.g., Bruno and Waddell 2006; Christman 2006; Kozinn 2006b; Midgette 2006; Noguchi 2006; Tsioulcas 2006; Wakin 2006).

Information on music is widely available via the Internet in the form of articles, blogs, artist Web sites, MySpace, and services that scan for information of particular interest. Articles, advertisements, friends, and record store clerks have always provided recommendations on recordings, but each necessarily was limited by his or her own experience and prejudices. Following a strategy popularized by Google, a number of sites now aggregate consumer-generated purchase lists that tell what other items people who have bought a particular product most often buy. Some of the answers are predictable, but others are quite diverse and illustrate omnivorousness at work. For example, iTunes reports that those who bought Osvaldo Golijov's song cycle "Ayre" also bought music by Alice in Chains, Amadou & Mariam, LeAnn Rimes, 2Pac,

Stan Kenton, or Anita O'Day (Tsioulcas 2006). It seems highly unlikely that anyone will buy all these records, but it may prompt curiosity about musical associations that otherwise may not have come to mind.

The power of the Internet to distribute music comes from two factors. First, the time to acquire music via Internet orders is very short, since CDs can be found and ordered with just a few clicks on the PC, or music can be downloaded and heard instantaneously. Second, the Internet facilitates the power of "the long tail." As Chris Anderson (2004) explained, retail record stores can afford to carry relatively few records, so all the rest of recorded work is effectively unavailable. But Internet outlets make it possible to find many more CDs, and many, many more performances can be streamed or downloaded. The result is that small independent record companies, and even individual artists, can advertise and market their works via the Internet, and the volume of Internet distribution of classical music is impressive. For example, though classical music accounts for just between 2 and 3 percent of CD sales, iTunes reports that in 2005 classical music accounted for 12 percent of all downloads. As impressively, the 2005 Internet-based "Beethoven project" sent out 1.5 million downloads (Midgette 2006).

The live Internet streaming of classical music that seemed so promising in 1998 was largely cut off by legal moves against the Internet providers initiated by record companies, performers, venues, and composers, all of whom resisted free distribution and argued over how to divide royalties (Kozinn 2006b). By 2003 some parts of the issue were settled, and more live broadcasts were being distributed over the Internet following a business model developed by AOL and HBO. For example, the Sydney Symphony broadcast ten downloadable concerts during its 2006–2007 season (Cunningham 2006). A much more ambitious live-Internet broadcasting called "The Gig" began in Los Angeles in 2004, when a number of small venues installed sound and video equipment to stream concerts live with a twenty-four-hour time delay. In addition "Live Nation" broadcast 350 concerts from around the world in 2005, and CenterStaging Musical Productions has wired eleven rehearsal rooms to capture artists as they rehearse for upcoming performances so that artists and tour venues can use excerpts from the rehearsal footage to promote upcoming events (Bruno and Waddell 2006). To date the focus has been on popular music aggregations, but there seems to be no

reason why classical music concerts and selections from rehearsals could not be used to increase interest in and knowledge of classical music.

It seems likely that numerous other ways will be found to use the Internet to enhance participation in classical music. But unfettered access to the Internet that is called net neutrality cannot be taken for granted. There are bills in the U.S. Congress that would give the Internet carriers the right to block or differentially charge for material being carried on these lines. The issue is being hotly contested by the various commercial interests, who on one side say that the U.S. government should guarantee equal access to all users and on the other side say this would be unnecessary government restraint on free enterprise.[23] This debate shows clearly why those interested in arts policy need to pay attention to ever-changing laws affecting the culture industry in this twenty-first-century omnivorous environment.

It is apparent to all that the arts audience is aging and that younger cohorts are not as likely to attend classical music concerts as were their elders. If nothing is done, in a decade hence, only the largest cities will be able to support resident classical music orchestras. To remain vital, the arts must actively recruit young audiences. A number of such efforts are being made, but many are likely to fail because they are built on appealing to the idea of highbrow exclusiveness. But as the present study shows, the potential audience does not shun popular culture. Rather, they make a virtue of being eclectic in their tastes, called here omnivorousness. The characteristics of the omnivorous in America are explored here to facilitate arts policymakers and programmers in tailoring their practices to recruit people, old and young alike, who see the fine arts not as a symbol of exclusion, but as part of their eclectic cultural consumption.

Acknowledgments

We profoundly appreciate all the help we have received in this project from Thomas Bradshaw, Alan Brown, Ann Brown, Katherine Claussen, Paul DiMaggio, Diane Grams, Bill Ivey, Sasha Kagan, Elizabeth Lingo, Francie Ostrower, David Touve, Claire Peterson, and Barry Schwartz, and we especially want to thank Steven Tepper and Jennifer Lena for

their thorough reviews. We are just sad that we could not follow all of the fascinating avenues suggested.

Bibliography

Adler, Andrew. 2006. "'Smaller Core Orchestra' a Necessity, Management Says." *Louisville Courier-Journal*, February 9. B4.

Adorno, Theodor. 1991. *The Culture Industry: Selected Essays on Mass Culture*. New York: Routledge.

Anderson, Chris. 2004. "The Long Tail." *Wired*, October 12: 10.

Anonymous. 2000. "Royal Opera Cuts Top Seat Prices." *Guardian*, February 2. 13.

Arnold, Matthew. 1875. *Culture and Anarchy*. New York.

Aronowitz, Stanley. 1993. *Roll over Beethoven: The Return of Cultural Strife*. Hanover, VT: Wesleyen University Press.

Askegaard, Soren. 1999. "Marketing, the Performing Arts and Social Change: Beyond the Legitimacy Crisis." *Consumption, Markets and Culture* 3: 1–97.

ASOL. 2006. "2005–2006 Orchestra Repertoire Reports." Washington, DC: American Symphony Orchestra League. http://www.symphony.org/research/index.shtml.

Balfe, Judith H., and Rolf Meyersohn. 1996. "Arts Participation of the Baby Boomers." In *Age and Arts Participation with a Focus on the Baby Boom Cohort*, edited by Erin V. Lehman, 68–114. Santa Ana, CA: Seven Locks Press.

Becker, Howard S. 1982. *Art Worlds*. Berkeley: University of California Press.

Beisel, Nicola Kay. 1997. *Imperiled Innocents: Anthony Comstock and Family Reproduction in Victorian America*. Princeton, NJ: Princeton University Press.

Bell, Daniel. 1976. *The Cultural Contradictions of Capitalism*. New York: Basic Books.

Bloom, Allan. 1987. *The Closing of the American Mind*. New York: Simon & Schuster.

Bork, Robert H. 1996. *Slouching towards Gomorrah: Modern Liberalism and American Decline*: New York: Regan Books.

Bourdieu, Pierre. 1984. *Distinction: A Social Critique of the Judgement of Taste*. Cambridge, MA: Harvard University Press.

Bradshaw, Tom, and Bonnie Nichols. 2004. "2002 Survey of Public Participation in the Arts." National Endowment for the Arts Research Division Report 45. Washington, DC: National Endowment for the Arts.

Briggs, E. Bruce (Ed.). 1979. *The New Class*. New Brunswick, NJ: Transaction Books.

Brooks, David. 2000. *Bobos in Paradise: The New Upper Class and How They Got There*. New York: Simon & Schuster.

Brown, Alan S. 2002. *Classical Music Consumer Segmentation Study*. Southport, CT: Audience Insight.

Bruno, Antony, and Ray Waddell. 2006. "Concert, Rehearsal Venues Get Wired." *Boston Globe*. July 22. boston.com/business/technology/articles/2006/07/22/concert_rehearsal_venues_get_wired/.

Bryson, Bethany. 1996. "'Anything but Heavy Metal': Symbolic Exclusion and Musical Tastes." *American Sociological Review* 61: 884–99.

———. 1997. "What about the Univores? Musical Dislikes and Group-Based Identity Construction among Americans with Low Levels of Education." *Poetics: Journal of Empirical Research on Literature, the Media and the Arts* 25: 141–56.

Butsch, Richard. 2000. *The Making of American Audiences*. Cambridge, UK: Cambridge University Press.

Cantwell, Robert. 1984. *Bluegrass Breakdown: The Making of the Old Southern Sound*. Urbana: University of Illinois Press.

Carey, John. 2006. *What Good Are the Arts?* New York: Oxford University Press.

Christman, Ed. 2006. "Tower Records Preps Download Store." *Billboard* magazine, June 23, http://www.Billboard.biz/bbiz/search/article_display.jsp?vnu_content_id=102726876.

Clark, Drew. 2006. "'Save the Internet' Coalition Intensifies Net Neutrality Effort." *National Review*, June 14. www.ugnn.com?2006?06?net_neutrality_effor.html.

Colbert, Charles. 1997. *A Measure of Perfection, Phrenology and the Fine Arts in America*. Chapel Hill: University of North Carolina Press.

Connolly, Paul. 2001. *Increasing Cultural Participation: An Audience Development Handbook*. New York: Wallace–Readers' Digest Funds.

Costa, J. and G. Barmossy, 1995. "Perspectives on Ethnicity, Nationalism, and Culture Identity." In *Marketing in a Multicultural World*, edited by J. Costa and G. Bamossy. London: Sage, p. 3–25.

Cowen, Tyler. 1998. *In Praise of Commercial Culture*. Cambridge, MA: Harvard University Press.

Cunningham, Harriet. 2006. "Sydney Symphony in Digital Deal." *Gramophone,* February 8. http://www.gramophone.co.uk/newsMainTemplate.asp?storyID=2527&newssectionID=1.

Delacoma, Wynne. 2006. "CSO Unveils Details of Its 1st Year after Barenboim." *Chicago Sun-Times,* February 9. 37.

DeVeaux. 1997. *The Birth of Bebop*. Berkeley: University of California Press.

Dewey, John. 1934. *Art as Experience*. New York: Penguin Putnam.

DiMaggio, Paul. 1982. "Cultural Entrepreneurship in Nineteenth-Century Boston: The Creation of an Organizational Base for High Culture in America." *Media, Culture, and Society* 4: 33–50.

———. 1987. "Classification in Art." *American Sociological Review* 52: 440–55.

Eijck, Koen van. 2001. "Social Differentiation in Musical Taste Patterns." *Social Forces* 79: 1163–84.

Eliot, T. S. 1939. *The Idea of a Christian Society*. New York: Harcourt, Brace.

_____. 1949. *Notes toward the Definition of Culture*. New York: Harcourt, Brace.

Ferguson, Andrew. 2004. "Radio Silence: How NPR Purged Classical Music from Its Airwaves." *Weekly Standard* 9 (June 14): 38.

Fidler, John. 2006. "Reading: It's Not Just Outlet Malls Anymore." *Washington Post*. July 19. C2.

Fisher, Timothy, and Stephen Preece. 2003. "Evolution, Extinction, or Status Quo? Canadian Performing Arts Audiences in the 1990s." *Poetics: Journal of Empirical Research on Literature, the Media and the Arts* 31: 69–86.

Florida, Richard L. 2002. *The Rise of the Creative Class*. New York: Basic Books.

Friedman, Viviana, and Michèle Ollivier. 2004. "Ouverture Ostentatoire à la Diversité et Cosmopolitisme: Vers une Nouvelle Configuration Discursive?" *Sociology et Sociétés* 36: 105–26.

Gans, Herbert J. 1999. *Popular Culture and High Culture: An Analysis and Evaluation of Taste*. New York: Basic Books.

Goffman, Erving. 1951. "Symbols of Class Status." *British Journal of Sociology* 2: 294–304.

Gould, Stephen Jay. 1996. *The Mismeasure of Man*. Revised and expanded. New York: Norton.

Gouldner, Alvin. 1979. *The Future of Intellectuals and the Rise of the New Class*. New York: Seabury Press.

Gusfield, Joseph R. 1963. *Symbolic Crusade: Status Politics and the American Temperance Movement*. Urbana: University of Illinois Press.

Hart, Kim, and Sara Goo. 2006. "Net Neutrality in the Eye of the Beholder." *Washington Post,* July 2, F04.

Holt, Douglas B. 1997. "Distinction in America? Recovering Bourdieu's Theory from Its Critics." *Poetics* 25: 93–120.

Horkheimer, Max, and Theodor Adorno. 1972. *Dialectic of Enlightenment*. New York: Herder and Herder.

Horowitz, Joseph. 1987. *Understanding Toscanini: How He Became an American Culture-God and Helped Create a New Audience for Old Music*. New York: Knopf.

_____. 2004. "Classical Music Criticism at the Crossroads." Paper presented at symposium, Columbia University Graduate School of Journalism, October 16–17.

_____. 2005. *Classical Music in America: A History of Its Rise and Fall*. New York: W.W. Norton.

Johnson, Julian. 2002. *Who Needs Classical Music? Cultural Choice and Musical Value*. New York: Oxford University Press.

Johnson, Lesley. 1979. *The Cultural Critics: From Matthew Arnold to Raymond Williams*. London: Routledge and Kegan Paul.

Johnson, Mark, and Richard Rubin. 2006. "Arts Plan Gets Rental Car Tax Boost." *Charlotte Observer,* July 12. B2.

Kelly, R. F. 1987. "Museums as Status Symbols: Attaining a Status of Having Been." In *Advances in Nonprofit Marketing,* edited by Russell W. Belk, 1–38. Greenwich, CT: JAI Press.

Kimball, Roger. 2004. *The Rape of the Masters: How Political Correctness Sabotages Art.* San Francisco: Encounter Books.

Koprowski, Gene. 2006. "The Web: Net Neutrality Discriminatory?" *United Press International,* July 12. www.upi.com/hi-tech/view. php?storyID=20060712-090145-8079r.

Kozinn, Allan. 2006a. "Continental Shift." *New York Times,* January 15. B1.

_____. 2006b. "Check the Numbers: Rumors of Classical Music's Demise Are Dead Wrong." *New York Times,* May 28. B4.

Kristol, Irving. 1978. *Two Cheers for Capitalism.* New York: Basic Books.

Laermans, Rudi, and Alexander Vanderstichele. 2004. "Cultural Omnivores and Univores in the Flemish Public for Performing Arts." European Sociological Association Research Network for the Sociology of the Arts. Conference proceedings.

Lamont, Michele, and Marcel Fournier (Eds.). 1992. *Cultivating Differences: Symbolic Boundaries and the Making of Inequality.* Chicago: University of Chicago Press.

Leavis, F. R. 1930. *Mass Civilization and Minority Culture.* Cambridge, UK: Minority Press.

Leeds, Jeff. 2006. "Iron Man Slows, and So Does the Industry." *New York Times,* June 25. B1.

Lehman, Erin V. (Ed.). 1996. "Age and Arts Participation." National Endowment for the Arts Research Division Report 34. Santa Ana, CA: Seven Locks Press.

Leonard, Neil. 1962. *Jazz and the White Americans.* Chicago: University of Chicago Press.

Levine, Lawrence W. 1988. *Highbrow/Lowbrow: The Emergence of Cultural Hierarchy in America.* Cambridge, MA: Harvard University Press.

Lopes, Paul. 2002. *The Rise of a Jazz Art World.* Cambridge, UK: Cambridge University Press.

Lynes, Russell. 1954. *The Tastemakers.* New York: Harper.

McCarthy, Kevin F., Elizabeth Ondaatje, Lauria Zakaras, and Arthur Brooks. 2004. *Gifts of the Muse: Reforming the Debate about the Benefits of the Arts.* Santa Monica, CA: RAND Corporation.

Midgette, Anne. 2006. "Classics on the Internet: Promising Prognosis." *New York Times,* February 8. E5.

Murphy, Raymond. 1988. *Social Closure: The Theory of Monopolization and Exclusion.* Oxford: Clarendon.

National Endowment of the Arts (NEA). 2004. "2002 Survey of Public Participation in the Arts." National Endowment for the Arts, Research Division Report 45, Washington, DC.

_____. 2006. "Airing Questions of Access: Classical Music Radio Programming and Listening Trends." National Endowment for the Arts, Research Division Note 92, Washington, DC.

Noguchi, Yuki. 2006. "With Online Music, It's a Buyer's Market." *Washington Post,* June 24, A01.

Ostrower, Francie. 1995. *Why the Wealthy Give: The Culture of Elite Philanthropy.* Princeton, NJ: Princeton University Press.

Pasles, Chris. 2006. "L.A. Phil Plans to Play Politics." *Los Angeles Times,* February 8. E8.

Peterson, Richard A. 1972. "A Process Model of the Folk, Pop, and Fine Art Phases of Jazz." In *American Music: From Storyville to Woodstock,* edited by Charles Nanry, 135–51. New Brunswick, N.J.: Trans-Action Books and E.P. Dutton.

_____. 1990. "Audience and Industry Origins of the Crisis in Classical Music Programming: Toward World Music." *The Future of the Arts: Public Policy and Arts Research,* edited by David B. Pankratz and Valerie B. Morris, 207–27. New York: Praeger.

_____. 1993. "The Battle for Classical Music on the Air." In *Paying the Piper: Contemporary Problems of Arts Patronage,* edited by Judith Balfe, 271–86. Urbana: University of Illinois Press.

_____. 1997. "The Rise and Fall of Highbrow Snobbery as a Status Marker." *Poetics* 25: 75–92.

_____. 2004. "Le Passage à des Goûts Omnivores: Notions, Faits et Perspectives." *Sociology et Sociétés* 36: 145–64.

_____. 2005. "Problems in Comparative Research: The Example of Omnivorousness." *Poetics* 33: 257–82.

Peterson, Richard A., and Albert Simkus. 1992. "How Musical Tastes Mark Occupational Status Groups." In *Cultivating Differences,* edited by M. Lamont and M. Fournier, 152–68. Chicago: University of Chicago Press.

Peterson, Richard A., and Carrie Y. Lee. 2000. "The Re-creation Indicator." In *Calvert-Henderson Quality of Life Indicators,* edited by Hazel Henderson, Jon Lickerman, and Patrice Flynn, 319–44. Bethesda, MD: Calvert Group.

Peterson, Richard A., and Darren Shirkat. 1996. "Effects of Age on Arts Participation." In Lehman, *Age and Arts Participation,* 13–66.

Peterson, Richard A., and John Ryan. 2004. "The Disembodied Muse: Music in the Internet Age." In *Society Online,* edited by Philip N. Howard and Steve Jones, 223–36. Thousand Oaks, CA: Sage.

Peterson, Richard A., and Roger M. Kern. 1995. "Hard-Core and Soft-Shell Country Music Fans." *Journal of Country Music* 17, no. 3: 3–6.

_____. 1996. "Changing Highbrow Taste: From Snob to Omnivore." *American Sociological Review* 61: 900–907.

Peterson, Richard A., Pamela C. Hull, and Roger M. Kern. 2000. "Age and Arts Participation: 1982–1997." National Endowment for the Arts, Research Division Report 34, Santa Ana, CA: Seven Locks Press.

Pitts, Stephanie. 2005. "What Makes an Audience? Investigating the Experiences of Listeners at a Chamber Music Festival." *Music and Letters* 88: 257–69.

Postman, Neil. 1985. *Amusing Ourselves to Death.* New York: Viking.

Rhein, Jon von. 2006. "Looking for Mr. Goodbaton: With No Barenboim in Sight, CSO Vamps with More Pop Fare." *Chicago Tribune,* February 9. 1.

Rogers, Michael. 2006. "How Washington Will Shape the Internet." MSNBC Interactive, July 11. http://www.msnbc.com.msn.com/id/13808101/.

Rossman, Gabriel, and Richard A. Peterson. 2005. "The Instability of Omnivorous Cultural Taste over Time." Paper presented at the Annual Meetings of the American Sociological Association, Philadelphia. August 13.

Ruhe, Pierre. 2006. "Will the Atlanta Opera Solve Its Problems by Moving to Cobb (County)." *Atlanta Journal-Constitution,* July 16. 1L.

Ruskin, John. 1857. *The Political Economy of Art.* London: Smith, Elder and Co.

Sandow, Greg. 2003. "Access Denied: Explaining the Death of New Music." *Symphony,* American Symphony Orchestra League Magazine. September–October. http://www.gregsandow.com/NewMusic.htm.

_____. 2004. "Concert Companion," *Arts Journal,* May 28. http://artsjournal. com/sandow/2004/05/concert_companion.html.

Scherman, Tony. 1994. "Country Music: Its Rise and Fall." *American Heritage* 45, no. 7 (November): 38–51.

Schlesinger, Arthur M., Jr. 1991. *The Disuniting of America: Reflections on a Multicultural Society.* New York: Norton.

Sennett, Richard, and Jonathan Cobb. 1972. *The Hidden Injuries of Class.* New York: Random House.

Severn, J. Millott. 1865. *Popular Phrenology.* London: W. Rider.

Shils, Edward. 1958. "Mass Society and Its Culture." *Daedalus: Journal of the American Academy of Arts and Sciences* 89: 288–314.

Simmel, Georg. 1904. "Fashion." *American Journal of Sociology* 9: 541–58.

Small, Christopher. 1998. *Musicking: The Meanings of Performing and Listening.* Hanover, NH: Wesleyan University Press.

Teachout, Terry. 1998. "The Death of the Concert." *Commentary* December. reprinted in: *The Terry Teachout Reader.* 2004. New Haven, CT: Yale University Press. 312.

_____. 2005. "Singing the Classical-Music Blues." *Commentary* 119: 71–74.

_____. 2006. "'Whose Tube Art Tube?': YouTube Is Shaping the Future of Fine-Arts Video on Demand." *Wall Street Journal,* September 30, 14.

Tichi, Cecelia. 1994. *High Lonesome: The American Culture of Country Music.* Durham, NC: Duke University Press.

Timberg, Scott. 2006. "At Andante.com, the Finale." *Los Angeles Times,* February 3. E14.

Toomey, Jenny, and Michael Bracy. 2006. "Indie-rock Revolution Fueled by Net Neutrality." *TheHill,* June 13. 29.

Toumani, Meline. 2006. "Get Them in the Seats and Their Hearts Will Follow." *New York Times,* February 26. B31.

Tsioulcas, Anastasia. 2006. "Classical Music Takes Digital Leap." *Billboard,* January 28. 44–45.

Veblen, Thorstein. 1899. *The Theory of the Leisure Class.* New York: MacMillan.

Virtanen, Taru. 2006. "Explaining the Taste for Cultural Consumption and Its Dimensions: Missing Patterns?" Paper presented at the International Sociological Association XVI World Congress in the session Arts Consumption (Research committee 37, Sociology of the Arts). July 24. Durban, South Africa.

Wakin, Danierl J. 2006. "Orchestra Musicians Reach Live-Recording Agreement." *New York Times,* August 4, E2.

Waleson, Heidi. 2005. "On a Smaller Scale: Chamber Ensembles with an Oberlin Accent." Oberlin Conservatory Magazine. http://www.oberlin.edu/con/connews/2005/feat_smaller.html.

Walker, Christopher. 2003. *Arts Participation: Steps to Stronger Cultural Community Life.* Washington, DC: Urban Institute.

Walker, Christopher, and Stephanie Scott-Melnky. 2002. *Reggae to Rachmaninoff: How and Why People Participate in Arts and Culture.* Washington, DC: Urban Institute.

Wilensky, Harold L. 1964. "Mass Media and Mass Culture: Interdependence or Independence?" *American Sociological Review* 29: 173–97.

Endnotes

1. Interestingly, it is not just the fine arts that are suffering from the aging of the population. Attendance at the large-arena pop-music events has dropped rapidly in recent years. The baby boomer generation, which was the prime audience for such music, has been aging out of rock festival participation (Leeds 2006).

2. *Median age* means that half the sample falls above and half below the age reported.

3. From the 1930s through the early 1950s jazz was the music of the young, and few outside the African American community over age of sixty in 1982 had learned to like it. What is more, in the early 1970s a fusion of jazz and rock championed by Weather Report, Pat Metheny, and John McLaughlin and his Mahavishnu Orchestra was briefly very popular among youthful rock fans.

4. One could argue that the panic following the events of September 11, 2001, significantly depressed attendance at live performances during the survey year. As Bradshaw and Nichols (2004, p. 4) showed, however, a corresponding drop in the number of U.S. adults who listened to the arts via the radio, played arts recordings, or watched the arts on television,

VCR, or DVD do not support the conjecture. Each one of the seventeen measures of consumption of the benchmark arts via the media dropped significantly from 1992 to 2002, strongly suggesting that the lower arts attendance figures for 2002 were not significantly affected by 9/11.

5. See, for example, Eliot (1939, 1949), Shils (1958), Horkheimer and Adorno (1972), Kristol (1978), Postman (1985), Bloom (1987), Horowitz (1987), Adorno (1991), Schlesinger (1991), Kimball (2004), Bork (1996), and Johnson (2002). For analyses of the cultural elitists and their fear of popular culture see Johnson (1979), Cowen (1998), and Gans (1999).

6. For a review of these studies see Peterson (2004, 2005).

7. For a study that shows the spread of omnivorousness across the fifteen nations of the European Union, see Virtanen (2006).

8. Although it would be interesting to know what kind of people do not like to listen to music, it seems unlikely that they are good prospects for becoming involved with the fine arts.

9. Persons who say they like all kinds of music sound as if they may be perfect omnivores, but their demographic characteristics are quite different from those people who express a good number of choices. There is circumstantial evidence that these people may have been bored with the interview as indicated by their all-or-nothing responses to blocks of questions near the end of the interview.

10. Jazz was chosen as a complement to liking classical music or opera in defining highbrow, because, over the past fifty years, jazz has become widely institutionalized as a form of fine art music (DeVeaux 1997; Lopes 2002; Peterson 1972). It has its musical canon, conservatories, and critical establishment, its own division within the National Endowment for the Arts, as well as performances and performers subsidized by diverse private and corporate foundations.

11. The threshold for dividing between highbrow univores and omnivores was set at five, whereas the threshold for dividing between lowbrow univores and omnivores was set at three because to be classified as highbrow, respondents had to choose as many as three highbrow forms, whereas to be classed as lowbrow, respondents did not have to choose any of the highbrow forms.

12. In addition, highbrows were significantly more likely than lowbrows to engage in each of the following seven arts-related activities: attend non-ballet dance performances, attend art fairs, visit historical or architectural monuments, read books, read plays, read poetry, and read novels. Highbrows were also significantly more likely than lowbrows to participate in the arts via television, radio, and phonograph recordings and CDs.

13. There are no questions about motor-car racing or professional wrestling, bowling or playing computer games, or the other elements of leisure activities (Peterson and Lee 2000).

14. Studies made in the 1990s used types such as local news, ESPN, sports, music televison, soap operas, comedy series, public television, and dramatic series. Today it would be possible to create a more discriminating list.

15. The proportion of Asians in the population is very small, so what we mean here is not that a high proportion of HUs are Asian born but that of the Asian-born respondents, a significantly higher proportion are likely to be HUs than is true for the sample as a whole.

16. Interestingly HOs are much more likely than HUs to have had courses in arts performance or appreciation. In line with the theories of the HU life experience (Bourdieu 1984; DiMaggio 1982), this suggests that HUs are more likely to get their taste for the arts in their early family experience, whereas HOs are more likely to gain it in formal arts classes.

17. We planned to follow up the finding of Peterson and Kern (1995), based on the 1992 SPPA survey, that over time HOs are replacing the older HUs, but this has proved impossible. The 2002 respondents, on average, reported liking fewer kinds of music than did respondents in 1992, resulting in a smaller proportion of highbrow and lowbrow omnivores than in 1992 (Rossman and Peterson 2005). This may represent a real change, as people reduced their options and focused their preferences in the months following 9/11. But this seems unlikely given the explosion in access to music via the media that took place between 1992 and 2002 (Peterson and Ryan 2004). Another possibility is that the difference is due to differences in the way the surveys were administered. There were a number of such factors, but most importantly the 1992 SPPA questions were attached to the Crime Victimization Survey, and in 2002 they were attached to the Current Population Survey. Whereas the former was quite brief for most respondents who had not recently been the victim of a crime, the latter is a mind-numbingly detailed set of questions about hours of employment, income, work place, health, job training, and the like. Under such conditions, one can well imagine the interviewee wanting to cut short the telephoned questions. For a further development of these factors, see Peterson (2005).

18. This logic may not hold in the competition for the money of major arts donors where a zero-sum is more nearly approximated (Ostrower 1995).

19. The subtlety of the issue of *status* for arts marketers is shown by Soren Askegaard (1999). He found that even though people are conscious of arts consumption having status dimensions, they deny its importance to themselves.

20. The statistics were computed by the authors from data provided in ASOL (2006).

21. For details see http://www.nashvillesymphony.org/main.taf?erube_fh=nso&nso.submit. SeasonEventList=1&nso.SeasonID=0607.

22. In line with the perspective long ago articulated by John Dewey (1934), John Carey (2006) took the idea of participation in art one step further, arguing that what is important is that people get involved in the art mak-

Richard A. Peterson and Gabriel Rossman

ing and that the focus should be on the process and not so much on the product. This latter strategy seems much more likely to prove satisfying in the visual arts where, for example, a large group of people cooperate in making a mural.

23. For articles favorable to net neutrality, see Clark (2006) and Toomey and Bracy (2006). For articles opposed, see Koprowski (2006) and Rogers (2006). For an article that reports both sides of the issue point by point, see Hart and Goo (2006).

14 The Crisis in
Culture and Inequality

Bonnie H. Erickson

Introduction: The Problem with Culture

Some kinds of culture are useful for getting ahead in the world. Bourdieu (1984) called such advantageous culture *cultural capital* because people can invest in and profit from it. He argued that cultural capital is the distinctive orientation of high-status people, who are the most powerful gatekeepers of success. Based on his research in France, his portrait of the culture in higher social circles features strong attachment to the most prestigious forms of culture, especially the fine arts, and firm rejection of popular culture. As Peterson and Rossman explain in chapter 13 in this volume, Bourdieu's portrait of high-status culture applied well to North America a century ago but is now outdated. Higher-status people today no longer stick to high-prestige culture; instead they enjoy many different kinds of culture, some prestigious and some popular, and delight in variety for its own sake.

Diversity has become the advantageous form of culture for high-status people, largely because their work now requires them to engage with many different kinds of people. The world of work is far more complex and volatile than it used to be, so upper-level people must connect with others in many different occupations, each with its own cultural profile. Though most high-status people engage with a variety of other occupations, they do not all connect with the same mix. The working network of, say, a hospital director is not the same as the working network of a manufacturing plant manager or of a high-level civil servant. Cultural variety is useful for all of them, but each needs a somewhat different cultural repertoire suited to his or her working network. Thus, high-status culture has changed from high-status fine arts to eclectic and variable mixes of different forms of art, media, and entertainment.

This leads to a crisis in culture and inequality: It is becoming ever more difficult for disadvantaged people to master high-status culture, which makes it ever more difficult for them to rise in education, work, or social networks. The core problem is that cultural capital has become much more subtle and complex. A century ago, or even half a century ago, cultural capital was not very hard to figure out. High-status culture was clearly identified with a small number of elite genres, primarily fine arts and literature. This was transparent even to disadvantaged people like my own parents, who grew up in small poor towns, dropped out of school early because of family poverty, and worked in a series of poorly paying low-level jobs. They still knew what upper-level culture was and could and did encourage me to get involved with it. Today, advantageous culture is no longer a short simple list of classy things. It is a complex combination: some high-status forms, some middle level, some popular. Variety is essential, and to make life still more difficult, the useful kind of variety differs from one part of the upper levels of society to another. Such subtle, variable cultural complexes are hard to identify and hard to learn.

This chapter begins with an overview of the historical changes in high-status culture and the reasons for them. Then the discussion turns to major trends in the world of work that continue to drive high-status culture in the direction of greater complexity and difficulty of access. One important trend is growing specialization of occupations, with culture differing from one specific occupation to another. Another trend is the growth of insecure employment, driving an individual to participate

in a number of working worlds. For upper-level people, this mobility both requires and develops diversity in networks and culture; for lower-level workers, mobility between poor jobs stultifies. A third trend is the influx of women into paid work, a trend that might further increase the complexity of culture in high-status workplaces, while also increasing cultural inequality for children whose cultural access increasingly requires paid help to replace the time working mothers no longer have.

Other social trends have contributed to the growing difficulty that disadvantaged people and their children face. Growth in income inequality means greater inequality in any kind of cultural access with a price tag, especially important in an era of marketized culture and multiplying options for buying superior forms of access to culture. Growth in residential income segregation, with people living next to others with incomes like their own, means that the poor live with the poor and lack neighborhood access to high-status people and their culture, whereas the children of the poor lack access to high-status schoolmates and their culture. Public schools serving disadvantaged people have fewer resources than ever and do less to teach culture than they once did, and there is a growing gap between their level of cultural training and that provided by schools with more resources and by the exploding growth in private tutoring.

Whereas higher-status people are diversifying their cultural portfolios and are reaping large gains in social network diversity and work success, poorer citizens find themselves locked in cultural ghettos with a narrowing range of choices and experiences. Their cultural lives can be narrow but deep, and shared pleasurably with their homogeneous social circles, so they can be rewarding. But these cultural lives are not culturally advantageous in moving up in schools, work, or networking.

Inequality in culture reinforces growing social and economic inequality and is a serious social problem. But it is not an irresistible force; we can and should do something about it. The chapter ends with a brief discussion of potentially helpful policy options.

Trends in Culture

In nineteenth-century North America, elite groups discovered the usefulness of high-status European art forms as a way to demonstrate

their cultural superiority. Feeling pressure from below, as in the Boston elite that lost urban political power to new immigrant groups, elites actively constructed organizations to promote the arts and to prove their leading role in arts support, thus establishing their cultural and social superiority (DiMaggio 1982). In Canada as well as the United States, elite groups patronized European fine arts and distanced themselves from the culture of workers, farmers, and immigrants (Tippett 1990).

The arts also became usefully portable signals of high status in an increasingly mobile world. Those who moved from towns to cities, or from one city to another, or to Europe, or even from lower levels to higher ones, could enter high-status circles new to them more easily because such circles came to share a focus on the arts. Elites made carefully lavish and public displays of art patronage to show their worthiness. They established museums and orchestras, collected art for their homes and boardrooms, supported artists, and attended arts events. These practices were well publicized in newspapers and magazines, so the nature of elite taste soon became widely known. Middle-class people followed the elite model, though to a lesser degree because of lower income and education. The arts became defined as intrinsically superior and worthy culture and thus became part of public school teaching, so that some disadvantaged children had a chance to acquire the finer things in life. The arts became prestigious in the eyes of most people, thus reinforcing the social standing of higher-status people with greater command of fine arts culture, while also allowing some lower-status people to become upwardly mobile in their culture.

But in the second half of the twentieth century, higher-status people could no longer rely on prestigious culture exclusively. The world of work had become vastly more complicated, with an explosion of many organizations, markets, and occupations in complex relationships with each other. Those in higher-level positions were in charge of the vital connections both within organizations, from level to level and branch to branch, and between their home organizations and important outside organizations and people. This meant that upper-level people had to work smoothly with a wide range of people from different backgrounds and in different parts of the working world, people with widely varying kinds of culture.

For example, when I studied the private contract security industry in Toronto (Erickson 1996) I found that owners and managers had to

relate to each other, employees, clients, suppliers, and members of the public. When dealing with other upper-level business people, they could establish business competence by discussing the trends covered in business journals and by power dining in the appropriate places, so owners and mangers read more business magazines and knew more about local restaurants than did those below them. When dealing with employees, however, they needed to connect with them by chatting about shared interests, so they also knew a good deal about popular culture. In this male-dominated industry, sports were the prevailing common interest shared from the top to the bottom of the ladder. When dealing with clients, owners and managers felt compelled to discuss anything the clients were interested in. Thus, higher-level people knew more about many kinds of culture, and their eclectic tastes were highly practical in their work. The fine arts played no useful role at all in this industry. Owners and managers knew more about the arts (painters and writers) than their employees did but made no use of this knowledge at work because art is defined as an irrelevant waste of time in the profit-oriented, competitive private sector. I concluded that cultural advantage (or cultural capital) had become not high-status taste but highly varied tastes combined with a keen sense of the rules of relevance of which kind of culture to use in which situation.

Other research in North America, Europe, and Australia has found the same pattern (Peterson 2005, p. 261). Higher-status people have diversified culture whereas lower-level-status people are much narrower in what they like or know about. Only a small fraction of upper-status people are exclusively devoted to the fine arts, and the number of such snobs is declining. Cultural variety, not necessarily including highly prestigious culture, is the defining feature of higher-status culture today.

Moreover, there is no one universal form of high-status variety. People in different segments of the elite world make different selections from the wealth of cultural possibilities. Veenstra (2005) conducted a study in British Columbia and found that overall variety of culture is greater for those in higher-level positions (i.e., those with workplace authority, high levels of work skill, or autonomy in their work) and for those with more education or income. However, when he looked at individual kinds of culture from literature to wrestling, he found that people in different kinds of high-status positions had different kinds of cultural competencies. For example, owners knew more about opinion magazines than

employees did but did not know more artists, whereas highly skilled people knew more about artists but not about opinion magazines.

The number of forms of high-status variety has been increasing in the United States in recent decades. For example, Lopez-Sintas and Katz-Gerro (2005) studied attendance at nine kinds of performances (i.e., jazz, classical music, opera, musicals, plays, and ballet) or displays (i.e., art museum, art fair, historical site) in 1982, 1992, and 2002. In all three years they found a group of people who rarely if ever attended any of the nine, thus showing little evidence of high-status variety. More interesting for the purposes of this chapter are those who did attend some things and the increase in the number of different combinations of things they attended. In 1982 attenders were of just three kinds: (1) people who rarely went to any performance but did go to museums, fairs or historical sites more often than average; (2) people with a wider range including classical music, musicals, and plays; and (3) people who attended everything at above-average rates. By 2002, the number of different attendance patterns had risen from three to five. One of the newer groups specialized in entertaining forms, going to musicals and plays much more than ballet or opera and to art fairs more often than art museums. If we could examine combinations including both these nine kinds of culture and the many other kinds available, we would see a much larger number of different cultural profiles, and we would see this number growing over time.

Differentiation: The Multiplication of Separate Occupational Worlds and Their Cultures

Small societies with simple technologies have only a few different kinds of work, but the kinds of work multiply greatly as technologies become more sophisticated and societies become larger and more complex. New technologies generate new occupations, and older occupations often divide into a larger number of more specialized kinds of work to gain efficiency, as in the proliferation of medical occupations. Social complexity itself creates new kinds of work, such as the transnational entrepreneurs who work across borders in increasingly global economies.

The growing number of distinct occupations is important because occupations are social worlds very significant in producing culture

(Weeden and Grusky 2005). Each occupation has its own cultural profile for several reasons. First, people get into occupations dominated by their own kinds of culture. Occupations have cultural reputations, being thought to include people with certain kinds of culture and to be suited to people with such culture. For example, people expect teachers to have a higher level of interest in poetry than engineers. The cultural reputation of an occupation attracts people who like that kind of culture and want to work in a world infused with it. Getting into an occupation is much easier if applicants speak the same cultural language as those already in. The occupation's gatekeepers easily find things in common with cultural peers, expect them to communicate well and work well with others, and see them as having a good fit. People often find work through other people—roughly half the time, at least, in North America—and those who know each other tend to share similar tastes, so those in an occupation pull in newcomers with culture similar to the prevailing occupational culture.

Second, occupations have different kinds of training requirements, each of which exposes people to culture in different ways. If the ticket of entry is a bachelor of arts, which includes both a humanistic formal education and a lively artistic student subculture, an occupation will have more avid leisure readers than one calling for an apprenticeship in a craft.

Third, people in the same kind of work do a lot of their work with each other, and not every minute of this time is just working. People talk, observe each other, and gradually share culture. Thus, those who enter an occupation are already similar to those who entered earlier, and they become even more similar as they work.

Weeden and Grusky (2005) found that people in different occupations differ in their reading, discussion of the arts, leisure activities, politics, and attitudes on social issues. They examined several popular ways to simplify the occupational world, either by grouping occupations into classes such as *self-employed professionals* or *laborers* or by using a single scale of an important occupational feature such as prestige, average education, or average income. None of the simplified versions matched up with culture very well. Cultures differ from one specific occupational world to the next, not from class to class or from top to bottom of ladders of prestige and so on. This is because occupations are real social worlds whereas classes or levels are not. Every class, in every

popular class scheme, is a motley collection of very different occupations with different cultures. Self-employed professionals, for example, have cultural reputations varying greatly in perceived interest in the arts (much greater for architects than engineers), perceived creativity and diversity of culture (greater for a museum curator than for an accountant), and so on. Similarly, every level in a scale of prestige or income or average education combines very different occupations. For example, a popular international prestige scale called Standard International Occupational Prestige Scale (SIOPS) (Ganzeboom and Treiman 1996) gives the same prestige score, 60, to the following: eighteen different kinds of managers, secondary teachers, economists, religious professionals, aircraft pilots, optometrists, and police detectives. Such motley miscellanies have little, if anything, in common culturally.

The growing number of distinct occupations, with distinctive cultures, implies a growing need for integration. Higher-status workers are most responsible for coordinating the work of others in different branches or levels within an organization and between organizations. Thus, more than ever, these higher-status coordinators need to link up with people with many different cultural repertoires. To make and maintain these linkages, and communicate well in them, higher-status people need to be familiar with a growing variety of cultural packages nurtured in the rising number of distinct occupational worlds. They build diversified networks to many kinds of people, and at the same time they diversify their cultural portfolios, with network and cultural diversity constantly reinforcing each other. These network and cultural advantages then help high-status people to continue to rise in their careers.

Mobility: Shifting between Occupational Worlds

Another major occupational trend is the rise of insecure employment, or frequent shifting from one workplace to another instead of having a job for life. Not only is the number of occupation-based cultures growing, but people also participate in more of them over their working lives.

Insecure employment is a very different experience for those at the top or the bottom of the social ladder. For those in relatively good lines of work, shifting work means moving from one good gig to another. A

higher-status job brings better opportunities to connect with others, not only meeting many but engaging in extended conversations and interactions. Culture is learned, and networks are enriched. These resources make it easy to find a new good opportunity when the current position ends. Shifting among such positions leads to large increases in social and cultural riches.

If people move between occupational cultures that differ a good deal, then they need to be culturally nimble. This is just what higher-status people are initially trained to do, because they are usually well educated and have learned how to learn. The higher-status person's impressive capacity for cultural accumulation is well illustrated by Griswold and Wright's (2004) study of *cowbirds*. They looked at the well-educated and cultivated people who answered an online *National Geographic* survey about culture—people whom they argue are members of the reading class. Those who moved into a region quickly got to know as much about the region's literature as those born there.

For lower-status people, the growth in work shifting has not brought the same social and cultural enrichment. Lower-level work brings little time for real social interaction on the job. Many workers work with few other people or work alone. Others work with large numbers of people but do not connect with them, like the cashier at the supermarket who speaks the same short functional phrases to hundreds of customers a day and never makes friends with any of them. There is little, if any, chance to learn new culture or to make new contacts through work. When such a position comes to an end, the worker looks for a new post with the same narrow resources that led to the current low-level job and finds another poor job. Cultural portfolios and social networks begin limited and stay that way.

Growing Income Inequality

One of the most consequential aspects of work is how well it pays, since most people gain their incomes from their work and since income has serious effects on culture. Unfortunately, income inequality has been growing for decades, especially in the United States, and is still growing now.

During the prosperous period following the Second World War, the level of income inequality in the United States changed little. But inequality started to grow in the early 1970s. Hourly wages, individual annual earnings, household total earnings, and wealth all became markedly more unequal over the following decades (Morris and Western 1999). Income inequality dropped a little from 2000 to 2002 because of a stock market crash that reduced very high incomes more than lower ones, but inequality bounced up again in 2003 (Shapiro and Friedman 2006). Looking at the long view, the U.S. Congressional Budget Office compared incomes in 1979 and 2003. The gap between the better and worse grew dramatically over that period. The average after-tax income grew by 4 percent for those in the bottom fifth of incomes and by 54 percent for those in the top fifth. Still more striking, income grew by 129 percent for those in the top 1 percent. To put this in terms of actual amounts of money, the average household in the bottom fifth had after-tax income of only $13,500 in 1979, and this crept up only to $14,100 in 2003, whereas the average income of the top 1 percentile went from $305,800 to $701,500 (Shapiro and Friedman 2006).

The trends in Canada have not been quite so dire until recently (Picot and Myles 2005). Whereas family income inequality grew in the United States from the late 1970s to the late 1990s, it did not change in Canada. This dramatic difference is rooted in social policy differences, notably the Canadian pension reforms of the 1960s that started to show effects in the 1970s and that have led to a remarkable improvement for Canadian seniors. Alas, the past decade or so has seen an American-style growth in income inequality in Canada. The incomes of wealthier families grew, the incomes of poorer families did not, and the extra income that poorer families get from government transfers fell (Picot and Myles 2005). Thus, in recent years inequality is growing all over North America, not just in the United States.

Growing income inequality implies growing inequality in the ability to take part in art and culture. There has always been a considerable range in the cost of culture, with much culture being out of reach for poorer people, but currently there is a boom in forms of culture that are both more expensive and more desirable. Increasingly, cultural distribution follows a rental model in which people pay some kind of fee for access or improved access. For example, those who can afford it are giving up the simple radio (which has a low one-time cost but offers limited

selection, variable sound quality, and a truly irritating number of commercials) in favor of satellite radio services (which have high start-up costs for a receiver and persisting monthly subscription fees but which offer variety and quality). Other examples include digital cable television and Internet sources of music and video. People with low incomes can still enjoy many forms of culture, especially if they have convenient access to good low-cost sources like well-stocked public libraries, but people with money can enjoy a far wider range of cultural possibilities much more easily. As incomes grow more unequal, so does the ability to develop a highly diversified cultural portfolio.

Income makes a difference not just for adults but also for their children. In Canada, the National Longitudinal Survey of Children and Youth has been following a large sample of Canadian children since 1994–1995. Children in lower-income families less often participated in sports activities, arts, music, clubs, or groups. Clearly their chances of learning various forms of culture were poor. Their lack of cultural participation had other costs as well. Those who did not participate showed delayed development in vocabulary and had more difficulty with reading and math, warning signals that they will not become well educated. Nonparticipants had lower self-esteem, critical to later achievement in education, work, and leisure activities. The parents of nonparticipants more often reported that the children had difficulties with friends and rarely saw friends outside of school, signs that they are off to a bad start in building their networks (Statistics Canada 2001). Not only do the children of the poor gain less culture while they are young; they also have less access to the resources that would help them to acquire culture later.

Income differences in culture are amplified by shifts in housing and education. Increasingly, North American neighborhoods are homogeneous in income: The rich live with the rich and the poor with the poor. This narrows the opportunity for the poor to learn higher-status forms of culture from their neighbors. Since schools draw students primarily from the local area, schools are also increasingly homogeneous in parental income. In wealthier areas parents can fund added school events and programs, can give their children tutoring outside of school, can support their children's artistic creativity (see chapter 7 in this volume), or can withdraw from the public schools in favor of private ones that usually have richer cultural programs. Since wealthier parents have many ways to enrich the cultural repertoires of their children, other

354 Bonnie H. Erickson

parents in the area are encouraged do the same for their children. Even
children without such culturally active parents can benefit from the cul-
tural interests of their friends. In poorer neighborhoods most parents
lack the money and knowledge to promote children's culture.

Thus children now have highly unequal access to culture. Neigh-
borhood homogeneity is especially problematic for poor children, since
children from disadvantaged backgrounds do much better in better
neighborhoods. They use neighborhood facilities such as parks and
community centers, they play with some children whose parents are
better educated and better off, and they are exposed to fewer environ-
mental pollutants while developing. Thus, they arrive at school healthier
and more ready to learn, and they do better in school. Their informal
learning about culture probably gets just as strong a boost as does their
formal learning in the classroom. Fewer and fewer poor children have
the advantage of living in a nonpoor neighborhood.

Globalization

Not only are today's higher-status people doing more and more to
coordinate the increasingly specialized work of others, but also the
work is increasingly spread out around the world. Growing interna-
tional trade, multinational firms with branches in several countries, and
a boom in transnational entrepreneurship all increase the number of
jobs in which people must work across borders in some way, and it is the
higher-level people who do most of this worldwide linking. Work with
an international component calls for a degree of working familiarity
with the cultures of many places, especially the culture dominant at the
top of their business and government circles.

Although the work of high-end North Americans reaches out to the
world, the world also comes to them in the form of immigrants who
enter the workplace and need to be coordinated. Even people with a
strictly local enterprise often must work with people from far away
and must pick up a little of their culture as they interact. Although
the native-born people who manage immigrants add still more to their
already powerfully diversified cultures, the immigrants themselves have
a huge cultural handicap because their own cultures are not of great

value here and because they do not know as much about the cultures dominant in North American workplaces (Erickson 1996).

In these comments I follow Peterson (2005, pp. 273–74), who saw global business and immigration as two powerful sources of the increasingly eclectic nature of upper-level culture. His view is supported by some research on recent trends in American culture. Analyzing arts attendance in the United States from 1982 to 2002, DiMaggio and Mukhtar (Chapter 12 in this volume) find declines in participation in strongly Eurocentric art forms (classical music and ballet) but rises in more multicultural and international forms (jazz, originally a black American genre, and attendance at museums, which include fine things from many cultures and places).

Educational Inflation: Rising Levels of
Education Requirements for Good Jobs

For at least a century, every generation of North Americans has been more highly educated than the one before it. In part, this follows from real rises in the average skill levels of occupations. The average skill level of starting jobs has gone up, so educational hiring requirements rose also, and education made more and more of a difference to the income and prestige of first jobs (Hunter 1988).

Whatever the reasons for the rise in education, it results in greater inequality as the high end becomes higher and thus more distant from the bottom. Rising cultural inequality follows because the longer people stay in schools, the more they learn about a wide range of cultures (Erickson 1996), not only from formal classes but also from extracurricular activities and fellow students. As increasingly well-educated people fill upper-end positions, they bring a wider range of culture with them, adding to the complexity and variety of high-status occupational cultures. At the same time higher education is increasingly specialized, and people with the same number of years of schooling have spent these years in quite different places and programs, developing different kinds of cultural diversity. They bring these varying cultural varieties with them to the different occupational worlds for which their certificates qualify them, adding to cultural differences between occupations.

More Women in the Workplace

The last major occupational trend considered here is one of the most massive: the huge growth in women's participation in the labor force. Students of culture were once quite concerned about this trend because they thought it might erode women's support for the arts. Women have historically participated in the arts more than men, as audience members, as workers in cultural organizations, and as volunteers. Collins (1992) traced this difference to a gender division of labor in which men were responsible for work, earning, and politics whereas women were responsible for home life, including family cultural participation and instilling higher culture in children. If so, women might have drifted away from the arts as they increased their participation in occupations outside the home and might have reduced their domestic cultural obligations by delaying marriage and having fewer children.

To great surprise, women are still more cultivated than men despite huge changes in their working and family lives. In their study of arts attendance in the United States from 1982 to 2002, DiMaggio and Mukhtar (chapter 12 in this volume) found that women kept their cultural edge. Both men and women declined somewhat in most kinds of attendance, probably because of competition from newer kinds of culture such as at-home entertainments, but women declined less and women stayed higher than men in their arts attendance rates.

Lizardo (2006) argued that the reason for this apparent puzzle lies in the world of occupations itself. As noted already, people are attracted to occupations that fit their own cultural profile. Since women are more interested in the arts, they outnumber men in the kinds of occupations where culture is valued more than mere money—occupations in which the average person is better educated than paid. Since culture is highly valued in such kinds of work, both men and women in these occupations are well above average in their consumption of highbrow culture—visiting art museums or galleries, and going to the ballet, theater, and a classical music or opera concert. Indeed, the men in very culturally oriented occupations are even more vigorous participants in the arts than their female peers. In occupational fields that are not culturally oriented overall, there are many different specific kinds of jobs, and women tend to seek—and to be sought for—jobs seen as suitable for them. Often these are jobs that draw on women's

stereotypically perceived greater social skills and cultivation, such as work representing an organization to outsiders. Thus, the particular work women do draws on and reinforces their high cultural advantage, even in noncultural industries. Further, women at work have stronger and more numerous ties to fellow women that men do, so women can support each other's cultural interests even in occupations that put no value on high culture. Lizardo found that women in economically oriented occupations—ones in which average income is relatively high compared to average education—are only a little less active in the arts than women in the most culturally oriented occupations. Men, however, show a truly drastic drop in arts activity when moving from culture-intense to money-intense occupational worlds.

The net result is that women are keeping their higher level of interest in the arts but are not yet passing their interests on to the men they work with, except in the small sector of very arts-inclined work. Women's charge into the work force may be making no difference to occupational cultures and, hence, no difference to the nature of cultural advantage. However, women in the labor force do have contacts with men in a wider range of occupations than do women not in the labor force (Erickson 2004), so they have potential opportunities to pass on a bit of their cultural interest to the men they meet at work. If this does start to happen, it would further increase cultural diversity, fueling the trend toward more complex forms of cultural advantage. In any case, the growth in women at work is doing nothing to counteract the growing subtlety of high-status culture and its difficulty of attainment.

Meanwhile, what is happening back at home? Mothers used to be the family cultural managers—arranging cultural participation for their spouses and children and taking charge of their children's cultural training from piano lessons to baseball practice—in the gendered division of labor that Collins (1992) described. Now, they have less time to manage this activity because they hold jobs outside the home. Wealthier mothers—and fathers—can easily compensate for that by shrewd financial investments in their children's cultural futures: hiring tutors, hiring nannies to ferry the kids to lessons and sports practice, sending children to educational summer camps. Cultural inequality among children will probably grow even more.

The Future of Culture?

Today, and even more tomorrow, people working in the upper end of the occupational structure must have command of very complex cultural resources. They need at least a smattering of knowledge of many different kinds of culture, because their work connects them to people in many kinds of occupations, each of which has its own cultural palette. To make the cultural challenge greater, the kinds of variety and depth they need are different in different occupations. To make the challenge greater still, the number of cultural options is huge and growing (see chapter 10 in this volume) so that the overwhelming number of possible cultural combinations makes it even harder to become culturally diversified in an advantageous way.

Given these difficulties, how can people make usefully strategic decisions about what culture to acquire? When people look for culture—for example, when they want to decide which book to read or movie to watch—most of the time they turn to their networks. A recent Toronto survey (Kayahara and Wellman 2007) found that four out of five people seek cultural information from their networks. About as many seek information from the Internet, but this information is largely practical details such as show times. Despite the seeming power of the Internet in the age of electronics (chapter 9 in this volume), people still mainly rely on those they know to make cultural choices.

People often consult those they are very close to (Kayahara and Wellman 2007). The use of close ties is more common for those who are younger; Steven Tepper, Eszter Hargittai, and David Touve in chapter 8 in this volume also find that young people rely on their friends as cultural advisors. People also consult close ties more often if they have more of them, probably because this increases the chances that one or more close contacts will be a well-informed source. However, the role of networks is not by any means confined to the near and dear. Many of our casual, fleeting contacts with mere acquaintances include culture, as people smooth their interactions by chatting about sports, current movies, or whatever else is a potential "something in common." Such interactions bring cultural information and influence, even when we are not deliberately seeking cultural guidance. Thus, I found that people know more, about many different kinds of culture, if they know a wide variety of people (Erickson 1996).

The most fortunate are those who have both many intimates and many widely diversified acquaintances. Those who know us well know our tastes and care about us and so will point us to those things we are sure to enjoy and will not want to miss. For example, my friend and colleague Nancy Howell has spent several years in Botswana and is a distinguished expert in the demography of the !Kung there. She is also a fellow fan of detective novels. As soon as I discovered *The Ladies' Number One Detective Agency* (the start of a charming series featuring a Botswana lady detective), I alerted Nancy, sure that she would love it—and she did. But being close, and rather similar in our tastes, Nancy and I are not each other's best sources of new kinds of books that we might like if we tried them. Our acquaintances do a better job of expanding our cultural horizons.

Research on networks consistently shows that people in higher-status occupations have both more intimates and more acquaintances, and both the close and not-so-close parts of their networks include a wider variety of people.

Occupational trends, especially growing numbers of occupations and growing mobility between positions, work to further increase the network advantages of those in higher-status positions. Thus, they will continue to acquire culture more richly and strategically and to race even further ahead of the lower-level people handicapped in both networks and culture. Trends in income inequality, residential segregation by income, and public school cultural training all amplify this growing inequality.

If these trends continue, cultural inequality will grow. The poorly educated and employed will have trouble identifying what advantageous culture is, both because cultural capital is highly complex and because the disadvantaged lack the rich networks that could inform them. Compared to the cultural elite, they will continue to have thinly stocked cultural portfolios, perhaps even thinner ones than ever. They may have a deep and rewarding engagement in a few kinds of culture shared with a small circle of people much like themselves, but they will lack the cultural diversity to connect usefully to a wider world. For those of higher status, ever more complex varieties of culture will be essential. Inequalities of culture, social networks, and occupations will amplify each other and all become greater, with the children of the poor suffering the most.

Fortunately, these trends are dismal but not inevitable.

What Is to Be Done?

Nothing can be done by small-scale actors like individual people or arts organizations. They simply do not have the power to counteract the occupational juggernauts behind the crisis. The only actor capable of tackling this crisis is big government, which can and should put strong policy levers to work. Some of the policy options are relatively limited ones aimed at ameliorating cultural inequality; some of the options are more ambitious ones aimed at the underlying structural problems that are making cultural inequality worse.

Let us begin with some of the modest policy possibilities. Governments could strengthen legislation and regulation to push back media consolidation, which further narrows the choices of people dependent on inexpensive and accessible cultural outlets such as broadcast radio and big box retailers (Ivey and Tepper 2006). Similarly, they could restrict rental models—in which, for example, a piece of music is downloaded from the Web for a fee—that help to give more prosperous people wider access to culture. They could subsidize cultural events and offerings to make them less expensive, as is standard practice in much of Europe. They could link funding to provisions making culture widely accessible, such as very cheap or even free access for the disadvantaged, and locating cultural events and venues all over communities to bring them within easy travel as well as financial reach. They could support widespread, easy-access public portals such as top-notch Internet access—and the training to use it—in public libraries, community centers, and public schools. Most important in the long run, governments could reinvest in public schools to greatly improve the ways they expand the cultural repertoires of all children through arts education, training in computer and Internet skills, sports activities, and clubs.

Though such initiatives would be worthwhile, they can only do a limited amount if we still have serious and growing inequalities in early childhood education and schooling, in incomes, and in access to good jobs. Ultimately, we need greatly improved public education including enhanced cultural and sports programs. We know that early-life experiences make a huge difference to cultural participation throughout life, so it is crucial to invest in the young. Governments should increase the ability of poor people to access culture and to build diverse networks.

In short, inequalities in culture are deeply tied to inequalities in a person's life chances, which means that there is a good deal of hard political work to be done before we can hope to expand participation in any meaningful way. Those people and organizations devoted to culture might well need to add politics to their already long list of diverse cultural resources. Nothing would do culture more good than a culturally informed social democratic movement.

Acknowledgments

I am grateful for very helpful comments and suggestions from Ann Mullen, John Myles, and Steven J. Tepper.

Bibliography

Bourdieu, Pierre. 1984. *Distinction: A Social Critique of the Judgement of Taste*. Cambridge, MA: Harvard University Press.

Collins, Randall. 1992. "Women and the Production of Status Cultures." In *Cultivating Differences*, edited by Michele Lamont and Marcel Fournier, 213–31. Chicago: University of Chicago Press.

DiMaggio, Paul. 1982. "Cultural Entrepreneurship in Nineteenth Century Boston: The Creation of an Organizational Base for High Culture in America." *Media, Culture and Society* 4: 33–50.

DiMaggio, Paul, and Toqir Mukhtar. 2004. "Arts Participation as Cultural Capital in the United States, 1982–2002: Signs of Decline?' *Poetics* 32: 169–94.

Erickson, Bonnie H. 1996. "Culture, Class, and Connections." *American Journal of Sociology* 102: 217–51.

_____. 2003. "Social Networks: The Value of Variety." *Contexts* 2: 25–31.

_____. 2004. "The Distribution of Gendered Social Capital in Canada." In *Creation and Returns of Social Capital*, edited by Nehk Flap and Beate Volker, 27–50. London: Routledge.

Ganzeboom, Harry, and Donald J. Treiman. 1996. "Internationally Comparable Measures of Occupational Status for the 1988 International Standard Classification of Occupations." *Social Science Research* 25: 201–39.

Griswold, Wendy, and Nathan Wright. 2004. "Cowbirds, Locals, and the Dynamic Endurance of Regionalism." *American Journal of Sociology* 109: 1411–51.

Hunter, Alfred. 1988. "Formal Education and Initial Employment: Unravelling the Relationships between Schooling and Skills over Time." *American Sociological Review* 53: 753–65.

362 Bonnie H. Erickson

Ivey, Bill, and Steven J. Tepper. 2006. "The Next Great Cultural Transformation." *Chronicle of Higher Education, Section B: The Chronicle Review*, May 19, B6–B8.

Kayahara, J., and B. Wellman. 2007. "Searching for Culture High and Low." *Journal of Computer-Mediated Communication*. 12(3) article 4. http://jcmc.indiana.edu/vol12/issue3/kayahara.html.

Lizardo, Omar. 2006. "The Puzzle of Women's 'Highbrow' Culture Consumption: Integrating Gender and Work into Bourdieu's Class Theory of Taste." *Poetics* 34: 1–23.

Lopez-Sintas, Jordi, and Tally Katz-Gerro. 2005. "From Exclusive to Inclusive Elitists and Further: Twenty Years of Omnivorousness and Cultural Diversity in Arts Participation in the USA." *Poetics* 33: 299–319.

Morris, Martina, and Bruce Western. 1999. "Inequality in Earnings at the Close of the Twentieth Century." *Annual Review of Sociology* 25: 623–57.

Peterson, Richard A. 2005. "Problems in Comparative Research: The Problem of Omnivorousness." *Poetics* 33: 257–82.

Picot, Garnett, and John Myles. 2005. "Income Inequality and Low Income in Canada: An International Perspective." Analytical Studies Research Paper Series 240. Ottawa: Statistics Canada.

Shapiro, Isaac, and Joel Friedman. 2006. "New CBO Data Indicate Growth in Long-Term Income Inequality Continues." Washington, DC: Center on Budget and Policy Priorities.

Statistics Canada. 2001. "National Longitudinal Survey of Children and Youth: Participation in Activities." *Daily*, May 30. http://www.statcan.ca/Daily/English/010530/d010530a.htm.

Tippett, Maria. 1990. *Making Culture: English Canadian Institutions and the Arts before the Massey Commission*. Toronto: University of Toronto Press.

Veenstra, Gerry. 2005. "Can Taste Illumine Class? Cultural Knowledge and Forms of Inequality." *Canadian Journal of Sociology* 30: 247–79.

Weeden, Kim A., and David B. Grusky. 2005. "The Case for a New Class Map." *American Journal of Sociology* 111: 141–212.

Conclusion

The Next Great Transformation: Leveraging Policy and Research to Advance Cultural Vitality

Steven J. Tepper

Engaging art, the title of this book, is a double entendre that encapsulates the transformations documented in the preceding chapters. As an adjective, *engaging* describes our cultural policy for the last forty years—if we are able to produce and present art that is engaging (i.e., attractive, compelling, beautiful), such as world-class music, theatre, and dance, then good things will happen. Audiences will be uplifted, converted, and inspired, and the public interest will be served. But, if we read engaging as a verb (e.g., to interlock, to involve, or to cause) then the title suggests that citizens actively connect to art—discovering new meanings, appropriating it for their own purposes, creatively combining different styles and genres, offering their own critique, and, importantly, making and producing art themselves. One important theme from the book is that perhaps we need to start thinking more about citizen involvement and less about bringing great art to the people. This aim requires focusing on the second definition of *engaging*. However, I do not mean to imply that viewing or listening to high-quality, profession-

ally produced art—from Pablo Picasso's *Guernica* to Martha Graham's *Appalachian Spring*—does not demand high levels of intellectual and emotional engagement. But the reality is that for most Americans, especially younger ones, engagement with hallowed master works is simply not the way they experience art and culture. For them, art is connected to everyday life; it is not a treasure to be taken out on special occasions, admired and celebrated. Culture is like modeling clay—something to be kneaded and worked on, rolled across the fingers until it takes the shape and contour of one's own hand.

We began the book with two basic questions: (1) What is the state of cultural participation and engagement in the United States, and (2) How is participation changing? Although we cannot offer an exhaustive survey of the state of participation, we can assess a few basic trends and patterns. With regard to the second question, the book provides a more textured analysis, but, again, we have sketched these changes in broad brush strokes, leaving room for other scholars to help fill in the details.

The State of Cultural Participation in the United States

First, in terms of current participation, our findings are mixed. It is very difficult to give the United States a single cultural bill of health. If we examine the relationship between the supply and demand of the benchmark art forms, it is clear that the accompanying expansion in the number of nonprofit art organizations over the last few decades has not led to an equal expansion in the size of arts audiences. According to data collected by the National Center for Charitable Statistics, the total number of nonprofit arts organizations—representing art museums, theatres, symphonies, opera, dance companies, and other performing arts organizations—increased by 59 percent between 1990 and 2001 (growing from 4,661 to 7,404 organizations). If we examine arts attendance during a similar period, we find that audiences for the benchmark art forms (i.e., jazz, classical music, opera, dance, theatre, museums) increased more slowly, by approximately 6 percent. In 1992, 76.2 million adults had attended at least one of the benchmark art forms; in 2002, that number had risen to 81.2 million (NEA 2004). The growth of nonprofits might lead to a number of positive benefits—including better and more diverse experiences for existing arts patrons, more

innovation, and better access for certain segments of the population. Nonetheless, it is clear that the growing size of the nonprofit sector has, for the most part, not created an equal ground swell in terms of participation in the benchmark art forms.

Regardless of whether supply has grown faster than demand, it is still possible that a greater percentage of Americans are participating today in the benchmark art forms than a decade ago. The findings in this regard are also mixed. In some areas, like jazz and museums, we see attendance rates staying constant or increasing. In others, like classical music, ballet, and theatre, we see slight decreases (in 1992, 12.5 percent of the public attended a classical music concert; in 2002, 11.6 percent had attended) (NEA 2004). Of greater concern are the significant declines in arts attendance across the benchmark arts for younger audiences. As Paul DiMaggio and Toqir Mukhtar suggest in chapter 12, the declines among the youngest cohorts suggest a failure of these art forms to renew their audiences. On the other hand, if we look at participation as art making—or what Steven Tepper and Yang Gao call *arts practice* in chapter 1—rather than arts attendance, we see some positive signs: with the youngest age group, eighteen- to twenty-four-year olds, increasing their participation in ballet, musical theatre, and pottery and ceramics.

We can also assess the state of participation by comparing ourselves with others. Many critics assume that Americans are less interested in the fine arts than our more cultured European neighbors. Cross-country comparisons are fraught with difficulties, as Mark Schuster explains in chapter 2. Nonetheless, based on his evidence, the United States seems to participate at rates that are comparable to other countries. Almost twice as many Americans attend ballet than do the British. Roughly the same percentage of Americans and French participate in opera and attend art museums. Other than Canada, the United States has one of the highest rates of attendance at jazz performances. In terms of classical music, the United States leads virtually every other nation, including places like Austria and Germany. So, depending on what diagnostics we use, cultural participation in the United States is doing reasonably well.

Our findings also suggest, however, that a true assessment of the state of cultural participation in the United States requires a broader and more nuanced set of measures that examine participation in less traditional places. For example, Robert Wuthnow in chapter 5 shows

how the arts are increasingly being used by churches as a means to revitalize faith and engage congregants. Almost 75 percent of all congregations include choir singing; 70 percent feature drama or skits; and one third host arts festivals. There is also evidence that the arts are flourishing in immigrant communities, where they are used as a means of passing on heritage, negotiating identity, and reaching out to mainline audiences (see Jennifer Lena and Daniel Cornfield in chapter 6). Over the next forty-five years, 80 percent of the projected growth in the U.S. population will be accounted for by immigrants or the children of immigrants (U.S. Census 2005). For these communities and citizens, the arts are often more integrated into the daily rhythms of their lives (Moriarty 2004). To be sure, immigrant arts face significant challenges—like access to grants, space, and audiences—but given the more central role of the arts in the lives of these new citizens, we may find that this activity represents a new and vital frontier for American arts participation.

Finally, the Pew Charitable Trusts research on technology and new media has found that the Internet is extremely fertile ground for arts and cultural participation. Some 57 percent of online teens create content for the Internet, sharing their own artistic creations as well as remixing existing content into new works (Lenhart and Madden 2005). According to research by Eszter Hargittai at Northwestern University, more college students visit Web sites to interact with others around music, art and culture (65 percent) than any other domain, including sports and politics (Hargittai 2006).

The research presented in this book should invigorate arts leaders and policymakers to reexamine their efforts to engage audiences. Overall interest and participation in the benchmark arts has remained relatively stable as other forms of participation—whether in religious settings, online, or among immigrants—blossom. In fact, by many measures, as the title of this book suggests, cultural participation may be witnessing a renaissance.

A Renaissance of Participation

One sign of this renaissance is the cosmopolitan tastes of audiences. Increasingly, educated citizens are less interested in defining themselves

as cultural snobs and more interested in engaging in a broad, eclectic set of arts activities. This is what Richard Peterson and Gabriel Rossman in chapter 13 refer to as the shift to omnivorousness among arts audiences. Throughout history, the breakdown of traditional hierarchies, the blurring of boundaries between genres, and the interchange between popular and elite forms of culture have resulted in extremely fertile and lively artistic environments (Hall 1998). The Renaissance, Impressionism, and the modernist movement in the early twentieth century were all characterized by a type of eclecticism and boundary crossing by both producers and consumers of art, not unlike what we are witnessing today.

This new cosmopolitanism is being fed by changes in technology. Several authors in this volume discuss the explosion of choice made possible by the emergence of digital culture. *Wired*'s editor-in-chief, Chris Anderson, discusses the emergence of the *long tail* phenomena, arguing that people are consuming culture that is off the beaten path—books and music that are deep in a publisher's catalogue—down the long, long list of available titles. As Barry Schwartz notes in chapter 10, more culture is available today than ever before. Most cable packages offer more than 100 television stations, and satellite provides hundreds of radio stations as well. From our computer screens, we can explore Seattle's latest indic rock band, Johann Pachelbel's *Canon in D* arrangement for electric guitar and performed by a teenage virtuoso in Japan, Sri Lankan hip-hop, short animated political films posted on YouTube, and a fashion show from London. Many of these cultural offerings have little need for the mass audiences demanded by global media, flourishing instead by linking up with small groups of committed fans.

The explosion of choice is contributing to the emergence of the *curatorial me*. Handed the capacity to reorganize cultural offerings at will through new devices like the iPod or TiVo, citizens are increasingly capable of curating their own cultural experiences. The curatorial me is an emerging form of active engagement with art and culture. Although not producing art themselves, many citizens have developed the skills and expertise to be connoisseurs and mavens, seeking out new experiences, learning about them, and sharing that knowledge with friends. We need to pay more attention to this type of variety seeking as an important dimension of cultural participation, which is, perhaps fundamentally, a process of discovery. Analysts need to understand better when and how people find out about and then experience previously

unfamiliar forms of art and culture. With regards to finding new music, my coauthors and I show in chapter 8 that social networks remain critical. Despite the abundance of new devices, people still rely on each other—or what some refer to as *mavens*—when exploring new artists and art forms. Social networks help us to filter the seemingly unlimited cultural offerings, which if we were left to navigate alone would likely cause the types of psychological and cultural disaffection that Schwartz in chapter 10 refers to as the *paradox of choice*.

The curatorial me and variety seeking fit into what many market analysts refer to as the experience economy, whereby consumers search for a broad range of cultural goods and services that are original and authentic and that link to their hobbies, creative passions, and identities. The popularity of custom-designed kitchens, art deco toasters, climbing walls, microbrewed beer, exotic cuisine, yoga, and theme vacations all highlight the way that citizens, in a postmodern world, use cultural consumption to playfully construct their identities. This type of identity work, some would argue, is particularly important for the expanding group of young, unmarried individuals who, in the absence of well-defined family roles and obligations, have the freedom and time to invent and reinvent themselves through culture. On the other end of the age spectrum, there is a growing proportion of Americans who are retired and in better health than previous generations of retirees. Although identity might not be their driving motivation, baby boomers have both the time and income to entertain themselves and to fill their worlds with interesting and stimulating cultural experiences.

In this experience economy, cultural goods and services need to connect to everyday life and to the varied lifestyles of consumers. In other words, it is not enough to market a symphony concert or theatre performance as a one-time distinct event. Increasingly, it will become important to synergistically tie together multiple cultural experiences—music, food, film, books, travel, and sports. In doing so, cultural producers and presenters will not only heighten the experience—through reinforcing and reverberating cultural stimuli—but they will also have a better chance of appealing to consumers and audiences whose preferences are increasingly diverse and whose attention is harder to capture amid the din of media offerings (see Joel Swerdlow in chapter 9).

A related trend highlighted in this book is the growing interactivity of audiences. Prior to the twentieth century, audiences were active

participants who interrupted theatre presentations to praise or censure performers, who formed audience leagues to debate the merits of different performances, who produced and performed art themselves, and who participated in parades, pageants, community sings, and other forms of collective expression (see Lynne Conner in chapter 4). Since the late nineteenth century, as the arts became both more professional and more national in scope, audiences have become more passive, leading to our contemporary norm of showing up to an event, sitting quietly in the dark, and applauding on cue. As the aura of high culture fades and as new generations are growing up on a daily diet of digital culture, audiences are no longer content with the arts; they want the arts experience. According to Conner, that involves being able to manipulate content, to use electronic media to project one's identity, and to seize the opportunity to be judges, critics, and experts.

Swerdlow documents the variety of new media and devices—from video games to social networking sites to handheld devices for use during concerts—that are allowing audiences to express their views and to control what and how they consume art and entertainment. The popularity of "American Idol" as well as a growing crop of reality TV shows that allow audience members to vote on their favorite performers, to join online discussion boards, or to otherwise express their opinions is testimony to this growing interactivity. Although some would see this democratization of the arts as a threat to artistic excellence, history suggests otherwise. There is evidence that a large proportion of the populace participated in the selection process of well-known works of art during the early Florentine Renaissance—providing suggestions, letters, and criticism. As Mihaly Csikszentmihalyi (1988, p. 336) noted, "It was [the] tremendous involvement of the entire community in the creative process that made the Renaissance possible. And it was not a random event, but a calculated, conscious policy on the part of those who had wealth and power."

Finally, there appears to be a trend in amateur art making. Charles Leadbeater (2004), a well-known British social critic, argued that the twenty-first century will be shaped by the "Pro-Am Revolution": professional amateurs. From rap musicians who got their start by recording homemade tape recordings to thousands of amateur astronomers whose careful observations that employ relatively cheap but high-powered telescopes contribute to scientific breakthroughs to the hundreds

and thousands of bloggers emerging as a shadow news-media corps, citizens are increasingly spending significant amounts of their leisure time engaged in serious, creative pursuits. Those pro-ams are people who have acquired high-level skills at particular crafts, hobbies, sports, or art forms; they are not professionals but are often good enough to present their work publicly or to contribute seriously to a community of like-minded artists or creators. Pro-ams typically make their livings in other work but are sufficiently committed to their creative pursuits to view them as a possible second career later in life. If we simply look at orchestra musicians, the presence of pro-ams is demonstrable. Of all symphony orchestras, 40 percent have annual budgets of below $700,000 a year. On average fifty-six of the sixty-one musicians in each orchestra are volunteers—and the five salaried musicians make less than $150 per week (Brooks 2002). In other words, almost half of the live symphonic music in America is probably performed by amateurs. The International Association of Music Manufacturers refers to these types of amateurs as weekend warriors—people who play music seriously in their free time—as part of bands, chamber groups, and ensembles.

In part, amateur art making is on the rise because technology has both reduced the high costs of artistic production and has met the challenges of finding an audience. Amateur filmmakers can purchase sophisticated cameras and editing software for a few thousand dollars and can distribute their films online, sometimes to a broad public, but often just to other filmmakers seeking a community where they can share work in progress, offer and receive advice, and develop networks to help them with future film projects. Many of those films are now showing up on Al Gore's television station, Current, where about a third of the programming is contributed by viewers. The same trend can be seen in recorded music, with the rise of do-it-yourself independent music, the growth of pro-am record labels, and the advent of affordable home studios. What is happening in today's world of music production makes the 1970s garage band phenomena look like a prequake tremor. The same trends are evident in publishing, home design, gardening, and other cultural pursuits.

Although attendance at some benchmark art forms may be waning, other types of participation are on the rise. Henry Jenkins and Vanessa Bertozzi (chapter 7 in this volume) describe the aforementioned trends as a type of revitalization of folk culture where art and art making is

participatory: Much of it can be produced and consumed in the home; many people contribute and learn from each other (without necessarily considering themselves professional artists); and much of what gets produced is considered community property. From this vantage point, the next great transformation of America's cultural life feels more like a return to an earlier era of participatory culture rather than the onset of some new, unfamiliar form of postmodern cyberculture.

Changes in Participation: New Inequalities and a Growing Divide?

Some critics and pundits see a less optimistic picture. Rather than a democratization of culture and the flourishing of citizen-based activity, they track a growing monopolization of culture brought about by the convergence and consolidation of media and entertainment industries. Consolidated ownership, centralized control of content, the increasing use of data-driven audience research (see chapter 11 in this volume), and bottom-line pressures in public companies, critics argue, are leading us toward less diversity, less risk, and fewer opportunities for new or emerging artists or art forms to find audiences. Such trends are crowding out local and independent voices. Citizens are confronting a homogenized culture that does not speak to their unique expressive needs. Thus critics see a growing cultural deficit, not cultural democracy, in the United States.

Bolstering their concerns, in many art forms there is strong anecdotal evidence suggesting that the gates are too narrow: Many artists and works of art find it difficult to connect with potential audiences. For example, most contemporary radio stations program only a few recordings, generally playing no more than two dozen titles in a given week, half of what they played ten years ago (Ivey and Tepper 2006). For a record industry that places more than 30,000 compact discs in distribution each year and that is dependent on radio to present new work to audiences, tight playlists keep far too many recording artists out of the system and limit consumer choice. Consolidation has produced similar constraints in book publishing and film.

Simultaneously, many critics contend, nonprofit museums and performing arts organizations have also narrowed the gates, attempting

to maximize attendance and contributions by advancing conservative, repetitious programming choices. Small and medium-sized organizations are facing competitive pressures from the growing number of big performing arts centers that might bolster a city's image but that bring with them some of the same constraints endemic in the consolidated media industries.

And, of course, there are the related issues of intellectual property. Today, consumers must navigate an increasingly complex network of payments for arts products. Moreover, cultural consumption is quietly making the transition from a purchase to a rental model. Even consumption that feels like a purchase, like an iTune download, is often really a rental, as digital rights management technology limits our ability to copy or transmit our download. In the future, renting songs, television shows, films, or perhaps even online pages of books will become a bigger proportion of our entertainment budgets, creating significant financial burdens for some segments of the population.

In addition to these larger changes in arts and entertainment production and distribution, there are inequalities in the labor market that have adverse consequences on cultural participation and consumption. Bonnie Erickson (chapter 14 in this volume) discusses the increasing division of jobs into those creative occupations that require highly skilled individuals to work across firms, divisions, sectors, and continents and those service-level jobs that require few skills and very little interaction across occupational groups and global borders. The former group—new, creative professionals—must have a broad knowledge of culture to interact with people in a variety of settings from a variety of backgrounds. Knowing a little about bhangra, classical music, jazz, and glamour punk can help a manager of an international media firm interact with programmers in India, board members in New York City, investors from New Orleans, and newly employed recent college graduates. Having a broad range of cultural knowledge and experiences helps these individuals succeed in their professional lives, and such success exposes them further to new groups of people who introduce them to still new and different types of culture. Workers in the service economy neither are rewarded for having broad cultural interests, nor are they exposed through their work to a diverse network of people. So their cultural options and opportunities start off limited and remain that way. Moreover, these workers often hold two or three jobs, have less access

to technology, and have less time for leisure. We expect, therefore, that, compared with creative professionals, service workers are less likely to have the time or resources to take advantage of either the pro-am revolution or the long tail phenomenon.

Who is right—the cultural optimists, who say, "A thousand flowers are blooming, we are drowning in a sea of possibility, and we are surrounded by a new creative ethos"; or the cultural pessimists, who say, "The market is too restricted, people are suffering from a dearth of cultural opportunities, and demands of the new service economy are leaving many workers with little time, energy, or resources to engage with art and culture?"

Both sides are right; each sees a different side of the cultural coin. They are both right because America is facing a growing cultural divide—a divide separating an expressive life that exudes promise and opportunity from one manifesting limited choice and constraint. It is not a gap marked by the common signposts—red versus blue states, conservatives versus liberals, secularists versus orthodox—and it is more embedded than the digital divide that separates citizens from technology. It is a divide based on how and where citizens get information and culture.

Increasingly, those who have the education, skills, right types of jobs, financial resources, and time required to navigate the sea of cultural choice will gain access to new cultural opportunities. They will be the ones who can invest in their creative hobbies, writing songs, knitting, acting, singing in a choir, and gardening. They will be the pro-ams who network with other serious amateurs and find audiences for their work. They will discover new forms of cultural expression that engage their passions and help them forge their own identities, curate their own expressive lives, and enrich the lives of others; they will be among the rising creative class (Florida 2002).

At the same time, those citizens who have fewer resources—less time and money, diminished social networks, and less knowledge about how to navigate the cultural system—will increasingly rely on the cultural fare offered to them by consolidated media and entertainment conglomerates. They will engage with arts and culture through large portals like Wal-Mart or Clear Channel radio. They will consume hit films, television reality shows, and blockbuster novels; their cultural choices will be limited to the narrow gates defined by the synergistic marketing that is the hallmark of cross-owned media and entertainment. Finding

it increasingly difficult to take advantage of the pro-am revolution, such citizens will be trapped on the wrong side of the cultural divide. Technology and economic change are conspiring to create a new cultural elite and a new cultural underclass.

Cultural Vitality: Participation and the Public Interest

How are we to make sense of these cultural changes? In some cases they will exacerbate the cultural divide, and in others they will reduce inequalities. But for policymakers and arts leaders to expand or enrich cultural participation in the face of these changes, it is necessary to have a clear set of criteria for what we would consider serving the public interest. What levels of participation and types of engagement should we aspire to? When will we know when we have achieved our goals? In other words, from the public's standpoint, what constitutes cultural vitality?

In many areas of public life, there exists consensus around the notion of vitality. Economic vitality includes low unemployment, modest inflation, strong economic growth, a strong housing market, and a positive trade balance. Political vitality includes high voter turnout rates and an active citizenry who participates in self-government. It also includes meaningful voter choice and healthy debate. But what is cultural vitality, and are the aforementioned changes increasing cultural vitality in America?

As discussed in chapter 1, arts participation was originally linked to notions of citizenship and participatory democracy in the nineteenth century. Like religion and politics, culture was seen as an arena where citizens exercised their entrepreneurial spirit, where they expressed their individual voices, and where they connected to their neighbors and fellow community members. From this perspective, cultural vitality can be judged by the same criteria as political vitality. First, do citizens have the capacity to create or influence culture? Similar to voting, organizing a rally, speaking at a school board meeting, or participating in a campaign, *cultural capacity* includes the ability to play an instrument, to edit a film, to sing in a choir, or to otherwise add one's creative voice and talents to the larger cultural domain. Second, do citizens have ample choices? Political theorists argue that elections are only meaningful if citizens have real choices between candidates

and if some of those candidates reflect the voter's own preferences. Similarly, it is important to ask whether people have access to culture that speaks to their individual needs and preferences. Before the 1960s, most citizens who lived outside of major metropolitan areas did not have the opportunity to enjoy professional theatre or classical music or to visit a local art museum. Their choices were limited and cultural policy responded by building nonprofit, professional arts organizations across America. How are choices constrained today and for whom? Do people have meaningful choices between culture that is local and global, between art works that are contemporary and those that reflect and celebrate the past (heritage), between work produced in a community context and work that is made and presented by outside professionals?

Finally, do citizens have the opportunity to critique culture and to share and exchange ideas with fellow citizens? Political theorists from Immanuel Kant to Jurgen Habermas have argued that political vitality requires a thriving public sphere where citizens can debate and discuss the most important issues of the day. Similarly, as Conner contends in chapter 4, it is important for citizens to be able to express opinions about culture. This is what I call *cultural criticism and connoisseurship*. Audience leagues served this purpose in the nineteenth century. Some would argue that online social network sites are serving this function today, as young adults share their opinions and preferences with each other regarding, for example, music, films, books, video games, art exhibits, or television shows. Cultural criticism and connoisseurship, like political discourse, requires literacy, general knowledge, and a willingness to speak out and share opinions. It also requires an accessible forum where Americans can debate art and culture, can share their judgments and ratings, and can connect to one another around common cultural tastes and interests.

In many ways the cultural changes discussed in this book have the potential to advance all three dimensions of cultural vitality: capacity, choice, and criticism and connoisseurship. To realize this potential, policymakers and cultural leaders need to be more thoughtful and deliberate about how to support cultural engagement in the twenty-first century.

Moving Forward: New Research on
Changing Patterns of Participation

Although the contributors to this volume have sketched the contours of the changing patterns of participation, more research is needed to fill in the texture and details. In many ways our current knowledge and discussion about arts participation in American mirrors the conversation that took place ten years ago with regard to civic participation. At that time, Robert Putnam published an article in the *American Prospect* (1996) that argued that according to most indicators (e.g., voting, church attendance, party affiliation, Parent–Teacher Association [PTA] and Rotary club memberships), America was suffering from a decline in civic participation. Putnam's argument, later expanded in his book *Bowling Alone* (2000), generated much publicity and scholarly interest. Many were convinced that the great civic generation—composed of those who came of age during the 1940s and 1950s—was behind us and that the social glue that held America together was beginning to wear thin. Putnam and others maintained that the decline was due, in part, to the growing pervasiveness of television and home entertainment.

Today, scholars and arts leaders lament the seeming decline of cultural participation. Similarly, they see the passing of the great cultural generation—those arts enthusiasts who filled our concert halls and theatres and whose patronage supported the flourishing of art across America. Some of the available indicators, as noted earlier, affirm these fears, consistently showing that young people are not maturing into their roles as consumers and patrons of the benchmark art forms. Like civic participation, many critics blame television, the Internet, video games, and other forms of popular entertainment for this imminent demise.

As it turns out, Putnam was only partly right about civic participation. Scholars began searching for other indicators, employing different methodologies, and asking new questions about the nature of participation. What they found was that civic engagement was alive and well but was showing up in new places: in soccer leagues rather than the PTA, in donations to the Sierra Club rather than local political parties, in support and self-help groups rather than established churches. These new forms of participation did not entirely replace old forms, nor did they serve the same functions or elicit the same types of social capital. But the emerging

picture of participation was much more complicated than Putnam first thought and the strategies for building participation more varied.

Similarly, we expect that our current fears about declining cultural participation are not without merit, but they are constrained by old assumptions and ideas. What are the cultural equivalents to soccer leagues, running clubs, and new political and spiritual movements? Do these new forms of cultural engagement provide the same rewards and expressive opportunities as older forms? Do they complement or compete with these established traditions? Do they meet the criteria for cultural vitality already discussed? Research is needed that documents how arts and culture fit into and animate the lives of a diverse sample of citizens. Scholars need to spend time with citizens in their homes and in their communities, listening to how they describe their cultural commitments and engagement—their habits of interacting with and expressing themselves through the arts.

Moving Forward: Increasing Cultural Vitality for All Americans

Build and Support Citizen Capacity

Forty-five years ago, Lyndon Johnson signed Public Law 209, which created the National Endowment for the Arts. At the time, he noted the importance of supporting a "nation's most precious heritage" and bringing national support to "a great national asset" (Zeigler 1994, p. 17). The ball was set in motion to support professional art making in this country through grants to state agencies, nonprofits, and individual artists. But what if instead of funding professional arts, the government had made millions of dollars available in the form of cultural vouchers—where individual citizens could apply for a voucher to use toward developing proficiency in an art form—from playing the guitar to drawing to basket making and animation? How would this alternative path have affected arts participation, nonprofit arts, or the size and quality of professional artists? It is impossible to know where such a policy would have led, but a comparison with another area of culture life—sports—provides some possible answers.

By most measures, sports continue to thrive in America. Cities line up to offer millions and millions of public subsidy to attract professional

football, basketball, and baseball teams; sports networks are flourishing; and sports coverage remains a prominent feature of daily newspapers and radio talk shows. How is it that professional sports have captured the imagination of so many Americans? John Kreidler (2005), of Cultural Initiatives of Silicon Valley, contended that sports, compared to the arts, has a much healthier ecosystem that blends sports literacy, amateur practice and professional goods and services. He argued that professional athletes sit on top of a pyramid whose base includes all of those Americans who know about sports, are familiar with the rules of the game, occasionally read the sports page, follow their favorite teams and athletes, and devote countless hours to watching games. The middle layer of the pyramid includes the millions of Americans who actually play sports—all of our children who are members of school and recreational teams, avid runners, amateur tennis and golf players, swimmers, bicyclists, and the millions of others who participate in some physical activity. The combination of sports literacy and practice combine to create a huge base of fans who care about professional sports because they understand, judge, and appreciate the excellence exhibited by professionals and because they can connect the activities they watch on TV and read about in the newspapers to their everyday lives. Of course, this thriving sports ecology did not just blossom overnight, nor was it the outcome of the market's invisible hand. Rather, it emerged as the result of strategic policy interventions, most of which have been directed at amateur athletes—investing in everything from parks, bike paths, and athletic complexes to youth sports leagues, physical fitness centers, and physical education in schools. The National Collegiate Athletic Association (NCAA) and intercollegiate athletics has been one of the most important and sizable policy tools to encourage and reward amateur sports.

Professional artists, like professional athletes, sit on top of a pyramid in which the base is made up of both avid fans and enthusiasts and amateur art makers. Unlike sports, however, cultural leaders focus their intervention only at the peak of the pyramid. This strategy ignores the reality of how art and culture is experienced by most Americans. Ruth Finnegan, an anthropologist from the Open University, puts it this way: "To focus on the professional side alone is to omit the symbiosis and interdependence of the amateur and professional worlds, where the first, at the least, provides the essential training ground, expert enthusi-

asts and reservoir for the second, and to miss the pervasive interaction, overlap, and movement between them" (Finnegan 2005, p. 3).

In summary, the old cultural policy model in the United States was predicated on the delivery of certain types of arts to citizens across the country; the new model must be focused on unleashing the creative and expressive potential of all citizens. In addition to supporting organizations that present professional arts, foundations and other cultural policy actors can provide cultural tool kits for citizens. They can create or support community-based media centers where aspiring filmmakers can go to learn to make films, find mentors and teachers, borrow equipment, edit films, present their work to the public, or otherwise further their expressive capacity. They can support libraries where musicians can borrow instruments, and arts collectives, where printmakers share a printing press or photographers share a dark room. They can partner with for-profit purveyors of instructional videos and DVDs (a blossoming market) so that citizens can get free access to videos that teach techniques of drawing and painting, playing an instrument, dancing, acting, photography, and other media arts. Funders can support spaces—stages, rehearsal spaces, studios, laboratories—where citizens can nurture and develop their creative capacities. Cultural policymakers can and should, in the words of Amartya Sen (1998, p. 317), "expand the facilities that local culture gets to present its own ware, both locally and beyond it."

Expand and Facilitate Choice

In terms of choice, we are living in an age of abundance. Given the explosion of cultural options, it is hard to make a case that policy leaders need to pay attention to choice as a dimension of cultural vitality. Nonetheless, there are significant areas where choice has been constrained, and evidence suggests that too much choice can have negative consequences for consumers and audiences (Schwartz in chapter 10).

First, as mentioned already, choice and diversity in cultural offerings can be constrained when media outlets are concentrated in the hands of a few big corporations. In those cases where the evidence suggests that diversity and choice are threatened, cultural leaders need to form alliances with public interest groups to push back against deregulation and consolidation.

Of course, expanding choice must be coupled with reliable filters to help people navigate the potentially overwhelming number of options. These filters might include software that helps people find the books, films, and music that they like (e.g., collaborative filters) or institutions that use their brand name and reputation to sell or recommend certain products and services (e.g., critics' picks for the *New York Times*; objects sold by the Guggenheim's museum shop), and they might include friends, colleagues, and others who share or make recommendations. Without such filters, Schwartz (chapter 10 in this volume) argues that consumers and audiences will turn into pickers rather than choosers— that is, we will settle on or pick from those cultural options that are most readily available rather than actively choosing art and culture that might challenge, invigorate, or otherwise enrich us. How can cultural policy ensure that the right intermediaries or filters exist? What values do we want to embed in those processes, tools, and technologies that help people filter and find culture?

This is a question that deserves broad debate and discussion. But, as a beginning, I would suggest a few important criteria. First, filters should help people widen, rather than narrow, their cultural horizons. Some observers fear that certain types of collaborative filters might only recommend items that feed the *daily me* phenomena—offering those things that narrowly reinforce existing preferences and tastes. And, as Rossman points out in chapter 11, the interests of organizations (both nonprofit and for-profit) often lead to the use of research and technology to give people what they know they want, thus reducing the risk of selling books, songs, or movies that are new and unfamiliar. Thus, neutral filters—technologies and cultural brokers—should be established that serve the interests of audiences and consumers rather than the specific needs of organizations to sell products or fill performance halls. Such devices and techniques should encourage variety seeking in ways that efficiently match people with potentially meaningful cultural experiences.

Second, we should prioritize and support those filters and devices that promote and rely on social networking. The process of discovering new art and culture is social: It involves forming and sharing judgments, opinions, and critiques. In short, filtering itself can be driven by connoisseurship, criticism, and connection, which is one of the key dimensions of cultural vitality. By nurturing modern-day audience leagues—arts clubs, forums, social networking sites—policymakers can

create the types of organic, social filters that help people narrow their choices without narrowing their horizons. Finally, policymakers could consider investing in and supporting cultural mavens. In addition to funding artists and arts organizations, perhaps resources could flow to mavens and cultural ambassadors, those people who are writing blogs, making mixed CDs, creating podcasts, or otherwise serving as information gateways.

Nurture and Enable Critique, Connoisseurship, and Connection

Critique and connoisseurship ultimately entail helping citizens form a deeper engagement with art and connecting audiences and fans to artists as well as to one another. One way to deepen engagement is to allow audiences to see behind the curtain—to witness, in the words of sociologist Erving Goffman (1959), the backstage interactions and behavior that lie behind every great performance or exhibition. Over the course of the twentieth century, as national art markets grew and as the arts became more professionalized, producers and presenters erected walls between audiences and art making. Art was presented to the public in its finished form as an embodiment of excellence and perfection; rough edges were polished down; blood and sweat were cleaned up; the creative process was out of sight. This form of presentation overlooks the interest that audiences have in the creative process itself. In chapter 9 in this volume, Swerdlow describes how technology can increasingly be used to give audiences insight into the creative process—describing one dance troupe that showed audience members a videotape of rehearsals that included missed jumps, jumbled choreography, and disagreements between dancers and artistic directors. Similarly, the wild success of reality TV shows, such as Bravo's "Project Runway," which follows the trials and tribulations of a group of fashion designers, provides evidence of the interest and enthusiasm audiences have for witnessing the creative process. Policy must help audiences get backstage to see the inner workings of creative pursuits.

Finally, audiences can be connected to the creative process by becoming patrons. One of the more interesting new models to support the arts is commissioning clubs. Anywhere from a few people to several hundred can come together to support the creation of new works of art—commissioning a series of paintings or prints, public sculpture,

plays, musical compositions, and dance. These projects can be small or large and can involve each club member giving anywhere from fifty to several thousand dollars each. Typically, a commissioning club meets with its chosen artists several times during the course of a project's evolution and often gets to see early versions of the final product. In short, commissioning clubs represent an opportunity not only to support professional artistic activity but, more importantly, to involve many more Americans in the creative process itself as well. Again, though such clubs have sprung up without outside support, it is possible for foundations, nonprofits, and agencies to facilitate commissioning clubs by providing advice and financial mechanisms often unavailable to such unincorporated groups.

Cultural criticism and connoisseurship can also be enhanced by linking dedicated fans together in a community of discourse. Marty Khan (2006, p. 88), a veteran jazz advocate and producer, argued that spending time cultivating serious fans is not only important in terms of developing an audience base, but it is also an opportunity for artists to get feedback from dedicated and smart connoisseurs: "New technology means that those two or three thousand fans worldwide that record companies and promoters view as not warranting an investment take on a much greater value to the artists." Jenkins (1992), scholar of comparative media at the Massachusetts Institute of Technology and contributor to this volume, wrote about the practices of serious fans who critique and write about the object of their affection through self-produced fanzines and online forums; they interact with artists and producers, offering feedback and suggesting new directions (e.g., new plot developments, new characters, new endings); they engage with other fans at conventions or through the Internet; and they often create their own forms of art—books, films, posters, music, drawings, costumes—derived from the artworks they love. In many ways, Jenkins's fans engage in the sorts of activities common to the types of audience leagues that Conner discusses in chapter 4 in this volume. Part of the challenge for policymakers who care about arts participation is to encourage more fan-like behavior—more connoisseurship and conversation. Fandom is more than being a season ticket holder: It means becoming an active member of a community in which the enjoyment and pleasure of participating includes sharing opinions, linking up with others, and incorporating one's cultural interests into daily life and conversation. Raising the bar of participation—

forcing audience members to go beyond mere attendance to become connoisseurs and critics—seems like a daunting challenge in a world where time and attention are scarce. But, somehow, millions and millions of sports fans rise to the occasion every day, finding time to read the sports pages, analyzing and responding to sports blogs, discussing and debating players, coaching strategies, rule changes, and controversial calls. For these audiences, fandom seems like a natural part of their lives. Cultural vitality requires the same devotion and commitment.

Thomas Bender (2003), historian at New York University, tracked "the thinning of American political culture" in a book of that title. Bender argued that, in the nineteenth century, there was a thick interdependence between social life and politics. People participated in political parties, they engaged in political debate with neighbors, and they attended rallies and campaign gatherings. In short, politics were embedded in social life and helped form and narrate everyday experience. Today, by contrast, the rise of national media, public polling, consumerism, celebrity politicians, expensive media-driven political campaigns, and weak political parties have created a thin political culture. Citizens have become passive political consumers. The exact same trend can be detected in our artistic and cultural lives.

In the twentieth century, as new media industries emerged, the United States moved away from thick cultural engagement. As art and art making were integrated less into everyday life, we experienced a type of thin participation, defined more by national celebrities, professionals, experts, spectacle, big media, and passive participation. In the twenty-first century, we can observe encouraging signs of renewed thickening, but not for everyone. A thick cultural life requires meaningful choices, the capacity to create and express oneself, and opportunities to develop and actively share opinions and ideas about culture with others. For some Americans, what we might call the cultural elite, the transformations described in this book are increasing each of these dimensions of vitality. But our suspicion, and the suspicion of several of the authors in this volume, is that not all citizens are benefiting equally from the changes. Our challenge today as educators, artists, and arts leaders is to harness the next great transformation in America's cultural life for the benefit of all citizens.

Bibliography

Anderson, Chris. 2006. *The Long Tail: Why the Future of Business Is Selling Less of More.* New York: Hyperion.

Bender, Thomas. 2003. "The Thinning of American Political Culture." In *Public Discourse in America Conversation and Community in the Twenty-First Century,* edited by Judith Rodin and Stephen P. Steinberg, 27–34. Philadelphia: University of Pennsylvania Press.

Brooks, Arthur. 2002. "Artists as Amateurs and Volunteers." *Nonprofit Management and Leadership* 13, no.1.

Csikszentmihalyi, Mihaly. 1988. "Society, Culture, and Person: A Systems View of Creativity." In *The Nature of Creativity: Contemporary Psychological Perspectives,* edited by Robert J. Sternberg, 325–339. Cambridge, UK: Cambridge University Press

Feldman, Henry. 1999. "The Development of Creativity." in *The Handbook of Creativity,* edited by Robert Sternberg, 169–188. New York: Cambridge University Press.

Finnegan, Ruth. 2005. "Who Are the Professional Artists and Why Support Them?" Curb Center Brief, Internal Document, October. Available at www.vanderbilt.edu/curbcenter/publications.

Florida, Richard. 2004. *The Rise of the Creative Class.* New York: Basic Books.

Goffman, Erving. 1959. *The Presentation of Self in Everyday Life.* New York: Doubleday Anchor.

Hall, Sir Peter. 1998. *Cities in Civilization.* New York: Pantheon Books

Hargittai, Eszter. 2006. "Just a Pretty Face(book)? What College Students Actually Do Online." Beyond Broadcast Conference, Harvard Law School, Cambridge, MA, May 12. http://forum.wgbh.org/wgbh/forum.php?lecture_id=3138.

Ivey, Bill, and Steven Tepper. 2006. "Cultural Renaissance or Cultural Divide?" *Chronicle of Higher Education* 52, no.37 (May 19), section B6–B8.

Jenkins, Henry. 1992. *Textual Poachers: Television Fans and Participatory Culture.* New York: Routledge.

Khan, Marty. 2006. "Valuing the Audience." *Chamber Music,* February, p. 88.

Kreidler, John. 2005. *Creative Community Index: Measuring Progress toward a Vibrant Silicon Valley.* Cultural Initiatives of San Jose, CA., Silicon Valley.

Leadbeater, Charles, and Paul Miller. 2004. *The Pro-Am Revolution: How Enthusiasts Are Changing Our Economy and Society.* London: Demos.

Lenhart, Amanda, and Mary Madden. 2005. *Teen Content Creators and Consumers.* Washington, DC: Pew Internet & American Life Project.

Moriarty, Pia. 2004. "Immigrant Participatory Arts: An Insight into Community-Building in Silicon Valley." *Inquiries into Culture Series.* Cultural Initiatives Silicon Valley. http://www.ci-sv.org/can_imm_pa.shtml.

National Endowment for the Arts. 2004. "2002 Survey of Public Participation in the Arts." Research Division Report 45. Washington, DC: National Endowment for the Arts.

Putnam, Robert. 1996. "The Strange Disappearance of Civic America." *American Prospect* 7, no. 24 (December 1): 37–39

_____. 2000. *Bowling Alone: The Collapse and Revival of American Community*. New York: Simon and Schuster.

Sen, Amartya. 1998. "Culture, Freedom, and Independence." In UNESCO, World Culture Report. Paris: UNESCO Publishing. p. 317–321.

Urban Institute. n.d. "National Center for Charitable Statistics: Unified Database of Arts Organization." http://nccs2.urban.org/udao_overview.pdf.

U.S. Census Bureau. 2004. "U.S. Interim Projections by Age, Sex, Race, and Hispanic Origin." March 18. http://www.census.gov/ipc/www/usinterimproj/.

Zeigler, Joseph. 1994. *Arts in Crisis*. Chicago: Acapella Books.

About the Authors

Vanessa Bertozzi lives in Brooklyn and works at the intersection of media, technology, and fan cultures. A graduate student of the Massachusetts Institute of Technology Comparative Media Studies Program, Bertozzi wrote a thesis examining the history of unschooling and participatory media. Currently she works for Etsy.com, an online community marketplace for all things handmade.

Lynne Conner is a theater historian, playwright, and arts consultant. She is associate professor in the Department of Theatre Arts at the University of Pittsburgh, where she teaches courses in theater and dance history and dramatic literature. As an arts consultant, her current research interests are focused on studying the history of audience behavior and psychology to design more effective audience enrichment programming for today's cultural consumers.

Daniel B. Cornfield is professor of sociology at Vanderbilt University, an advisor to the Curb Center for Art, Enterprise and Public Policy at Vanderbilt, and editor of the international scholarly journal *Work and Occupations*. His research addresses labor, the careers of music professionals, and immigration in new destination cities and has been supported by the National Science Foundation, Russell Sage Foundation, and the United Nations International Labor Office.

Paul DiMaggio is professor of sociology at Princeton University and research director of Princeton's Center for the Arts and Cultural Policy Studies. In addition to research on participation in the arts, he is studying the implications of information technology for social inequality as

well as patterns of cultural conflict in the United States during the last third of the twentieth century.

Bonnie Erickson is a native of Vancouver, Canada, and has a B.A. and M.A. from the University of British Columbia and a Ph.D. from Harvard University. She is professor of sociology at the University of Toronto and also teaches in Asia and Europe. Her major research interests are social networks, culture, and inequality.

Yang Gao is a graduate student in sociology at Vanderbilt University. After graduating from Peking University in China as an undergraduate majoring in sociology, she received a master's degree in sociology from the Chinese University of Hong Kong in 2005. Gao's interests are the sociological study of communication, mass media, and culture in general.

Eszter Hargittai is assistant professor of communication studies and sociology and is faculty fellow of the Institute for Policy Research at Northwestern University, where she heads the Web-Use Project. She received her Ph.D. in sociology from Princeton University, where she was a Wilson Scholar.

Bill Ivey is director of the Curb Center for Art, Enterprise, and Public Policy at Vanderbilt University. From May 1998 through September 2001, Ivey served as the seventh chair of the National Endowment for the Arts. Ivey holds degrees in history, folklore, and ethnomusicology as well as honorary doctorates from the University of Michigan, Michigan Technological University, Wayne State University, and Indiana University. His book about the public interest and America's cultural system will be published by University of California Press in 2008.

Henry Jenkins is director of the Massachusetts Institute of Technology Comparative Media Studies Program and the Peter de Florez Professor of Humanities. He is the author and editor of nine books on various aspects of media and popular culture. His latest books include *Convergence Culture: Where Old and New Media Collide* (New York University Press, 2006) and *Fans, Bloggers and Gamers: Exploring Participatory Culture* (New York University Press, 2006).

Jennifer C. Lena is assistant professor of sociology at Vanderbilt University. She received her Ph.D. in sociology from Columbia University. Her research program aims to understand the field, organization,

and small-group dynamics that give rise to innovation and construc-
tions of authenticity.

Toqir K. Mukhtar was formerly research project director for the Princ-
eton University Center for Arts and Cultural Policy Studies. Her research
interests include empirical studies of arts participation and copyright.

Francie Ostrower is senior research associate at the Urban Institute
Center on Nonprofits and Philanthropy, where she conducts research on
foundations, governance, and cultural participation. Ostrower received
her Ph.D. in sociology from Yale University, where she also served as
associate director of the Program on Nonprofit Organizations. Prior to
joining the Urban Institute in 2000, she was a sociology faculty member
at Harvard University.

Richard Peterson is emeritus professor of sociology at Vanderbilt
University. He worked a year in the Research Division of the National
Endowment for the Arts exploring culture indicators and helping to
develop the Survey of Public Participation in the Arts. His work centers
on the sociology of culture, organizations, social class, and the music
industry.

Gabriel Rossman is assistant professor of sociology at the University
of California, Los Angeles. His specialties are the mass media, culture,
and economic sociology. He earned his Ph.D. in sociology from Princ-
eton University with the dissertation "The Effects of Ownership Con-
centration on Media Content."

J. Mark Schuster is professor of urban cultural policy at the Mas-
sachusetts Institute of Technology and is a public policy analyst special-
izing in the analysis of government policies and programs with respect
to the arts, culture, and urban design. He has served as a consultant to
the Council of Europe, UNESCO, the Arts Council of Great Britain,
National Endowment for the Arts, the Canada Council, Canadian Her-
itage, the Arts Council of Ireland, the London Arts Board, the British
Museum, and National Public Radio, among many others.

Barry Schwartz is the Dorwin Cartwright Professor of Social The-
ory and Social Action in the psychology department at Swarthmore
College, where he has taught since receiving his Ph.D. in psychology in
1971. He works at the intersection of psychology and economics and is

the author of many articles and several books, including the *Paradox of Choice: Why More Is Less* (Ecco Press, 2004).

Joel Swerdlow is a professor, author, journalist, and researcher who studies the impact of communication technologies. He has lectured at the Baylor University School of Medicine and the Massachusetts Institute of Technology and numerous other universities. Swerdlow holds a Ph.D. and M.A. from Cornell University.

Steven J. Tepper is associate director of the Curb Center for Art, Enterprise, and Public Policy and assistant professor in the Department of Sociology at Vanderbilt. He has published articles on the sociology of art, cultural policy, and creativity and holds a bachelor's degree in international relations and Latin America from the University of North Carolina, Chapel Hill; a master's in public policy from Harvard University's John F. Kennedy School of Government; and a Ph.D. in sociology from Princeton University.

David Touve is in the Ph.D. program in management at Vanderbilt University, within the organizational studies group at the Owen Graduate School of Business. He received an M.B.A. from the Australian Graduate School of Management, with additional coursework at the Stern School of Business at New York University, and received a B.A. in economics from Northwestern University.

Robert Wuthnow is Andlinger Professor of Sociology and director of the Center for the Study of Religion at Princeton University. He is the author of more than twenty books and has received numerous grants and scholarly awards, including the Martin Marty Award for Religion and Public Life from the American Academy of Religion, a Guggenheim Fellowship for his work on religion and diversity, and the 2003 Graduate Mentoring Award in Social Science from Princeton University.

Index